Yale Publications in the History of Art
Walter Cahn, editor

Frederic Remington & Turn-of-the-Century America

Alexander Nemerov

Yale University Press / New Haven & London

 Yale Publications in the History of Art are works of critical and historical scholarship by authors for-
merly or now associated with the Department of the History of Art of Yale University. Begun in 1939,
the series embraces the field of art historical studies in its widest and most inclusive definition.

Series logo designed by Josef Albers and reproduced with permission of the Josef Albers Foundation.

Published with assistance from the Mary Cady Tew Memorial Fund.

Designed by Deborah Dutton.

Set in ITC Century type by Highwood Typographic Services, Hamden, Connecticut.

Printed in the United States of America by Thomson-Shore, Dexter, Michigan.

Library of Congress Cataloging-in-Publication Data

Nemerov, Alexander.

 Frederic Remington and turn-of-the-century America / Alexander Nemerov.

 p. cm. — (Yale publications in the history of art)

 Includes bibliographical references and index.

 ISBN 0-300-05566-8

 1. Remington, Frederic, 1861–1909—Criticism and interpretation.

 2. West (U.S.) in art. 3. Art and society—United States—History—19th century. I. Title. II. Series.

 N6537.R4N46 1995

 709′.2—dc20 95-1223

 CIP

A catalogue record for this book is available from the British Library.

The paper in this book meets the guidelines for permanence and durability of the Committee on Production
Guidelines for Book Longevity of the Council on Library Resources.

10 9 8 7 6 5 4 3 2 1

For my mother and in memory of my father

Contents

Acknowledgments

Without the support and guidance of many people, I could not have written this book. At Yale University, Jules Prown, Howard Lamar, Jonathan Weinberg, and Bryan Wolf read my dissertation on Frederic Remington; their eloquent criticisms and suggestions have made this a better book. John Peters-Campbell gave the dissertation an exceptionally thoughtful close reading. Diane Dillon, Kenneth Haltman, David Lubin, and Angela Miller have been valued friends and counselors over the years. Finally, I could not have asked for a better, friendlier place to research and write the dissertation than the Smithsonian's National Museum of American Art, where I was a Material Culture Fellow from 1989 to 1992.

During my time at Stanford University, many people have taught me about Remington and about being a historian of culture. Jay Fliegelman, Jennifer Roberts, and Jessica Seessel read earlier drafts of the manuscript and offered invaluable suggestions, talking me out of certain readings and offering insights I could not have conceived on my own. My research assistant, Lisa Lenker, covered every topic from marionettes to the moon, making great finds that are reflected in these pages. The students in my Art of the Old West seminar, taught in fall 1993, pursued original projects that influenced my view of Remington. They also provided a first critical audience for some of the ideas presented here, notably those in Chapter 2.

Many people at various museums and galleries helped me in the preparation of this book. In particular I would like to thank Melissa Webster, assistant curator at the Buffalo Bill Historical Center's Whitney Gallery of Western Art, in Cody, Wyoming, who was never too busy to answer my frequent questions on Remington; and Laura

Foster, curator of the Frederic Remington Art Museum, in Ogdensburg, New York, who was likewise gracious and patient.

Others I would like to thank include Elizabeth Anderson, collections manager of the National Museum of American Art, for securing the details of *Fired On*, which looks wonderful in its new black frame; Allen Burns, of Ogdensburg, New York, for his excellent close-up photographs of Remington's *Polo*; David Kurtz, of Palo Alto, California, for his help in the preparation of the manuscript; Doris McNamara, of Palo Alto, for grants to offset the cost of research and photography; Margy Sharpe, of the National Museum of American Art, for her help in securing details of *Apache Medicine Song*; and Nicole Squires, assistant slide librarian at Stanford, for her photographs from some books in Stanford libraries. At Yale University Press my editors, Judy Metro and Mary Pasti, have been supportive, helpful, and patient.

There are three people I would like to thank especially. One is Jules Prown, my adviser at Yale, for being unfailingly supportive and—no small thing—giving me a way to look at art. Another is Bryan Wolf, whose class on American art, taught in winter 1987, during my first year in graduate school, introduced me to many of the methods that I use in this book. The third is William Truettner, my adviser at the Smithsonian, for encouraging me to work on Remington and for reminding me that I had something to say.

Introduction

For several years I examined the vitiated mementos of the strenuous life—the arti-
facts inhabiting the gloomy re-created studios, cabins, and hunting lodges that, these
days, evoke the world of Frederic Remington. I mean the rusted animal traps and
stuffed buffalo heads, accession numbers painted on their horns; the grizzly hides sag-
ging from log-cabin walls, stiffly snarling at the crinkled silver paint-tubes strewn in
approximate period array. Many Remington scholars have attempted, literally and
figuratively, to take his art out of this decrepit, dark realm. They have often seen
Remington's trademark pictures as literal transcriptions of either the facts or the
spirit of westward expansion and as aesthetically valuable contributions to American
art.[1] As such, the pictures may still speak to us today. Much of this kind of work—
Peter Hassrick's account of Remington's impressionism, for example—has helped
place the artist more securely in his time (even as it has sought to lift him out of
that time, transforming him into a transcendent master of American art). Other
accounts—notably G. Edward White's *The Eastern Establishment and the Western
Experience: The West of Frederic Remington, Theodore Roosevelt, and Owen Wister*
(1968)—have done a fine job of placing Remington himself, if not his art, in historical
context. Still other accounts have condemned Remington for conspicuously failing to
live up to contemporary standards of morality.[2] My approach differs from all of these.
I confess to a fascination with the dark spaces that most accounts of Remington seek
to avoid.

 What I have in mind is a certain historical ambience of which the tenebrous, relic-
filled period room is the emblem. Something about these spaces, I feel, is intrinsic to

the culture they represent, as if they had been decrepit and dark before falling into disrepair—as if disrepair were something like their original state. Granting that my authorial gaze inevitably darkens the obscure places into which I stare, I nonetheless hope that a certain form of historical illumination will appear from this double darkness—as if the dark room of the past were beheld more clearly at night. In this book I examine Remington's art in terms of various discourses, dominant at the time he worked, that inhabit his art like artifacts in a period room: theories of social evolution; belief in (and doubt about) a strenuous and misogynistic masculinity; belief in (and doubt about) the imperialist conquest of Cuba and the Philippines; fears about widespread immigration to the United States and a corresponding crisis of "Anglo-Saxon" identity; theories of memory, telepathy, and the recovery of the past; and anxiety about the materiality of representation.

My goal is neither to celebrate Remington nor to debunk him in the manner of a revisionist history; it is to look closely at his art and to treat it with the attention it deserves. In this way, I hope, the book may help restore Remington's art to its centrally important place, largely forgotten now, in the fascinating, untranscendent spaces of turn-of-the-century American culture. The book may also provide a new way of looking at this culture generally, both in terms of the meanings available to its artists and writers and in terms of the methods we might bring to its examination.

Several rules are necessary to navigate the darkness of Remington's world. The book does not treat turn-of-the-century discourses as "contexts," where the art in question is a passive reflection of ideas prior to and apart from itself. Instead, it is an attempt to show how the works shaped the discourses of which they were part—and how they did so not just in terms of their obvious content (cowboy shoots Indian, Indian shoots cowboy) but also in terms of their less prominent features: brushwork, signatures, and other details. Further, I take it for granted that the works in question do not schematically embody just one of these discourses but perhaps several or all of them; that they may do so in a conflicting, confused, and thoroughly overdetermined manner; and that, finally, they may do so in ways that do not necessarily embody hegemonic attitudes.

I do not treat Remington as a creator, an autonomous subject capable of generating his own authentic approving or disapproving belief about the issues in question. Some of his pictures, to be sure, are "about" these discourses, in the sense of being intentional allegories. *The Story of Where the Sun Goes*, for example, is clearly a deliberate allegory about social evolution (see fig. 21). For the most part, however, these discourses are generally invisible within Remington's art; they exist as the tacit

assumptions according to which he made his paintings and sculptures. Invisible though they may be, the discourses are somehow present, existing as a kind of inform-ing essence that dictates the content and form of each work. They are the smoking guns we do not see. The invisibilities informing Remington's art—meanings of which he himself was unconscious—are chiefly what we can hope to discover in this book.[3]

Much recent scholarship has shown that the theory of a discourse opens a work to all sorts of previously unthought-of and fascinating connections.[4] I hope this book is no exception. If various figures living at the same cultural moment each have access to the same set of metaphors, employing these metaphors freely and easily—as matters of fact—then it stands to reason that a great many contemporaneous writers and artists, even without explicit knowledge of one another's work, will express the same or similar ideas. This principle is a key methodological feature of this book. In what follows I have linked Remington's ideas to those of his contemporaries, well known and obscure alike. These include fellow western artists like Charles Russell and Charles Schreyvogel and writers, historians, and philosophers (not all of them Amer-ican) like Edgar Rice Burroughs, Joseph Conrad, Arthur Conan Doyle, George Du Maurier, Henry James, William James, Rudyard Kipling, Jack London, Theodore Roosevelt, Upton Sinclair, Bram Stoker, Augustus Thomas, and Owen Wister, as well as lesser-known figures (magazine writers, university professors, soldiers).

Remington knew some of these people—Thomas, Roosevelt, and Wister. But the connections I discover are rarely matters of "influence"—a limited art-historical cate-gory that I have largely avoided. Rather, the connections are indirect. If Remington and London say virtually the same thing, as they often do, it is not because they knew each other (they did not), nor because they were influenced by each other, nor even because they spoke the same language, but rather because this same language spoke through them. Instead of being an artist parochially limited to documentable influ-ences, Remington begins to appear as an integral part of the vast culture that gener-ated the meanings in his work.

Although my goal is to link Remington's art to that of other writers and artists and thus to the culture at large, I focus on Remington's art itself. Only sharp attention to the works—coupled with careful examination of Remington's papers and other per-tinent period documents—can begin to reveal their less obvious and invisible mean-ings.[5]

That complexity of this sort should be an issue may seem odd. Surely it is the strength—or failing—of Remington's art, depending upon your point of view, that it should be absolutely straightforward. The art critic Sadakichi Hartmann explained the

view during the artist's lifetime, arguing that Remington can "'suggest' absolutely nothing" but "only 'represent.'"[6] According to this idea, a painting by Remington, like any realist work, depicts nothing more or less than what it shows—with perhaps, at most, a harmless gloss or sprinkle of symbolism on top. Yet Remington's work often does suggest a lot. The power of suggestion is partly the artist's own doing—the result of a plan, as he said, to "let your audience take away something to think about—to imagine."[7] It is also the result of his occasional ability to hit upon visual metaphors compelling enough to embody, in a powerfully overdetermined manner, many of the preoccupations of his culture. The circular hole in *Fight for the Water Hole* (see fig. 4), easily one of his greatest pictures, is such a metaphor. Finally, the power of suggestion is also partly inherent in representation. Even works that Remington himself regarded as literal illustrations—works which he came to hate and even burned up in his backyard, immolating them for their lack of evocation (*Your Soldier—He Say*, a painting that exists now only in reproduction, is an example [see fig. 108])—get credit in the pages that follow for being among the most suggestive he ever made.[8]

I try several ways of discovering this figuration. One is the location of formal relations between disparate motifs in the same painting or sculpture. I believe that these relations—between, say, the veins in the horses and the creases in the riders' clothes in *Polo* (see fig. 7)—operate as metaphors: the formal relation establishes a relation of meaning wherein the properties of one motif are transferred to the other, so that in this case the creases in the riders' clothes function as veins, establishing a series of metaphors about a kind of passionate (though contained) wildness for which blood itself is a metaphor. A second method is the location of similar formal relations in different works by Remington: The three sleeping figures in the late painting *In from the Night Herd* (see fig. 114) repeat the supine forms of three dead men in the earlier illustration *We Discovered in a Little Ravine Three Men Lying Dead with Their Bodies Full of Arrows* (see fig. 115), allowing us to understand the sleeping men in *Night Herd* as in some sense dead. Third is the location of relations between Remington's work and his contemporaries'—as, for example, in the virtually identical social-evolutionary views of Remington and London. Fourth is the location of relations between Remington's work and that of other artists from earlier times. Occasionally this last formulation is useful, as, for example, in elucidating Remington's inheritance from the baroque, yet it has to be used with care in historical inquiry; to map a relation between a work by Remington and an earlier artist—a relation based on their use of an identical motif—is no doubt illuminating in literary-theoretical terms (here I am

thinking of the Barthes of *S/Z*), for such a relation would demonstrate the "vast perspective of the *already-written*" in Remington's work, yet such a map can distort the motif's historical meaning.[9] Therefore I have avoided this kind of vertical intertextuality except where the meaning of a similar motif seems relatively unchanged across the centuries.

The kind of figuration that I locate in these ways may seem to be almost New Critical, in the sense that nothing more is desired than to bestow each motif in a work with a maximum and basically hermetic rhetorical power; yet I have tried to make it clear that the metaphors in Remington's work are not only potentially contradictory but also historically specific and quite politicized; that *Polo*'s equation between wild blood and stoic Anglo-Saxon riders, for instance, is fundamentally evolutionary—an equation connoting, for Remington, the animal passion lurking within the white man.

The complexity of Remington's art lies partly in its unexpected figurative richness. Yet an art can be complicated without ever presenting questions about its fundamental premises. Remington's most powerful pieces show evidence of an artist challenging inherited conventions of content and form. Certainly this is not true of most of his works. He made close to three thousand images, and to look at many of them, predominantly the early ones, is to be struck by their routine and uncritical inheritance of a variety of realist conventions. Yet many of Remington's late paintings—the ones made in 1906–9—display a wondering, not about the West, but about the nature of historical recovery and representation itself. These paintings prompt some important questions: Does the past simply exist, prior to and apart from the attempts of consciousness to retrieve or hold it? Or does it exist evanescently, held only "with the eye of the mind," to quote the title of a late painting? Are paint and canvas capable of mimesis, or do they refer primarily to themselves? One of the fascinating things about Remington is that he sought to preserve the past in paint and canvas at precisely the time when this kind of straightforward realism was being thrown irrevocably into doubt. Correspondingly, his late pictures—in particular, the moonlight and daub-and-dash impressionist scenes—betray an uncertainty about what paint and canvas are capable of representing. Is paint its self or what it represents? Remington's uncertainty about the question—he was a realist suddenly anxious about the founding principle of his art—is what makes these late pictures dark and powerful.

Remington himself, as I say, was probably unconscious of virtually all of the meanings I uncover in this book. I take him at his word when he writes, as he did many times in his later career, that he was interested only in preserving the West and becoming known as a good painter. His work is far more complicated than his own

description of it, however. *Unconscious* has two separate meanings here. One is akin to Fredric Jameson's theory of a "political unconscious." The other, subsumed under the first, is more psychoanalytic: certain motifs in Remington's art have the Freudian quality of repressed meanings returning, in displaced form, to inhabit the very works from which the artist would exclude them. In Remington's work, "mere paint," as well as the presence of the artist—both of which tend to haunt his realist scenes—are examples.

The artist's unconscious is often another term for the interpreter's imagination. With no proof, how do I know that the meanings I find are really *there*? I do not know. Yet we risk seeing nothing if we stare at the blinding illumination of documented or intentional meanings. I take it to be true that the meanings of which the artist is not conscious are often those that are most powerfully revelatory of the work's historical moment. Paradoxically, it is my job as historian—if I would be, as it were, most historical—to see into and speculate about the darkness. In so doing, I hope not to describe with immaculate clarity, giving the works a cold life, but to reinscribe the darkness in which they lie: to let my readers, like me, see Remington's art with closed eyes.

Chapter One / Stirring and Crawling

This animal was thoroughly a man of the world.
—Owen Wister, *The Virginian* (1902)

Wolf Larsen paused once or twice . . . to glance curiously at what must have been to him a stirring and crawling of the yeasty thing he knew as life.
—Jack London, *The Sea-Wolf* (1904)

Remington kept near the ground in all his thinking.
—Augustus Thomas, "Recollections of Frederic Remington" (1913)

In 1908, the year before he died, Frederic Remington painted *Apache Medicine Song*, an image of seven Apaches seated around a campfire (fig. 1, plate 1). Remington made the painting near the end of his nineteen-year residence in New Rochelle, New York, where he lived for most of his career. He and his wife, Eva, had moved to New Rochelle in 1890, after having lived in Brooklyn, Manhattan, and the Bronx the previous five years. By 1908, however, Remington was lamenting the change of this "pretty little American village" into a "d—— crowded . . . dry goods clerk European City" laden with immigrants and blacks. "I wish I could get out of it," he wrote in his diary on January 17, 1908, and the next year he and Eva did—selling their New Rochelle house as well as their summer home in the Thousand Islands to move into a custom-built house called Lorul Place on fifty acres in the rural community of Ridgefield, Connecticut. One visitor felt that the new house looked "like an old tower on which

wind and rain has blown for hundreds of years."[1] It was in this simulated baronial estate that Remington died, on December 26, 1909, at forty-eight, of appendicitis.

Remington's residences in the East exemplified his remove from the Old West depicted in his art. So did the making of *Apache Medicine Song*. The model for the picture's figures may have been the Kinrade he speaks of in his diary: "'Kinrade' my indian came to pose—says he is a Sac and Fox—he had a good figure but don't know how to put on a G string and is innocent of indian business. He acts tongue bred and dresses 'Western' actor fashion."[2] Although Remington made numerous trips west throughout his career, he always lived near Manhattan. If he wanted to sketch a buffalo, he went to the Bronx Zoo. If he wanted to portray a mounted soldier or Indian, he posed a model on a saddle display in his backyard in New Rochelle. Kinrade would call him on the telephone to schedule posing sessions.[3] In the era of automobiles and airplanes, it was not surprising that Remington wondered about preserving the Old West. "I

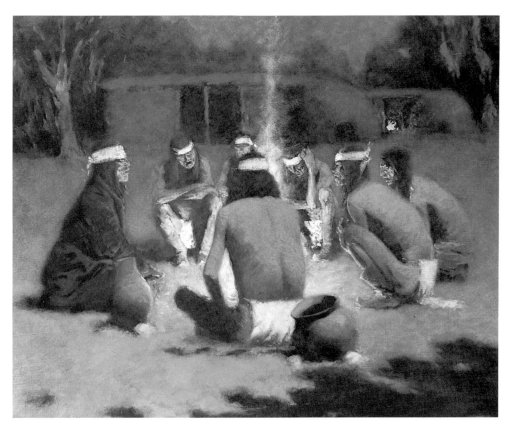

1. *Apache Medicine Song,* 1908. Oil on canvas, 27 ⅛ × 29 ⅞ in. Courtesy of Sid Richardson Collection of Western Art, Fort Worth, Texas. See plate 1.

sometimes feel that I am trying to do the impossible in my pictures in not having a chance to work direct," he wrote in his diary on January 15, 1908, possibly referring to his experience with Kinrade earlier in the month, "but as there are no people such as I paint it's 'studio' or nothing." The name of Remington's New Rochelle house was Endion, a mix of *Indian* and *end*.

Like other nighttime scenes from late in his career, *Apache Medicine Song* self-consciously recalls a moment from the trips that Remington took west as a young man. "I am now painting the things which I saw as a boy or things which I heard about from men who took active part in the stir of the early West," he told an interviewer in 1907.[4] *Apache Medicine Song* in fact recalls at least three campfire scenes that Remington either witnessed or participated in during the late 1880s and early 1890s. The first event, held on an Apache Reservation, was "a strange concert" full of "strange discordant sounds" and "shrill yelps," in which "half-naked forms huddled with uplifted faces in a small circle around a tom-tom." The second was at a campfire before which Remington himself was readying to sleep, when "I felt moved to sit up. My breath went with the look I gave, for, to my unbounded astonishment and consternation, there sat three Apaches on the opposite side of our fire with their rifles across their laps." A third and still more powerful firelit moment involved not an Apache but a Sioux. In South Dakota one night, Remington "sat near the fire and looked intently at one human brute opposite, a perfect animal, so far as I could see. Never was there a face so replete with human depravity, stolid, ferocious, arrogant, and all the rest." Of the painting's seven Apaches, the one second from the left—the only one fully facing us—most vividly recalls this description. He sits across the fire from the vantage point of viewer and painter, duplicating that moment in South Dakota, and his countenance is all menace. We can see the "human brute," the "perfect animal."[5]

Here, as elsewhere, Remington's language is that of social evolution. His writing and painting repeatedly refer to evolutionary processes that he hoped would eventually leave all but the Anglo-Saxon race extinct. He referred to Indians and so-called half-breeds, for example, as part of "the scrap-heap of departing races."[6] In these views, typical of his time, Remington voiced the ideas of such well-known evolutionary theorists as John Fiske, several of whose books he owned. Within three days of purchasing Fiske's *Century of Science and Other Essays* in 1908, Remington reported in his diary that he was reading it.[7] In "The Doctrine of Evolution: Its Scope and Purport," an essay in *A Century of Science*, Fiske laid out the tenets of social evolution. Following the approach of Herbert Spencer, his mentor, Fiske believed that history is synonymous with progress and that consequently no historian can operate

without a theory of progress. "[Spencer] could see that the civilized part of mankind has undergone some change from a bestial, unsocial, perpetually fighting stage of savagery into a partially peaceful and comparatively humane and social stage, and that we may reasonably hope that the change in this direction will go on." Spencer's observation of this change, continued Fiske, caused him to look to the biological development of human beings as a way of understanding history—hence the turn to nature to understand culture. "Between a savage stage of society and a civilized state," Fiske wrote, "it is easy to see the contrasts in complexity of life, in division of labour, in interdependence and coherence of operations and of interests. The difference resembles that between a vertebrate animal and a worm."[8]

The work that most graphically illustrates Remington's interest in evolution is a little-known sculpture, *Paleolithic Man*, from 1906 (fig. 2). The sculpture shows a crouching prehistoric man holding a club in one hand and a clam shell in the other as he stares intently (note the furrowed brow) from the mouth of a cave. With his strange appearance (the animal-like face, the pointy ears, the talon toes), paleolithic man is an evolutionary prototype of a human being. Moreover, his rudimentary activity, cracking open clams with a stick, tells us that his way of gathering food (and his technological knowledge generally) is primitive. It was not for nothing that Remington gave a copy of the sculpture to his friend Theodore Roosevelt, himself a staunch evolutionist historian.[9]

Paleolithic Man transforms our understanding of *Apache Medicine Song*. Crouching by the fire, the Apaches are much like the prehistoric man crouching at the lip of his cave. Indeed, the figures crouch not very far from "caves" of their own—the blackened entryways of their huts. In particular, the Apache second from left, the "human brute," closely recalls the pose of Remington's caveman (fig. 3). The relationship is no coincidence. For Remington, Apaches were modern-day cave dwellers, primitive beings permanently arrested at an earlier stage of evolutionary development. This was a pejorative connection, to be sure. The Apaches in Remington's painting are members of "the scrap heap of departing races." Yet clearly, in the fetishistic examination of the assembled warriors, Remington's painting also exhibits an evident, if not quite laudatory, fascination with Apaches and "primitives" in general.

Fight for the Water Hole, one of Remington's most famous works, can explain that fascination (fig. 4, plate 2). In the painting, made in 1901, five cowboys fight desperately to defend a water hole against Indian interlopers. Some of the Indians are visible in the distance; the gaze of the foremost cowboy implies other attackers in front of the picture plane. Without question, it is this foremost cowboy who mainly attracts

our attention (fig. 5). He is more carefully and richly painted than any of his fellow defenders; he is also nearest to us; and his vigilant pose—rifle at the ready, eyes narrowed, body tense—epitomizes the bravery of all five cowboys. The pose epitomizes something else about the defenders as well. Crouched in a defensive posture, peering from a cavity in the earth, holding a long weapon, and even surrounded by shells (bullet shells instead of clam shells), the cowboy is himself a species of cave dweller. Far from being pejorative, such a link was in perfect keeping with the social evolutionism of the era. "Out on the frontier," wrote Roosevelt approvingly, "life is reduced to its elemental conditions."[10] For Roosevelt, modern Anglo-Saxons had grown soft behind their big-city desks. They had lost touch with the race's conquering, martial spirit— the very spirit that had gotten them behind the desks in the first place. Although Remington eventually came to weigh almost three hundred pounds—and was by no

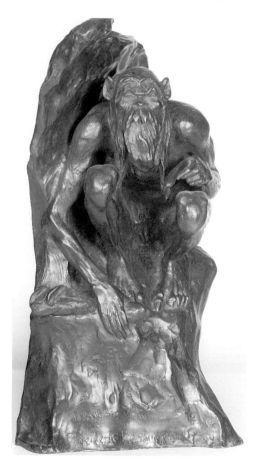

2. *Paleolithic Man,* 1906. Bronze, h. 15½ in. Rockwell Museum, Corning, New York.

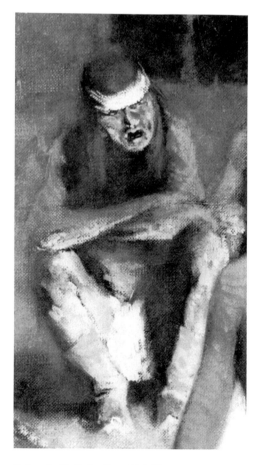

3. *Apache Medicine Song* (detail).

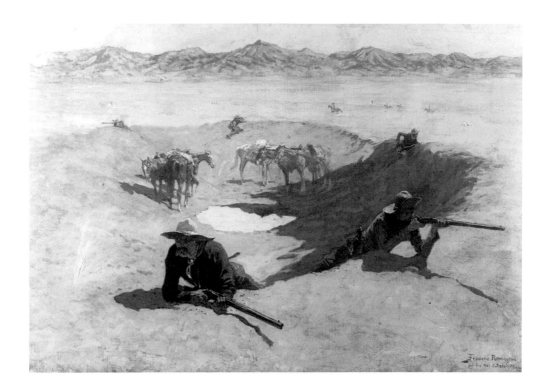

means averse to enjoying the "soft" civilization he professed to deplore—he, too, was an advocate of the strenuous life. "The Derby hat and the starched linen," he wrote in 1892, are "those horrible badges of the slavery of our modern social system, when men are physical lay figures, and mental and moral cog-wheels and wastes of uniformity— where the greatest crime is to be individual, and the unpardonable sin to be out of fashion."[11]

An anonymous photograph from the 1904 Saint Louis World's Fair diagrams this enervation (fig. 6). It shows a monumental plaster cast of Cyrus Dallin's equestrian sculpture on the fairgrounds, *The Protest of the Sioux*. Seated beneath the sculpture is a man dressed in a dark suit and derby hat. Although the man serves ostensibly to mark the sculpture's scale, he is cast in a series of pejorative relationships with that embodiment of primitive virility, the Sioux warrior. Both figures are seated, the warrior upon a horse, the little man upon a less noble steed, a park bench. Both extend their right arms, the warrior in a gesture of fist-shaking defiance, the little man in a gesture of slack-armed leisure. Both wear hats, the warrior a headdress streaming past his toes, the little man a derby of the kind identified with oncoming civilization. The warrior is huge, dwarfing not only the little man but his own horse, which

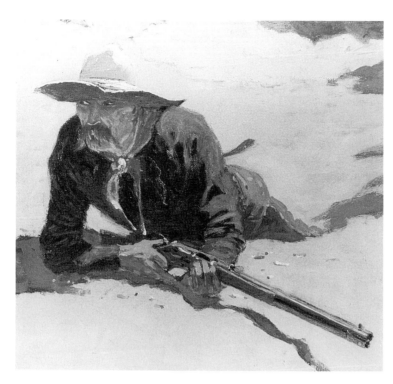

4. *Fight for the Water Hole,* 1901. Oil on canvas, 27¼ × 40¼ in. Hogg Brothers Collection, Museum of Fine Arts, Houston, Texas. Gift of Miss Ima Hogg. *(Opposite page.)* See plate 2.

5. *Fight for the Water Hole* (detail).

requires a strut beneath its belly to support the rider's weight. The little man exists in an excremental position beneath the horse.

The waste that is modern life is the subject of the photograph. The little man is plopped on the bench, a polished turd. As in many works from the time, like Dallin's Sioux warrior himself, the photographer shakes a fist at the very civilization celebrated at the 1904 world's fair. The photographer does so, however, with a casual wit and irony that are themselves as much emblems of modernity as the little man himself. As a protest, the photograph has more in common with the languid and leisured little man than with the defiant warrior. What Remington and Roosevelt wanted, by contrast, was a return to a time when being angry was not so comfortable, so leisured. Extreme, violent action—a bona fide, if only temporary, reversion to the "elemental conditions" of the frontier—would restore the Anglo-Saxon's martial spirit.

In *Fight for the Water Hole,* the cowboys find themselves in just such "kill or be killed" conditions. They are cast into a primordial situation, defending their lives and the little they have in exactly the manner of their prehistoric ancestors. Thus the familial resemblance between Remington's cowboy and his caveman is neither accidental nor derogatory. The desperate cowboy recovers the latent beast within him-

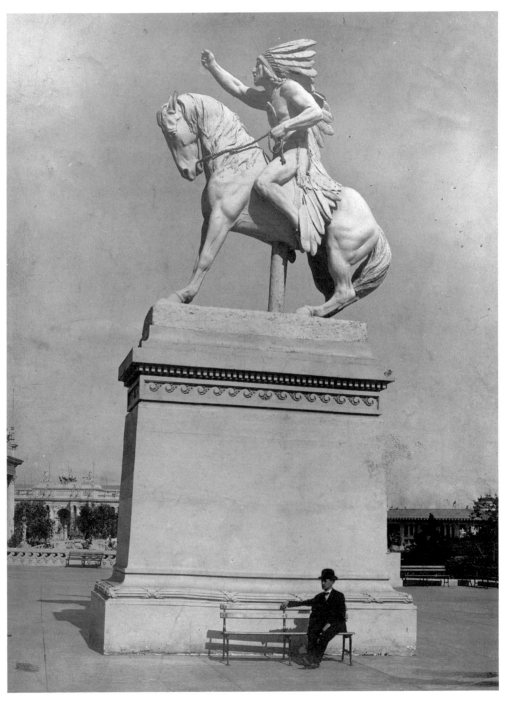

6. Anonymous, *Cyrus Dallin's* Protest of the Sioux *at the Louisiana Purchase Exposition of 1904 in Saint Louis,* 1904. Missouri Historical Society, Saint Louis.

self. At the lip of the cave once more, he incarnates the spirit of that first cowboy, that first mountain man, that Wyatt Earp of Olduvai Gorge. He is like Humphrey Van Weyden, hero of Jack London's *Sea-Wolf* (1904). Stranded on an uninhabited northern island, clubbing seals for food and shelter, the man they used to call "Sissy" Van Weyden marvels that "the Youth of the race seemed burgeoning in me, over-civilized man that I was, and I lived for myself the old hunting days and forest nights of my remote and forgotten ancestry."[12]

Remington's primitive water-hole defender also evokes Buck, the hero and almost-human dog of London's *Call of the Wild* (1903): "He was older than the days he had seen and the breaths he had drawn. He linked the past with the present, and the eternity behind him throbbed through him in a mighty rhythm to which he swayed as the tides and seasons swayed."[13] The evolutionary spirit, according to London, makes humans into "puppets"; we are *swayed* by evolutionary ancestors, both persuaded, as by a good argument, and manipulated, as by a puppeteer.[14] This equivocation between persuasion and manipulation—between individual agency and utter loss of autonomy—is part of London's sour evolutionary philosophy. "[Man] is a puppet. He is the creature of his desires," claims Wolf Larsen, the character in *The Sea-Wolf* who voiced the author's own "black moods."[15] For Remington, only the darker races were evolutionary puppets.

A comparison between *Fight for the Water Hole* and *Apache Medicine Song* demonstrates this point. The two pictures are similar in many ways. The foremost cowboy in the *Water Hole* recalls not only the caveman but also the crouching Apaches, particularly the one second from the left. Each painting features a circle of men; each circle is deployed at roughly the same place on the canvas; each includes a second, smaller circle echoing the larger one—the circle of water in the *Water Hole* and the circle of the lip of the nearest container (probably a basket) in *Medicine Song*; finally, wrapped around the hat of the nearest cowboy is a telltale band of white exactly like the Apaches' headbands. Each painting represents a "tribe" of primitives. The tribes are similar, with one exception. For Remington, Apaches were possessed of a "demon nature" and were thus permanently prehistoric.[16] The sociologist Georg Simmel wrote in 1903, "The most elementary stage of social organization which is to be found historically, as well as in the present, is this: 'a relatively small circle almost entirely closed against neighboring foreign or otherwise antagonistic groups but which has however within itself such a narrow cohesion that the individual member has only a very slight area for the development of his own qualities and for free activity for which he himself is responsible.'"[17] Remington's primitivized cowboys also form "a relatively small circle,"

but theirs—to borrow from the metaphors of both Simmel and Fiske—is more individuated: despite their common purpose, the front two cowboys are quite different, whereas the Apaches all look very similar (even including the one fully clothed figure; "Kinrade" may have posed for all of them). And whereas the cowboys look outward, the Apaches turn in upon themselves. Their centripetal closure to outside influences connotes an ultimately fatal inability to expand or evolve. According to theories of social evolution, the Anglo-Saxon kept a primitive, bestial spirit *latently* within. This spirit emerged only in moments of dire exertion, and even then, it did so in a way that cost the Anglo-Saxon neither individuality nor progressive, outward-looking instinct.

The Calm of the Wild

Nor did reverting to an ancient type cost the Anglo-Saxon any self-control—a point embodied in *Polo*, a sculpture that Remington made in 1904 (fig. 7). Although the subject was atypical for Remington, and although only two copies were executed (in contrast to approximately one hundred lifetime casts of *The Bronco Buster* [1895]), *Polo* deserves our attention as being almost as powerful an evolutionary statement as *Paleolithic Man* itself. One of the work's most striking features is the impassive gaze of the topmost figure (fig. 8)—a gaze all the more notable when we realize that the figure is shown not only playing a strenuous game of polo but caught in an especially perilous moment: his horse has stepped on the belly of the fallen horse, throwing the horse off balance and threatening to topple the rider to the ground. The other mounted player, though perhaps in less danger than his counterpart, also displays an expression so preternaturally calm as to be out of keeping with the dire exertion of the moment.

The inordinate calm of the two men contrasts with the energy and action of the horses. The three horses together create a swirling (though contained) motion that recalls such vibrant compositions as Antoine-Louis Barye's Rubensian hunt sculptures. Only one of the twelve hooves in *Polo* actually touches the ground, which gives the horses a certain lack of stability and thus the appearance of movement. Also, the veins in the horses' legs and torsos are plainly visible (fig. 9). This detail, shared by only one other Remington sculpture, tells us that the horses are under the kind of heavy exertion that expands the blood vessels with pumped blood.[18]

Having made this neat division between human beings and beasts, the calm and the wild, the sculpture then creates a confusion between the two. The prominent folds

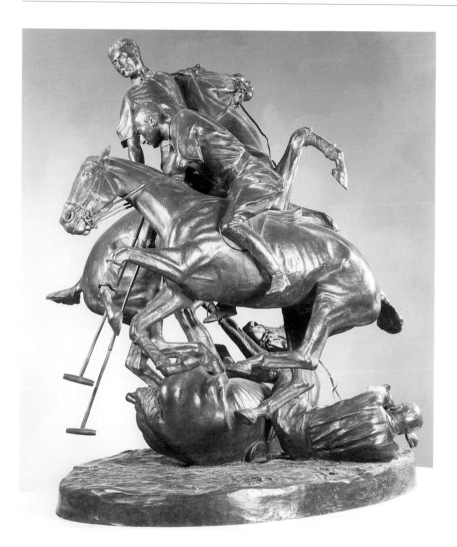

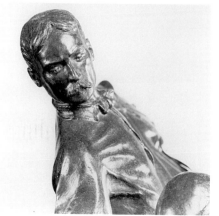

7. *Polo*, 1904. Bronze, h. 21¾ in., base
19½ × 14½ in. Frederic Remington Art
Museum, Ogdensburg, New York.

8. *Polo* (detail).

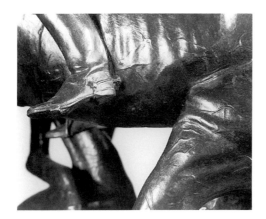

9. *Polo* (detail).

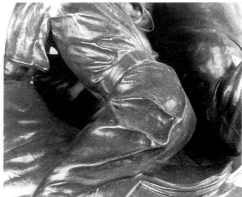

10. *Polo* (detail).

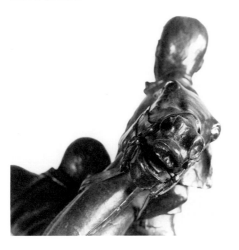

11. *Polo* (detail).

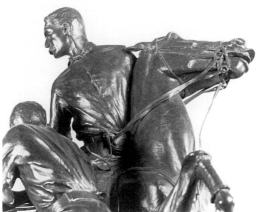

12. *Polo* (detail).

of the men's clothes—for example, the folds on the nearer man's left thigh—evoke the traditional sculptural use of folds of drapery to connote spiritual excitement (fig. 10). These spiritual creases, rustled as though by some divine afflatus, reach their apogee in the work of Claus Sluter and, of course, Gian Lorenzo Bernini. More important for us, the folds in the polo players' clothes create patterns that echo the network of veins in the horses' bodies. The metaphorical effect is to show blood running through the men in a sculpture wherein blood is manifestly linked to energy and movement—more specifically, to animality and wildness. Indeed, the prominence of the metaphorical veins, their greater size and relief, suggests that animality is, if anything, exaggerated in the men—the wild blood running through them almost audibly pounds in their own and our ears.

One other detail expresses the wildness of the men. The head of the topmost man is linked formally to the head of the horse (fig. 11). The two heads turn in exactly opposite directions on the same line. The man's left shoulder picks up the line of the top of the horse's head. Several apertures—the horse's flared nostril and open eye and the man's ear—occur on the same axis. The swell of the horse's throat is echoed by the man's button-down shirt front and by the tendon in the man's neck. One of the reins, the one that extends from the horse's mouth past the right side of its neck, is picked up by the most prominent of the folds in the man's shirt, creating a V-shape that links man and horse as part of the same compositional triangle. Finally and most tellingly, man and horse are literally fused together, like Siamese twins. They are so symmetrically organized—so joined—that they invite interpretation as two sides of the same figure. On one side is an incredible calmness; on the other side, a bestial wildness (fig. 12). The horse, like the blood running through its veins, evokes an allegorical image of passion. Like the blood, the horse is a visualization of the flow of polo man's inner spirit. In *The Virginian* (1902), Remington's friend Owen Wister described the hero in words that might just as well apply to Remington's polo player: "I began to know that the quiet of this man was volcanic."[19]

Remington's sculpture also tells us that not just warfare but sports—a representation of warfare about which I shall have more to say in the next chapter—can successfully evoke this inner wildness. More specifically, the sculpture tells us that polo, a sport with English connotations, is a way for Anglo-Saxons to find this wildness: in a letter, Remington referred to the figures in *Polo* with a British expression, calling them the "fellows by Jove."[20] (Remington also illustrated Rudyard Kipling's "Maltese Cat" [1895], a story about a group of English polo ponies in India.) But why, then, is the topmost polo player not shown straining and screaming like the racial ancestors whose wild blood he embodies? Why is his wildness displaced onto, or sublimated in, the form of his horse and the folds of his clothes? The answer is that the man's calm demeanor is what distinguishes him as superior, in evolutionary terms, to his ancestors. To show the face of a polo player in a savage contortion would be to suggest that he had become wild—that he had reverted completely and irrevocably to an earlier evolutionary type. This was emphatically not the point of the strenuous life. The reversion that *Polo* posits is contingent and partial. The game of polo, like warfare, does produce a state of savagery in its mild-mannered players, but the savagery is contained. It is channeled like the blood and harnessed like the horse. The process of control is analogized in two ways: first, the Baryeian energies of the sculpture are contained within a closed composition from which nary hoof nor mallet disquietingly

protrudes; and second, the wild beast is tightly reined. The grasp of the man's hand on the reins evinces the state of mind—the *self*-control—that allows him to appear so calm in the midst of such peril. It was self-control that was integral to the maintenance of Anglo-Saxon evolutionary superiority: "Free people can escape being mastered by others only by being able to master themselves," Theodore Roosevelt told an audience at Oxford in 1910.[21]

The sculpture's representation of the beast within resonates with Remington's depiction of the paleolithic water-hole defender. Like the cowboy, the polo player is inhabited by the spirit of a wilder evolutionary stage. There is a difference, however. Whereas the cowboy readily merges with his evolutionary prototype, polo man retains exactly the dignified and almost languid demeanor that he might display were he dispensing a cup of tea. There is more of Roosevelt's "self-knowledge and self-mastery" about him, less of London's puppetry. He is the man on the park bench all over again. Although both he and the cowboy are calm, polo man has achieved a greater mastery over his inner beast. He is the highest evolutionary type. This is simultaneously commendable and worrisome for Remington. On the one hand, the polo player is a "fellow by Jove"—the acme of Anglo-Saxon civilization. On the other hand, his civilized qualities—prim, proper, buttoned—are what threaten him, like the man on the bench, with an enervated existence.

The horses simultaneously confirm the polo players' high evolutionary place and announce the martial means by which this place can be retained. In "Petey Burke and His Pupil," one of the stories in *People We Pass* (1896), a collection of tales of immigrant life written by Remington's friend Julian Ralph, young Petey Burke falls in love with an Anglo-Saxon girl: "She's a dead thoroughbred," he says. "Blooded to de heels," affirms another character.[22] Unlike many of the horses that Remington depicts, those in *Polo* are thoroughbreds. The purity of their racial heritage is identical with the purity of the men's. Here again the metaphorical equivalence between blood and horses comes into play. Breeding and blood naturally go together, never more so than at the time Remington was working. "There aint a drop of anything but English blood in my veins," Remington wrote to a friend in 1887, "—pure saxon at that—no Norman—bred on the soil and Every Remington that a herildric fiend can trace was a British soldier."[23] In Remington's polo players, blood equals both martial passion and ancestry, which were synonymous in social-evolutionary logic. "The Anglo-Saxon blood of us," wrote Frank Norris in his pamphlet *The Surrender of Santiago* (1898), "the blood of the race that has fought its way out of a swamp in Friesland, conquering and conquering and conquering, on to the westward, the race whose blood instinct is

the acquiring of land, went galloping through our veins to the beat of our horses' hoofs."[24]

The ancestral blood of an Anglo-Saxon, then, was militaristic and passionate. Perhaps this is the meaning of Remington's *Soldiers Opening Their Own Veins for Want of Water*, an illustration from 1896 (fig. 13). The painting concerns thirst: trekking through the desert, the troopers have no water and must resort to opening their own veins to wet their parched mouths. The painting exemplifies the deliberately graphic images of frontier life by which Remington tried to distance himself, early in his career, from more romantic conceptions of the West. But the soldiers in this strange work may also thirst for their martial ancestry: in auto-Dracula fashion, they suck their own blood to reinvigorate themselves with their ancestral Anglo-Saxon spirit. Blood becomes a whiskeylike form of courage.

Anglo-Saxon courage is what we see in *Captured* (1899), another work that concerns inner racial spirit (fig. 14). The picture shows a lone trooper, stripped to his underwear, his arms tied together, the cold wind blowing against his back (note the direction of the campfire smoke). The trooper sits with four Indian captors (a fifth sits on the cliff, watching for pursuers). The trooper's demeanor does not match the calmness of the polo players'—his fist is clenched, his jaw is set, his head juts forward. Nevertheless, he faces extreme privation and probable death with notable impassivity. The standing Indian holds a weapon partly concealed beneath his blanket; he stands, moreover, in a curiously solemn and ritualistic way, as though he were some high priest about to offer a human sacrifice. And in fact the trooper's creamy skin calls to mind the purity of Christian martyrs and thus relates his suffering to a centuries-old rhetoric of innocent victims and swarthy oppressors. His skin is a clothing of sacrifice. In this way, Remington's painting conventionally depicts the whites of the Old West as sacrifices to progress: they died so that the West could be settled.

Then there is the manner of the trooper's sacrifice. His creamy flesh contrasts forcefully with the buffalo hide worn by the adjacent Indian. Remington emphasizes the contrast by rhyming light- and dark-skinned horses behind the two figures. Associating the Indian with the buffalo skin and thus with the act of flaying, Remington's picture not only implies what is in store for the trooper but also establishes a complex evolutionary metaphor contrasting white nobility and Indian savagery. As a Dionysian rite, flaying had long been associated with passion, frenzy, barbarousness—with qualities usually ascribed by European cultures to any nonwhite others. Its association here with Indians is part of this tradition. Yet the act of being flayed had also come to stand for a kind of divine purification by which a person's out-

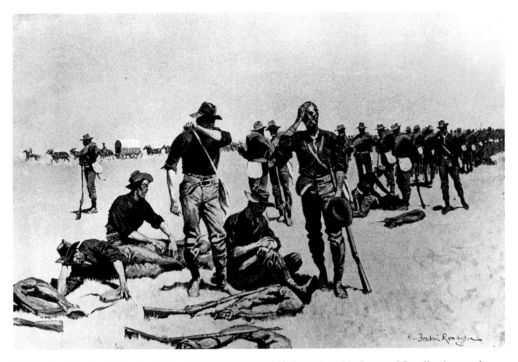

13. *Soldiers Opening Their Own Veins for Want of Water,* 1896. Reproduced in *Personal Recollections and Observations of General Nelson A. Miles* (Chicago: Werner, 1896), 111.

ward body could be stripped away to reveal the soul beneath.[25] In the theme of flaying, with its ancient origins in the story of Apollo and Marsyas and the martyrdom of Saint Bartholomew, Remington's picture compactly established both the barbarousness of his Indians and the soulfulness—the inner spirit revealed in suffering—of his white captive. How better to show Anglo-Saxon lineage than to show a trooper about to be "blooded to de heels"?

Other works from the time showed flaying even more explicitly. *Skinned Cats* (1893) is an anatomical study made by Carl Rungius, the foremost animal painter of Remington's generation (fig. 15). Although Rungius was born in Germany, he spent virtually all of his career in the United States; he had a studio in Brooklyn from which Remington, paying an unexpected visit, came away disappointed that the painter he so admired was away.[26] (The two never met.) Rungius made *Skinned Cats* when he was eighteen and still living in Germany. Though ostensibly just an anatomical study, *Skinned Cats* is heavily informed by paradigms derived from social evolution. Where, in Berlin in 1893, would Rungius have had access to skinned big-game cats? The answer is nowhere. The cats in question were alley cats, shot and skinned by Rungius

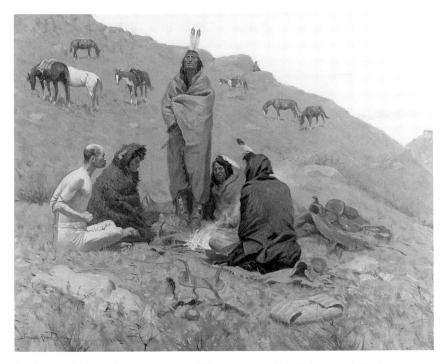

14. *Captured,* 1899. Oil on canvas, 27 × 40¼ in. Courtesy of Sid Richardson Collection of Western Art, Fort Worth, Texas.

in his backyard. Although alley cats stalk prey, in the drawing Rungius suggests that these neighborhood creatures are versions of the big-game cats that he saw and sketched at the Berlin Zoo.

The transformation from alley cat to stalking beast, from pussycat to predator, resonates with the transformation of Sissy Van Weyden to Stone Age killer and with other devolutionary transformations in the art and literature of the time. Moreover, the beast reveals itself only after the cat has been skinned: the predator is again inside the inoffensive creature, just as the primordial wolf is inside Buck, and just as martial passion courses through Remington's soldiers and polo players. The same evolutionary paradigm informs Remington's little drawing *My Cat,* an image whose very reason for being is perhaps so that the artist can marvel at the predator latent within the family pet (fig. 16).

For an image of the "outer" animal, one that can return us to *Apache Medicine Song,* we need to focus on another of Remington's images of cats, his grisaille painting *Mountain Lions at the Deer Cache* (around 1888), an engraving of which is reproduced here (fig. 17). The image illustrates an episode from Roosevelt's story "Sheriff's

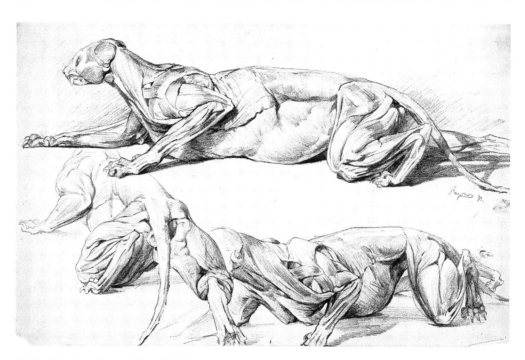

15. Carl Rungius, *Skinned Cats,* 1893. Colored pencil on paper, 13⅛ × 19 in. Glenbow Museum, Calgary, Alberta.

16. *My Cat,* ca. 1900. Pen and ink on paper, 1⅜ × 5⅞ in. Frederic Remington Art Museum, Ogdensburg, New York.

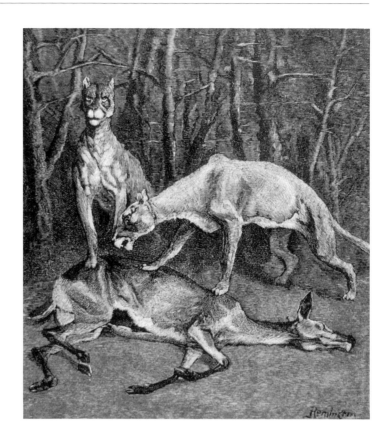

17. *Mountain Lions at the Deer Cache,* ca. 1888. Reproduced in Theodore Roosevelt, "Sheriff's Work on a Ranch," *Century* 36 (May 1888): 43.

Work on a Ranch," published in *Century* magazine in 1888 and reprinted the same year as part of Roosevelt's book *Ranch Life and the Hunting Trail.*[27] Roosevelt and two of his ranch hands discover that mountain lions have raided a cache of deer they strung up during freezing weather. In the story Roosevelt and his men come upon the remnants of the deer; the mountain lions have departed. Remington, however, chose to paint the mountain lions interrupted, as though by Roosevelt himself, as they prepare to feast. His choice is all the more interesting in light of the strange, almost human stare of the mountain lion at the left. Its stance is also humanlike, resembling that of a hunter in an attitude of conquest. This equivocation between man and beast—the blending of the two into one another so seamlessly that we cannot properly speak of which, man or animal, corresponds to inner or outer states—suggests that Remington's mountain lion is to be understood as occupying a liminal moment between the animal and the human, a state not quite one or the other. This might explain the intensity of the lion's stare, which might be seen as mirroring the fascinated gaze of Remington himself. The mountain lion is primitive, an externalization of

the Anglo-Saxon inner beast, yet not so primitive as to eradicate all signs of a nascent humanity pervading its features and behavior. It is very much like London's Wolf Larsen, a "physical man" in whom nonetheless "the jungle and wilderness lurked in the uplift and downput of his feet. He was cat-footed, and lithe. . . . I likened him to some great tiger, a beast of prowess and prey. He looked it, and the piercing glitter that arose at times in his eyes was the same piercing glitter I had observed in the eyes of caged leopards and other preying creatures of the wild."[28]

Van Weyden's fascination with Wolf is similar to Remington's with the lion, yet simple fascination does not explain the specifically pictorial discourse at work in Remington's image. At the 1893 Chicago World's Fair, Remington wondered what it would be like to merge the likenesses of all the foreigners on the Midway: "A composite photograph might be a goat or something else dear to the Darwinian heart."[29] Here Remington refers to the composite photography of Francis Galton, the English social scientist who developed a method of superimposing a number of photographs of a common "type"—a career criminal, for example—in order to arrive at a composite image of what a "typical" criminal would look like (fig. 18). Among the many late nineteenth-century taxonomies developed to classify an increasingly heterodox social field, Galton's stood out then and now as the one most indebted to Spencer's biology-based theories of social evolution. People's characteristics, according to Galton's composites, were biologically determined; social deviance, for example, could be ascer-

18. *Galtonian Composite*. Reproduced in Havelock Ellis, *The Criminal* (London: Walter Scott, 1890), frontispiece.

tained simply by a person's features.[30] It is not surprising, then, that Remington, with his similar belief in biology-based social evolution, should allude to Galton. Nor is it surprising that Remington's mountain lion should look like a Galtonian composite. The lion's face contains two sets of features—animal and human—that have not quite coalesced. In Remington's image, however, the composite method is used not to arrive at a common type but to merge inner and outer, modern and ancient states. The image anticipates Remington's description of an old Mexican fiddler in his story "An Outpost of Civilization" (1893). "I could not keep my eyes off him," the narrator recounts. "He was never handsome as a boy, I am sure, but the weather and starvation and time had blown him and crumbled him into a ruin which resembled the pre-existing ape from which the races sprang." In the very next sentence Remington makes a Galton-style connection between biology and deviant behavior: "If he had never committed a murder, it was for lack of opportunity."[31] As nascent humanity appears within the face of the mountain lion, the violent evolutionary animal shows within the face of the Mexican fiddler.

As liminal human-animals, the mountain lion and the fiddler resemble Remington's staring caveman, water-hole cowboy, and full-front Apache. The resemblance demonstrates Remington's conception of the animal quality of the evolutionary primitive: each is perched (though to different degrees) between human and animal states. Finally, it explains the evident fascination with which Remington portrays all of these figures: "I could not keep my eyes off him." The Apaches by the fire, like the mountain lion, offered a chance to see—in the age of park-bench man—what the Anglo-Saxon race had looked like many thousands of years earlier. "They howled and leaped, and spun," says Conrad's Marlow, in *Heart of Darkness* (1902), describing African tribesmen, "but what thrilled you was just the thought of their humanity—like yours—the thought of your remote kinship with this wild and passionate uproar."[32] For Remington, the Apaches were the "perfect animals" that his ancestors had been. They also embodied the perfect animal still swaying somewhere within himself.

Ancient Children

We have not yet explored the most graphic of the evolutionary metaphors informing Remington's work. A side view of *Paleolithic Man* shows the caveman crouched in his cave unmistakably like a baby in a womb (fig. 19). According to social evolution, he is humanity in its infancy. The sculpture thus makes explicit Spencer's equation between biological and cultural development. Spencer asked the following question, as Fiske

relates it: "Where do we find the process of human development most completely exemplified from beginning to end, so that we can follow and exhaustively describe its various phases?" The answer: "Obviously in the development of the ovum. There, and only there, do we get the whole process under our eyes from the first segmentation of the yolk to the death of the matured individual."[33] On an evolutionary scale, Spencer and Fiske regarded primitive cultures as equivalent to a fetus in the womb; Anglo-Saxons were equivalent to human adults. Remington subscribed to this view, representing a remarkably infantilized group of Indians in *Apache Medicine Song*. Like children, the Apaches (all but one) are near naked; like children, they communicate with incoherent, bawling cries: "the strange discordant sounds" and "shrill yelps" of Remington's description. But it is the figure second from the right—the one whose fetal crouch almost exactly repeats that of the cavebound paleolithic man—who is most strikingly childlike (fig. 20). This pose was especially important for Remington to depict. The man immediately behind and to the right of the fetal Apache—and thus less prominently shown—is in a similar, though far less fetal, position: his knees are

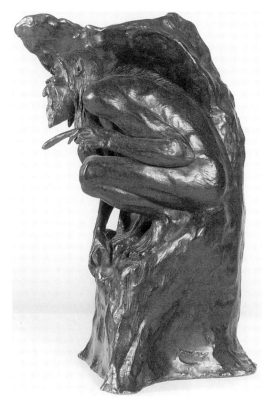

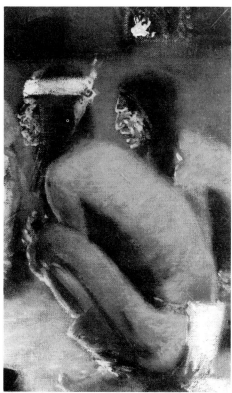

19. *Paleolithic Man* (side view).

20. *Apache Medicine Song* (detail).

thrust forward instead of pulled up toward his body; his weight rests on the balls of his feet rather than the heels (see plate 1). That Remington granted such a conspicuous fireside place to his most explicitly childlike Apache suggests the symbolic importance he attached to the fetal position. Gathered around the fire, the Apaches are simultaneously cavemen and infants, ancient newborns.

Apache Medicine Song is one of several Remington works making an evolutionary link between birth and death. *The Story of Where the Sun Goes*, painted in 1907, shows an old man telling three boys about the sun, whose setting rays illumine them (fig. 21). The clearest symbolism is familiar: as in other Remington paintings, and in dozens of works by other western artists, the sun is setting on Indians. Their day is passed. Yet this interpretation does not explain why Remington chose an old man and three children, of all people, to contemplate this augury. In similar works, such as *The Outlier* (see fig. 133), he depicted warriors. Remington's choice is even odder when we consider the infrequent appearance of children in his art. Certainly his comparative lack of skill in drawing children—never more in evidence than with the wide-eyed

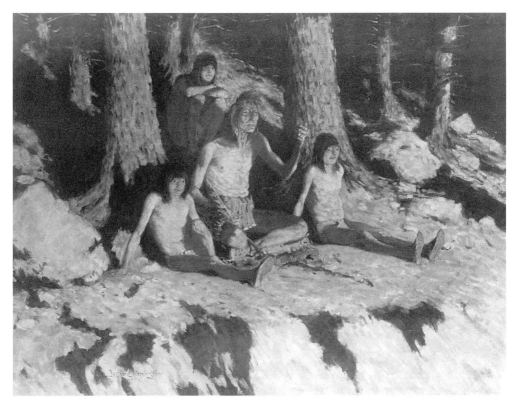

21. *The Story of Where the Sun Goes,* 1907. Oil on canvas, 27 × 36 in. Private collection.

boys of *Where the Sun Goes*—helps to explain their rarity in his work. Only an explicitly allegorical purpose, I feel, could persuade him to try, not once but three times, a kind of figure at which he did not excel.

Evolution is the allegory. *The Story of Where the Sun Goes* does not so much contrast the old man and the young children as link the two extremes. The sun's golden glow unifies the figures, tinting each an identical coppery hue. The seated old man has lowered himself to the children's level, a visual embodiment of what he presumably does in the telling of his story. He is slightly below the level of the notably fetal boy above him. The children are not so much auditors of the old man's story as personifications of his own childishness. By the same token, the children are ancient. Evolutionary theory, as we have seen, cast Indians as remnants of an ancient, even prehistoric time. Thus the old man personifies the paleolithic age of the racial child. Together, these four ancient children are linked to the deathly sun. They watch it: the old man, as if in sympathy with its sinking, lowers himself; the boys, or "sons," will presumably go the way of the sun itself; and all are bathed in that coppery glow. The light on their bodies expresses their own fading, as if the heated color of their skin, in the painting's social-evolutionist view, were but the sign of that skin's eventual immolation. Born old, Indians die young. Death dawns on them.

Apache Medicine Song, painted a year later, is more naturalistic, much less of a deliberate allegory. Yet it tells the same story of birth and death. The childlike Apaches are surrounded by signs of their doom. A palpitating light plays over their bodies, functioning simultaneously as primal source of heat and as memento mori, as if the warmth for which the evolutionary baby clamors comes from the flickering candle flame. The night, here as in all of Remington's evening scenes, suggests an elegiac mood, a fading of remembered figures from view. The shadow of a tree, in the lower right corner, seems to move in the Apaches' direction, ready to eclipse them. It is this principle of movement, of flux, that most powerfully evokes change and death. Although the composition of *Apache Medicine Song* is stable, Remington attends to movement—very slight movement—with an acuity, a sensitivity, intense enough to suggest that it is one of the painting's most important themes. Although the night is virtually windless (note the vertical column of smoke from the fire), branches in the shadowed foreground nonetheless appear to move; leaves seem to flutter in a breeze; the very flutterings bend, as shadows, upon an uneven ground. The picture is thus a threefold sign of evanescence, a picture not only of a shadow but of a shadow that slightly moves, bent by wind and ground, disturbed by earth and air. Remington shows more movement here than he does in all of his snot-and-froth action pictures,

for here, employing a discourse of social evolution, he evokes a principle of silent, creeping, imperceptible forces—forces of nature or, rather, forces of history construed as natural—that imply, ever so gradually, the evolutionary eclipse of the figures gathered round the fire.

Just such a shadow extends ominously across part of *Water Hole* (see plate 2). The shadow is part of the painting's network of temporal symbols. The bullet cartridges strewn around the foremost cowboy, the evaporated water, and the Ozymandian desert sand all suggest passing time. The painting comes from a culture obsessed with time: I think of Frederick W. Taylor's theories of scientific management, designed to maximize output among factory workers, and of Henri Bergson's and William James's writings on time and memory.[34] In this context, the shape of Remington's water hole becomes particularly interesting. The hole bears a strong, but certainly unconscious, relation to a clock, with the eleven, twelve, two, five, and six o'clock positions marked and the two nearest guns suggesting hour or minute hands in motion. The field of battle is transformed into a huge timepiece, with enemies at points on the clock—yet for Remington, using combat terminology is a way to express not only the position of the combatants but also the expiration of time as they fight. The time that passes so relentlessly in *Fight for the Water Hole* refers not just to the cowboys' desperate situation but to the entire historical era that they represent. In a modern world (the painting was first reproduced on December 5, 1903, twelve days before Orville and Wilbur Wright's first flight), the primitive white men are as doomed, the picture tells us, as the Indian they fight. The cowboys are doomed by a specifically modern kind of time, measured in precise Taylorian increments. Roosevelt's elemental conditions will soon be gone. The hole is clock, cave, and grave—a last ditch.

Born to Kill

If paleolithic man peers from a geologic womb, Remington's *Water Hole* cowboys find themselves in a similar situation. It is difficult to imagine a more graphic feminine symbol in Remington's art, indeed, in any art, than the hole that confronts us so directly in this painting. Remington's novel *John Ermine of the Yellowstone* (1902) explains some of the hole's feminine symbolism. *John Ermine* is the story of a man—biologically white but culturally Indian—tragically ill equipped to cope in either world. As a boy, Ermine is captured and raised by Indians. As a teenager, he learns English language and customs from a white man, a hunchbacked recluse whom the Indians call Crooked Bear. Eventually, after his tutelage with Crooked Bear, Ermine

becomes an army scout, and it is in a cavalry camp that he meets and falls in love with Katherine Searles, the daughter of an army officer. Katherine is attracted to this Indianized white man—"he seems to have the primitive instincts of a gentleman," she says—especially after she falls from her horse and he rescues her. But she has no intention of marrying him. "I am truly sorry that our relationship has not been rightly understood," she tells him after he proposes.[35] Rejected, Ermine flees the camp, returns, and is shot—in the heart, as it turns out—by a sluggard Indian with whom he had once quarreled about Katherine.

Ben Merchant Vorpahl has argued that *John Ermine* is Remington's strongest statement of the irreconcilability of America, past and present, wild and civilized.[36] In the novel it is not possible for an Indian, or even an Indianized white man, to join the civilized Anglo-Saxon culture represented by Katherine Searles. Instead, primitive men like John Ermine must die out. What is also interesting about the novel, however, is the portrayal, full of longing and hatred, of the relationships between men and women. Ermine's desire for Katherine is graphically sexual. After an early meeting with her, where Ermine is presented as her second choice (after a white lieutenant), the reader is treated to this eye-catching series of autoerotic metaphors: "He wanted to do something with his hands, something which would let the gathering electricity out at his finger-ends and relieve the strain, for the trend of events had irritated him. Going straight to his tent, he picked up his rifle, loaded it, and buckled on the belt containing ammunition for it. He twisted his six-shooter round in front of him, and worked his knife up and down in its sheath. Then he strode out, going slowly down to the scout fire."[37]

As the references to weaponry make clear, Ermine's sexual feelings are violent. In *John Ermine of the Yellowstone*, relationships between men and women are called hostilities. Crooked Bear sets the tone. He is alone in his wilderness den because of a woman's rejection. "*She* could see nothing but my back," he says bitterly. He also scorns the feminized nature that has left him deformed: "Nature served that boy [Ermine] almost as scurvy a trick as she did me, but I thwarted her, d—— her!" A subsequent battle scene reintroduces this feminized nature in a way that suggests rape: "[Men] sweated and grunted and banged to kill; nature lay naked and insensate."[38] The men—in this case, Sioux and soldiers—are bonded in Remington's generic description; their enemy, lying vanquished at their feet, is not each other but the feminized nature in which they fight. Like nature, it is Katherine who a little later lies unconscious in Ermine's arms, the victim of her fall. Ermine, looking at her, fantasizes about stealing Katherine away; although he ultimately does not adopt this plan "to

"kidnap, rape, and keep Katherine with him in the mountains," as the literary historian John Seelye describes it, his sexual aggressions are clear.[39]

Women are not just the objects of aggression in *John Ermine* but are themselves threats. *John Ermine* abounds with descriptions of lethal eyes. "She played the batteries of her eyes on the unfortunate soldier," the narrator says of Katherine, "and all of his formations went down before them." Her gaze "penetrated Ermine like buckshot." Before her eyes Ermine "could not use his mind, hands, or feet; his nerves shivered like aspen leaves in a wind."[40] In particular, eyes eat what they see. Says Katherine, eyeing Ermine, "I wonder if he would let me eat him."[41] Perhaps this is why the hole of *Fight for the Water Hole* unmistakably resembles an eye. Its circularity is foreshortened into an oval, and its limpid blue iris is centrally placed, perfectly mimicking the pools of the nearest cowboy's vigilant eyes. As the cowboy trains his vision on the enemy, a larger and vaginized eye rapaciously consumes him.

Other passages from *John Ermine* suggest that some feminized force victimizes the water-hole cowboys. While the camp awaits a Sioux attack, the narrator makes an odd analogy: "To the silent soldiers this was one of the times when a man lives four years in twenty minutes; nothing can be compared to it but the prolonged agony between your 'will you have me?' and her 'yes' or 'NO.'"[42] The passage echoes *Fight for the Water Hole*: the narrator describes silent white men (here, soldiers instead of cowboys) facing an attack; his temporal metaphors, moreover ("when a man lives four years in twenty minutes"), prefigure the clock of the water hole; finally, the soldiers' "prolonged agony," strikingly related to that of a suitor awaiting an answer to a proposal, resonates with the water-hole cowboys' endangerment within their feminized symbol. In other *John Ermine* passages, women are clearly the enemy. At one point, Ermine is terrified of the object of his desire: "He wanted her body, he wanted her mind, and he wanted her soul merged with his, but as he looked at her now, his mouth grew dry, like a man in mortal fear or mortal agony." At another point, Ermine prays to his personal god: "Why did you not take the snake's gaze out of her eyes, and not let poor Ermine sit like a gopher to be swallowed?"[43]

Gophers in their holes, prey to be swallowed—the image again recalls the *Water Hole*. (Ermines, like gophers and like the cowboys in Remington's painting, do live in holes.) In the *Water Hole*, as in the novel, women, not Indians, are the more dangerous enemy. However much the cowboys fight the surrounding Indians, it is by the enormous hole that they seem more threatened. The distant Indians, as the Remington scholar James Ballinger has pointed out, are unnaturally small.[44] Perhaps it is not with the Indians as enemies that Remington was concerned. The hole itself, richly

modeled, dominating the canvas, is far more prominent than the minuscule assailants: it threatens to swallow the cowboys. Katherine's "I wonder if he would let me eat him" comes to mind. So do the words of Lieutenant Shockley, who tells Katherine: "I shall do myself the honor to crawl into the first badger-hole we come to and stay there until you dig me out." "Don't be absurd," Katherine replies. "You know I always bury my dead."[45]

Here is where evolution and misogyny come together. As in *The Story of Where the Sun Goes* and *Apache Medicine Song*, Remington's figures appear to be born and to die in the same instant. Although the nearest cowboy appears to be halfway in the grave, a doomed figure, he, like his comrades, also appears to wriggle from the grave, as if the hole were a place not only of burial but of birth. Even the way the cowboy cradles his gun suggests his own status as an evolutionary baby. John Ermine, given his first gun, "could say nothing, and soon sat down, still holding the firearm, regarding it for a long time. . . . When he comprehended that he really did own a gun, he passed into an unutterable peace, akin to nothing but a mother and her new-born child." Like such a mother, Ermine waits for his baby's first words: "Your gun may speak first," Crooked Bear tells his protégé.[46] As primitive speech, the rifle's "harsh bang" is the equivalent of the Apaches' "shrill yelps." In *Fight for the Water Hole*, the foremost cowboy, surrounded by bullet shells, has let his cradled gun do the talking.

The birth imagery in the painting resonates with other metaphors of evolutionary origins. As a crater, the hole evokes a meteor crashed to earth and hence the evolutionary origins of the planet itself. (Perhaps this is why it reflects the heavens in its nebulous water.) The hole also evokes the crater of a volcano, a metaphor that relates both to explosive internal energies of the kind possessed by polo man, Wister's Virginian, and the cowboys themselves and to actual volcanoes, of which I will have more to say in the next chapter. Then there are the cowboys themselves: propped on their elbows, supine, their backs to the central pool of water, they appear like nothing so much as protohumans, creatures wriggling, slithering, out of some primordial slime. "These two figures, crawling, sliding, turning, and twisting" is how Remington describes John Ermine and his companion, Wolf-Voice, on their trek to the army camp.[47] The "stirring and crawling of the yeasty thing" is how Wolf Larsen thinks of life.

"Coursing Rabbits on the Plains," a story that Remington wrote in 1887, offers a striking correlative to the figures emerging from the water hole.[48] The narrator and several others have been chasing rabbits when Old Jane, one man's horse, falls into a "slew-hole." "Mr. Robert was dumped in the mud," says the narrator. "When we met he still carried a nice coating of slime and blue clay on his person, while Old Jane was

gradually growing white as the clay dried in the cool air that was blowing." The slime-covered rider suggests not only an evolutionary primitive emerging from the muck but also—very pertinent in Remington's case—a developing sculpture. "Mr. Robert C—— presented himself in a guise which I can only compare to a sketch in plaster," says the narrator, whose own horse is named Terra Cotta. Remington did not make a sculpture until 1895, eight years after "Coursing Rabbits on the Plains," when he made his famous *Bronco Buster*, but the passage prefigures his descriptions in later years of working in "mud": "I have only one idea now—," Remington wrote Wister as he worked on *The Bronco Buster*, "I only have an idea every seven years & never more than one at a time but its *mud*—all other forms of art are trivialities—mud—or its sequence 'bronze' is a thing to think of when you are doing it and afterwards too."[49]

The very process of working in sculpture—of building a figure from clay—suggested evolutionary processes. "His heredity was a life-stuff that may be likened to clay," wrote Jack London of the eponymous wolf in *White Fang* (1906). "It possessed many possibilities, was capable of being molded into many different forms. Environment served to model the clay, to give it a particular form." For London, environment is the sculptor, a "thumb of circumstance," modeling the figure's hereditary characteristics, softening them in a civilized situation or, if the environment is primitive, chiseling them into an intractable savage bony hardness. Grown into an adult wolf, White Fang finds it hard (though ultimately not impossible) to soften himself, to become civilized, "when the face of his spirit had become iron and all his instincts and axioms had crystallized into set rules, cautions, dislikes, and desires."[50] The smooth hard surfaces of Remington's bronzes bespeak the primitiveness of the figures as much as their countenances, actions, and accoutrements do (see fig. 124). The figures have developed to a certain evolutionary point—they have moved beyond the mud—but there they are frozen. Indeed, the figures in many of Remington's sculptures (and paintings) appear unnaturally still, despite the extreme action depicted. This static movement bears more discussion than I can give it here—I shall return to it in my last chapter—but for now let me note that the stillness suggests figures frozen, like the "iron" White Fang, at a certain evolutionary moment.

More than they resemble any of Remington's sculpted figures, the cowboys in *Fight for the Water Hole* are very much like those in another Remington painting from the same time: *A New Year on the Cimarron*, painted in 1903 (fig. 22). Having made camp in the bed of the mostly evaporated Cimarron River, the two cowboys in *A New Year* gaze at a column of smoke rising from their dinner fire. Like the figures in the *Water Hole*, they are primitives. The heavily bearded figure is a virtual double

of Remington's contemporaneous image of Crooked Bear seated in his mountain den, even down to the way he sits on the riverbed as though on a piece of furniture. Hunched over, he also recalls London's Van Weyden, whose devolutionary journey transforms him from Humphrey to "Hump," as Wolf Larsen repeatedly calls him.

The two figures in Remington's painting contemplate the smoke very much the way the sun-watching Indians of *Where the Sun Goes* do, implying a similar allegory. The new year and the new century signal that, like the smoke, the cowboys will disappear. Whereas the Indians sit upon a cliff, close to the edge, the two cowboys (like Crooked Bear, paleolithic man, and the water-hole cowboys) already reside within the earth: nestled in their river bed, they are underground. The cowboys' fate, the picture suggests, is that of the remnant riverwater that bears their dissolute reflections. Yet the same cartographic puddles, which evoke an evaporating space on the map even as they evoke the figures' own evaporation, also suggest a primordial ooze from which the figures have been born. Neither figure represents an especially high walk of life: the bearded cowboy is like Crooked Bear; the figure on the right reclines on the ground, his right foot hidden behind the left and his legs tapered to a single point, as if he were some sort of evolutionary protocreature just emerged, like the cowboys at the water hole, from the water.

The figure is one of the era's many evolutionary amphibians. *After the Hurricane* (1899), one of Winslow Homer's Caribbean watercolors, shows a black man and the wreckage of his boat washed ashore after a storm (fig. 23). As Helen Cooper has pointed-ed out, the boat's stern resembles a fish tail, giving the man the appearance of an exotic sea-creature.[51] Homer curls the figure into a fetal and thumb-sucking position, as well as equivocates—in classic evolutionist manner—between whether the figure was just born or has just died. Homer's man, lying on the sand much like Remington's cowboys, is another ancient child.

So are the figures in two other of Homer's Caribbean watercolors. In *Under the Coco Palm* (1898), another black figure, this time explicitly a child, drinks milk from a breastlike coconut that he holds in his palms under a coco palm (fig. 24). As with the man in *After the Hurricane*, the legs of the child disappear, replaced by a frond or piece of bark resembling a fish tail. In *The Turtle Pound* (1898), one black man hands a turtle to another black man located within the pound, or pen, of the title (fig. 25). Although the turtle's white belly contrasts with the men's blackness, Homer rhymes the impounded man's stubby fingers with the flippers of the turtle, suggesting that he, too, is something of a primitive victim. As Albert Boime has argued concerning Homer's *Gulf Stream* (1899, Metropolitan Museum of Art, New York), these watercol-

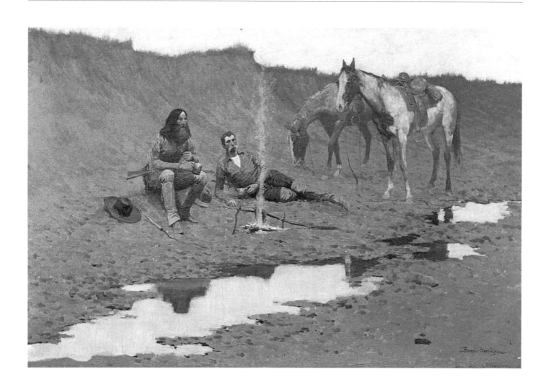

22. *A New Year on the Cimarron,* 1903. Oil on canvas, 27 × 40 in. Hogg Brothers Collection, Museum of Fine Arts, Houston, Texas.

23. Winslow Homer, *After the Hurricane,* 1899. Watercolor on paper, 15 × 21⅛ in. Mr. and Mrs. Martin A. Ryerson Collection, Art Institute of Chicago.

24. Winslow Homer, *Under the Coco Palm,* 1898. Watercolor over graphite on white paper, 14¹⁵⁄₁₆ × 21¹³⁄₁₆ in. Harvard University Art Museums.

25. Winslow Homer, *The Turtle Pound,* 1898. Watercolor over pencil on paper, 14¹⁵⁄₁₆ × 21⅜ in. Brooklyn Museum, New York.

ors—particularly *The Turtle Pound*—can be understood as sympathetic statements about the continued impoundment of blacks in the wake of *Plessy v. Ferguson*, the Supreme Court's separate-but-equal decision of 1896, and the failure of Reconstruction generally.[52] Yet it is also clear that Homer's sympathy is contained within a discourse of social evolution.

Frogs were a favored evolutionary metaphor. John Ward's evolutionist paean to imperialism, *Our Sudan: Its Pyramids and Progress* (1905), contains a photograph of leapfrogging children called *Progress—the Young Idea—Omdurman* (fig. 26). Placed near the front of the book, facing the table of contents, the photograph announces Ward's main theme. The Sudanese are not only explicitly children; they are also at a primitive evolutionary stage, corresponding to that of an amphibian. If each Sudanese child is not quite the worm of John Fiske's description, each is only the most primitive form of "vertebrate animal." Progress for the Sudanese will come in fits and starts; their very ability to move forward, the photograph tells us, will be circumscribed by their primitive manner of doing so. In Great Falls, Montana, a contemporary of Remington's, Charles Russell, advised Joe De Yong, a friend and aspiring painter, how to draw Indians. "Draw Frog with lance and shield," Russell scribbled to De Yong (fig. 27). This brings us back to *Apache Medicine Song*, for it now becomes clear that Remington's green Apaches, perched on their haunches as though ready to spring, are froglike. Further, Remington paints the countenance of the full-front figure, as well as those of the two rightmost figures, in a particularly suggestive manner, allowing the canvas's raised edges to catch dots of orange paint that rhyme the canvas's own scaly "skin" with that of the figures painted on it. The effect is to suggest a scaly, amphibian, or, at any rate, not quite human quality to the crouching figures. Certainly Remington was not the only artist at the time to paint a circle of green creatures (fig. 28).

Operating within all of Remington's images of amphibious children is a fear and hatred of women—or, at least, of what women at the time came to represent. The sheer monstrousness of Remington's evolutionary infants, for example, suggests that for him the womb—and feminine space in general—was monstrous. The swaddled savages of *Apache Medicine Song*, not to mention clam-drooling paleolithic man, could hardly be more antithetical to other contemporary renditions of childhood, such as those of Mary Cassatt or William Merritt Chase. There is also the symbolic sexual violence of Remington's work. Paleolithic man's use of a notably phallic club to crack open clams—clams that formally duplicate the feminine cave—suggests the kind of sex and aggression so insistently thematized in *John Ermine*. (The phallic club is best seen in figure 19.) Remington's hunched caveman is all but an image of the freakish hermit

To much Coventry

Dont make them all old

draw Frog will lance and
shield

26. Anonymous,
*Progress—the Young
Idea—Omdurman*,
1905. Reproduced in
John Ward, *Our Sudan:
Its Pyramids and Pro-
gress* (London: John
Murray, 1905), xii.

27. Charles Russell,
Untitled, n.d. 8 × 10
in. Charles M. Russell
Museum, Great Falls,
Montana.

28. Beatrix Potter, *The Toads' Tea Party*, 1905. Watercolor and pen and ink on paper, 20½ × 16 in. Victoria and Albert Museum.

Crooked Bear, peering from his mountain den, hating the woman who rejected him. He is also an image of Ermine, who, rejected by Katherine, reverts to the evolutionary status, the narrator tells us, of "a shellfish-eating cave-dweller."[53] Similarly, the vaginal hole in *Fight for the Water Hole* conjures nature "lay[ing] naked and insensate" as "men sweat and grunt and bang to kill." The painting's resonance with the novel's imagery of rape suggests a theme of sexual aggression that informs the manifest theme of racial warfare. Racial and temporal divisions are cast in gendered terms.

For Remington, Roosevelt, and others, women symbolized the advent of civilization on the frontier. It is no coincidence that Katherine arrives on a steamboat: the two are icons of progress. The heading of chapter 12 reinforces this, showing a picture of a steamboat above the chapter title, "Katherine," as if to imply that the steamboat's name *is* Katherine. Nor is it a coincidence that Ermine first glimpses Katherine in a photograph, itself an emblem of technology that anticipates his first view of the thousands of white soldiers among whom he will be doomed: "The camp slowly developed before [his] eyes like a photographic negative in a bath of chemicals."[54] And in fact, when we consider that Katherine is literally the death of Ermine, she comes to

appear as toxic an emblem of civilization as any of the army camps, locomotives, steamboats, or telegraph wires that routinely allegorize the doom of the Old West in paintings of this era.

Remington's misogynistic evolutionism relates to the discourse of the strenuous life. A number of writers and artists lamented (or at least commented on) the impending feminization of American culture. In Stephen Crane's "Bride Comes to Yellow Sky" (1898), Scratchy Wilson is "about the last one of the old gang that used to hang out along the river here," according to the barkeeper. Although the authenticity of even this old-time westerner is not quite what it seems—Crane points out that his "maroon-colored flannel shirt" had been "made principally by some Jewish women on the East Side of New York"—Scratchy nonetheless waits, a holdover from the old days, for the arrival of Sheriff Jack Potter, whom he intends to kill. Yet when he confronts Potter, Scratchy pauses, incredulous: his enemy has a bride. "[Scratchy] was like a creature allowed a glimpse of another world," Crane writes. "He moved a pace backward, and his arm, with the revolver, dropped to his side." Then Scratchy "went away."[55]

In Charles Russell's *Last of His Race* (1899), a depiction of his new hometown of Great Falls, Montana (complete with the smokestack of the Boston and Montana smelter in the distance), a surcharge of death signs—town, smokestack, telegraph poles and wire, buffalo skull—surrounds the decrepit warrior (fig. 29). The warrior is a weakened remnant of Old American manhood. His pipe is flat on the ground, its fires extinguished, whereas the smelter stack spills billows containing the ghosts of his own buffalo-hunting virility. There is, however, no more threatening image of modernity— no greater icon of the once-virile Indian's doom—than the woman riding past the warrior. Literally an out-skirt, she personifies the feminized civilization expanding to supplant the old arrow-shooting frontier. The dust kicked up by her bicycle (itself an emblem of modernity) tells us that the expansion is happening quickly. Russell repeats the bell of the woman's dress in the curves of the buffalo skull: woman and skull alike toll the decrepit Indian's death. In characteristic evolutionist fashion, Russell paradoxically claims that the cycles of history travel on a straight path.[56]

Teddy Roosevelt was the most famous purveyor of this sentiment. Motivating his endorsement of the strenuous life was a fear of the feminization of American men, especially himself. "The cowboy," wrote Roosevelt in *Ranch Life and the Hunting Trail*, "possesses, in fact, few of the emasculated, milk-and-water moralities admired by the pseudo-philanthropists; but he does possess, to a very high degree, the stern, manly qualities that are so valuable to a nation."[57] Just keep him dirty and out of civi-

29. Charles Russell, *The Last of His Race,* 1899. Pen and ink on paper, 15¼ × 25¼ in. Charles M. Russell Museum, Great Falls, Montana.

lization's chemical bath. Development is death. *Fight for the Water Hole*, a picture of just such stern and manly cowboys (it was the frontispiece for volume 4 of Roosevelt's *Winning of the West*), addresses the paradox within Roosevelt's statement. That is, the nation to which the cowboys are so valuable is precisely the realm of the feminized milk-and-water civilization they hate. The water-hole cowboys carve settlements in the vast American desert, but in doing so, they help create the feminized culture that will devour them. "The big eat the little that they may continue to move, the strong eat the weak that they may retain their strength," Wolf Larsen tells Humphrey Van Weyden.[58] "Throughout his career," Wister writes of the Anglo-Saxon frontiersman, "it has been his love to push further into the wilderness, and his fate thereby to serve larger causes than his own. In following his native bent he furthers unwittingly a design outside himself; he cuts the way for the common law and self-government, and new creeds, polities, and nations arise in his wake; in his own immense commonwealth this planless rover is obliterated."[59] Ermine, writes Remington, "was to aid in bringing about the change which meant [his] passing."[60] For the pioneer, to carve a settlement is to dig one's own grave.

A New Emotion

It is odd, then, that *Apache Medicine Song* departs somewhat from this hatred and fear of a feminized civilization. The half-naked Indians are types of Remington's monstrous infant, as we have noted, but much else in the painting softens the stance that the artist took in painting such earlier works as *Fight for the Water Hole*. The two foreground baskets are rounded, swollen, pregnant forms recalling the classical imagery of women as vessels. In one sense, these thoroughly feminized baskets augment *Apache Medicine Song*'s theme of evolutionary birth. Their curves echo those of the Apaches' backs and the sloping huts, emphasizing the link between these three icons of primitiveness. Yet the baskets serve another purpose. The one in the center is the nearest humanmade object in the entire painting, an artifact shown seemingly for its own sake, apart from any narrative role. In light of the artist's misogyny, what sort of Remington painting would thus give pride of place to an art object—moreover, one with distinct feminine connotations?

The answer concerns Remington's self-conscious late-career change from documentary to fine artist. In the last few years of his life, as Peter Hassrick and others have demonstrated, Remington sought to shake the role of illustrator and become known as a serious painter. For Remington, this meant emphasizing the formal as much as the narrative qualities of his art. Partly the change involved study of impressionist brushwork, like that of his friend Childe Hassam. Partly it involved studying the work of James McNeill Whistler. In 1908, the year he painted *Apache Medicine Song*, Remington wrote in his diary: "There is a Whistler [at] the Met Museum as black as the inside of a jug."[61] Remington's own "moonlights," as he called them, manifestly owe more to the work of the California artist Charles Rollo Peters than they do to Whistler's, but by 1908 he was clearly interested in Whistler's painting. In that year he made two trips into New York to see Whistler's art, examining it in January at the Metropolitan and in March at Macbeth Gallery. He owned Arthur Jerome Eddy's *Recollections and Impressions of James A. McNeill Whistler* and E. R. and J. Pennell's two-volume *Life of James McNeill Whistler*. His sculpture scrapbook includes a reproduction of Victor D. Brenner's commemorative *Whistler Plaque*.[62] Remington's interest was natural enough: as a well-known painter of nighttime scenes—he made approximately twenty in 1906–9—he wanted to examine the work of the most famous nocturne painter of all, the artist whose night images had originated the very use of *moonlight* and *nocturne* to describe Remington's own night scenes.

Remington's admiration carried powerful gendered associations. For him, Whistler epitomized art-for-art's-sake aestheticism. "Saw some 'punk' Whistlers and how peo-

ple can see everything in there I do not know," Remington wrote after his trip to Macbeth Gallery.[63] Although the Whistlers he saw at Macbeth and the Metropolitan were probably darker than Whistler had intended (the result of too much bitumen), Remington's comment reveals that as far as he could see, the paintings contained little subject matter.[64] Mostly, such works were just paint. For Remington, paint that was not subsumed by "strenuous" subject matter was as feminized an instance of civilization as Russell's out-skirt, the woman on a bicycle. Upon seeing impressionist paintings of the kind he was then making, he is alleged to have said, "I've got two maiden aunts in New Rochelle who can *knit* better pictures than those!"[65] He was even more explicit in a letter he wrote to his friend Al Brolley in 1909: "I stand for the proposition of 'subjects'—painting something worth while as against painting *nothing* well—merely paint. I am right—otherwise I should as soon do tatting, high-art hair pins or recerchia ruffles on women's pants."[66] Nor was Remington alone in thinking of paint in this way. In *White Fang*, London describes Beauty Smith, a primitive and exceptionally ugly character: "His eyes were yellow and muddy, as though Nature had run short on pigments and squeezed together the dregs of all her tubes."[67] Here, nature is not only figured as a painter before her easel; strikingly, the phrase *her tubes* recalls a woman's reproductive organs as much as it does tubes of paint.

Paint for its own sake was like Katherine Searles: pretty, lacking in ideas, and utterly insincere. "Sir Walter Clark lecture says, 'American Art must have ideas. Paint for paint's sake is out of date,'" Remington reported in his diary. The implication was that "paint for paint's sake" was wholly lacking in intellectual content. Along these lines, Remington regarded his little landscapes as "merely pretty." Privately he criticized the impressionist work of Robert Reid: "Bobbie's hand is cunning at small landscape but it lacks sincerity—[the paintings] have a paint for paint's sake draw to artists but [are] d—— by public. The public while not knowing why can detect sincerity."[68]

Remington consequently found Whistler a very feminized artist. In *John Ermine* the hero's first feelings of love for Katherine evoke both feminized paint and Whistler himself. Ermine's love is "a new emotion, indefinite, undefinable, a drifting, fluttering butterfly of a thought which never alighted anywhere. All day long it flitted, hovered, and made errant flights across his golden fancies—a glittering, variegated little puff of color."[69] This little puff of color, likened to a butterfly, also calls to mind a bit of paint. The butterfly—clearly feminized in Remington's description—was Whistler's private emblem, a device he used in his signatures.

The hostility conveyed in each of these three quotations indicates that Reming-

ton's interest in Whistler—and in painted mood generally—was halting and ambivalent. Yet his move toward this more feminized form of art is easily tracked. In *The Way of an Indian*, White Otter, the hero, approaches an Indian man playing a flute to woo a lover to a secluded forest. In a passage that demonstrates Remington's antipathy to such sentiment, White Otter viciously kills the man: "The knife tore its way into his vitals—once, twice, three times, when, with a wild yell, he sank under his deluded infatuation."[70] In 1909, however, Remington made a painting, *The Love Call* (location unknown), showing a solitary Indian man playing a flute beside a tree. Remington was now depicting the feminized scenes that he had claimed to hate. And he would have understood not just the subject but the style as feminine: he completed *The Love Call* in one day, implying that his method, as in many of his late works, was more bravura and impressionistic.[71] He had "knitted" the surface.

Remington's many late nocturnes also signaled his turn to a feminized art. The moon in *John Ermine* is "She of the night, soft and golden, painting everything with her quiet, restful colors, and softly soothing the fevers of day with her cooling lotions."[72] In a dense feminization, the passage conflates moonlight, painting, and mothering. The application of cooling lotions to a fevered body, echoing the act of painting quiet, restful colors, connects the work of the painter with the nighttime ministrations of a mother to a bedridden child.

The starkest feminization in *Apache Medicine Song*, however, concerns Whistler. Remington's painting contains at least three tantalizing, though clearly unconscious, references to the artist whose nocturnes he had been examining that year. One occurs in the upper right-hand corner, where a fire is visible inside a hut. The entryway is rectangular; its border, lit by the fire within, is a golden frame; the fire itself suffuses this picturelike entryway with rockety streaks of sparkling light. All in all, the entryway strikingly resembles such Whistler nocturnes as *Nocturne in Green and Gold* (fig. 30). The title of Remington's painting—specifically, the inclusion of the word *Song*—also obliquely refers to Whistler, recalling that painter's manner of naming his works symphonies, arrangements, and harmonies. Finally, the nearest basket, confronting us with its black mouth, vividly recalls Remington's description the same year of a Whistler "as black as the inside of a jug," prompting questions about why Remington would choose this particular metaphor to describe Whistler's bitumen-darkened painting. The answer concerns the kind of multivalent feminization at work in the *John Ermine* passage above. A basket or jug, as a vessel, was as feminine a symbol for Remington as Whistler's butterfly. It also called to mind Whistler's feminized painting technique: the icon of the artist's aestheticism was, in John Ruskin's

famous phrase, "a pot of paint."[73] Ruskin's accusation—that Whistler had flung "a pot of paint in the public's face"—derogated an art destitute of subject matter. Remington's swollen basket, a beautiful object isolated from the surrounding narrative, ambivalently evokes Whistler, women, and the "pot of paint."

In these unconscious ways Remington identified his painting with feminized civilization. Certainly the work of artists like the urbane Whistler and the members of the American impressionists seemed to him progressive. "Saw Bobbie Reid's new work—splendid—a good long stride," wrote Remington in 1908. "By gad a fellow has got to race to keep up now days—the pace is fast."[74] The evocations of forward movement—in particular, the phrase "a good long stride"—suggest the evolutionary interest not only in career progress but in the mechanics of walking; Reid's impressionist work comes from a higher walk of life, one productive of good long strides. It

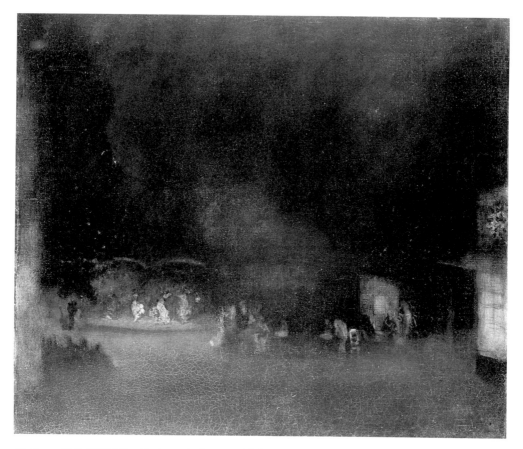

30. James McNeill Whistler, *Nocturne in Green and Gold: Cremorne Gardens, London at Night,* ca. 1876. Oil on canvas, 25¼ × 30¼ in. Metropolitan Museum of Art, New York. Gift of Harris C. Fahnestock, 1906.

was the kind of forward progress that Remington himself wanted desperately to achieve. When critics favorably reviewed his December 1909 exhibition at Knoedler's Art Gallery, he was pleased to announce—in opposition to his letter to Brolley, written the same month—that "the art critics . . . ungrudgingly give me a high place as a 'mere painter.'"[75]

A somewhat earlier picture is one of Remington's clear equations of painting and civilization. In *His First Lesson* (1903), two cowboys attempt to tame a wild horse (fig. 31). With one of the horse's hind legs tied to prevent running or kicking, the man on the left holds the horse's head steady with a rope while the man on the right perhaps readies to mount the wild beast. The picture allegorizes the taming of the Wild West; it does so, moreover, in the manner of *Fight for the Water Hole*: the cowboys assist in the taming that will mark their own demise. This much the composition alone implies. There are three horses and four men in the picture. From the central foreground group, the viewer's eye travels to a middleground figure watching the action from the back of a complacent white horse. Behind this figure, in the darkened doorway at the right, another man and horse also look on. In this progression the picture implies a

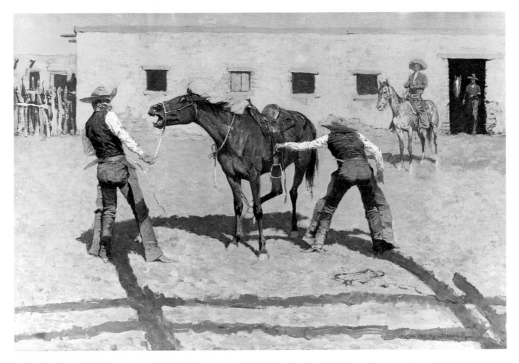

31. *His First Lesson,* 1903. Oil on canvas, 27¼ × 40 in. Amon Carter Museum, Fort Worth, Texas.

transition culminating in the domesticated state of the man and horse in the doorway.

What is especially interesting about *His First Lesson* is the way it identifies picture making itself as one of the taming forces of civilization. Peter Hassrick has pointed out that *His First Lesson* "was the first Remington painting which *Collier's* published in color. Shortly thereafter, Remington signed a contract with the magazine in which he agreed to furnish them a dozen comparable paintings each year in return for $12,000 salary."[76] It was up to Remington to determine the subject matter of these pictures. *His First Lesson*, in other words, began Remington's move away from illustration—from scenes in which the subject matter was, to an extent, prescribed—to an art in which he could develop his own subjects and experiment more with form. The first lesson of the title, then, refers not just to the taming of the horse but to Remington's own initial training in a more imaginative art. Although this equation seems to identify Remington with the horse, each a rough untrained thing now required to learn something new, the career change for Remington was liberating. As Hassrick and others have noted, he was anxious to be known as more than a mere illustrator. Thus the artist's freedom is linked to the wild horse's entrapment.

Such a link is also suggested by the action of *His First Lesson*. In the foreground, the shadow of a gate and part of a fence extends into the picture space. The unseen gate and fence presumably form part of the same fence that we can see in the left background, allowing us to understand the horse as confined by corral as well as ropes. The shadow of the gate frames the horse, intimating the doorway's penultimate state of enclosure. The gate also extends from the realm of the painter himself. As a rectangular threshold between realms, it evokes a canvas, as though it were Remington's compulsion to represent the canvas on which he makes the picture *within* the very scene that the canvas portrays. The horse, then, is further trapped by an image—the shadowed gate—evocative of the painting itself. It is as if Remington wished to identify his own act of painting as complicit with the forces that constrain and tame the Wild West.

The metaphor is all the more suggestive if we look at the left cowboy. In several ways the figure resembles a painter in the act of painting. The man's right hand is connected to the horse via a taut rope that suggests a paintbrush umbilically linking the two. His defensive stance away from the horse evokes that of an artist standing back to survey work in progress. The act of painting is like a harness closing round, tightening, taming, the wild thing portrayed. The background building, with its neat row of four windows and one door, represents the realm of the horse's ultimate domesticity as a kind of picture gallery: windows and door are like pictures hung on a wall.

Framed in the doorway at the right, cowboy and horse stand as though in a formal portrait. Remington is ambivalent, on the fence, about the forces of civilization he shows.

Apache Medicine Song, as we have seen, similarly identifies the act of painting with domesticity and civilization. In fact, the background "Whistler" in the later painting—the fire in the background hut—recalls the similarly placed doorway "portrait" in *His First Lesson* as a marker of domestic civilization. Yet in *Apache Medicine Song*, Remington also unconsciously identifies the act of painting with the primitive. There is something strange about the Apache closest to us (fig. 32). He is the only figure with his back turned. Space on either side separates him from the six other figures. Also, he does not so much face the campfire as lean into the painting. His body is oriented to the picture plane at an angle, so that his left hip and left shoulder are closer to us than his hidden right hip and right shoulder. The modeling of his hair where it meets the shoulders suggests that his head also leans inward. His right arm, although we feel its presence, is entirely absent. He is probably meant to be stoking the fire, perhaps with a stick. Yet, with his back turned, leaning into the scene, and implicitly holding a (brushlike) stick in his right hand, he also dramatically recalls a certain conventional

32. *Apache Medicine Song* (detail).

33. Jan Vermeer, *The Artist in His Studio*, ca. 1666–67. Oil on canvas, 48 × 40 in. Kunsthistorisches Museum, Vienna. Photograph courtesy of Art Resource.

manner of showing the artist in the act of painting, a resemblance that I illustrate with one example chosen from among many possibilities (fig. 33). More specifically, this figure recalls Remington's self-portrait, explicitly in the act of representation, sketched in an IOU to his friend Joel Burdick (fig. 34). Across the fire from a "perfect animal" (as Remington was in South Dakota), across the fire from an array of three Apaches (as Remington was in Arizona), this back-turned Apache reads as an unconscious Remington self-portrait. *Apache Medicine Song* and *His First Lesson*, as we shall see in the last chapter of this book, are two of many late works that express Remington's unconscious compulsion to represent the act of painting within the very scene he paints.

"He worked unhampered by rule, example, or opinion, a veritable child of nature, and he died untamed." So wrote Augustus Thomas, playwright and friend of the artist, in posthumous appreciation. Thomas continued: "Remington thought he believed in 'art for art's sake,' but I know of nothing that he ever did in any of its departments that did not primarily attempt a story. His wish to tell something that had touched him, and tell it at first hand, was as primitive as the instinct of a caveman."[77] For Thomas, Remington's storytelling art was as primitive as the cultures it

34. *Untitled,* 1889. Ink on paper, 7 × 9 in. Frederic Remington Art Museum, Ogdensburg, New York.

records. Remington himself would have approved of this characterization. "Gus T says I am 'a mental hermit,'" he noted in his diary without evident dissatisfaction. Elsewhere in the diary he attached a newspaper clipping, written by an anonymous art critic and addressed to Remington. "You are a primitive man, born a few centuries after your time," the critic wrote. "Instead of painting on rocks you have used a canvas." In the painter-figure of *Apache Medicine Song*, Remington likewise identifies his story-based mode of art with primitive cultures.

Granted, his identification is equivocal. First, the painter-figure—together with the fully clad figure at the left—sits instead of crouches by the fire; and second, the Whistlerian pot (palette) of paint is at the painter-figure's side, suggesting that the very medium with which he tells his stories is de facto a civilized or merely pretty substance (I shall have considerably more to say on this topic in the last chapter). *Apache Medicine Song*, like Thomas's appreciation, nonetheless posits the realist painter as a cave dweller. In social-evolutionary logic, the rudimentary tool of the brush recalls the phallic sticks of racial ancestors. The storytelling brush, it seems, is as masculine and primitive as paleolithic man's penile club. The memory of these primitive activities is somehow encoded in the physical practice of applying the paint to canvas. The brush, in London's terms, "linked the past with the present." It itself swayed.

For Thomas, who wrote his appreciation in 1913, the year of the Armory Show in New York, realist painters are as doomed as the evolutionary primitives they paint. *Apache Medicine Song* makes the same point. Painted in 1908, at the end of the centuries-old realist tradition—at the moment when the long-assumed mimetic abilities of paint were irrevocably thrown into question—Remington's painting announces its own evolutionary eclipse. The forces creeping to replace it, like the shadows of the unseen tree in *Apache Medicine Song*, are vague, only quasi-representational. Again, like the shadows of the nonexistent tree, these forces evoke objects for which the only evidence is the shadows or images themselves. Remington hints at a new kind of art, one altogether distant from the old realist belief in a one-for-one correspondence between painted image and real world. What we see, then, is that the evolutionary paradigms governing Remington's conception of race governed his conceptions of art as well. "I am frankly of the opinion," he wrote in his diary on January 16, 1908, "that painting is now in its infancy."

Chapter Two / The Death of Triumph

I fled. I could not run.
—A soldier's dream, reported in Remington, "The War Dreams" (1898)

Remington went to Cuba in June 1898, he said, to satisfy "a life of longing to see the greatest thing which men are called on to do."[1] The Spanish-American War had broken out two months after the U.S. battleship *Maine* had exploded in Havana harbor on February 15, an act widely attributed to Spanish sabotage, although no evidence ever conclusively implicated Cuba's colonial rulers. Two American rallying cries— "Remember the *Maine*!" and "*Cuba Libre*"—signified the ostensible causes for American intervention. War was declared on April 21; a U.S. "army of invasion" sailed from Tampa on June 5; and on July 26 the Spanish sued for peace, allowing the evolutionary baby to take its "first steps alone," to quote a *Puck* cartoon of 1902 (fig. 35). As part of the peace agreement, the Americans received the Philippines, and sought to transform the former Spanish possession into an American colony. The Filipinos resisted in a bloody war that lasted from 1899 to 1901.

Remington had been to Cuba in 1897 at the behest of William Randolph Hearst, the editor of the *New York Journal*, but had soon returned, disappointed that a war involving the United States seemed unlikely. When the USS *Maine* blew up the following year, Augustus Thomas heard the news and "immediately called him on the telephone. His only thanks or comment was to shout 'Ring off!' In the process of doing so I could hear him calling the private number of his publishers in New York."[2] The next

53

35. Samuel D. Ehrhart, *The First Steps Alone—
May 20th, 1902*. Reproduced in *Puck* 51 (May 20,
1902): cover.

year Remington produced seven articles, three vignettes, and numerous illustrations concerning the war and its aftermath. In probably the most famous of these images, *The Charge of the Rough Riders at San Juan Hill*, Col. Theodore Roosevelt (on horseback) leads a group of the Rough Riders, the elite all-volunteer regiment he helped form and command, in an assault on the Spanish stronghold that blocked the road to Santiago, the Cuban capital (fig. 36, plate 3). Although the Rough Riders were only part of a widespread assault on the Spanish fortifications, their charge on San Juan Hill (actually Kettle Hill) quickly became the most famous incident of the war. Remington's painting, reproduced in Roosevelt's article of 1899, "The Rough Riders," played its part in making the charge an icon of American heroism during the war.

A Game Battle

Scholars like to point out that in Remington's painting the Rough Riders' charge looks much like a football play. Peter Hassrick links the football quality of *Charge* to Remington's own experience as a rusher for the 1879–80 Yale team; the picture, he writes, "is a restatement of . . . an end run such as Remington's teammates might have made in his Yale football days—but now in a man's rather than a boy's game."[3] John Seelye evokes the rush of *Charge* by comparing it to *A Run Behind Interference*, a Remington football illustration (fig. 37).[4] It is the orchestrated action of *Charge*'s cen-

36. *The Charge of the Rough Riders at San Juan Hill,* 1898. Oil on canvas, 35 × 60 in. Frederic Remington Museum, Ogdensburg, New York. See plate 3.

37. *A Run Behind Interference,* 1893. Reproduced in *Harper's Weekly,* December 2, 1893, p. 1152. Thomas J. Watson Library, Metropolitan Museum of Art, New York.

tral group, containing the officer dressed in khaki, that most specifically recalls the blocking (or interference, as it was then called) in Remington's football painting. Why did Remington show the Rough Riders in such a football-like way?

On the most basic level, we can turn to Remington's artistic skills. His football illustrations were among the only images he had made of running figures by the time he went to Cuba. Already safe in his reputation as an expert painter of horses, he had gone to war expecting to see and paint cavalry charges; he was stunned and angry when told in Tampa, where the army was staging, that some of the cavalry would be converted to infantry. "I wanted to damn some official, or all officialism, or so much thereof as might be necessary," he wrote. He felt for the cavalry officers, who "were to a man disgusted"; "besides," he complained, "the interest of my own art required a cavalry charge."[5] As it turned out, the Rough Riders themselves were dismounted. Denied the customary visual device of the cavalry charge, limited by the illustrator's need to be true to the facts, Remington resorted in *Charge* to his few precedents for running figures: the football images.[6]

But there is much more to the painting's football allusions. Many of the Rough Riders were collegiate football players and star athletes generally. Roosevelt himself was quite proud of this; recollecting a few Rough Riders who had fought with distinction, he said: "So it was with Dudley Dean, perhaps the best quarterback who ever played on a Harvard Eleven; and so with Bob Wrenn, a quarterback whose feats rivaled those of Dean's, and who, in addition, was the champion tennis player of America, and had, on two different years, saved this championship from going to an Englishman. So it was with Yale men like Waller, the high jumper, and Garrison and Girard; and with Princeton men like Devereux and Channing, the football players."[7]

Battlefield and playing field (specifically, the football field) were both proving grounds for the Anglo-Saxon elite. Perhaps this was why Roosevelt and Leonard Wood, who would become the commander of the Rough Riders, liked to discuss the possibility of war with Spain on their way to and from "kicking a football around in an empty lot" during the prewar year of 1897.[8] "Do we want a race of Americans fearful of bagging its trousers or of sustaining a few bruises?" wrote Remington's friend Caspar Whitney in 1896, responding to claims that football had become too dangerous, "or is this country the better off for having citizens made courageous and hardy and alert by vigorous games in which there is an element of danger?" Whitney continued, in a passage I quote from Michael Oriard's excellent book *Reading Football* (1993): "Ignorant editors may criticise, and pusillanimous detractors may slander, but strength and valor and pertinacity of purpose are among the necessary qualities to

successful human endeavor, and no game nourishes them more abundantly than football. These, together with a sound mind, are the characteristics of men of action. And men of action keep the world moving."[9]

Remington's charging Rough Riders are just such men of action. The world they keep moving, in turn, is at least partly the business world. Wrote Walter Camp, Remington's teammate at Yale and the acknowledged founder of many modern football rules, "If ever a sport offered inducements to the man of executive ability, to the man who can plan, foresee, and manage, it is certainly the modern American football."[10] Football, like war, teaches managerial teamwork and leadership—an assertion not lost on today's military recruiters. Even as football and war prepared the future business leaders of the United States, however, such pursuits were also prized as noble endeavors unsullied by cash. Unlike baseball and prizefighting, sports played by professionals often cast as lowlifes, football retained the air of "the gentleman amateur," in the words of one commentator writing in 1890. It was partly this purity and nobility of purpose that made its players such good businessmen, because it taught them the "strength and valor and pertinacity of purpose" that were more important than, though they contributed to, the bottom line.[11] The Rough Riders, like gentleman amateurs, volunteered their services.

The relation between war and sports in Remington's time was not purely a matter of metaphor. War was regarded and treated as a game. In World War I this idea got its most literal enactment: "One way of showing the sporting spirit was to kick a football [a soccer ball] toward the enemy lines while attacking." A survivor recalled one such charge: "As the gun-fire died away I saw an infantryman climb onto the parapet into No Man's Land, beckoning others to follow. As he did so he kicked off a football. A good kick. The ball rose and travelled well towards the German line. That seemed to be the signal to advance."[12] Such spectacles were the sad culmination of a concept that was dominant in 1898. The two stanzas of Henry Newbolt's "Vitaï Lampada," a poem written in 1898, describe successively the fields of cricket and battle:

> There's a breathless hush in the Close tonight—
> Ten to make and the match to win—
> A bumping pitch and a blinding light,
> An hour to play and the last man in.
> And it's not for the sake of a ribboned coat,
> Or the selfish hope of a season's fame,
> But his Captain's hand on his shoulder smote—
> "Play up! play up! and play the game!"

The sand of the desert is sodden red—
 Red with the wreck of a square that broke;
The Gatling's jammed and the Colonel dead,
 And the regiment blind with dust and smoke;
The river of death has brimmed his banks,
 And England's far, and Honor a name;
But the voice of a schoolboy rallies the ranks:
 "Play up! play up! and play the game!"[13]

It is not just any game that Remington's charging Rough Riders play; in America, of all sports, football was regarded as most interchangeable with war. In 1897 the *Herald, World,* and *Journal* of New York—the last the paper of Hearst, the man who sent Remington to Cuba—"ran season-long exposés of the carnage on football fields," tracking the number of players killed across the nation.[14] *The Twelfth Player in Every Football Game,* a cartoon in the *World* of November 14, 1897, shows Death preparing to snap a ball inscribed with fatality statistics (fig. 38). "In 1889," reports Oriard, "the *World* contracted to have two ambulances, four stretchers, and an 'expert army surgeon' present at the Yale-Princeton game."[15] Although muckraking newspapers were most often responsible for these reports, even the game's most austere adherents knew and celebrated its military resonance. The controversial flying wedge, so lethal that it was eventually outlawed, was adapted by the Harvard coach Lorin F. Deland from his studies of Napoleon's military tactics.[16] Both *A Run Behind Interference* and the central group of *The Charge of the Rough Riders* show something akin to this infamous mass-momentum play.

As a game of forward progress, football resonated with imperial warfare, that other late nineteenth-century endeavor of territorial acquisition. Colonial conquest not only brought civilization to the "untamed" parts of the earth but also brought progress itself to the inhabitants of the untamed places. One "scrimmaged with the wilderness," in Frank Norris's phrase, to tame it and its inhabitants.[17] The Carlisle School Indians who were taught football in the 1890s embodied progress not only in their adaptation to this white man's game but also in their adherence to the rules: when marching the ball down the field, they were part of the proverbial "steady march of civilization."[18] Likewise the Sudanese children, leapfrogging through the streets of Ward's Omdurman, played the only game in a progressive town (see fig. 26).

The gallantry of football, its purity and nobility of purpose, rhetorically extended to imperial conquest. In *Charge* this gallantry is exemplified by the young man just to the left of the khakied officer (fig. 39). Clutching his heart, he raises his face to the sky:

THE TWELFTH PLAYER IN EVERY FOOTBALL GAME.

38. C. G. Bush, *The Twelfth Player in Every Football Game,* 1897. Reproduced in the *New York World,* November 14, 1897.

39. *The Charge of the Rough Riders at San Juan Hill* (detail).

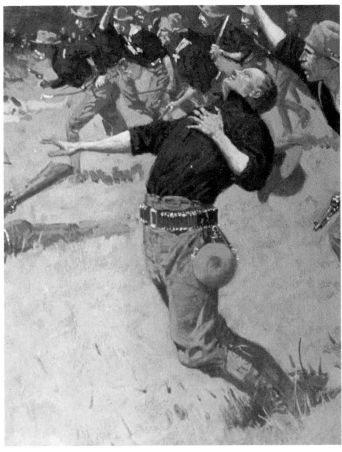

he is mortally wounded, patriotic, and pious—a heady mix. His pose evokes "For God, for Country, and for Yale," the last line of the song "Bright College Years," passionately sung at a special all-college meeting at Yale on the night of May 20, 1898. The last line, "sung with such an emphasis and impressiveness, was the text of the whole meeting," according to Lewis Sheldon French and Walter Camp, authors of *Yale: Her Campus, Class-Rooms, and Athletics* (1899).[19]

But something else about the young man's death pose deserves our special attention. He thrusts his chest and head back in the manner of a sprinter who has just crossed the finish line. He is finished in two senses, having both won the race and died, a version of that heroic figure, the athlete dying young. In 1893 Walter Camp recalled "one of the most magnificent dashes ever made on an American foot-ball field," the touchdown run of Lamar, the Princeton captain, in 1885: "How he ran! But Lamar—did he not too know full well what the beat of those footsteps behind him meant? The white five-yard lines fairly flew under his feet; past the broad twenty-five yard line he goes, still with three or four yards to spare. Now he throws his head back with that familiar motion of the sprinter who is almost to the tape, and who will run his heart out in the last few strides, and, almost before one can breathe, he is over the white goal-line and panting on the ground, with the ball under him, a touch-down made, from which a goal was kicked, and the day saved for Princeton. Poor Lamar! He was drowned a few years after graduation."[20]

Oriard, from whom I quote the passage, rightly points out the surprise of Lamar's death, "unexpectedly appended to his moment of heroics."[21] Yet, in some sense, the touchdown sprint prefigures Lamar's moment of death: "Did he not too know full well what the beat of those footsteps behind him meant?" The phrase conjures a figure running from the specter of death. Camp has transformed the moment of Lamar's fame into a symbol of the sprint of his short life, at the end of which he lies "panting on the ground," a state that evokes the drowning victim he would become. (It is the condition of the spectator, whom excitement has rendered unable to breathe, that precisely predicts Lamar's drowned body.) Remington's young soldier, "throwing his head back, running his heart out," is like Lamar: a figure paradoxically fleeing death by seeking the finish. He is also like the soldiers that Remington saw brought from a Cuban battlefield. "One beautiful boy," Remington writes, "was brought in by two tough, stringy, hairy old soldiers, his head hanging down behind. His shirt was off, and a big red spot shone brilliantly against his marblelike skin. They laid him tenderly down, and the surgeon stooped over him. His breath came in gasps. The doctor laid his arms across his breast, and [shook] his head."[22] In the context of a Spanish-American

War scene, the dying beautiful boy, playing the game, establishes the innocence of the colonial enterprise.

Camp and French, writing about Yale in the patriotic stir after the war, equate a dead young hero to the martyrs of the American Revolution. "Young Miller, the manly trooper of the Rough Riders, who received his mortal wound at San Juan," was moved to his battlefield bravery by the spirit of Nathan Hale.[23] For other observers, the relation of the Spanish-American War to the American Revolution was much more problematic. A viewer of Howard Pyle's *Battle of Bunker Hill*, also made in 1898, might have reflected on the similarities between Bunker and San Juan Hills (fig. 40). "The Republican party has accepted the European idea and planted itself upon the ground taken by George III," said William Jennings Bryan, the prominent anti-imperialist politician, in his nomination speech at the Democratic National Convention in Indianapolis on August 8, 1900.[24]

Bryan often contrasted the contemporary interest in imperial conquest with the Founding Fathers' attempts to refrain from just such imperialism. In this he was competing with Republicans like Roosevelt, who sought to align their interest in territorial acquisition with such precedents as the Louisiana Purchase. "The advocates of

40. Howard Pyle, *The Battle of Bunker Hill*, 1898. Oil on canvas, 23¼ × 35¼ in. Delaware Art Museum, Wilmington.

imperialism," Bryan wrote in the *New York Journal* on December 25, 1898, "have sought to support their position by appealing to the authority of Jefferson. Of all the statesmen who have ever lived, Jefferson was the one most hostile to the doctrines embodied in the demand for a European colonial policy. . . . Jefferson taught the doctrine that governments should win the love of men. What shall be the ambition of our nation—to be loved because it is just or to be feared because it is strong[?]"[25] Bryan refers to the Philippines, a case not exactly analogous to Cuba. After the Americans defeated the Spanish in the Philippines, the Filipinos themselves turned on the Americans; the Cubans, on the contrary, did not fight the Americans after the two had combined to defeat the Spanish. Nevertheless, in this volatile political climate, the ostensibly unequivocal meaning of *The Charge of the Rough Riders* was unstable. The un-American import of the Rough Riders' charge—the imperial acquisition of territory—made it easy to see them in terms of George III and not Nathan Hale.

Grabbing the Land

The language of Remington's Spanish-American War pictures—and not just the climate for reading them—was also unstable. In *The Scream of Shrapnel at San Juan Hill*, infantrymen awkwardly cower as they hear the warning scream of incoming shrapnel (fig. 41, plate 4). Figures sprawl on the ground or bend in undignified ways. One figure just to the left of the center, bugle and drum strapped to his back, takes off for the woods. Only the officer at the far left, acting the bookend to the toppling column, stands stoically straight.

The painting illustrates something Remington describes often in his Cuban writing: Soldiers "were hugging the hot ground to get away from the hotter shrapnel"; "They flattened themselves before the warning scream of the shrapnel"; "I threw off my hat and crawled forward"; "I wormed my way up the fateful road to Santiago." Even descriptions that do not concern shrapnel evoke this preoccupation with the ground: "The troops came pouring up the road, reeking under their packs, dusty, and with their eyes on the ground." If eyes were on the ground, so were eyebrows: "The heat," Remington wrote, quoting Rudyard Kipling, "'would make your blooming eyebrows crawl.'"[26]

Remington was interested in the ground even before the expeditionary force reached Cuba. In Tampa, arguing with General Miles about plans to dismount much of the cavalry, Remington was prone before the general's superior rhetoric: "He had me flat on the ground." At this beginning point in the story, the ground is a locus of humil-

iation, where Remington discovers himself before the general and where the cavalry will wind up, as infantrymen. Soon, however, lying on the ground becomes a coveted position: "Do anything to me, but do not have me entered on the list of a ship," Remington writes of his seasickness on the voyage to Cuba, punning as though the passenger list were indicative of the ship's nauseating pitch and yaw. "It does not matter if I am to be the lordly proprietor of the finest yacht afloat," Remington goes on. "Make me a feather in a sick chicken's tail on shore, and I will thank you."[27]

In Cuba, Remington became by his own admission "a sick chicken." He left the island soon after becoming ill and nearly being shot: "A ball struck in front of me. . . . It jolted my [field]glass and my nerves, and I beat a masterly retreat, crawling rapidly backwards, for a reason which I will let you guess." But it is another of Remington's ground accounts that can take us into the meaning of *The Scream of Shrapnel*. "Directly came the warning scream of No. 2 [an artillery battery]," he writes, "and we dropped and hugged the ground like star-fish."[28] Why this simile? Manifestly it evokes the desire to flatten oneself as low as possible. On another level, though, it is a variation on the classic idea that battle brings out the evolutionary primitive, except here what is released is not the primordial warrior so much as a primordial state of helplessness.

41. *The Scream of Shrapnel at San Juan Hill,* 1898. Oil on canvas, 35¼ × 60¾ in. Yale University Art Gallery. Gift of the artist, 1900. See plate 4.

42. *The Scream of Shrapnel at San Juan Hill* (detail).

43. *The Scream of Shrapnel at San Juan Hill* (detail). *(top, opposite page)*

44. W. D. Stevens, *Swimming to Newburgh,* detail from *Hazing at the West Point Military Academy,* 1901. Reproduced in *Harper's Weekly* 45 (February 2, 1901): 120–21. *(bottom, opposite page)*

Remington's Cuban imagery seems to contain two examples of "starfish": the bodies of the two dead Spaniards in *The Charge of the Rough Riders*—in particular, the leftmost one, whose splayed limbs recall those of a starfish—and, more to our purposes, the ground-touching starfish-sized hands of two of the troopers in *The Scream of Shrapnel,* especially the more central hand (fig. 42). The shrapnel reduces the men to a low state of life; in a primordial state of fear, they are no longer Fiske's vertebrate animal: they have lost their backbone. In a Galton-style composite, Remington shows us the starfish within the hand, combining disparate evolutionary emblems—the one prehistoric, the other, with its opposable thumb, the very essence of civilization—in order to emphasize the evolutionary reversion taking place.

Starfish are not the only primitive creatures that the picture suggests. Men flop around like fish out of water (fig. 43). According to the war correspondent Richard Harding Davis, the heat, let alone the gunfire, made it so that "men gasped on their backs, like fishes in the bottom of a boat."[29] The floundering of Remington's soldiers also evokes the West Point hazing ritual of "swimming to Newburgh," as though the wartime conditions had reduced the simmering soldiers to the lowest life form at the military academy: the plebe (fig. 44). Still other soldiers hunch over "like the preexisting ape from which the races sprang," as Remington described the Mexican fiddler in

Swimming
To Newburgh

45. John Singer Sargent, *Theodore Roosevelt*, 1903. Oil on canvas, 58½ × 40½ in. White House, Washington, D.C.

"An Outpost of Civilization." The road to San Juan Hill—turnpike to progress—becomes a veritable evolutionary menagerie.

The fearful earth-hugging in *The Scream of Shrapnel* inverts an imperialist maxim. In his portrait of Theodore Roosevelt (1903), John Singer Sargent shows Roosevelt grasping a globular finial, a marker of Roosevelt's interest in imperial expansion (figs. 45 and 46). The world in Sargent's painting is in a white hand. That the globe also resembles an athletic ball confirms the sense in which imperialist discourse tended to present territorial acquisition as a challenge or game. The aim of the imperialist enterprise, as Sargent's picture shows it, was to carry the world itself over the goal line. Equivocation was nonetheless again in evidence: for the United States to carry the ball—to assume the "white man's burden"— entailed global domination. The black boy sucked a coconut, but the world was under a milk-white palm. The earth-grabbing conceit was everywhere at the time. "A long reach, but his arms are equal to the emergency," says a *Boston Globe* cartoon from about 1899 showing Uncle Sam embracing the world (fig. 47). In both Sargent's painting and the *Globe* cartoon the imperialist is presented as ecologist: he loves the earth. The soldiers in *The Scream of Shrapnel* love the earth, too, but not in the name of progress but in fear of progress. Despite their officer's demand, they do not want to move forward. Like football play-

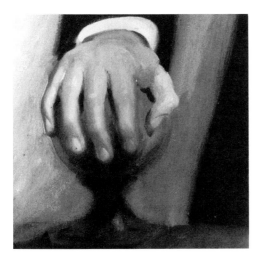

46. Sargent, *Theodore Roosevelt* (detail).

47. Anonymous, *A Long Reach, but His Arms Are Equal to the Emergency,* ca. 1899. *Boston Globe* cartoon reproduced in *Exciting Experiences in Our Wars with Spain and the Filipinos* (N.p., n.d.), 167.

48. Caravaggio, *The Conversion of Saint Paul,* 1601. Oil on canvas, 92 × 70 in. S. Maria del Popolo, Cerasi Chapel, Rome. Photograph courtesy of Art Resource.

49. *The Indian War,* 1878. Pen and ink on paper, 8 × 10½ in. Frederic Remington Art Museum, Ogdensburg, New York. *(opposite page)*

ers, they have been tackled; like fish, they flop. They exemplify what Roosevelt liked to call "cumberer[s] of the earth's surface," people unable or unwilling to progress.[30]

The soldiers fear not only their own literal progress but also, just as literally, the technological progress represented by the shrapnel about to rain down. The advent of long-range and unprecedentedly lethal weapons like high-powered shrapnel shells threatened to transform the traditional conception of soldiering. The new soldier, Remington wrote, "may go through a war, be in a dozen battles, and survive a dozen wounds without seeing an enemy."[31] Beginning with the American Civil War and concluding with World War I, a newer model of warfare was replacing the old one predicated on face-to-face combat. Remington regarded the new weapons suspiciously as "boxes of tricks."[32] He evinced his loathing of the latest military technology even before he landed in Cuba: on board the battleship *Iowa* outside Havana harbor, he was given a tour of the vast engine rooms. He "crawled and scrambled" through these rooms much like the figures he would paint cowering beneath the shrapnel. "At last when I stood on deck," he writes, "I had no other impression but that of my own feebleness, and, as I have said, felt rather stunned than stimulated. Imagine a square acre of delicate machinery plunging and whirling and spitting, with men crawling about in its demon folds! It is not for me to tell you more."[33]

Technology is the new god. Like Henry Adams before the giant Langley engine at the Great Exposition in Paris in 1900, the *Iowa*'s engine-operators "fairly worship this throbbing mass of mysterious iron."[34] Remington's Cuba paintings also cast technol-

THE INDIAN WAR.

ogy as godlike. The burst of shrapnel exploding behind Roosevelt in *The Charge of the Rough Riders* usurps the place of the sun. The floundering figures in *The Scream of Shrapnel* derive from the baroque manner of showing violent and convulsive spiritual conversion (fig. 48). The area of meadows and lagoons around San Juan Hill, including the Siboney-to-Santiago road shown in Remington's picture, was locally called a Paradise.[35] Remington's Adamic soldiers, in fear of a wrathful sky, bowing before a weapon they fairly worship, do not want to leave an Eden.

No wonder, then, that Remington's soldiers pound on the earth as though begging to be let in. What they want, from both a military and a metaphorical point of view, is a trench, a womb of the kind in which the *Water Hole*'s cowboys find themselves snugly sequestered. Seeking the earth, they desire to return to a feminine, pre-social space having nothing at all to do with progress. In *The Indian War*, a drawing that Remington made when he was seventeen—one of a number of images he made after attending the Highland Military Academy in Worcester, Massachusetts—the artist portrayed a cavalry officer, his scabbard dangling between his legs, fleeing an Indian assailant (fig. 49). In the distance is a cave or tunnel, marked "BIG HOLE." The drawing reads as an image of Remington himself wishing to return home from a threatening social space, the military school where he was a disappointment to his father, the Civil War veteran Seth Pierre Remington. Unable to raise his own sword—that is, unable to assert his manhood by following the heroic example of his father—Remington transforms the unraised sword into an emblem of cowardice (it hangs like a tail

between the officer's legs) and seeks a maternal space of safety very much like the sink in which his *Water Hole* cowboys would hide. Oedipal implications aside, the drawing resonates with Remington's Cuban imagery. Like the dying young trooper of *The Charge of the Rough Riders*, like the flopping soldiers of *The Scream of Shrapnel*, the figure in the youthful drawing paradoxically seeks to evade death by climbing into the grave. *The Scream of Shrapnel*, like *Fight for the Water Hole*, embodies the contradiction in the masculinist discourse of progress—namely, that in moving forward one hastens the coming of the feminized civilization that renders oneself doomed. Progress, for Remington, clearly means the extinction of the figures—the brave Anglo-Saxon boys—who were the only hope for the future.

Outer Space

From starfish to stars: Roosevelt is on the *Yucatán*, the Rough Riders' transport ship, while it steams to Cuba. As he recounts the scene in *The Rough Riders* (1906), Roosevelt stands on deck one night with Bucky O'Neill, one of his favorite soldiers, an "iron-nerved, iron-willed fighter from Arizona" who could discuss "Aryan word-roots" or "the novels of Balzac." In an eve-of-battle meditation, a classic set-piece evoking Henry's "Upon the King" soliloquy in *Henry V*, the two men lean on the railing and gaze at the Southern Cross. "Who would not risk his life for a star?" asks O'Neill. The star, Roosevelt tells us, stands for military rank: "If, by risking his life, no matter how great the risk, [O'Neill] could gain high military distinction, he was bent on gaining it."[36] But the star also calls to mind the immortality of the dead hero: O'Neill, who was killed in the war, contemplates the star he will become. He regards his own heavenly image, perhaps even his ascension, as does London's Humphrey Van Weyden in a dream of death: "I seemed swinging in a mighty rhythm through orbit vastness. Sparkling points of light spluttered and shot past me. They were stars, I knew, and flaring comets, that peopled my flight among the suns."[37]

The star also evokes imperial ambition. Gazing at the Southern Cross, Roosevelt and O'Neill contemplate a veritable icon of territorial exploration. Steaming to Cuba, Roosevelt and his men behold a whole new celestial world: "At night we looked at the new stars, and hailed the Southern Cross when at last we raised it above the horizon."[38] The Southern Cross is to be hailed for at least three reasons. First, synonymous with the southern skies, its appearance indicates to its North American beholders that they are in a distant part of the world. Second, it points to the south pole; a giant celestial finger, it gestures onward in much the way that Roosevelt points

onward in *The Charge of the Rough Riders*. Third, Roosevelt's laden description—"we raised it above the horizon"—indicates the meaning not only of the constellation but of the U.S. mission: the Rough Riders steam southward to construct American-style Christianity, and its correlate, progressive civilization, in Cuba.

The Southern Cross in fact evokes the entire history and politics of European exploration of the Southern Hemisphere. Named by Spanish explorers, the constellation implied the Christian conversion of the Southern Hemisphere not only in its naming but in the very way it was formed: the four stars of the Southern Cross all belong to Centaurus.[39] With the creation of the Southern Cross, the centaur—half man, half beast—was converted into an icon of Christianity, much the way the "animal" inhabitants of southern lands would be converted. Roosevelt and O'Neill were on a similarly civilizing mission.

Describing himself gazing on the Southern Cross, Roosevelt located the Rough Riders' journey within the history of imperial exploration—specifically, at the evolutionary zenith of such exploration. It was the Spanish, creators of the Southern Cross, whom the Rough Riders were sailing to fight. (The Southern Cross also lies not far from the Magellanic clouds, named for the sixteenth-century Spanish explorer Ferdinand Magellan.) In Roosevelt's evolutionist understanding of history, Spain was a country whose time had come and gone. The United States was advancing to claim this cross, to hang its own imperial lantern above the Southern Hemisphere.

Other facts evoked the contest between Americans and Spanish for imperial domain. The Rough Riders trained for the war in San Antonio, where the Spanish defeated the Americans at the Alamo in 1836.[40] The rallying cry of the Mexican-American War was matched by the cry of the Spanish-American War; "Remember the Alamo!" and "Remember the *Maine*!" alike called upon Americans to punish alleged Spanish treachery. Roosevelt's mount and pistol for the charge at San Juan Hill—a pony called Texas or Little Texas and a pistol given to him, he claimed, by an officer of the *Maine*—were for him appropriate reminders not just of Spanish brutality but of the war's context within a progressive history of imperialism.[41] Even the name of the Rough Riders' ship—*Yucatán*—evoked a politics of exploration identical to that evoked by the night skies beheld from its decks. I quote from Stephen Greenblatt, who in turn quotes the sixteenth-century Spanish writer Antonio de Ciudad Real: "'When the Spaniards discovered this land, their leader asked the Indians how it was called; as they did not understand him, they said *uic athan*, which means, what do you say or what do you speak, that we do not understand you. And then the Spaniard ordered it set down that it be called *Yucatán*.'" Thus, Greenblatt writes, "the Maya

expression of incomprehension becomes the colonial name of the land that is wrested from them."[42] More than three hundred years later, it becomes the name of the boat steaming forth to raise another Southern Cross—a cross intended to replace that of the very nation that had first erected it in the Southern Hemisphere.

O'Neill, however, in mentioning a single star for which he will die, most specifically evokes Cuba itself. "Until recently the southern sky was, even to astronomers, almost a *terra incognita*," wrote the astronomer Solon Irving Bailey in 1905, "and even now it is, in some respect, little known."[43] Bailey's comment—in particular, his striking metaphor of the heavens as an unknown *land*—suggests that the heavens are a metaphor for the "outer space" into which the United States then wanted to expand. In a speech in Lincoln, Nebraska, on December 23, 1898, William Jennings Bryan chided imperialists for wanting to add stars to the U.S. flag: "Shall we adorn our flag with a milky way composed of a multitude of minor stars representing remote and insignificant dependencies?" Elsewhere in his speech Bryan pursues the equation between two types of outer space: "Shall we keep the Philippines and amend our flag? Shall we add a new star—the blood-star, Mars—to indicate that we have entered upon a career of conquest? Or shall we borrow the yellow, which in 1896 was the badge of gold and greed, and paint Saturn and his rings, to suggest a carpet-bag government, with schemes of spoliation?"[44]

Edgar Rice Burroughs's *Princess of Mars* (1917), first published in 1912 in serial form as "Under the Moons of Mars," makes the same equation. The novel opens in Arizona, where John Carter, a heroic young soldier, miraculously escapes a band of marauding Apaches. Like Bucky O'Neill, Carter has a penchant for gazing at the heavens: "I turned my gaze from the landscape to the heavens where the myriad stars formed a gorgeous and fitting canopy for the wonders of the earthly scene. My attention was quickly riveted by a large red star close to the distant horizon. As I gazed upon it I felt a spell of overpowering fascination—it was Mars, the god of war, and for me, the fighting man, it had always held the power of irresistible enchantment." Then something strange happens: "As I gazed at it . . . it seemed to call across the un-thinkable void, to lure me to it, to draw me as the lodestone attracts a particle of iron . . . I closed my eyes, stretched out my arms toward the god of my vocation and felt myself drawn with the suddenness of thought through the trackless immensity of space. There was an instant of extreme cold and utter darkness."[45] Mars, where Carter alights, is populated by ponderous and brutal childlike barbarians who marvel at his superiority. Much smaller than his Martian counterparts, Carter discovers that in the lighter Martian atmosphere he possesses a thirty-foot vertical leap that can transport

him one hundred feet per jump; he is literally a "higher walk of life." Writes John Seelye, "[Burroughs] projected the American imperial (and protective) zeal into outer space, making of Mars what Theodore Roosevelt had made of the western hemisphere, a ward of the United States."[46]

Carter's imperial flight in turn resembles another famous space voyage. "The house whirled around two or three times and rose slowly through the air. Dorothy felt as if she were going up in a balloon," wrote L. Frank Baum in *The Wizard of Oz* (1900). Oz, where Dorothy lands, is populated by "the queerest people she had ever seen." The Munchkins are child-adults living in a land, says the Witch of the North, that "has never been civilized, for we are cut off from all the rest of the world." In this remote place, Dorothy is revered, ostensibly like the Americans in Cuba and the Philippines: "We are so grateful to you for having killed the Wicked Witch of the East," an old Munchkin woman tells her, "and for setting our people free from bondage." Dorothy's house, emblem of middle-American domesticity, crushes a foreign despot. Although she continues to help those who cannot help themselves—the scarecrow, the tin man, and the cowardly lion—her goal is to return to Kansas. Says Dorothy to the scarecrow, "No matter how dreary and grey our homes are, we people of flesh and blood would rather live there than in any other country, be it ever so beautiful." In Baum's story Americans intercede, irrevocably bettering the lives of a distant land's downtrodden inhabitants, before ultimately departing for home. Dorothy's politics nearly duplicate the rhetoric surrounding American intervention in Cuba. Nonetheless, in the urgency of Dorothy's desire to get back to Kansas, Baum equivocates on the merits of the American imperial presence throughout the world. Says Dorothy, "There is no place like home."[47]

The most dramatic link between exotic outer spaces and imperial wards concerned the moon. In "The Origin of Our Moon," a *Harper's Monthly* article of 1907, William H. Pickering of the Harvard Observatory outlined the theory that moon and earth had once been part of the same mass and that the moon had been separated from the earth by centrifugal force. The part of the earth from which the moon had separated was the Pacific Ocean. Pickering based his theory on the roughly similar sizes of the moon and the Pacific Ocean, as well as on the similarity of some volcanoes on the moon and in Hawaii. "Numerous other curious formations seen upon the Moon are now found to exist also in Hawaii," Pickering concludes, "and there is scarcely a lunar feature which does not have its counterpart somewhere in this interesting newly acquired possession of the United States."[48]

Pickering metaphorically identifies Hawaii, annexed on July 7, 1898 (six days

after the Battle of San Juan Hill), as a satellite of the United States. This also suggests that the moon itself is American property, a suggestion implicitly borne out by the powerful telescopic photographs—taken at the Yerkes Observatory in the United States—included in his article. The practice of astronomy was explicitly linked to expanded American global influence. Lamenting the small number of observatories in the Southern Hemisphere, Solon Irving Bailey writes, "The inevitable result is that our knowledge of the two parts of the sky is unequal." After citing, among other examples, the "astronomical stations recently established in Chile by the Lick Observatory," he continues: "This undesirable lack of harmony is being rapidly reduced, however."[49]

All of this returns us to the crater of Remington's *Fight for the Water Hole*, starkly displayed in a study for the final painting (fig. 50). The study emphasizes not only the sexual implications of Remington's motif but its relation to a historically specific discourse of craters, volcanoes, and exotic outer spaces. Wister's *Virginian*, with its references to volcanoes—"his volcanic wrath," "the quiet of this man was volcanic," "the hot glow of his words, and the vision of his deepest inner man it revealed"—also marks itself as a product of the years of Hawaii's annexation and of American equatorial imperialism generally, when volcanoes came unprecedentedly to the attention of the American public.[50] In *Fight for the Water Hole*, the crater evokes a meteor crashed to earth and suggests that the space in which the cowboys fight is itself an exotic lunar landscape, redolent at once of the moon and of newly annexed Hawaii. "Still another kind of lunar crater," writes Pickering, "has absolutely no outside cone

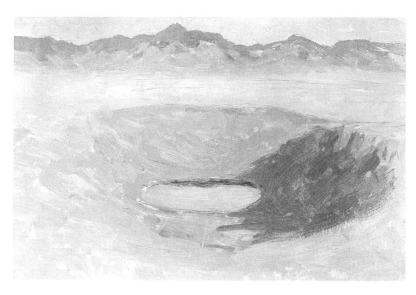

50. *Study for Fight for the Water Hole*, ca. 1901. Oil on board, 12 × 17⅞ in. Buffalo Bill Historical Center, Cody, Wyoming.

at all, and is known as a crater pit" (fig. 51). "It consists of a hole in the ground and nothing more. It once was brimming full of lava, but the lava has long since withdrawn, leaving nothing but the empty hole—an object very unlike our ideas of a volcano."[51] Imported into Remington's arid Southwest scene and operating over and against a probable basis for the painting—a water-hole photograph that James Ballinger has convincingly identified as the source—the discourse of imperialist outer spaces nonetheless operates in *Fight for the Water Hole*.[52]

Outer space makes its way into several contemporary accounts of the Old West. For Burroughs, writing about Arizona in *A Princess of Mars*, it is "as though one were catching for the first time a glimpse of some dead and forgotten world, so different is it from the aspect of any other spot upon our earth."[53] As John Carter travels from Arizona to Mars, implying at once the identity of the two territories and the abandonment of the one for a new and outer frontier, so, too, Remington's paintings hint at the possibility of a new frontier emerging from the old. Viewers from our time have also seen the Old West in terms of outer space. Of *The Luckless Hunter* (Sid Richardson Collection, Fort Worth, Texas), a Remington moonlight of 1909, Brian W. Dippie writes, "The snow-covered landscape [is] as barren as the moon that washes it in pale light."[54]

As the evening scenes attest, Remington was fascinated by the night skies and, in particular, by the moon. Remington's diary entry of April 27, 1907, a report that he went to "the Jew Pawnbroker for a telescope which he promised," is just one of his many references to studying the night skies. "We have first moon now. Clear nights

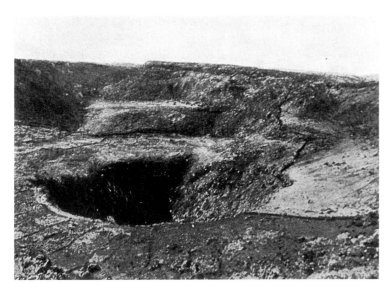

51. Anonymous, *Volcano Crater, Hawaii*, 1907. Reproduced in William H. Pickering, "The Origin of Our Moon," *Harper's Monthly* 115 (June 1907): 129.

and I studied until near 11 o'c last night," he wrote on June 25, 1907. "Beautiful moon more than half full," he reported on August 17 of the same year. Remington studied moonlight so that he could incorporate its effects into his nighttime scenes. But the paintings indicate that his study of the night sky went beyond an interest in pictorial effects.

The Old Stagecoach of the Plains (1901) is one such scene. It depicts a compelling metaphor for an earlier America (fig. 52). "These antique vehicles," wrote Henry James in *The American Scene* (1907), "repudiated, rickety 'stages' of the age ignorant of trolleys, affected me here and there as the quaintest, most immemorial of American things, the persistent use of which surely represented the very superstition of the past."[55] In Remington's picture the hearselike stage moves precipitously downhill; like the Old West itself, it rolls out of the picture—an evolutionary stage of history. Indeed, the gravity of the picture is a function not only of the stagecoach's downward movement but also of the orientation of the canvas. The dimensions of the painting— forty by twenty-seven inches—tell us that Remington took one of the regular-sized canvases on which he often made his horizontal compositions and turned it on end. Before he even made a mark on the canvas, its inversion on the easel might well have struck him; the gravity of the painting may be merely a recapitulation, or expression, of the primary action of the blank canvas.

The sky is nevertheless a crucial part of *The Old Stagecoach*. The painting shows the funereal box of the stage dramatically silhouetted against the sky. Our eyes go straight to the gun-bearing figure atop the stage. Sitting on the stagecoach, he is also enthroned in the heavens; he looks like a god drawn upon the night sky, as in a map of the constellations. Remington's figure is much like Roosevelt's Bucky O'Neill, a man traveling downward to death, contemplating the heavens that he already figuratively occupies. Rhyming the light of the lanterns with the shine of the stars, Remington announces the figures' transformation from flickering earthly existence to heavenly permanence. *The Old Stagecoach* confirms his interest in constellations and ascension in the lower left corner of the sky, where a distinct box of four stars is identifiable as Pegasus, the winged horse. The resultant note of ascension or, at any rate, flight could not contrast more sharply with the descent of the horses pulling the stagecoach. Duplicating the box of the stage, as well as the boxy forms of the horses and their ominous shadows, the box of stars implies the immortality of the dead.

In *A Reconnaissance* (1902), another Remington nocturne from this same time, two figures have tracked through the snow, presumably to study an enemy position on the other side of the tree line (fig. 53). A third figure stays with the horses in the fore-

52. *The Old Stagecoach of the Plains,* 1901. Oil on canvas, 40¼ × 27¼ in. Amon Carter Museum, Fort Worth, Texas.

53. *A Reconnaissance,* 1902. Oil on canvas, 27¼ × 40⅛ in. Amon Carter Museum, Fort Worth, Texas.

ground. As much as the two scouts seem to reconnoiter the enemy, however, they also appear to examine the stars that fill the sky. (In fact, their vantage seems best situated to give them a view of the sky, not a plateau below.) Directly before the two figures lies the distinctive belt of three stars constituting the belt of Orion, the hunter. Perhaps, in this salient position, Orion represents the violence that is to issue from the reconnaissance. Except for the northern locale of the picture, the two men might almost be Roosevelt and O'Neill on the deck of the *Yucatán*. Theirs is another eve-of-battle contemplation. As in Roosevelt's description, moreover, the object of conquest is displaced and somehow purified. What they gaze upon is hidden behind the trees. Like Roosevelt's passage, Remington's painting obfuscates the hard core of imperialism—the crass realities of economic and racial exploitation—with a dreamy nobility whose emblem is the star. Imperial warfare, as in Roosevelt's passage, becomes a poetic matter of mood.

There is nonetheless a decisive difference between the two heavenly contemplations. Roosevelt mourns the loss of one person, O'Neill, but the loss is the country's gain. The single word *for* in O'Neill's question—"Who would not die for a star?"—simultaneously suggests that O'Neill will die *in the name of,* that is, *for* Cuba, and

that he will die *in order to obtain*, or *in exchange for*, Cuba. Sacrifice is inseparable from territorial acquisition. In *A Reconnaissance*, however, as in *The Old Stagecoach of the Plains*, the heavens do not seem to signify the outer spaces into which the United States might expand. Instead, they suggest an ending point. Walking to the edge of the hill, the two figures can go no farther. There are only the heavens left to contemplate. They may gaze upon Orion as John Carter gazes upon Mars, with a spell of overpowering fascination, but they stare at the space of their deathly transcendence rather than at future frontiers. In the dominant motif—the footprints of the figures—*A Reconnaissance* illustrates what Remington spent his whole career doing: documenting the vestiges of a progression leading to an end.

An Invisible Enemy

Why are such works as *The Old Stagecoach of the Plains* and *A Reconnaissance* ambivalent about imperial expansion? Remington unequivocally supported the extension of American influence in much of what he wrote, especially before going to Cuba. His story "An Outpost of Civilization" (1893) concerns an American cattle rancher playing the feudal baron to his grateful Mexican employees, childlike minions who "altogether occupy the tiniest mental world, hardly larger than the *patio*" of their patron.[56] It is a far cry from Joseph Conrad's "Outpost of Progress" (1896), a sordid tale of two European ivory-traders, Carlier and Kayerts, left to lose their minds and lives in their own outpost, a small trading station in the middle of the African jungle. Remington loathed Bryan and his anti-imperialist views. On November 4, 1908, the day after Bryan lost the presidential election to Taft (he also lost to McKinley in 1900), Remington was awakened by his hired man and told that Bryan had won: "I jumped out of bed and found it was his little joke. Taft elected . . . all fine and dandy."[57] Nevertheless, many of Remington's images of outer spaces—not just those concerning the night skies—express little confidence in the imperial endeavor.

In *The Ninth U.S. Infantry Entering Peking, August 15, 1900* (1900), a wholly imagined scene (Remington never went to China), a group of Remington's quintessentially stalwart, square-jawed American soldiers march through a Chinese village during the Boxer Rebellion (fig. 54). They, like the Americans in the Philippines, are there to assert control. As much as they dominate the image, however, Remington's troopers look fearful: warily they eye the surrounding villagers, as if expecting to be shot at any moment. The tunnel out of which they march—visible in the background as a black semicircle—hearkens back to the big hole of Remington's youthful drawing (see

54. *The Ninth U.S. Infantry Entering Peking, August 15, 1900.* Reproduced in *Harper's Weekly* (October 27, 1900). Thomas J. Watson Library, Metropolitan Museum of Art, New York.

fig. 49). Whereas in that early work the cowboy runs *toward* a maternal space of safety, the soldiers in Remington's Boxer Rebellion image march away from the same space. Venturing into the world, leaving home, they are rendered exquisitely vulnerable. Their vulnerability is akin to that of London's White Fang, peering at the wide world from the cave in which he was born: "A great fear came upon him. This was more of the terrible unknown. He crouched down on the lip of the cave and gazed out on the world. He was very much afraid. Because it was unknown, it was hostile to him." White Fang's dilemma is that of imperial America: whether to leave a safe but unchallenging home for the whole wide world. White Fang sets out, suffering at first, but eventually coming to revel in his role as "an explorer in a totally new world." Exhilaration at the prospect of the exciting new world overcomes his trepidation: "Fear had been routed by growth, while growth had assumed the guise of curiosity." Sitting outside, he "gazed about him, as might the first man of the earth who landed upon Mars."[58] For Remington's soldiers, the Asian countryside is a veritable Martian landscape. Perhaps from Kansas, the state from which much of the U.S. army in the

Philippines was drawn, the soldiers do not patrol Oz so much as "guguland," as one soldier called the Philippines.[59]

Yet Remington's soldiers experience a coming out much different from White Fang's. Whereas White Fang quickly ascends to near the top of his domain, Remington's soldiers do not appear so comfortably in control. Remington made his image when the American presence in other parts of the world was far from welcome. In the next year would come the most infamous single slaughter of American soldiers in the Spanish-American War: the massacre of an American garrison at Balangiga on the Philippine island of Samar in September 1901. Attending a mass held for the assassinated President McKinley, the soldiers were surprised and killed by native men disguised as mourning women.[60] The episode was chilling not just because Americans were massacred but because it dramatized that local respect for U.S. authority was feigned. Although Remington's *Ninth U.S. Infantry* depicts American soldiers in China in 1900, it embodies the same American anxiety about involvement in far-flung places that would follow the slaughter at Balangiga.

It's "Up to" Them, a *Puck* cartoon of 1901, shows a tuxedo-clad Uncle Sam formally offering two options—the soldier or the schoolteacher—to a group of Philippine islanders (fig. 55). The cartoon's caption (not shown in the illustration) reads, "You can take your choice;—I have plenty of both!" In offering the choice, Uncle Sam indicates that the Filipinos will be civilized by either book or gun, but he also seems to extend soldier and schoolteacher as sacrificial victims, asking the Filipinos which they would rather kill: "You can take your choice;—I have plenty of both!" In a picture in which Uncle Sam's own plumed hair repeats the feathers of the Filipino warrior at the right—a representative of one of the so-called lower grades of civilization on the islands—which is the "savage" side is entirely debatable.[61] Remington's anxious soldiers, themselves extended by Uncle Sam, echo the *Puck* cartoon's undecidable mixture of American command and vulnerability.

Remington's Cuban reporting betrays the same lack of confidence. The head of Brig. Gen. Adna Chaffee, Remington writes, "might have been presented to him by one of William's Norman barons. Such a head! We used to sit around and study that head. It does not belong to the period . . . it has warrior sculptured in every line."[62] Remington's description, although it is meant to extol Chaffee's martial virtues, also manages to suggest that the Norman baron whom Chaffee resembles had killed him, for what else are we to make of the singular image of Chaffee having his own head "presented to him by one of William's Norman barons"? *The Night Patrol*, a painting of 1899 showing a lone soldier marching through a deserted Havana street (fig. 56),

55. Joseph Keppler, Jr. *It's "Up to" Them,* 1901. Reproduced in *Puck* 50 (November 20, 1901): 8–9.

raises the same doubts. Like his cohorts in China, he is ostensibly in control—a large, imposing, and vigilant figure. Havana, the picture tells us, is a prison patrolled by an American warden: the street evokes a penitentiary corridor, the rooms to either side—one with prominent bars—the cells of the inmates. The metaphor is striking, because it was precisely the liberation of the Cubans from Spanish dominion that was the stated goal of the war. And the picture does account for this liberation in its myriad open doors; the space, we begin to see, was *once* a prison, figuratively speaking, but is now a place of freer movement. Under American rule the prison bars of the past are remnants.

That "liberated" Havana should still seem so prisonlike in *The Night Patrol* suggests the fearful consequences of the colonial subject's liberation. It is precisely the open door—the aperture divested of prison bars—that most threatens the American warden. The drama of the picture lies in what will happen when the trooper passes the illuminated door at the far right. Casting his glance to the left, he has yet to see the group of men occupying this particular room. (The figures are difficult to see in the illustration.) What the picture makes clear is that the prospect of free movement—the potential of any quiet gathering to spill into the street—is one horrible consequence of the colonial subject's "liberation." "There'll Be a Hot Time in the Old Town Tonight," the tune that American soldiers were "never too tired or too hungry to . . . yell themselves hoarse over" during the war, now comes to signify the possibility of an entirely undesirable sort of revelry.[63] The last thing that Remington's lone

soldier wants is a hot time in the old town tonight. To be killed, like the Americans at Balangiga, by the very people one fancied one had set free—this is the prospect set forth in *The Night Patrol*. It casts Uncle Sam as a policeman in an alleyway of a world—an alleyway converted from a prison, an alleyway from any door of which a newly liberated populace might pounce. The lone trooper can keep his eyes on only so many places at once. And having one's head on a swivel is perilously close to having one's head on a stake—the fate of Capt. Thomas Connell, American commander at Balangiga. "It does seem tough," Remington wrote to Wister in 1896, when war was still brewing, "that so many Americans have had to be and have still got to be killed to free a lot of d—— niggers who are better off under the yoke."[64]

The discursive ambivalence about American imperialism extended to Remington's images of historical exploration. *Zebulon Pike Entering Santa Fe*, one of his Great Explorers series of 1905–6, repeats the compositional format of *The Night Patrol* (fig. 57). Although the stalwart Pike is accompanied by a number of his own men (visible behind him), he and his followers face a perilous situation analogous to that of the lone trooper in Cuba: they have been brought into town by a potentially hostile Spanish escort (including the gesturing figure at the left); and they are sur-

56. *The Night Patrol*, 1899. Reproduced in *Collier's Weekly* (April 1, 1899): 6.

rounded by the proverbially inscrutable inhabitants of the village down whose narrow street they pass. The cur sniffing the leg of Pike's horse suggests the uncertain reception that Pike and his men receive from the town's "mongrel" inhabitants.

The main drama of the painting concerns the interaction between Pike and the Spanish man at left. At what or whom the Spanish man gestures is outside the picture, but the confusingly realized space of the town makes it seem as if he gestures to the man, woman, and child immediately to the left of his hand—even though these figures are behind him in the painted scene. Mediating between Pike and these miniaturized figures, the Spanish man seems to suggest that the Spanish inhabitants of Santa Fe are small and unthreatening. "They were not as big as the grown folk she had always been used to," wrote Baum of Dorothy's reaction to the Munchkins.[65] Once again, however, the position of the Anglo-Saxon is far from safe: hemmed in, scrutinized by figures at his back, Zebulon Pike is in a position of ignorance much like that of Captain Connell at Balangiga: knowing nothing of the place he occupies, he must take the word of potentially untrustworthy intermediaries.

Hernando de Soto, another of the Great Explorers paintings, is another ambivalent image of historical exploration (fig. 58). The caption accompanying the illustration in *Collier's Weekly* ran: "In 1539 De Soto led 600 men across our present Southern states to the Mississippi. The expedition constantly fought Indians but the greatest hardship was wading through miles of swamps."[66] Wading through the swamp, peering into the shadows for hidden enemies, Remington's Spanish soldiers, marching in their column, resemble the boat nudging upstream in Conrad's *Heart of Darkness*: "The face of the forest was gloomy, and a broad strip of shadow had already fallen on the water. In this shadow we steamed up—very slowly, as you may imagine."[67] They also evoke the words of Lieutenant Charpentier, in Burroughs's *Tarzan of the Apes* (1914), as he recounts his fear of the jungle and implicitly of the hazards of colonial rule: "It was not the roaring and growling of the big beasts that affected me so much as it was the stealthy noises—the ones that you heard suddenly close by and then listened vainly for a repetition of—the unaccountable sounds as of a great body moving almost noiselessly, and the knowledge that you didn't *know* how close it was, or whether it were creeping closer after you ceased to hear it."[68] "It takes a tenfold stouter heart," wrote Remington's friend Julian Ralph in *Towards Pretoria* (1900), his account of the Boer War, "to fight an unseen enemy, than to join issue with a substantial line of flesh-and-blood." Discussing the Boers' use of smokeless powder, Ralph asks: "Can the keenest student of war comprehend what it means to go on week after week, and month after month, fighting an invisible enemy?"[69]

57. *Zebulon Pike Entering Santa Fe,* 1906. Reproduced in *Collier's Weekly* (June 16, 1906): 8. Original destroyed. Thomas J. Watson Library, Metropolitan Museum of Art, New York.

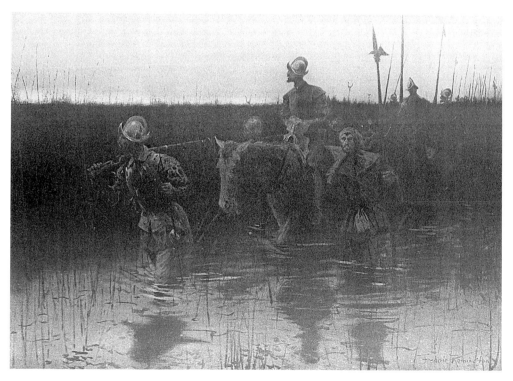

58. *Hernando de Soto,* 1905. Reproduced in *Collier's Weekly* (November 11, 1905): 8. Original destroyed. Thomas J. Watson Library, Metropolitan Museum of Art, New York.

Ralph's question brings us back to *The Scream of Shrapnel at San Juan Hill*. The painting, as we have seen, evinces Remington's fear of technology: the troopers dive and duck before the technologized fire of an unseen enemy. (The Spanish also used smokeless powder.) Yet, as the quotations from both Burroughs and Ralph make clear, the invisibility of the enemy was unnerving for other reasons. With no one to fight, the purpose of imperial warfare could seem correspondingly illusory. In a great scene in *Heart of Darkness*, Conrad describes a French man-of-war shelling the African coast: "In the empty immensity of earth, sky, and water, there she was, incomprehensible, firing into a continent. Pop, would go one of the six-inch guns; a small flame would dart and vanish, a little white smoke would disappear, a tiny projectile would give a feeble screech—and nothing happened."[70] The fog that descends at the conclusion of "An Outpost of Progress," after Kayerts has killed his friend Carlier, is "the morning mist of tropical lands; the mist that clings and kills; the mist white and deadly; immaculate and poisonous." As a "white shroud," the fog symbolizes not only the implacable deadliness of the jungle but also the mental and political fog—the exceeding lack of vision—of the European inhabitants that it kills. In the fog Kayerts "looked round like a man who has lost his way" before spotting the cross on which he will hang himself. This cross—"a dark smudge, a cross-shaped stain, upon the shifting purity of the mist"—could not contrast more strongly with the heavenly form that beckons Roosevelt, O'Neill, and his fellow troopers on their imperial mission.[71] In Conrad's story the cross you raise is your own. Staring into the smudgy swamp, the figures in *Hernando de Soto* look around as though they had lost their way. The foul water through which they wade staring anxiously from side to side is another version of Remington's Havana alleyway.

In Cuba, no one could see what was going on. "The march from the sea to Santiago," wrote Thomas Vivian in *The Fall of Santiago* (1898), "was for the most part through roads which were so bordered with forest and thickets of under-brush that, except when on an eminence, it was almost impossible to see beyond the turn of the road or to form any idea of what danger lurked in the tangles on either side."[72] Long-range weapons and the Spanish use of smokeless powder added to the invisibility of people in the war. Roosevelt reported that his men greeted a rare Spanish charge "with shouts of delight at seeing their enemies at last [come] into the open."[73] At the surrender Frank Norris reported that soldiers from both sides examined one another with "abnormal curiosity" just to see what the others looked like.[74]

The two dead Spanish soldiers in *The Charge of the Rough Riders*, included even though almost all the Spanish were actually ensconced in hilltop fortifications,

evoke—in a war predicated on invisibility—the old-time sense of personally vanquishing an opponent. If the Rough Riders did not see Spanish soldiers until they were on the hilltop, Remington did not see their charge. His one-sentence account of the battle evokes the invisibility of the entire war: "It was the most glorious feat of arms I ever heard of."[75] Although the officer in *The Scream of Shrapnel* gestures onward, he points at an invisible enemy; what remains, at last, is simply the gesture—to go forward, to conquer. "There was a touch of insanity in the proceeding," Conrad writes of the man-of-war shelling the African coast.[76]

Finishing the Race

Unlike the other images, *The Charge of the Rough Riders* seems to speak an unequivocal language of imperial progress. Although a few men fall, the Rough Riders move inexorably forward. Yet at the very center of this iconic burst of Anglo-Saxon progress runs a lone black man (fig. 59). Why is he there?

The actual dynamics of the battle partly explain his presence. Massing in the cramped, lagoon-pocked space at the foot of San Juan Hill, various American regiments were subjected to heavy Spanish fire from the hilltop. In such a situation, wrote Thomas Vivian, "anything like distinct regimental segregation" was impossible.[77] Vivian's mention of failed segregation refers to the collapse on this occasion of the army's strict policy of racial separation—and therefore to the collapse of the nation's identical policy, made manifest in *Plessy v. Ferguson* in 1896. At the top of the hill, Roosevelt found the Rough Riders similarly desegregated, and looked around to find "perhaps a score of colored infantrymen" among his own soldiers.[78]

Remington's lone black soldier is not solely a matter of historical accuracy. The figure becomes all the more interesting in light of the vastly different interpretations of the black presence in the battle. There was the liberal view, all sentiment and condescension, which was expressed by Jacob Riis in *The Outlook*: A white soldier abandons the charge to stem the bleeding of a fallen black soldier, wounded in the neck. Afterward the black man "told of it in the hospital with tears in his voice: 'He done that to me, he did; stayed by me an hour and a half, and me only a nigger.'"[79]

There was the view of Roosevelt himself. Although he praised the "gallantry" of the black soldiers during the charge, he believed that many of them tried to desert once the hill was taken. "None of the white regulars or Rough Riders showed the slightest sign of weakening," he wrote, "but under the strain the colored infantrymen (who had none of their officers) began to get a little uneasy and drift to the rear."

Roosevelt took immediate action: brandishing his revolver, he said that he would "shoot the first man who, on any pretense whatever, went to the rear." For Roosevelt, the black soldiers' loss of nerve related to their separation from their white officers. "No troopers," he wrote, "could have behaved better than the colored soldiers had behaved so far; but they are, of course, peculiarly dependent upon their white officers. Occasionally they produce non-commissioned officers who can take the initiative and accept responsibility precisely like the best class of whites; but this cannot be expected normally, nor is it fair to expect it."[80]

Then there was the view of black soldiers who had fought at San Juan Hill. "Colonel Roosevelt has said they shirked," wrote Preston Holliday, a sergeant in the Tenth Cavalry, in a letter to the editor of the *New York Age*, "and the reading public will take the Colonel at his word and go on thinking they shirked." Holliday continued: "His statement was uncalled for and uncharitable, and considering the moral and

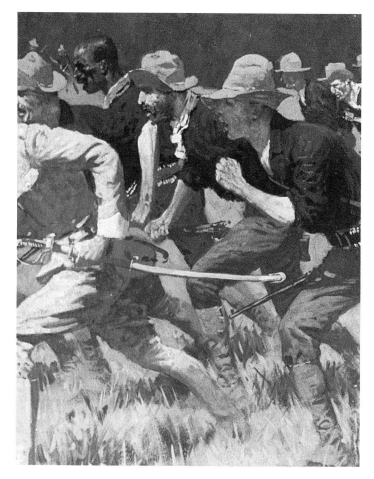

59. *The Charge of the Rough Riders at San Juan Hill* (detail).

physical effect the advance of the Tenth Cavalry had in weakening the forces opposed to the Colonel's regiment, both at La Guasima and San Juan Hill, altogether un-grateful, and has done us an immeasurable lot of harm." Holliday closed with a threat to tell what he believed really happened at San Juan Hill: "When our soldiers, who can and will write history, sever their connections with the Regular Army, and thus release themselves from their voluntary status of military lockjaw, and tell what they saw, those who now preach that the negro is not fit to exercise command over troops, and will go no further than he is led by white officers, will see in print held up for public gaze, much to their chagrin, tales of these Cuban battles that have never been told outside the tent and barrack room—tales that it will not be agreeable for some of them to hear."[81]

Others were even blunter. "If it had not been for the Negro Cavalry the Rough Riders would have been exterminated," said an eyewitness quoted in an Associated Press story. The talk extended beyond those who had been participants. "All this talk about the Rough Riders is poppy-cock and tommy-rot," said W. B. Phillips, who admitted to not being in the battle, in a lecture in Chapel Hill, North Carolina, on September 28, 1898. "But for those Negroes the Rough Riders would have been annihilated."[82]

Remington's picture, as we might expect, takes Roosevelt's position. Certainly Remington did not mind attesting to the bravery of black soldiers—in particular, those of the Tenth Cavalry, a regiment he had reported on many years earlier in Arizona. "As to their bravery, I am often asked, 'Will they fight?'" he wrote in "A Scout with the Buffalo-Soldiers" (1889). "That is easily answered. They have fought many, many times. The old sergeant sitting near me, as calm of feature as a bronze statue, once deliberately walked over a Cheyenne rifle-pit and killed his man. . . . These little episodes prove the sometimes doubted self-reliance of the negro."[83] After San Juan Hill, Remington found a white officer of the black Twenty-fourth, who "threw his arms about me, and pointing to twenty-five big negro infantrymen sitting near, said, 'That's all—that is all that is left of the Twenty-fourth Infantry,' and the tears ran off his mustache."[84]

Remington's praise of black bravery partly explains the presence of the black soldier. Yet what about his prominence? Situated just above and to the left of center, the black man is a key figure (see plate 3). His head is bisected by the line of trees and grass, further calling our attention to him. He alone among the soldiers in the central group has lost his hat, giving us a clearer view of his blackness than we would have had otherwise, right down to the gleam of the sun on his sweaty bald head. Most

strikingly, the central group is arrayed in a solid triangular mass, its base parallel to the bottom edge of the picture, that tapers perfectly to an apex at the black man's head. The black man's prominence rhetorically reinforces the validity of the cause of the war, as Remington understood it. By depicting a black man at the center of a battle that took place on July 1, 1898—the thirty-fifth anniversary of the first day of the battle at Gettysburg—Remington linked the charge of the Rough Riders to the rhetoric of racial emancipation. *Cuba Libre*, as we have seen, was one of the American rallying cries. The black soldier therefore refers not just to the blacks freed by the American Civil War but also to the Cubans for whom the Gettysburg-day charge at San Juan Hill takes place.

But the black man's presence is paradoxical. Everything leads to the one figure, yet the man is invisible—or almost invisible. The wedge of figures pointing in his direction hides him from view, affording us unsatisfying glimpses of his body: the head, part of the left shoulder, some of the back, part of one leg. He is also all alone. He is relegated, we might say, to the center of the painting. In the most peculiar way, Remington's picture simultaneously underscores and hides the black presence in the battle.

The evolutionary politics of the battle—and of the Rough Riders' participation in it—affords a partial explanation. The Rough Riders represented the cream of Anglo-Saxonism: "We drew recruits from Harvard, Yale, Princeton, and many another college," wrote Roosevelt, "from clubs like the Somerset, of Boston; and Knickerbocker, of New York; and from among the men who belonged neither to club nor to college, but in whose veins the blood stirred with the same impulse which once sent the Vikings over sea."[85] San Juan Hill was, then, a proving ground, almost a laboratory, for Anglo-Saxon evolutionary superiority. Remington himself clearly regarded the battle in this way. His praise of the Tenth Cavalry took place within the limits of social evolution. "The utmost good-nature seemed to prevail," he wrote in "A Scout with the Buffalo-Soldiers." "They discussed the little things which make their lives. One man suggested that 'De big jack mule, he behavin' hisself pretty well dis trip; he hain't done kick nobody yet.'"[86] In *Troopers Singing the Indian Medicine Song* (1890), the black troopers of the Tenth Cavalry sit and chant by a fire much as the Apaches would in *Apache Medicine Song*. (Indeed Brian W. Dippie, from whom I borrow the comparison, has identified *Troopers Singing* as Remington's source for the latter painting.)[87] To show such figures running—taking progressive strides up the evolutionary hill— would suggest that Roosevelt's Vikings had been outdone by lower walks of life.

If this is the case, however, why show a black man at all? Is it enough to say that the black man relates to Remington's desire for historical accuracy, to his respect for

the bravery of the Tenth Cavalry, and to an ideological link between the Spanish-American and American Civil Wars? It seems as though the black man's presence, as his action implies, is still more highly charged. Roosevelt's argument about the black troopers—that they needed white officers in order to be effective—encapsulates the logic of the entire war: the Cubans, he felt, also were incapable of self-government. Like Riis's wounded black trooper, they do not know how to stop their own bleeding. In Riis's anecdote, it was left for a white soldier to do that, in an act of utter selflessness, and for the "poor nigger," like the scarecrow thanking Dorothy for being stuffed again with straw, to be fawningly grateful. On the other hand, Holliday's argument—"No officers, no soldiers," he concludes—implicitly questions the war's logic: If the black soldiers need not be governed by white officers, why, it follows, should a form of quasi-colonial rule be imposed upon Cubans? As Amy Kaplan writes in her essay "Black and Blue on San Juan Hill," "The threat of black soldiers in blue uniforms . . . lies in their direct representation of American nationhood in lands defined as inhabited by those unfit for self-government, those who cannot represent themselves, and who are thus in need of the discipline of the American Empire."[88]

Remington's black American soldiers certainly differ from his black Cubans. The figures at the right in *The Return of Gomez to Havana* (1899) recall the racial caricatures of his friend Edward Kemble more than they do Remington's images of the Tenth Cavalry (fig. 60). Yet, as we have seen, Remington could explicitly equate Cuban and American blacks as "niggers better off under the yoke" of oppression. Thus, the lone black soldier in *The Charge of the Rough Riders* refers to the Cubans for whom the charge is ostensibly conducted. Inasmuch as the painting makes him visible, it crucially identifies the black man as a follower. In so doing, it expresses one of the evolutionist tenets of the imperialist enterprise—namely, to lead the backward races of the earth forward, to allow them, in theory at least, the chance eventually to share space atop the evolutionary hill vacated by a crumbling European despotism. As for the Cuban baby itself, the goal is for the black man to take the first steps alone.

In the way Remington's painting hides the black man from view, however, it evinces a fear of the racial progress it ostensibly endorses—a conundrum not unlike that expressed in *The Night Patrol*. Elevating the darker races to human status—freeing them of their chains—which imperialists like Roosevelt believed it was their solemn duty to do, raised the possibility that the same races would one day supplant their benefactors as kings of the hill. Universal progress could hasten what the Columbia professor Orison Madison Grant called "the passing of the Great [Anglo-Saxon] Race" in his book of the same name, published in 1916.[89]

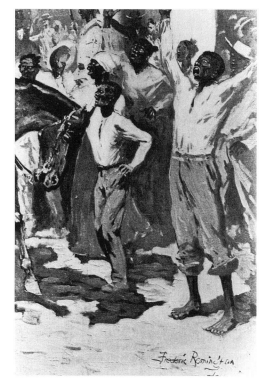

60. *The Return of Gomez to Havanna* (detail), 1899. Reproduced in *Collier's Weekly* (March 18, 1899): 12–13.

61. Winslow Homer, *Rum Cay*, 1898–99. Watercolor over graphite on off-white wove paper. 14⅞ × 21⅜ in. Worcester Art Museum, Worcester, Massachusetts. *(opposite page)*

A comparison with another running black man from around 1898, the Caribbean islander in Homer's *Rum Cay*, demonstrates the point (fig. 61). Unlike Remington, Homer offers us an untrammeled view of the black man on his progressive way. Yet the progress of Homer's figure is severely circumscribed; the black man's act of overtaking a turtle, like the Sudanese children's game of leapfrog, suggests that his progress needs to be understood in severely relative terms. In Remington's picture, however, the black man runs with the Anglo-Saxons; there is theoretically no circumscription to his progress—hence Remington's need to hide the figure, precisely as Homer has not. It appears as though the exigencies of the battle—the very fact that black soldiers *did* play an important part, acknowledged even by Roosevelt himself—compelled Remington to portray a kind of figure, a black man up from the fetal fire, matching the long, powerful strides of the Anglo-Saxons, who was entirely too threatening to visualize fully. The result was the peculiarly fractured image of the black man: central yet invisible, powerful yet broken and obscured in his very centrality.

The Charge of the Rough Riders even seems to predict the result of the black figure's untrammeled progress. The black man is hidden in the middle of the pack, but

being the winner, the one to *finish* first, is a dubious distinction: winning the race is identical to being killed. The finish of the race may, moreover, be just a stage, not an actual finish at all: Dropping the gun, Remington's white boy drops the baton; he will fall in the vicinity of, if not on top of, the nearest dead Spanish soldier. The Anglo-Saxons' place is to be as finished, as spent, as the Old World denizens they replace. Meanwhile, the competition goes on. Although the young soldier will be passed mostly by a slew of his brethren—aside from the black man, everyone in the charge is white—we can understand these figures as running in a reaction formation. That is, the very vigor with which Remington conceals the black man indicates his importance. Screaming up the hill, Remington's Rough Riders protest too much. Each Rough Rider occluding our view functions as an individual denial of the black man's role and symbolism, as though at this central point the picture issues a suspiciously loud chorus of nos.

The picture's emphasis on the death of triumph, if triumph it even is, perhaps indicates why Roosevelt's gaze stops on the very trooper who is finished. In the midst of heroic portrayal, the painter stops, like Roosevelt himself, to consider that the

progress of the earth's yoked peoples might be an insufficient reason for martyrdom. "Did he not too know full well what the beat of those footsteps behind him meant?" What was the good in leading the way if winning was synonymous with being killed? Remington's picture, like much of his work on Cuba, presents the discursive tensions underlying imperialist action in these years. It shows the finish of the Anglo-Saxon race.

So, last, does the dream of a white soldier in "The War Dreams," a story that Remington wrote while the Americans waited for battle in Cuba: "I thought I was standing on the bluffs overlooking the Nile. I saw people skating, when suddenly numbers of hippopotamuses—great masses of them—broke up through the ice and began swallowing the people. This was awfully real to me. I even saw Mac there go down one throat as easily as a cocktail." The soldier continues: "Then they [the hippos] came at me in a solid wall. I was crazed with fear—I fled. I could not run; but coming suddenly on a pile of old railroad iron, I quickly made a bicycle out of two car-wheels, and flew. A young hippo more agile than the rest made himself a bike also, and we scorched over the desert. My strength failed; I despaired and screamed—then I woke up."[90] In the dream's paranoid racial logic, the hippos, representatives of Africa, here seem displaced images of blacks, rising up to kill, first, the skaters on the Nile and then the dreamer himself. (I think of the Sudanese Mahdi's defeat of General Gordon at Khartoum in 1885, among other examples of contemporary African uprisings.) The manner of the killing evokes cannibalism. The skaters simultaneously suggest the Nordic nature of the hippos' victims and the thin ice on which their presence in Africa rests. The white soldier's stationary flight—"I fled. I could not run"—suggests the attitude of the falling soldier in *Charge*. So does the way he is pursued by a representative of Africa—one who has fashioned himself an implement of progress, the bicycle made of railroad iron. Like the black man in *Charge*, the progressive hippo—"more agile than the rest"—is terrifyingly able to keep up with the Anglo-Saxon. Pursued, the dreamer is like the falling boy in *Charge*: "My strength failed; I despaired and screamed—then I woke up." Remington's picture seems to show a similar culminating moment in a racial nightmare. To show the black man passing by the white soldier or even gaining on him in a more prominent way than the picture indicates would have matched the soldier's dream had he not woken up in the nick of time. The soldier in *Charge* wakes to his death for fear of dying in his dreams.

Chapter Three / Bloody Hands

In 1890 Remington painted *The Last Stand*, one of the first and most complex of his numerous treatments of the last-stand theme (fig. 62, plate 5). The painting has occasionally been taken as an image of Custer's Last Stand; the lone buckskin-clad scout, a figure that evokes then-iconic images of the lone Custer at the center of the doomed phalanx, is perhaps most responsible for the misidentification. Yet neither the scout's military role nor his appearance corresponds to Custer's. If the work did not explicitly refer to Custer and the Little Big Horn, however, Remington thought the subject every bit as important. In addition to having many figures and a monumental composition—the painting aspires, it seems, to be western art's *Raft of the Medusa*—*The Last Stand* is also an unusually large painting for Remington. At forty-seven by sixty-four inches it is much larger than his typical twenty-seven by forty format. Also, Remington put a very high price on *The Last Stand*, asking—and not getting—$1,500 just as a starting bid in an 1893 auction. By contrast, *Cavalryman's Breakfast on the Plains* (Amon Carter Museum, Fort Worth, Texas), a similarly multifigured work now much esteemed by Remington's admirers, sold at the same auction for $205.[1]

The Last Stand shows a group of cavalry troopers, together with the lone scout, huddled together as they fight an enemy that we cannot see. The cavalry troopers have stuck their swords in the rock-strewn ground, announcing that they will go no farther. Several soldiers in the right background discharge their weapons in unison, directly above a wounded comrade; the remaining figures—those in the central foreground—compose a perfect triangle, with the head of the white-mustached figure at the apex (fig. 63). This figure, like the kneeling man to his right (see fig. 62), reaches

behind his back with his right hand to retrieve a cartridge. The simple act of reloading his gun does more, however, than impart information concerning his role in the battle. It also gives the trooper a swaggering, arm-akimbo posture that his hipshot pose and dashing cape do nothing to dispel. This man, we are reminded, is not just a cavalry-man but a cavalier. "Ah, there is that King Charles cavalier, Mr. Ermine," says Katherine Searles, "for all the world as though he had stepped from an old frame."[2]

Searles's reference suggests that she has a painting in mind—specifically, one by Anthony Van Dyck, court painter to Charles I in England from 1632–40. The frontispiece to *John Ermine* shows Ermine replete with flowing hair, broad-brimmed hat, and knee-length riding boots (fig. 64). Ermine's features and demeanor, along with the vantage at which Remington shows him—fairly close, from below, so that the hero fills the frame—suggest such Van Dyck pictures as *James Stuart, Duke of Lennox and Richmond*, a work acquired by the Metropolitan Museum of Art in 1889 (fig. 65).

Remington made other explicit references to seventeenth-century cavaliers, notably in *The Last Cavalier*, one of his illustrations for Owen Wister's article "The

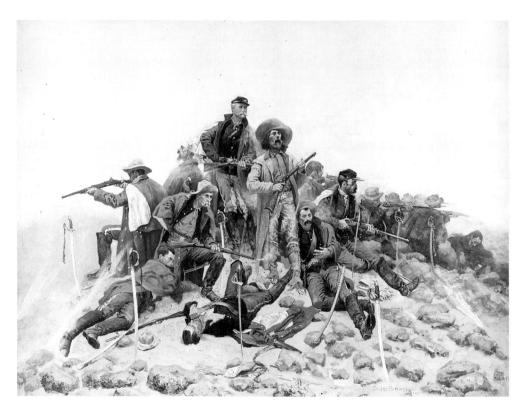

62. *The Last Stand*, 1890. Oil on canvas, 47 × 64 in. Woolaroc Museum, Bartlesville, Oklahoma. See plate 5.

63. *The Last Stand* (detail).

64. *John Ermine*, 1902. Reproduced in Remington, *John Ermine of the Yellowstone* (New York: Macmillan, 1902), frontispiece.

65. Anthony Van Dyck, *James Stuart, Duke of Lennox and Richmond*, 1633. Oil on canvas, 85 x 50¼ in. Metropolitan Museum of Art, New York. Gift of Henry G. Marquand, 1889 (cropped slightly).

Evolution of the Cow-Puncher" (fig. 66). The painting shows a cowboy as the last in an evolutionary line of noble horsemen—Mongols, crusaders, and (on the right) a cavalier. Alone among the ghostly array parading alongside the cowboy, the cavalier looks back at him, as though to announce some special affinity between the two. In the article Wister describes a cowboy and an English aristocrat (albeit a modern-day one) as "the same Saxon of different environments."[3] In *The Last Stand*, the man at the apex, evoking Van Dyck's English aristocrats with their swagger and bravado as much as the U.S. cavalry, melds these same Saxons of different environments.

The references to Van Dyck and seventeenth-century English aristocracy generally were not just idle art-historical quotations. *James Stuart* was one of many Old Master paintings then arriving in U.S. museums after centuries in private European

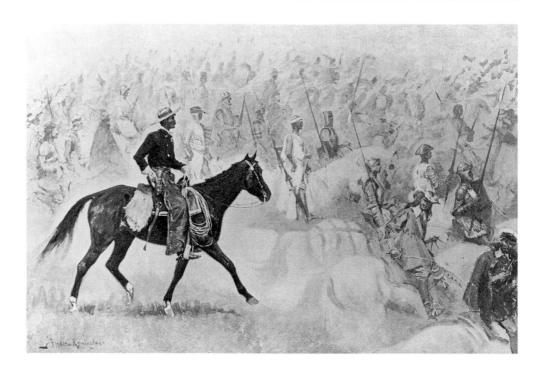

collections. (It had been in the same private collection from the year it was painted until 1886, when it was acquired by Henry Gurdon Marquand, who subsequently gave it to the Metropolitan.)[4] Not surprisingly, such Old Master paintings, so long sequestered in private homes, acquired a new ideological valence when abruptly inserted into turn-of-the-century urban America. Van Dyck pictures like *James Stuart*, for example, provided an image of domineering Anglo-Saxon nobility at precisely the time of unprecedented non–Anglo Saxon immigration to the United States. By 1908 the annual number of immigrants was 650,000.[5] Van Dyck made his works during a different era of immigration—the era of the *Mayflower* and the beginnings of English culture on the North American continent. The prominence of *James Stuart* in William T. Smedley's *Harper's Weekly* cover illustration of the Marquand Collection opening relates partly to the work's ability to suggest a continuity between the cultured museum-goers and the Anglo-Saxons of the past (fig. 67). The museum in the illustration evokes an ancestral hall, affording visitors a simulation of noble ancestry. The reference in *The Last Stand* to Van Dyck, then, helps transform Remington's cavalry into cavaliers, swaggering English-Americans.

Remington was self-conscious about his own seventeenth-century English roots. There was his youthful claim that "every Remington a herildric fiend can trace was a British soldier." Lieutenant John Remington, the first of the English Remingtons to

66. *The Last Cavalier,* 1895. Reproduced in Owen Wister, "The Evolution of the Cow-Puncher," *Harper's Monthly* 91 (September 1895): 605. *(opposite page)*

67. William Smedley, *The Autumn Reception at the Metropolitan Museum of Art, New York,* 1889. Reproduced in *Harper's Weekly* 33 (November 16, 1889): cover.

emigrate to the colonies, arrived in Massachusetts in 1637.[6] In letters, Remington tended to use such English expressions as *bloody, bully,* and *old chap,* and he referred to himself as an English American.[7] At some point, he acquired a seventeenth-century copy of *The Saints Everlasting Rest,* a popular book published in England in 1659, whose presence in his library makes sense only within the context of his fascination with the England of that time.[8] Remington's friend George Wharton Edwards, editor of *Collier's Weekly,* wrote:

> Freddy, these things in thy possessing
> Are better than a bishop's blessing . . .
> A goodly print of Chaucer bound long since
> When Charles the first was simply prince.[9]

His self-conscious Englishness clearly related to his loathing of the wave of immigrants from southern and eastern Europe. "Read two Sunday newspapers and never see one that I don't think of the passing of the American forest. What has America done with its forests gone and the scum of Europe in its place[?]"[10] The newspapers represent not only the transformation of American lumber into paper products but also, through their stories, the transformation of an America—symbolized by the primeval forest—into a land as densely populated with immigrants as it once was

with trees. Remington focused on the immigrants in New Rochelle, where he lived from 1890 to 1909: "New Rochelle is a d—— crowded—Jew, Nigger—dry goods clerk European City and I wish I could get out of it. It was formerly a pretty little American Village—so time don't improve things hereabouts."[11] For Remington, the change from American Village to European City, like the change from forest to news-paper, symbolized the change in the country at large.

It is in this context that we can understand the embattled English Americans of *The Last Stand*. Their situation, like the weather, is bleak. They huddle together on a barren graveyard of a hilltop. The swords and stones—each a marker planted in the ground—imply that commemoration has already begun, as though the figures' tomb-stones and other memorials have been raised even prior to their deaths. (In the same year that Remington painted *The Last Stand* he made an illustration documenting the dedication of the Custer Monument at the Little Big Horn.) A number of the figures—the scout, the two men reloading their guns, and the prone figure at lower left—stare with bulging eyes at something, probably an enemy charge, taking place outside the picture to the right. The scout opens his mouth in shock and terror. In an age of wide-spread immigration, the end is near for Remington's English Americans. The troopers

68. Louis Dalrymple, *The High Tide of Immigration—a National Menace*. Reproduced in *Judge* 45 (August 22, 1903): centerfold.

cower and recoil much like the figure of Uncle Sam in the era's anti-immigration cartoons (fig. 68).

The metaphor of the doomed American surrounded by racial enemies informs many of Remington's works. *The Intruders* (1900) features a group of outnumbered whites much like the group in *The Last Stand*, except here Remington arrays the figures in an inverted pyramid, thereby connoting their teetering position (fig. 69). The title of the painting, with its implication of racial intrusion, is an all but literal irruption of the discourse of immigration into a professedly western scene. The Indians visible in the distance are the intruders; and even when no enemy is visible, as in *The Last Stand*, the implication is that it is Indians who threaten the troopers.

In other works, Remington's battle scenes contain white troopers and "good" Indians fighting side by side (fig. 70). The juxtaposition is partly due to Remington's literalism; he adheres to the facts of the West by showing Indians as scouts for the army. Yet the juxtaposition also owes to the way Indians and Anglo-Saxons alike could be considered embattled "Native Americans." In "Immigration," a poem in *At the Sign of the Dollar* (1905), a book of satirical verse owned by Remington, Wallace Irwin makes the case, albeit only half seriously, that Indians are the "only real" Americans:

> . . . covered with ancestral tan,
>> Beside his wigwam door,
> The only real American
>> Counts idle talk a bore.
> "Ugh! Pale-face man he mighty thief.
>> Much medicine talk about—
> It heap too late for Injun chief
>> To keep-um alien out."[12]

In the last year of his life Remington hoped to make a colossal sculpture of an Indian for New York harbor. At a New York City dinner for William ("Buffalo Bill") Cody on May 12, he reported that "there was a good deal of talk about a big monument down [by] the bay by yours [truly]." Three days later, Remington's wife, Eva, received a letter from their friend Homer Davenport, who described the sculpture as "the one necessary statue of the whole country."[13] Leonard Wood, who visited Remington in early September 1909, would later lament the artist's death on December 26 of that year: "Remington has been doing remarkably good work in bronze, and was looking forward with much interest to doing a large bronze figure of an Indian for the

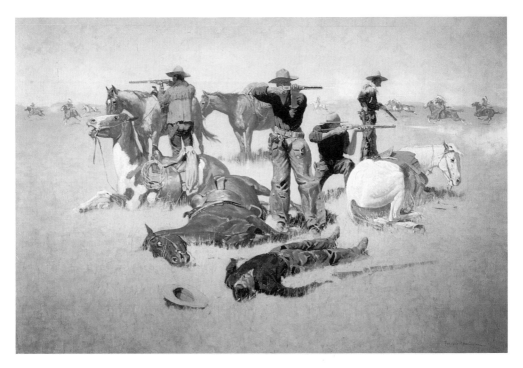

69. *The Intruders,* 1900. Oil on canvas, 27 × 47 in. Private collection. Photograph courtesy of Gerald Peters Gallery, Santa Fe, New Mexico.

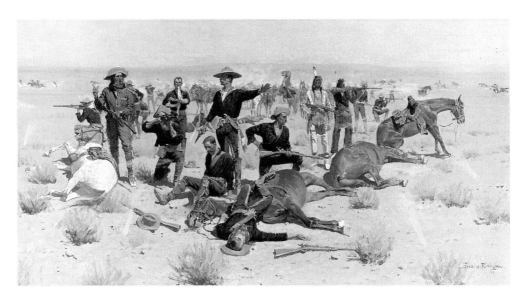

70. *Rounded-Up,* 1901. Oil on canvas, 25 × 48 in. Courtesy of Sid Richardson Collection of Western Art, Fort Worth, Texas.

entrance to New York Harbor."[14] At the turn of the century, images of Indians could represent not just immigrant marauders but "real" Americans. Indians became a symbol of the mythic national values—pride, defiance, freedom—in whose name Indian cultures had been decimated.

The White Country

Images of Indians were the most potent contemporary statements of the decline and doom of racial purity. In *The Snow Trail*, a Remington painting of circa 1908 (fig. 71, plate 6), a line of Indians follows tracks through a snowy landscape much like the one that Remington sketched in Connecticut in January 1908: "I went down to the gorge and I sat down and painted a most beautiful place and d—— near froze to death doing it." The title of one of Remington's Connecticut sketches, *The White Country* (1909, private collection), connotes not only the innocence of a preindustrial place that made Remington feel, as he said, "quite out of touch with the world," but also racial purity; the painting nostalgically links whiteness with innocence, as though the white country—America before immigration—were a land like that shown in the painting: quiet, pristine, quite out of touch with the world.[15]

The reference was not only to New England as a contemporary version of an earlier and racially homogeneous version of the United States—a metaphorical status

71. *The Snow Trail*, ca. 1908. Oil on canvas, 27 × 40 in. Frederic Remington Art Museum, Ogdensburg, New York. See plate 6.

that it shared in these years with the West—but also to the original "white country" from which Remington and other self-professed Anglo-Saxons tirelessly claimed inheritance: northern Europe. In *John Ermine*, Remington describes the land from which Ermine the Anglo-Saxon came: "Any white man could see at a glance that White Weasel [Ermine's openly symbolic name at this point in the story] was evolved from a race which, however remote from him, got its yellow hair, fair skin, and blue eyes amid the fjords, forests, rocks, and ice-floes of the north of Europe. The fierce sun of lower latitudes had burned no ancestors of Weasel's; their skins had been protected against cold blasts by the hides of animals. Their yellow hair was the same as the Arctic bear's, and their eyes the color of new ice."[16] Body and land express one another, just as the white in *The White Country* is simultaneously snow and skin.

Remington was not the only one in his era to assign a racial meaning to a cold climate. "Into the Primitive," the opening chapter of *The Call of the Wild*, where Buck finds himself transported from sunny southern California to Alaska, ends symbolically with an account of Buck's first confused experience with snow (the final words of the chapter are "first snow").[17] For London, the snow augurs the primitive conditions in which Buck will discover his wild racial identity. In *The Great Gatsby* (1925), a later work containing the same metaphors, Fitzgerald's Nick Carraway travels home to Minnesota for Christmas, a journey on which he, too, has a mystical experience with snow: "When we pulled out into the winter night and the real snow, our snow, began to stretch out beside us and twinkle against the windows, and the dim lights of small Wisconsin stations moved by, a sharp wild brace came suddenly into the air. We drew in deep breaths of it as we walked back from dinner through the cold vestibules, unutterably aware of our identity with this country for one strange hour, before we melted indistinguishably into it again."[18]

As Nick and his fellow passengers journey from the urban East to the Middle West, they return to a simpler America, the place of their youth. The snow is a metaphor for the innocence of this place, but the snow and coldness are racial as well. Carraway's journey to a more primal place is like that of London's Buck from southern California to Alaska. Each story concerns a journey to a place of wildness and the discovery in that place of Anglo-Saxon purity—the "sharp wild brace," "the call of the wild"—within oneself. In Fitzgerald's passage, purity is a kind of spirit, conveyed in the air, that infuses Nick and his fellow passengers, inhaled by them, making them as sharp and wild as the land itself, and producing therefore the "unutterable" awareness of identity that Nick talks about. As in Remington's *John Ermine* passage, body and land express one another.

As an Indian scene, *The Snow Trail* also celebrates "native" racial purity. The figures, particularly the leader, are shown heroically from below in the tradition of the equestrian portrait of the war hero. The leader holds his head high, but not to look at the sky or the tracks; with his regal bearing, he personifies the noble wildness and purity of the land. Remington's Indians travel through the snow, unutterably aware of their identity with it, just as Nick Carraway and his fellow passengers move through a winter night in *The Great Gatsby*. The sharp wild brace of the air is one and the same with the sharp wild group of Indians riding proudly through it.

The Native Americans of *The Snow Trail* are doomed. It is late in the afternoon; the foreground snow is ominously blue, colder than cold; the sun is fading on the Indians and the Old America they represent. They travel on ice as thin as the layer covering the Nile in Remington's "War Dreams." As doomed representatives of an earlier America, they relate to the figures in Remington's *End of the Day* (1904), an elegiac snow scene depicting a solitary figure unhitching a pair of horses from a sled (fig. 72). The dusk comes and a dusty snow falls: a primitive era is disappearing under night and snow. The disappearance is again a racial one: the snowflakes, each one dif-

72. *The End of the Day*, 1904. Oil on canvas, 27 × 40 in. Frederic Remington Art Museum, Ogdensburg, New York.

73. Winslow Homer, *The Fox Hunt,* 1893. Oil on canvas, 38 × 68½ in. Pennsylvania Academy of the Fine Arts, Philadelphia. Joseph E. Temple Fund.

ferent, each a matter of a unique and pure white identity, float in the picture like the stars in *A Reconaissance* (see fig. 53), testifying, for the worried Remington, to the heavenly fate of racial uniqueness.

Remington's snow scenes were among many with similar themes at the time. In Winslow Homer's *Fox Hunt* (1893), a lone fox, its face averted from us, flees through the snow to escape a swarm of crows rising over the hillock at the right (fig. 73). There are many ways to interpret this rich painting; one option is to understand it as part of the same discourse informing Remington's images of racial intrusion. The title, referring to the sport of the landed English gentry, inverts the meaning of the ritual, conflating the prim and proper hunters with the hunted—the prim and proper little fox—and transforming the hunters into ominous flesh-eating birds. That the scene occurs on a New England shoreline suggests that we are to understand the fox as a resident of this pure Old American place. Homer's fox is as pure as the powder through which he makes his own snow trail; he is attacked by dark intruders emanating from the shore in the distance. Breaking through the snow, about to be attacked and (perhaps) eaten, the fox epitomizes the "I fled. I could not run" of the terrified soldier in "The War Dreams." He is another native American facing a last stand. In these ways, *The Fox Hunt*, like Remington's frontier images, is not so much *about* immigration as it is *informed by* metaphors concerning immigration.

Opening the Flood Gates

That the crows appear from the direction of the shore—we see the tide breaking upon the rocks—also suggests immigration. Once Homer moved to Prout's Neck, Maine, in 1883, he made many paintings of the confrontation between land and sea. In *Northeaster* (1895), for example, a powerful wave breaks against the foreground shore, sending forth a cloud of spume (fig. 74). Such pictures were determined by a great many causes, including Homer's lifelong preoccupation with the sea and his late career move to increasingly simple motifs and compositions. It is also possible, however, to link Homer's preoccupation with violent waves crashing upon the shores of New England to the then dominant metaphor of an immigrant tide, as seen in cartoons like *The High Tide of Immigration—a National Menace* (see fig. 68). In Van Wyck Brooks's *Wine of the Puritans: A Study of Present-Day America* (1908), Italian culture is likened to a product of the tide, "idly tossed" into existence. For the two Americans sitting on an Italian seashore at the beginning of the book, the tide is coming to America, too: "As a little ripple broke along the beach we looked up to see a great black ship moving westward from Naples in the outer bay. 'Another shipload of Italians going to take our places at home,' [Graeling] said."[19] John Dos Passos referred in his later *Manhattan Transfer* (1925) to a New York dockside as a "streak of water crusted with splinters, groceryboxes, orangepeel, cabbageleaves, narrowing, narrowing between the boat and the dock"—a figurative connection between tide and garbage that compactly expressed his anti-immigration views.[20] In *The American Scene*, Henry James likened Manhattan's lower East Side, with its "Jewry that had

74. Winslow Homer, *Northeaster,* 1895. Oil on canvas, 34⅝ × 50¼ in. Metro-politan Museum of Art, New York. Gift of George A. Hearn, 1910.

burst all bounds," to a place where "the rising waters . . . rose, to the imagination, even above the housetops and seemed to sound their murmur to the pale distant stars." The lower East Side, for James, was "the bottom of some vast sallow aquarium."[21] City streets, as many writers noted, were full of "urchins"—little children begging or selling newspapers.[22] Remington's description of change overtaking the Old West relies on the metaphors of the immigrant tide: "I knew the derby hat, the smoking chimneys, the cord-binder, and the thirty-day note were upon us in a resistless surge."[23]

An Interesting Question, a political cartoon by E. M. Ashe, deploys not just the tide metaphor but another of the dominant anti-immigration motifs: the open door (fig. 75). Uncle Sam, in the chair at right, is powerless to stop a horde of rats with what are supposed to be immigrants' heads from pouring through the open gates of his garden-fortress. In the distance, visible as the "tail" of the long slithering procession of rats spilling through the gate, are boats resembling the "great black ship" that Brooks would write about in *The Wine of the Puritans*.

The open fortress door recurs in western art of the time, most dramatically in Charles Schreyvogel's *Defending the Stockade* (around 1905), in which troopers scurry to close the gates of the garrison to enemy Indians (fig. 76). No intruder has penetrated the fort, and the troopers, despite their disarray, have managed partly to close

75. E. M. Ashe, *An Interesting Question*, 1893. Reproduced in *Life* 21 (June 22, 1893): 398–99. *(opposite page)*

76. Charles Schreyvogel, *Defending the Stockade*, ca. 1905. Oil on canvas, 28 × 36 in. Private collection. Photograph courtesy of Kennedy Galleries, New York.

the gate, but several of the soldiers are dead and others are wounded; the enemy is climbing the walls; and the two figures attempting to close the gate do so with strained force, implying enemies exerting pressure on the other side. The perilous situation parallels Henry's dream in *White Fang*: "It seemed to him that the fort was besieged by wolves. They were howling at the very gates, and sometimes he and the Factor paused from the game to listen and laugh at the futile efforts of the wolves to get in. And then, so strange was the dream, there was a crash. The door was burst open. He could see the wolves flooding into the big living room of the fort."[24]

In Schreyvogel's painting the gate itself—the point of highest light-dark contrast—is the focus not only of the soldiers but of the viewer. It is the site of a threat more profound than the concept of entry would imply. The standing figure directly in front of the gate, holding his revolver over his head like a lion tamer's whip, stares forward as if into a blast furnace or the maw of some monstrous creature. The smoke piercing the gate is the breath of an alien dragon or, in view of its relation to the crashing waves of Homer's coastal scenes, a racial tide slamming against the soldiers' frail sea wall. The space on the other side of this American wall is, in Schreyvogel's picture, too horrific to be seen fully. The figure standing in the gate's maw beholds a scene perhaps as terrifying as the one that confronts Edgar Rice Burroughs's English settler John Clayton at the threshold of his jungle cabin: "The sight that met his eyes

must have frozen him with horror, for there, within the door, stood three great bull apes, while behind them crowded many more; how many he never knew."[25]

Rather than being visualized in this way, the threatening presence at the gateway in Schreyvogel's picture is displaced onto the open gate itself. The open gate, symbol of racial intrusion, receives the insidious characteristics of the unseen forces that threaten to penetrate it. It growls like the monsters that in Schreyvogel's imagination threaten to enter the fort. The displacement implies the artist's sense of the "horror," to use the word of Conrad's Kurtz, on the other side of the civilized wall; only by hiding the horror could Schreyvogel make it visible.

At other times Anglo-Saxon artists fantasized violent solutions to the immigrant "problem." *The Hold Up* (1899) is Charles Russell's account of an actual event: the robbery of the Deadwood stage in 1880 by a notorious outlaw, Big Nose George, and his gang (fig. 77). In several ways Big Nose George, holding his shotgun in the foreground, is an unsympathetic figure. He is dirty and unkempt; he is related tonally to the blasted trees; his big nose is unceremoniously displayed in profile. Yet he is also something of a hero. He stands straight and firm, a romantic figure backed by his white horse. He is firmly and boldly modeled, unlike the caricatured lineup of victims. "We had outlaws, but they were big like the country they lived in," Russell told an interviewer about his early days in the West.[26] For Russell, Big Nose George is a

romantic figure from the old days of the West. For the art historian Peter Hassrick, too, *The Hold Up* is related to the spirit of Brandywine School illustrations showing the outlaws of Sherwood Forest or South Seas pirates "living by a code of bravado and greed."27

By contrast, the stagecoach passengers, with the possible exception of the prospector and the gambler (second and fifth from the left), represent immigrants that Russell considered to be taming, and ruining, the wildness of the West. The two women are versions of the bicycling woman in Russell's *The Last of His Race*, made in the same year (see fig. 29). The men—prospector, preacher, gambler, and (at the far right) Jewish businessman—are portrayed as weak and pitiful. They resemble the farmer in Russell's *Cow Puncher—New Style, A.D. 1896* (Amon Carter Museum, Fort Worth, Texas), a takeoff on Remington's *Last Cavalier* (see fig. 66) showing an immigrant farmer slouching along holding a pitchfork instead of a lance.

In *The Hold Up*, moreover, it is not far from emigrant to immigrant. The lineup of passengers evokes the way in which cartoons portrayed multiracial and multi-ethnic lineups of new Americans (fig. 78). Further, the passengers in Russell's pictures are arrayed parallel to the picture plane—an odd note in a painting otherwise incessantly preoccupied with marking its own depth. The rocks and fallen trees in the foreground, among other objects, persistently establish the depth of the depicted space—a depth

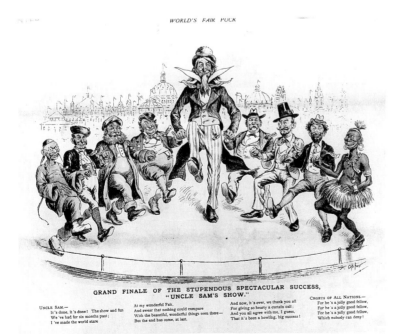

77. Charles Russell, *The Hold Up*, 1899. Oil on canvas, 30¾ × 48¼ in. Amon Carter Museum, Fort Worth, Texas. (*opposite page*)

78. Frederick Opper, *Grand Finale of the Stupendous Spectacular Success, "Uncle Sam's Show,"* 1893. Reproduced in *Puck* (October 30, 1893): 3194. Library of Congress, Washington, D.C.

against which the static line of passengers is an aberration. The lineup, even if required by the narrative, also evokes the compositional principles of ethnic cartoons—images that allowed the beholder a clear view of the racial and ethnic "types" portrayed. Also, the title of Russell's picture evokes the well-known delay, or hold up, confronting immigrants at Ellis Island.

Unlike in *Defending the Stockade*, where possession of the fortress is in doubt, in Russell's picture the immigrants will not conquer. They are helpless before the commanding figure of Big Nose George, the Robin Hood of Deadwood Forest. Russell's picture is a fantasy about checking the immigrant invasion. Big Nose George is outnumbered, like Remington's figures in *The Last Stand* (see plate 5), but he stands defiantly in the path of emigrant-immigrant, holding the intruders at bay, preserving an old-time place that is simultaneously the West and America.

The idea of almost single-handedly blocking an immigrant threat, moreover, is something that Russell's picture shares with Remington's images of strikebreaking. Covering the Pullman strike for *Harper's Weekly* in 1894, Remington wrote and illustrated three articles, "Chicago Under the Mob," "Chicago Under the Law," and "The Withdrawal of the U.S. Troops." (He also wrote a fictional story about the Pullman strike, "The Affair of the ——th of July," which we shall consider shortly.) In an illustration, *Lieutenant Sherer, Seventh Cavalry, Standing Off a Mob at the Stock-Yards*, a young army lieutenant operates a hand-cranked rail switch while a group of immigrant strikers looks on (fig. 79). Single-handedly, Lieutenant Sherer switches things back, transforming the rule of Chicago from "Mob" to "Law." Although his pistol is drawn, Sherer does not aim at the strikers; he holds them at bay as much by his stoical stance and stare as by his weapon. One striker (third from the left, front row) appears ready to lunge toward the officer. Yet the striker's legs remain firmly planted; he is going nowhere. Like his fellows, he is stood off, not just by a gun but by some magical or even mesmeric force. We do not need to argue for a direct connection between Remington's strike picture and *The Hold Up* to see that Russell shows Big Nose George in much the way Remington depicts Lieutenant Sherer: as a lone defender of a besieged earlier way of life, switching things back, staring down, standing off, a line of newcomers.

These violent fantasies are reactions not only to the immigrants' sheer numbers but also to liberal, pro-immigrant legislation. In "Chicago Under the Mob," Remington wrote that the city has "had some politics for twenty years which would make a moral idiot suck for his breath."[28] Such politics threatened to disrupt the "natural" processes of social evolution. "It was well enough to treat some earthworms, some climbing-plants, and some brightly colored birds as fit, and others as unfit, to survive; but when

79. *Lieutenant Sherer, Seventh Cavalry, Standing Off a Mob at the Stock-Yards,* 1894. Reproduced in Remington, "Chicago Under the Law," *Harper's Weekly* 38 (July 28, 1894): 705.

this distinction is extended over human beings and their economic, social, and political affairs, there is a general pricking-up of ears"—so said Nicholas Murray Butler in "The Revolt of the Unfit," a lecture delivered at Columbia University in 1910 to, among others, Eva Remington.[29] Butler continued: "The revolt of the unfit primarily takes the form of attempts to lessen and to limit competition, which is instinctively felt, and with reason, to be part of the struggle for existence and for success. The inequalities which nature makes, and without which the process of evolution could not go on, the unfit propose to smooth away and to wipe out by that magic fiat of collective human will called legislation."[30] *People We Pass*, the title of Julian Ralph's book of immigrant life, would have been an apt point of reference: if such legislation continues, Butler tells his audience, the people we pass will pass us. As Remington wrote in 1894: "To temporize with a mob means more blood to shed in the future. Chicago should have been put under martial law immediately; a few rioters shot, and this would all have been over before now."[31]

Yet such fantasies underscore the complexity of the very issues they would resolve. In *The Hold Up* the immigrants, as in a dream, are so hyperbolically weak as

to suggest that Russell may have understood immigrants in fact to be not so stoppable as the motley passengers; Big Nose George, for his part, is so preternaturally commanding as to suggest that in the "real" world such old-time Americans were not nearly so powerful. (Actually, Big Nose George was captured, hanged, and transformed into a lampshade by the forces of civilization.) Russell's fantasy was nonetheless a popular one, and *The Hold Up* became one of his most famous works. The position of Big Nose George and (more precisely) his horse, blocking the immigrants' path, tells us that fantasized violence against and the humiliation of immigrants were not the preoccupation solely of maverick criminals but also of "average" Americans—people who, like the white horse, occupy the middle of the road.

"A Thousand Times Worse Than Death"

The women in *The Hold Up* represent a pernicious sort of civilization, but in other contemporary works, civilized women must be saved. In Schreyvogel's *Rescue at Summit Springs* (around 1908), Buffalo Bill shoots an Indian warrior just as the Indian prepares to scalp one of two white women at his feet (fig. 80). In so doing, Buffalo Bill is a savior not once but twice: he saves the white women from death and also from a fate, to use Burroughs's phrase in *Tarzan*, "a thousand times worse than death."[32] The women kneel in the conventional pose of the passive female martyr, yet their kneeling at the Indian's feet, helpless and slack, suggests Schreyvogel's conception of their sexual subservience were Buffalo Bill not to have intervened. (The Indian's naked chest also intimates the sexual nature of the relationship that Buffalo Bill has prevented.) One of Frank Schoonover's colonial illustrations, painted in 1901, tells much the same story (fig. 81). With the telltale open fortress gate behind them, a white man grapples with an Indian while a terrified white woman looks on. In all of these cases, the fear and fantasy concern miscegenation. Reporting on Chinese lepers in Havana, Remington said that he saw "a thing which might taint my people."[33] "If the valuable elements in the Nordic race mix with inferior strains or die out through race suicide," wrote Henry Fairfield Osborn in 1916, summarizing a prevalent view, "then the citadel of civilization will fall for mere lack of defenders."[34]

One of the most dramatic of these works is Irving Couse's *Captive* (fig. 82). Couse's painting, which he showed at the Paris Universal Exposition in 1892, depicts a historical event set a full forty-five years earlier, in 1847: seventeen-year-old Lorinda Bewly held captive by the Cayuse chief Five Crows, who wished her to be his wife.[35] On the most basic level, Couse's picture, like Remington's novel *John Ermine*,

80. Charles Schreyvogel, *The Rescue at Summit Springs,* ca. 1908. Oil on canvas, 48 × 66 in. Buffalo Bill Historical Center, Cody, Wyoming. Bequest in memory of Houx and Newell Families.

81. Frank Schoonover, *The Rescue,* 1901. Oil on board, 20 × 16 in. Private collection.

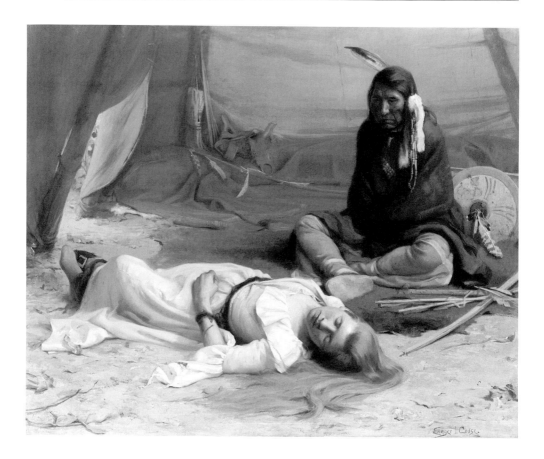

concerns the incompatibility of savage and civilized states. Contemplating a woman he cannot make his own—Bewly, the story goes, refused his invitation—Five Crows is like Ermine gazing upon Katherine Searles. Couse's picture, however, goes considerably beyond this evolutionary allegory. Although Five Crows does nothing more than stoically regard the fallen woman before him, the picture makes it clear that he has reached his contemplative state only after a fit of violence. Bewly lies unconscious before him, her face a vivid shade of blue, her left forearm bloody from the bonds of a rope. A red handprint appears on Five Crows's blanket, testifying not only to the wounds of his victim but also to her desperate attempt to push him away. But the picture, while showing us Five Crows's brutality, also emphatically states that Bewly has not been sexually assaulted. Her white dress, rip on the left sleeve aside, is still intact. Her legs are bound together. Her left hand covers her genitals as though to indicate that they are still covered or protected.

In an era of widespread miscegenation fears, the charged subject of Couse's picture—a white woman and an Indian man in the same interior space, alone—had sex-

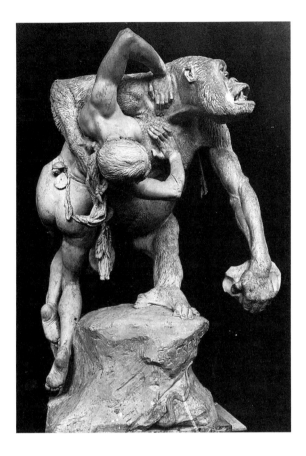

82. Irving Couse, *The Captive,* 1892. Oil on canvas, 50 × 60 in. Phoenix Art Museum, Phoenix, Arizona. Gift of Mr. and Mrs. Read Mullan and others by exchange. *(opposite page)*

83. Emmanuel Frémiet, *Gorilla Carrying Off a Woman,* 1887. Bronze, h. 17½ in. Musée des Beaux-Arts, Nantes, France. Photograph courtesy of Art Resource.

ual implications. The composition is similar to that of the sculptures of Emmanuel Frémiet (an artist well known to the Paris audiences inspecting Couse's painting), whose works sometimes show white women carried off or watched over by gorillas (fig. 83). More specifically, to the extent that Couse's picture manifestly denies a sexual encounter, it lets such an encounter resurface elsewhere in the image. The array of phallic arrows pointing in Bewly's direction, the tepee's open entry, and the feathers penetrating the center of the shield behind Five Crows all read as sublimated sexual imagery. What is too threatening to be shown, as in Schreyvogel's *Defending the Stockade,* is displaced onto other parts of the image. The name of the Cayuse chief, Five Crows, evokes the same racial narrative, implying a dark and multifarious racial presence not unlike that in Homer's contemporaneous *Fox Hunt.* It does not seem beside the point, either, that both figures in *The Captive* place a hand or hands in their lap.

It was consciously permissible, however, for Couse to make Lorinda Bewly an object of the viewer's erotic inspection. If Bewly's body is skewed and foreshortened, cut and cut off, it is at the same time almost gently displayed for the viewer. Her face

is turned toward the picture plane; her flowing hair, a conventional sign of promiscuity, also extends in our direction. Couse is careful, finally, to remove one of Bewly's shoes. "'That's my foot,'" says the heroine of George Du Maurier's *Trilby*, the hugely popular novel of 1894. "'It's the handsomest foot in all Paris. There's only one in all Paris to match it, and here it is,' and she laughed heartily (like a merry peal of bells), and stuck out the other." The narrator rejoins: "And in truth they were astonishingly beautiful feet." After a page of further commentary on Trilby's feet, the narrator summarizes the erotics of seeing one of them: "The sudden sight of it, uncovered, comes as a very rare and singularly pleasing surprise to the eye that has learned how to see!"[36]

Trilby, who dies after being manipulated by the evil Jewish magician Svengali, exemplifies the era's sexualized fetishization of the fallen (and even dead) woman.[37] In Bram Stoker's *Dracula* (1897), Dr. Seward remarks on the unbelievable beauty of the dead Lucy Westenra: "All Lucy's loveliness had come back to her in death, and the hours that had passed, instead of leaving traces of 'decay's effacing fingers,' had but restored the beauty of life, till positively I could not believe my eyes that I was looking at a corpse."[38] In *Trilby*, Svengali imagines the heroine lying on a surface that is both dormitory bed and morgue slab as he warns her of her fate should she not return his love: "Look a little lower down between the houses, on the other side of the river!" he commands. "There is a little ugly gray building there, and inside are eight slanting slabs of brass, all of a row, like beds in a school dormitory, and one fine day you shall lie asleep on one of those slabs—you . . . who would not listen to Svengali, and therefore lost him! . . . And over the middle of you will be a little leather apron, and over your head a little brass tap, and all day long and all night the cold water shall trickle, trickle, trickle all the way down your beautiful white body to your beautiful white feet till they turn green."[39]

Svengali is much like Five Crows; Trilby (and Lucy Westenra), much like Bewly. "Ah what a beautiful woman was that! Look at her!" Svengali imagines people will say when they see Trilby's lifeless body at the morgue.[40] And Couse's Lorinda Bewly—alive and alluring yet blue-faced and somehow dead—precisely recalls not only the fallen women of Frémiet's sculptures but the then popular genre of the fallen woman at the morgue or anatomical table. In Enrique Simonet's painting *La Autopsia de Corazón*, made in 1890, a doctor holds the heart of the corpse before him; yet the body, like Lucy Westenra's, is cast as alluring even (perhaps especially) in death (fig. 84). Although her right arm hangs lifelessly, we can see neither the doctor's incision nor any other conclusive evidence that the body is a corpse. The body is stiff yet languid. The heart—marker here of both autopsy and passion—embodies the picture's necro-erotics.

Plate 1. *Apache Medicine Song,* 1908. Oil on canvas, 27⅛ × 29⅞ in. Courtesy of Sid Richardson Collection of Western Art, Fort Worth, Texas.

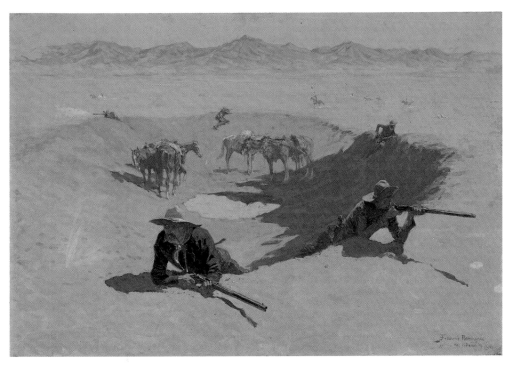

Plate 2. *Fight for the Water Hole,* 1901. Oil on canvas, 27¼ × 40⅛ in. Hogg Brothers Collection, Museum of Fine Arts, Houston, Texas. Gift of Miss Ima Hogg.

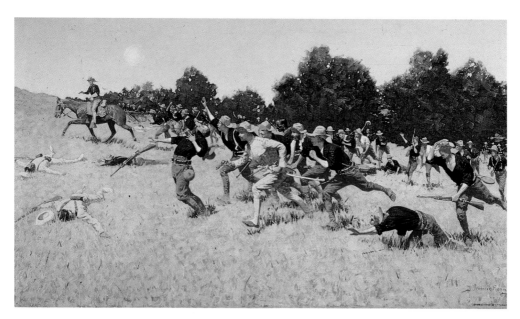

Plate 3. *The Charge of the Rough Riders at San Juan Hill,* 1898. Oil on canvas, 35 × 60 in. Frederic Remington Museum, Ogdensburg, New York.

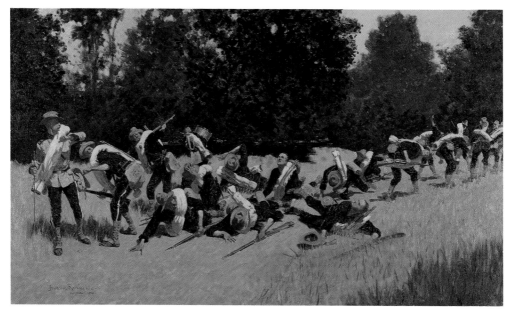

Plate 4. *The Scream of Shrapnel at San Juan Hill,* 1898. Oil on canvas, 35¼ × 60¾ in. Yale University Art Gallery. Gift of the artist, 1900.

Plate 5. *The Last Stand,* 1890. Oil on canvas, 47 × 64 in. Woolaroc Museum, Bartlesville, Oklahoma.

Plate 6. *The Snow Trail,* ca. 1908. Oil on canvas, 27 × 40 in. Frederic Remington Art Museum, Ogdensburg, New York.

Plate 9. Remington,
The Snow Trail (detail).

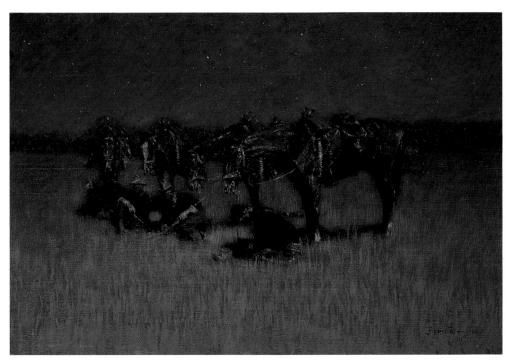

Plate 7. *Night Halt of the Cavalry,* 1908. Oil on canvas, 27 × 40 in. Private collection. Photograph courtesy of Gerald Peters Gallery, Santa Fe, New Mexico.

Plate 8. *The Stranger,* 1908. Oil on canvas, 27 × 40 in. Caldwell Gallery, Manlius, New York.

Plate 9 is a detail of plate 6.

Plate 10. Childe Hassam, *Indian Summer in Colonial Days,* 1899. Oil on canvas mounted on board, 22 × 20 in. Private collection. Photograph courtesy of David Findlay, Jr., Inc., New York.

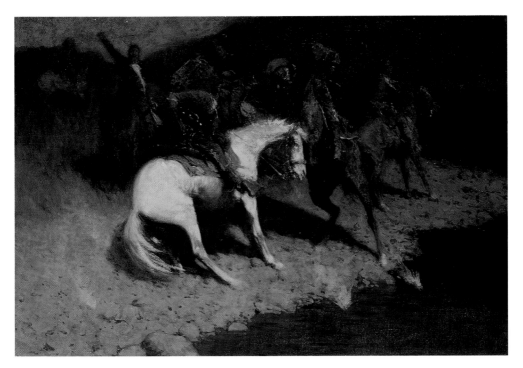

Plate 11. *Fired On,* 1907. Oil on canvas, 27⅛ × 40 in. National Museum of American Art, Smithsonian Institution, Washington, D.C. Gift of William T. Evans.

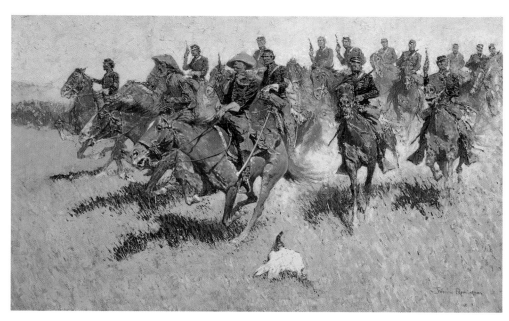

Plate 12. *Cavalry Charge on the Southern Plains in 1860,* 1907–8. Oil on canvas, 30⅛ × 51 1/8 in. Metropolitan Museum of Art, New York. Gift of Several Gentlemen, 1911.

The Captive, like *Trilby, Dracula,* and Simonet's painting, performs a double ideological function. It demonizes an other (racial, ethnic, or, in the case of Simonet's tousle-haired "mad" scientist, deranged), implying thereby the violent consequences should such others lay demented dark hands upon virginal white womanhood, yet at the same time, Couse's painting, like our other examples, lovingly dwells on the very violence it condemns. In each of these representations, misogynistic fantasies become acceptable to the extent that they are displaced onto the likes of Five Crows or Svengali or Dracula. Bewly, in her white dress, becomes erotic for her 1892 audience to the extent that she is darkened by sexuality. Like the leaves strewn at the lower left, she has fallen. The bloody handprint that testifies to her struggle to escape a "fate a thousand times worse than death" nonetheless marks where she has placed her hand upon this dark man—where she has given him her hand.

Remington—who owned a copy of *Trilby* and loved it so much that he even wrote Du Maurier a fan letter—shared many of the author's preoccupations.[41] "The girl was half damp in death," he wrote of Katherine Searles, the victim of a fall, after John Ermine has carried her unconscious form to the banks of a river. Says the narrator, "Oh, if he could but impart his vitality to her."[42] Here, in the typically sexualized language of the novel, Remington combines Ermine's need to breathe life into the woman with Ermine's sexual desire, as though he would impregnate Katherine with his breath; indeed, the double sense of the phrase *impart his vitality* recalls the way the word *ejaculate* could refer acceptably to a sudden and seminal exclamation.

A sublimated imagery of ejaculation is not uncommon in frontier literature, although the sexual object is not always a woman. Sometimes orgasm is simply a metaphor for evolutionary strength, as in this Jack London passage concerning Buck: "Life streamed through him in splendid flood, glad and rampant, until it seemed that it would burst him asunder in sheer ecstasy and pour forth generously over the world."[43] At other points, if in a slightly less diluvial sense, a sublimated imagery of ejaculation describes erotic feelings between men. Humphrey Van Weyden, in *The Sea-Wolf*, marvels at Wolf Larsen: "[He] was the man-type, the masculine, and almost a god in his perfectness. . . . I could not take my eyes from him. I stood motionless, a roll of antiseptic cotton in my hand unwinding and spilling itself down to the floor."[44] The white cotton in Van Weyden's hand, unwinding and spilling itself down to the floor, expresses his erotic and indeed ejaculatory attraction to Larsen even as it tries to cleanse, or antisepticize, that attraction. In *The Virginian*, the male narrator confesses that he has "never seen a creature more irresistibly handsome" than the Virginian himself. Of the Virginian's smile, the narrator adds: "Had I been a woman, it would have made me his to do what he pleased with on the spot."[45]

In *Spaniards Search Women on American Steamers*, a sketch that Remington made for William Randolph Hearst's *New York Journal* in 1897, three Spanish men appear to do just what they please, strip-searching a light-skinned Cuban woman (fig. 85). The sketch caused an outrage in the United States and helped fuel popular sentiment against Spain. (The actual search was conducted by women.) Swarthy and hulking, the Spanish surround the woman much like Arabs examining a slave in one of Jean-Léon Gérôme's slave-market scenes. In "The Affair of the ——th of July," the fiction that Remington wrote concerning the possible outcome of the Pullman strike, U.S. troopers engage in a pitched citywide battle with drunken immigrant strikers. At one point, some troopers discover a group of strikers—"a half-dozen of the most vicious-looking wretches"—occupying a mansion. The soldiers kill the strikers and then a "form appeared in the door. It was a woman. She was speechless with terror, and her eyes stared, and her hands clutched. We removed our hats, and the woman closed her eyes slowly."[46] The woman faints and is caught by the captain—"a rather engaging scene," says the narrator. Lying in the captain's arms, the woman is safe from a class threat—immigrant laborers invading her mansion—and from a sexual threat as well. The pun in *engaging scene* even implies that a same-race union might issue from this chance coupling. Saving the Chicago woman, Remington's captain is little different from Schreyvogel's Buffalo Bill, rescuing the white captives at Summit Springs.

84. Enrique Simonet, *La Autopsia de Corazón*, 1890. Museo Provincial de Bellas Artes, Málaga, Spain. *(opposite page)*

85. *Spaniards Search Women on American Steamers*, 1897. Pen and ink on paper. Reproduced in the *New York Journal*, February 12, 1897. Thomas J. Watson Library, Metropolitan Museum of Art, New York.

The Urban Frontier

The frontier quality of Remington's Chicago scene underscores his sense that the immigrant "invasion" was far from solely a bad thing. Even if immigrants endangered "American ideas and institutions," as the *Judge* cartoon proclaimed (see fig. 68), they also excitingly transformed the urban world, heretofore the place of feminized enervation, into a new kind of frontier. In "The Affair of the ——th of July," the streets of Chicago are transformed into one of Remington's typical frontier battlefields, complete with a familiar piece of iconography: "Half a block ahead was a great hole in the pavement." Says Remington in another of his Pullman articles, "[Chicago] is much like Hayes City, Kansas, in early days."[47]

Industrial Chicago also evoked an even more primitive place, one suggesting the volcanic beginnings of the world. In *The Jungle* (1906), the famous exposé of labor conditions and meat contamination in the Chicago stockyards, Upton Sinclair describes the smoke billowing from the stacks of the meat-preparing charnel houses: "It might have come from the centre of the earth, this smoke, where the fires of the ages still smoulder. It came as if self-imperilled, driving all before it, a perpetual explosion." Of Bubbly Creek, an "open sewer" into which "all the drainage of the square mile of packing houses empties," Sinclair writes: "Bubbles of carbonic acid gas will rise to the

surface and burst, and make rings two or three feet wide. Here and there the grease and filth have caked solid, and the creek looks like a bed of lava."[48]

For Remington, Chicago was "a social island." This meant that the immigrant laborers were as primitive, as savage, as the space in which they worked. "Say, do you know them things ain't human?" a soldier says of the strikers in Remington's story "Chicago Under the Mob." "Before God," the soldier continues, "I don't think they are men."[49] Even Upton Sinclair, who was far more sympathetic to immigrant laborers than Remington was, nonetheless characterized them in similar evolutionary terms: "Elzbieta was one of the primitive creatures: like the angle-worm, which goes on living though cut in half; like a hen, which deprived of her chickens one by one, will mother the last that is left her." Jurgis Rudkus, the protagonist, is repeatedly cast as an animal: "a wounded bull," "a wild beast," "a startled animal."[50] At one point, new to the stockyards, Rudkus solemnly watches the pig-flinging machine—"*Dieve*—but I'm glad I'm not a hog!" he says—yet it is the main conceit in the novel that Jurgis and his family are as much animals, as much meat, as the animals they slaughter, skin, gut, and can. Having attacked the man who forced his wife into prostitution, Jurgis is dragged away: "It was only when half a dozen men had seized him by the legs and shoulders and were pulling at him, that he understood that he was losing his prey. In a flash he had bent down and sunk his teeth into the man's cheek; and when they tore him away he was dripping with blood, and little ribbons of skin were hanging in his mouth."[51] Jurgis is less like a human being here than he is like London's Buck: "Buck loosed his teeth from the flesh of the arm and drove in again for the throat. This time the man succeeded in only partly blocking, and his throat was torn open. Then the crowd was upon Buck, and he was driven off."[52]

If Chicago was a primitive place, Anglo-Saxons had an unexpected opportunity to rediscover the race's martial spirit. Various rhetorical stratagems were produced to continue the frontier experience—and in that way stave off the threat of a fully civilized (feminized) country. Mechanical engines were referred to in terms of horsepower. In a 1908 *Everybody's* article, workers on Manhattan skyscrapers were called cowboys of the skies.[53] In "The Frontier Gone at Last," an essay posthumously published in 1903, Frank Norris argued that modern international business continued the masculine ethos of the frontier: "It is a commercial 'invasion,' a trade 'war,' a 'threatened attack' on the part of America; business is 'captured,' opportunities are 'seized,' certain industries are 'killed,' certain former monopolies are 'wrested away.'"[54]

An actual urban war in Chicago would have made a modern-day frontier. There was no more Hayes City, no more Klondike, but there was this jungle with its rivers of lard and "savage" inhabitants. Remington's Pullman coverage makes it clear that

here, he felt, was a chance to fight again the glorious racial wars of the nation's past. A cavalry officer standing off a horde of ethnic enemies, Lieutenant Sherer assumes the defiant gaze and posture of the aristocratic English Americans in *The Last Stand*. Like earlier frontiers, Chicago had become a place to develop Anglo-Saxon masculinity. "And this country is that for which our fathers fought!" exclaims an American officer, surveying the city in "Chicago Under the Mob." "I suppose . . . we will have to fight some for it ourselves."[55] The resultant violence, as Richard Slotkin has argued, will be regenerative; it will restore civic order and, in a larger sense, the order of things: the untrammeled dominance, evinced through martial action, of the Anglo-Saxon race.[56]

In his Pullman reporting, as we have seen, Remington envisioned limited violence: "Eventually this unlicked mob will have to be shot up a little, or washed, before it will get into a mental calm."[57] In his fantasies, however, he imagined a far worse kind of killing. "You cant glorify a Jew," he wrote to his friend Poultney Bigelow in 1893. "I've got some Winchesters and when the massacreing begins which you speak of, I can get my share of 'em and what's more I will. Jews—injuns—chinamen—Italians—Huns—the rubish of the earth I hate." In "The Affair of the ——th of July," a fantasy about what would have happened "if the mob had continued to monkey with the military buzz saw," the narrator recounts the fate of strikers taken prisoner: "I saw some of the execution of those hundreds of prisoners next day, but I didn't care to see much. They piled them on flat-cars as though they had been cordwood, and buried them out in the country somewhere. Most of them were hoboes, anarchists, and toughs of the worst type, and I think they 'left their country for their country's good.' Chicago is so thoroughly worked up now, and if they keep with the present attention to detail, they will have a fine population left."[58] Remington's genocidal fantasy suggests not only a form of eugenics ("they will have a fine population left") but also a way for Anglo-Saxons to reassert their martial heritage in a frontierlike mode of killing: the piled bodies conjure those of the Sioux at Wounded Knee, where Remington was a correspondent and Gen. Nelson Miles, the commander in Chicago, was the officer in charge.

A Captive Audience

Not everyone, however, was a saber-wielding cavalryman. Most Anglo-Saxons would come to know the race's martial spirit not by drawing guns on immigrants or Indians but by contemplating the *image* of this kind of violence—in magazines, galleries, and

living rooms. Here, then, was a problem: Was not the den- or gallery-bound examination of art about as distant from the activities of an intrepid soldier as one could imagine? By asking people to look at art, of all things, Remington seemed to perpetuate the enervated social behavior that the example of the Old West was meant to oppose. We are back to the man on the park bench, for it is this sort of viewer that Remington's pictures—simply by virtue of being pictures—tend to evoke.

At least one Remington painting expresses this conundrum. In 1907 he submitted to *Collier's Weekly* a picture for reproduction called *The Quarrel*, an image of two cowboys about to draw their guns while others, surprised and horrified, look on (fig. 86). One man, his back to us like the painter-figure in *Apache Medicine Song*, twists and flinches; directly beyond him, three other cowboys recoil and exclaim, one man peeping from behind another as though from a hiding place. The painting contains a goodly amount of Remington's characteristic violence: the scene, he wrote, "promises to be sangu[in]ary in about 1/8 of a second."[59] Yet *Collier's* initially rejected the painting, returning it to Remington, who then abandoned it six days later, reflecting in his diary: "The boys in cow picture too ladylike—so we gave it up."[60] He did not say specifically what was ladylike about his cowboys, but it might have been the central cowboys' purely spectatorial role—they do nothing—as well as the fearful spectatorship in which they engage.

Coming between the two opponents, the four central cowboys occupy the customary position, in such pictures, of the damsel in distress—the woman over whom the combatants fight. These figures are important, I think, because they allow us to see in one of Remington's paintings his conception of the ladylike viewers of his works. In this respect, he adopts the realist convention of placing a feminine spectator inside—the cringing woman in Thomas Eakins's *Gross Clinic* is a famous example—as a suggestion that only a man can steadily contemplate the work. *The Quarrel* was not a success, either for the editors of *Collier's* (who eventually published it in 1909) or for Remington (who in the last month of his life was trying to sell it through a friend, frame included, for a mere five hundred dollars).[61] This was perhaps because the dramatization of viewing in *The Quarrel* was at odds with his more typical dramatization of his viewers as the kind of violent, virile men whom the paintings depict.

The stoic demeanor of Remington's figures and the violent actions in which they engage were meant to be imparted—as a kind of lesson—to his viewers. One of Remington's closest friends in New Rochelle was the nationally famous playwright Augustus Thomas, the author of the *Century* magazine reminiscence on the artist. Thomas wrote his plays according to his carefully articulated belief in theories of a col-

lective racial unconscious.[62] In the novel version of *The Witching Hour*, a play that I shall discuss in the next chapter, one character succinctly expresses Thomas's views: "He saw before him a picture of the sea. Over the deep bosom of the water were billows, waves, and individual crests separating into drops of blown spray. To his mind's eye these drops and crests and waves and billows symbolized the objective minds of individuals, families, communities, and peoples sprung from an ocean of infinite mind of which each was part and with which each and all had possible communication."[63] The playwright could tap this infinite mind in the audience, Thomas believed, through subliminal appeal to racial ideals, such as "ideal heroism, ideal sacrifice, ideal charity, ideal mercy, ideal justice."[64]

For Thomas, the best way to make the appeal was with images. His plays stress the visualization of themes and motifs, rather than their explanation, because, he wrote, "the eye 'deals . . . more directly' with the mind than does the ear."[65] If successful, a dramatized emotion will be "'understood and sympathized with' by all the spectators who possess the instinct from which the emotion was called into existence."

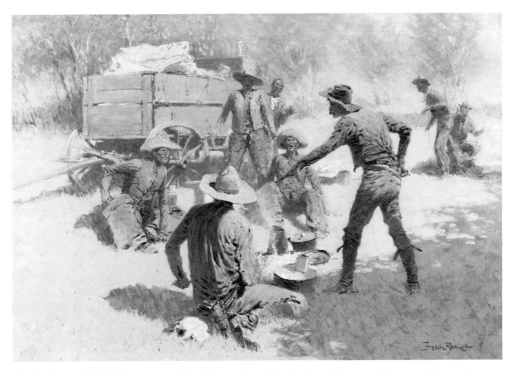

86. *The Quarrel*, 1907. Oil on canvas, 27 × 40 in. National Cowboy Hall of Fame and Western Heritage Center, Oklahoma City, Oklahoma.

87. *Missing,* 1899. Oil on canvas, 29½ × 50 in. Thomas Gilcrease Institute of American History and Art, Tulsa, Oklahoma.

These spectators will feel a "like, though feebler, emotional state" to the state dramatized in the play.[66] The result, Thomas believed, will be an antidote to the spectators' enervation. As Ronald Davis explains it, "According to Thomas, emotions can die from atrophy, the threat of which was greater in his time than ever before, he thought, because of the monotonous and specialized nature of work in the modern industrial system. Thus Thomas considered drama and other art forms as extremely valuable for stirring and consequently 'keeping the emotions malleable.'"[67] The mind is a muscle; like a muscle it must be kept limber and strong. Those works of art that do not keep the racial mind strong, Thomas believed, failed to assist the evolution of the race and would even cause the race to regress. Art should be a moral force.

As a close friend, one who had even suggested to Thomas the idea of writing a play about the West (the play was *Arizona,* one of Thomas's two most popular works), Remington was almost certainly acquainted with Thomas's theories of a collective unconscious and the primacy of the visual image as a means of subliminal communication. Remington's advice to a writer friend, "Take note of the little things which make pictures in the mind of the reader," sounds like one of Thomas's own directives about artistic method.[68]

If Remington's paintings convey not only concepts of ideal heroism and ideal sacrifice but also a belief that the display of these ideals will produce a like, though feebler, emotional state in their viewers, there was always the possibility—perhaps a strong one—that turn-of-the-century viewers of Remington's paintings might stop and stare and, if anything, become more aware of their *lack* of resemblance to the figures than of their identity with them. The gallery, after all, was hardly the place to rediscover "the old hunting days and forest nights of [one's] remote and forgotten ancestry." In one painting Remington tries very hard to merge gallery and frontier. *Missing*, made in 1899, shows a procession of Indians leading a lone trooper to a fate indicated by the buffalo skull at the lower right (fig. 87). His arms are tied behind his

88. Anonymous, *Nincompoopiana*, 1880. Reproduced in *Punch's Almanack* (December 13, 1880).

89. *Missing* (detail).

back; he is led by a rope around his neck. Yet, like the trooper in *Captured* (see fig. 14), he remains notably calm in a perilous situation. What is also interesting about him is the way his pose—arms behind the back; eyes front; a forward movement that almost appears not to be movement at all—corresponds closely to conventions of showing viewers before paintings (figs. 88–89).

Remington submitted *Missing* to the annual exhibition of the National Academy of Design in 1899, hoping that it would win him full membership (he had been an associate member since 1891).[69] It makes sense, then, that this particular picture would tend to thematize viewing within itself, for rarely had Remington made a picture that he knew would so certainly be officially viewed and judged. He wanted and showed a captive audience. The conflation of frontier trooper and austere gallery-goer is interesting for another reason, however. It is as if the picture presents a claim that having one's hands tied behind one's back is not far, after all, from simply placing them there, connoisseur fashion, in a leisured stance of perusal. Yet the attempt to evince an indissoluble identity between trooper and viewer, a synonymous masculinization of soldiering and gallery-going, called attention to the fracture that it was meant to close. The placement of a viewer-figure amid the sagebrush and alkali reinforced the discrepancy between gallery and desert. Even Thomas, in his formula for such correspondences, tellingly used the word *feebler* to characterize his ideally invigorated audience—as though the condition of empowerment evinced the enervation, or feebleness, that it was meant to dispel. What was missing in the civilized space of the gallery or theater was not only the trooper but the ideal heroism and ideal sacrifice that he represented. The very title of Remington's picture concerns absence. If there was any identity between soldier and gallery-goer, it was not a common stoic bravery but a common helplessness. Hands tied, each is a victim of superior forces.

Give Me Your Hand; Lend Me Your Ears

The attempt to identify the male viewer with his primitive soldierly counterpart suggests an anxiety, in the urban world where Remington lived, about identity itself. Only by asserting the viewer's bond with the trooper could the civilized act of viewing art be recuperated as part of a distinct Anglo-Saxon self. Sitting leisurely on a park bench meant having lost touch with one's primitive ancestry and therefore with one's identity. This brings us back to *The Last Stand* (see plate 5)—more particularly, to a drawing of hands that Remington made, probably after its completion.

The drawing shows the hands of six figures (fig. 90). The top row, containing the one visible hand of the officer and the hands of the scout, labels them accordingly: "officer hand" and "scouts hands." A slippage occurs in the bottom two rows, where the hands are no longer identified as hands but simply in terms of their possessors: "right man," "dead man," and "wounded man." (The other pair of hands, at the middle left, is identified only by location: "left.") In these cases, the hands become synonymous with the entire figure—the part substituting for the whole—as "portraits" of the figures. Indeed, it is not difficult to imagine the drawing, given by Remington to a friend, as a kind of copy of the painting, for the deployment of the hands on the page roughly evokes the soldiers' positions in the painting. The attitudes of the hands—for example, the almost arthritically palsied fingers of the wounded man's left hand—convey as much of the figures' emotion and feeling as do their entire bodies in the finished painting. The hands are all that we need to see to understand the identity of the wounded man.

The focus on hands suggests that Remington's drawing is part of a period discourse emphasizing hands as markers of unique identity. In *Italian Painters* (1893), Giovanni Morelli offered a purportedly scientific method for establishing the authorship of Old Master paintings, then much disputed. Morelli believed that by focusing on the less significant details of a painting—ears, fingernails, hands—a viewer could discern the styles of individual artists. He reasoned that in the rendering of such details, artists would develop and repeatedly follow their own idiosyncratic style. Fra Filippo Lippi, for example, would portray hands in exactly the same manner in all of his paintings, and his work could be identified accordingly (fig. 91).[70] Like Remington's *Last Stand* sketch, Morelli's drawing substitutes a part for the whole; below a single hand is simply the name Fra Filippo Lippi—the hand is all that is needed to identify the artist.

Fingerprints also came to be incontrovertible marks of identity around this time. Used in the system of criminal taxonomy developed by Alphonse Bertillon in the 1880s, fingerprints not only helped classify a complex social space but also asserted that each person, including the taxonomists themselves, had a unique identity. In Couse's *Captive*, as we have seen, a lone bloody handprint marks the spot where Lorinda Bewly has placed her hand on the Cayuse chief Five Crows. Besides marking her resistance to and possible desire for her Indian assailant, the handprint, we can now see, stands for Bewly herself. In an era during which notions of traditional identity were being undermined, the hand is as much a marker of her uniqueness as the blood with which it is printed. In *The Last Stand*, the most idiosyncratic hand—in

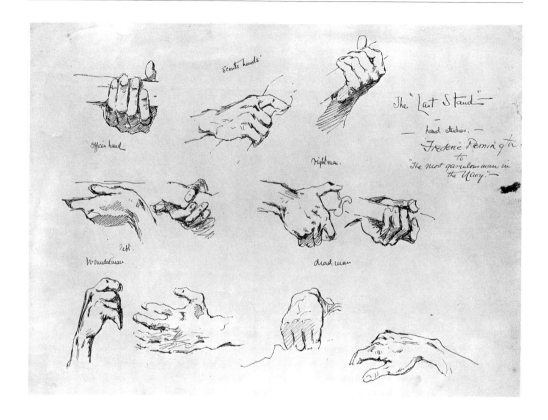

both the painting and the sketch—is that battered left hand of the wounded man. Almost dead, the man presses his left hand against the bloody wound in his stomach. Although we cannot see a handprint on his uniform, we can suppose a bloody mark very similar to Bewly's handprint on Five Crows's blanket. Like Bewly's handprint, this one detail in Remington's painting combines synonymous marks of identity: blood and hand.

The discursive interest in hands and marks cannot be understood apart from the practice of making art, along with the special claims of artists to possess unique identities. Morelli's hands help us to identify the unique style, or "hand," of different artists. Bewly's handprint, a pigmented mark superimposed simultaneously upon two pieces of fabric—Five Crows's blanket and the canvas on which the blanket itself is painted—is a comment on the unique identity of the artist making the mark. (The resonance between the proper nouns Cayuse, Crows, and Couse suggests in still other ways that the artist's identity is also intertwined with that of the Indian chief.) Finally, Remington's concentration on the hands of his *Last Stand* figures—hands that in four of six cases grip cylindrical objects not unlike the paintbrush itself—suggests

FRA FILIPPO LIPPI.

FILIPPINO.

ANTONIO POLLAJUOLO.

BERNARDINO DE' CONTI.

GIOVANNI BELLINI.

COSIMO TURA.

BRAMANTINO.

BOTTICELLI.

90. *Hand Sketch from* The Last Stand, ca. 1890. Ink on paper, 10 × 13 in. Private collection. Photograph courtesy of Kennedy Galleries, New York. *(opposite page)*

91. *Typical Hands,* 1893. Reproduced in Giovanni Morelli, *Italian Painters* (London: John Murray, 1900), 77.

that he coalesced his own artistic identity, his own virile artistic hand, with the identities of his heroic fighters.

Nor were hands the only parts of the body that registered unique identity. In "The Adventure of the Cardboard Box" (1893), Sherlock Holmes must explain why a woman, Susan Cushing, received a pair of severed human ears in the cardboard box of the story's title. Susan Cushing is one of three sisters—the others are the evil Sarah and the virtuous Mary. Holmes solves the mystery by noting that Susan's ears "corresponded exactly with the female ear" found in the box. It then becomes clear that the victim is her sister Mary. As it turns out, Jim Browner—Mary's husband—killed Mary and her lover, Alec Fairbairn, in a jealous rage. Blaming Sarah for "poisoning [his] wife's mind against [him]," Browner decided to send her the severed ears as bloody tokens of her meddling, except that he mistakenly sent them to Susan instead.[71] The membranous part of the ear, also called the labyrinth, evokes this maze of motivations and relationships. But it also represents the incontrovertible identity (in this case, family instead of personal identity) that allows Holmes to solve the mystery.

Yet hands and ears, in these examples, tend to recapitulate the anxiety about identity that they are meant to resolve. As a labyrinth, the ear evokes not only the

maze of Cushing family history but the chaotic urban environment of which this family history is a metaphor. The ear is a model of the winding city streets in which the crimes that Holmes must solve frequently take place. Holmes's ability to solve the crimes suggests, according to Steven Marcus, that the streets can be ordered, yet the icon of solution is an emblem of the cacophony in which the successful resolution of this one case is but as a pin dropping.[72] The very means of evincing identity—disembodied ears and hands—suggests that the only way to assert the body's identity was to fracture it or assert its absence. Identity in these representations is inseparably linked to death, as if one's identity could truly be known only in dying. How else to explain this mélange of broken fingers, severed ears, and bloody handprints? In *The Last Stand* the wounded man's hand, pressed flat against the uniform fabric, is almost its own print, auguring the vestige that will soon be the only mark of its presence. Like Doyle's story, like Couse's painting, *The Last Stand* eulogizes the identity that it asserts. All the examples tell us that the identity—in evolutionary terms, the identity between civilized Anglo-Saxons and their primitive forebears and consequently the identity *of* these civilized people—is indeed "missing."

Numerous tracking pictures also concern traced bodies and lost identities. Remington's *Trail of the Shod Horse*, painted in 1907, shows a column of Indians moving through a landscape thinly covered in moonlit snow (fig. 92). A vanguard of three Indians has stopped to examine a trail that informs them that another party has lately passed by. The standing figure, who dismounted to look at the trail, gives the sign of the shod horse, which is echoed by the mounted man to his right.

Remington's Indians interpret the track serendipitously. The sons of Serendippo, recounts Carlo Ginzburg, "meet a man who has lost a camel (or sometimes it is a horse). At once they describe it to him: it's white, and blind in one eye; under the saddle it carries two skins, one full of oil, the other of wine. They must have seen it? No, they haven't seen it. So they're accused of theft and brought to be judged. There follows the triumph of the brothers: they immediately show how from the barest traces they were able to reconstruct the appearance of an animal they'd never set eyes on."[73] The ancient legend, writes Ginzburg, suggests that hunters were the first storytellers, because they alone "knew how to read a coherent sequence of events from the silent (though not imperceptible) signs left by their prey."[74]

Although the tracking Indian appears throughout the literature of the American frontier—the improbable skills of James Fenimore Cooper's Uncas come to mind—the meanings of the motif were quite specific at the time that Remington was painting. The caption for one of Sidney Paget's "Cardboard Box" illustrations—an image of

Holmes, Watson, and a detective examining the ears of Mary Cushing and Alec Fairbairn—might just as well apply to Remington's Sherlock Holmes of a scout; the caption reads, "He examined them minutely" (fig. 93). Indeed the resemblance between the two images—each showing three figures staring at small bodily traces on a slightly tilted white ground—tells us that each picture is informed by a common discourse of solution: Holmes is an Indian, and the Indian is a detective. Remington's picture, like Doyle's story, is an attempt to solve, to make whole, a social world whose mysterious complexity resides in its fragmentation—a world that appears, like the ears in the box, as a series of disconnected marks and traces.

History, in *The Trail of the Shod Horse*, is similarly lost and fragmented. Like the Indians, Remington must decipher vestiges from the past, reconstruct a whole world from slight evidence. Although the reconstruction in all our examples is meant, on some level, to be a source of marvel—the tracking Indian, like Holmes, soothingly suggests that such a reconstruction is possible—*The Trail of the Shod Horse* leaves us with a sense only of thin wintry air. The picture concerns the absence, the invisibility, that it is ostensibly meant to fill. The snow, the night, the straggling column, the quality of dejection and stillness in the bowed head and slack form of the dismounted scout—these are in keeping with what greets us at the very front of the painting as a sign of loss: the tracks themselves. Above and beyond their status as vestiges, the tracks in *The Trail of the Shod Horse* metaphorically evoke passing time. Frozen, they look almost fossilized, suggesting that the presence for which Remington's Indians search is not nearby but almost prehistorically distant. Arranged diagonally across the front of the picture, the tracks evoke the evaporating maplike puddles of *A New Year on the Cimarron* (see fig. 22); their capacity to suggest a presence is as transient as the presence itself. As holes in the ground, they recall the crater-grave of *Fight for the Water Hole* (see plate 2).

Mostly, however, the tracks in Remington's painting evoke the fragmented body. The most defined track, fourth from the right, looks much like the ears that Holmes examines on the snowy board. All of the tracks, as roughly circular prints impressed upon a white ground, resemble fingerprints inked on a white page. The tracks are the cartography of a unique identity, yet the lead Indian's slack, dejected posture—and the picture's overall quality of elegy—bespeak their insignificance. Like the beaten hands of Remington's *Last Stand* sketch—like the various broken and vestigial bodies that we have examined—the tracks in the painting point to the absence of the historical body that they would help us reconstruct. In this way, the enterprise of historian and urban detective intertwine: each attempts to reconstruct wholeness—and thus a

92. *The Trail of the Shod Horse,* 1907. Oil on canvas, 27 × 40 in. The Philip Ashton Rollins Collection of Western Americana, Princeton University Library.

93. Sidney Paget, *He Examined Them Minutely,* 1893. Reproduced in Arthur Conan Doyle, "The Adventure of the Cardboard Box," *Strand Magazine 5* (February 1893).

sense of order—from fragments and vestiges. In each case, however, emphasis is on the gap between part and whole, between trace and body, suggesting that even the solution of the crime, or of the past, does not render whole what is irrevocably just a shred of evidence.

Written Down

If even indexical marks such as tracks—marks bearing an intrinsic relationship to the object they signify—betokened the loss of this object, one can imagine the feelings occasioned in this era by written language, with its merely abstract, socially agreed upon relationship to signified objects. Remington, especially toward the end of his career, had little faith in writing's power to recount the past. In 1905, for a special "Remington issue" of *Collier's Weekly*, the magazine invited him to write a brief statement concerning his career. The fascinating statement, "A Few Words from Mr. Remington," is worth quoting almost in full:

> From behind the breastworks of his big desk the editor is banging at me to write about myself. I find the thought very chilly out here in the garish light, but his last shot says, "If you don't, I will send a person to interview you, and he will probably misquote you." Quite so—one doesn't need that character of help when about to play the fool; so if you find the going heavy, gentle reader, camp here.
>
> I had brought more than ordinary schoolboy enthusiasm to Catlin, Irving, Gregg, Lewis and Clark, and others on their shelf, and youth found me sweating along their tracks. I was in the grand silent country following my own inclinations, but there was a heavy feel in the atmosphere. I did not immediately see what it portended, but it gradually obtruded itself. The Times had changed.
>
> Evening overtook me one night in Montana, and I by good luck made the campfire of an old wagon freighter who shared his bacon and coffee with me. I was nineteen years of age and he was a very old man. Over the pipes he developed that he was born in Western New York and had gone West at an early age. His West was Iowa. Thence during his long life he had followed the receding frontiers, always further and further West. "And now," said he, "there is no more West. In a few years the railroad will come along the Yellowstone and a poor man can not make a living at all."
>
> . . . The old man had closed my very entrancing book almost at the first chapter. I knew the railroad was coming—I saw men already swarming into the land. I knew the derby hat, the smoking chimneys, the cord-binder, and the thirty-day

note were upon us in a resistless surge. I knew the wild riders and the vacant land were about to vanish forever, and the more I considered the subject the bigger the Forever loomed.

Without knowing exactly how to do it, I began to try to record some facts around me, and the more I looked the more the panorama unfolded. . . . If the recording of a day which is past infringes on the increasing interest of the present, be assured there are those who will set this down in turn and everything will be right in the end. Besides, artists must follow their own inclinations unreservedly. It's more a matter of heart than head, with nothing perfunctory about it. I saw the living, breathing end of three American centuries of smoke and dust and sweat, and I now see quite another thing where it all took place, but it does not appeal to me.[75]

"A Few Words" is Remington's most explicit statement about his desire to document the Old West. On the surface, he seems confident in the ability of writing—a few words—to perform this documentation. There is apparently a sharp division between Remington's scene of writing and the historical scene that he describes. The piece opens with Remington reading a letter from his editor and then shifts to the young Remington's meeting with an old wagon freighter. (The editor's "banging" I take to be a reference to typing, which would suggest that Remington is not actually meeting his editor but reading a typewritten letter from him.) The sentence at the end of the second paragraph, "The Times had changed," signals this clean break between present and past, between writing and the world described. At the beginning of the third paragraph, we are transported effortlessly back in time to the campfire scene.

Yet the second paragraph also suggests that the two realms—present and past, writing and the world—are not as easily separated as the simple declaration "The Times had changed" would indicate. In spite of the shift into the past tense and the reference to Remington with words like *schoolboy* and *youth*, the second paragraph nonetheless evokes a librarylike or studylike setting: (volumes of) "Catlin, Irving, Gregg, Lewis and Clark, and others on their shelf." The setting is similarly evoked in a subsequent paragraph, where the old man has "closed my very entrancing book almost at the first chapter."

The confusion of present and past, writing and world, becomes particularly clear when the opening scene is read against the historical scene in Montana. In each scene Remington encounters another man (first the editor, then the old wagon freighter). Each man imparts disquieting information concerning the unwelcome intrusion of another party (first an interviewer, then the railroad). In fact, the editor's banged let-

ter, produced by a piece of machinery, is a prophetic instance—in the very first sentence of Remington's statement—of the technological intrusions that he disparages throughout "A Few Words." (The unwelcome interviewer also presages the "men already swarming into the land.") Finally, there is the odd sentence in the first paragraph that begins, "I find the thought very chilly out here in the garish light," which, as a description of Remington's scene of writing, resonates strangely with the scene in which the youthful Remington is illumined by a campfire (garish light) out in the presumably cold (chilly) night. As if to emphasize the connection, Remington ends his first paragraph by advising his reader—oriented at that point to the author's study or library—to "camp here." In the final paragraph, moreover, he assures the reader that a representation of the past will not preclude a representation of the present—that "there are those who will set this [an account of the present] down in turn and everything will be right in the end." The sentence epitomizes the confusion of past and present scenes throughout "A Few Words."

No one can be certain to what degree Remington unconsciously incorporated the imagery in his library or study into his historical narrative. But it is fair to say that Remington's historical subject here is to some extent a representation of the scene where it was written.[76] Remington literalizes this assimilation when he describes the method of his historical documentation: "I began to try to record some facts around me."

The kind of representation of the scene of writing in "A Few Words" was not unprecedented in Remington's work. A *Harper's Weekly* story that he wrote about his friend Julian Ralph, published in 1894, explicitly confuses outdoors and indoors, the world and the scene of writing: "His travels for the Harpers have made the United States and Canada Mr. Ralph's study-room. As it were, Tacoma is the mantel-piece, Colorado is an easy chair, Florida is a picture on the wall, Montreal is a bookcase, and New York city is a desk."[77] In *John Ermine*, Crooked Bear's cabin, or "den," in the mountains contains "a table and a chair made with an axe, and in one corner some shelves, equally rude, piled with brown and dirty books." The den—fully imaged as both a cave and a library—adumbrates the dominance of the scene of representation in "A Few Words."

For Remington, there is no such thing as a world outside writing. Written words betoken the loss, not the presence, of a directly perceived world. At one point Crooked Bear is teaching John Ermine how to read English: "The two waded carefully across the lines of some well-thumbed book, taking many perilous flying leaps over the difficult words, but going swiftly along where it was un-seasoned Saxon."[78] Reading is like crossing a body of water. *Wad[ing]* and *going swiftly along* imply

moving through water or else the movement of water itself. Indeed, when we reach the end of the first clause, we are surprised that the word there is *book* and not *brook*. In this context, "taking many perilous flying leaps" conjures the stones in such a b(r)ook and thus amounts to still another reference to moving through water or a waterway. Thus the word *passage* has a double sense. The point of the passage seems to be to illustrate the unavoidably represented quality of the world. Crooked Bear teaches Ermine to read not so much that he may perceive the world but that he may perceive that the world itself is a text, made of books and not brooks.

The same theme seems to prevail in "A Few Words from Mr. Remington," a piece that openly evokes writing in its title. Remington's sentence of dejection, "The old man closed my very entrancing book at the first chapter," states the impetus behind and the failure of his first trip west. The impetus: the entrance to the West is entrancing—there is nothing like seeing something for the first time. The failure: through "Catlin . . . and others on their shelf," Remington had entered and been entranced with the West *before* ever going there; he can only "sweat along the tracks" of earlier artists and writers. In such moments, "A Few Words from Mr. Remington" reads almost as a knowing parable of the way "realistic" representation of any kind is fated to follow a worn trail of earlier images. Such representation, Remington suggests, is paradoxically dependent on its ability to conform to what has come before. The real is a matter of staying within the ruts. To go to the West, then, was a matter of closing a shelf full of books in order to see an extratextual world only to find, tragically, that no West existed apart from the books. A set of words does not magically present a world to us, hence Remington's discouraged, cynical tone. "If you find the going heavy, gentle reader, camp here," he advises, permitting us to discontinue reading the merely written story that follows.

In spite of the suggestion of a rut, a path, and thus a lack of immediacy, the track was an indexical mark. Perhaps this is why Remington tried, in some of his art, to bestow writing with the quality of a track. The tracks in *The Trail of the Shod Horse*—dark marks, each one slightly different, arranged on a white ground—evoke writing. They evince Remington's desire to make a kind of alphabetical footprint and thus let some of the track's indexicality rub off on written language. In his "initial pieces," Remington did combine pictographs and abstract language (fig. 94). The initial pieces, which other artists also employed, depict human bodies or their accoutrements in the shape of letters of the alphabet. The purpose, again, was perhaps to heal written language of artifice, redeeming it through reference to a type of writing, the pictogram, that more intimately embodies its referent. The nostalgia in Remington's pictures is not only for the past but also for a primitive kind of representation—

one alleged to correspond directly to the objects of its description, one that might make direct sense of the world.

Yet the pictogram itself, as we might expect, also came to signify the arbitrariness of its connection to the world. In "How the Alphabet Was Made," one of Rudyard Kipling's *Just So Stories* (1902), set in "Neolithic" times, a little girl and her father devise an alphabet based on pictures of natural things. An open-mouthed carp feeding at the bottom of a stream, for example, becomes the model for the capital letter *A* (fig. 95). Kipling's story for children is an attempt to think back to the beginnings of language—to a time when written signs were derived organically from the world around—yet, tellingly, this original system of marks is no less arbitrary than "civilized" alphabets. There is a resemblance, but no intrinsic relation, between the letter *A* and the carp's mouth. The entry into language thus signifies an estrangement from other people, as well as from the world. "These picture-sounds are rather a bother!" the little girl says at one point, finding a message her father has left her. "Daddy's just as good as come here himself and told me."[79] Even pure pictograms seemed arbitrary and distanced from events. In "How the First Letter Was Written," the preceding tale in *Just So Stories*, told before the little girl and her father have devised an alphabet, the girl's seemingly straightforward pictographic explanation of an event causes a huge misunderstanding.[80] Even at its most primitive, writing is doomed to artifice.

In Remington's time, moreover, pictograms came to signify the danger of the primitive. In "The Adventure of the Dancing Men" (1903), another Sherlock Holmes story, an English aristocrat is alarmed by his wife's terrified reaction to a series of seemingly childish scribbles that begin to appear, graffiti-like, around his estate. Brought in to explain these "dancing men," Holmes quickly deduces that the scribbles are a coded alphabet. Eventually he cracks the code, determining that the aristocrat, Hilton Cubitt, and Elsie, his wife, are in grave danger. Abe Slaney, a criminal from the Chicago neighborhood where Elsie grew up, is in love with her and has come to England to take her away from her husband. With the dancing men—a pictographic alphabet that he, Elsie, and others in their working-class neighborhood learned as children—Abe has scrawled such messages as "ELSIE, PREPARE TO MEET THY GOD" (fig. 96). Holmes solves the puzzle too late, however: Slaney has shot Hilton dead and seriously wounded Elsie.[81]

In Doyle's story the pictogram is linked to the danger of racial and class primitives. The dancing men, as stick figures, evoke some of the libidinal energies coursing through Abe Slaney. A swarthy urban criminal—Sidney Paget's illustration casts him as a dark-complected figure not unlike Remington's searching Spaniards (see fig. 85)—Slaney is himself cast as primitive. Like the graffiti that he scrawls on Cubitt's prop-

erty, he is a "straggling, irregular character."[82] The dancing men also suggest that the world of which Slaney is part—an urban space teeming with poverty and crime—has its own codes of representation, codes that require an expert intermediary like Holmes to make intelligible.

Finally, Doyle's story suggests that this urban world is lethal to an old aristocratic order—represented by Hilton Cubitt—without the means to understand it. Cubitt is a kind of Gulliver; large, dull, slow, amiable, earnest, he allegorizes an English aristocracy losing its pretense to authority. Besieged, like Remington's soldiers in *The Last Stand*, Cubitt sees but cannot interpret the fateful writing on the wall. Like Belshazzar, he needs an intermediary, a Daniel, who appears in the form of Holmes to declare in so many words, "Your kingdom has been found wanting." The hieroglyphic dancing men suggest a kingdom threatened not only by class enemies like Slaney but by racial enemies as well; it is not too far, perhaps, from the dancing men to the African tribespeople who were frequently rebelling against British colonial rule.

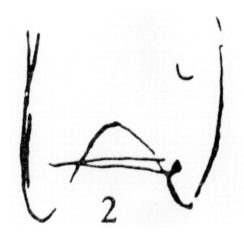

94. *Untitled ("Initial Piece")*. Reproduced in *Harper's Weekly* 42 (April 1898): 727.

95. Rudyard Kipling, *Untitled (Letter* A *in the Shape of a Carp's Mouth)*, 1902. Reproduced in Kipling, *Just So Stories* (New York: Macmillan, 1902; reprint, New York: Penguin, 1987).

96. Sidney Paget, *Dancing Men*, 1903. Reproduced in Arthur Conan Doyle, "The Adventure of the Dancing Men," *Strand Magazine* 26 (December 1903).

(Slaney's appearance in Paget's illustration evokes images of the Sudanese Mahdi, who until his death in 1898 had been the best known and most feared of England's enemies in Africa.) Hilton Cubitt's unease is like that of Burroughs's Lieutenant Charpentier in the African jungle: "It's bad enough," Cubitt tells Holmes, "to feel that you are surrounded by unseen, unknown folk, who have some kind of design upon you."[83]

Pictograms like the dancing men, Doyle's story suggests, are not a viable option for an embattled aristocracy nostalgically searching for a return to origins. Instead, pictograms conjure, and are a product of, the primitive social orders, banging at the gate, whose threat has sent the ruling class on a search for lost origins in the first place.

The irony of Doyle's story is that at the end Cubitt himself becomes a kind of pictogram. In the climax Cubitt lies dead on the floor, his prone form resembling the dancing men themselves. His "huge frame lay stretched across the room" like the bodies stretched across the plains in Remington's *What an Unbranded Cow Has Cost* (1895), one of his illustrations for Wister's "Evolution of the Cow-Puncher" (fig. 97).[84] The painting depicts the aftermath of a dispute over an unmarked cow; the cow, its legs tied together, surrounded by branding irons, is at the lower center, just to the left of the one figure still standing. Here Remington follows Wister's description: "The tied animal over which they had quarreled bawled and bleated in the silence."[85] What is most interesting about the picture, however, is not so much the adherence to Wister's narrative as the interest in the kind of pictographic marks that we have been discussing. On a light and markedly flat piece of ground—extending miles and miles, we feel, into the distance—Remington arrays a series of dark straggling characters. The forms of the cowboys, splayed upon the ground, evoke the absent mark—the brand itself—over which the fighting has taken place. Branded upon the surface, they are a kind of pictographic writing—a compilation of brandlike initial pieces placed on a suggestively pagelike piece of ground.

Yet the figures do not imply the presence of what they describe; on the contrary, as pictograms, they imply the death of their object. Included in a story that eulogizes the frontier, *What an Unbranded Cow Has Cost* is about the death of an older, aristocratic way of life—a death not so much forestalled as betokened by writing such pictographic figures. The attempt to bring something back is further acknowledgment of its loss. Remington's picture links documentation to the forces that kill the last cavaliers. Indeed, although not everyone besides the central figure is dead, the picture is much like *The Last Cavalier* (see fig. 66), another illustration for Wister's article, a similar image of one live figure surrounded by others fading and gone. The lone gun-toting figure, like Hilton Cubitt, is another doomed remnant from an earlier time.

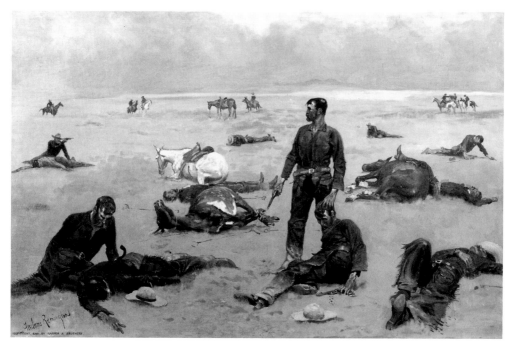

97. *What an Unbranded Cow Has Cost,* 1895. Oil on canvas, 28¹⁄₁₆ × 35⅛ in. Yale University Art Gallery. Gift of Thomas M. Evans, B.A., 1931.

The very means at Remington's disposal to record the Old West—the halcyon days when male Anglo-Saxons were in control—were themselves tokens of the modernity whose fragmentation and lack of direct experience had occasioned the desire to preserve the past in the first place. The pictogram—a drawing of a dead body signifying a dead body—somehow, in its subject, called attention to the absence that it would recover. Written language was not a means to describe present fragmentation and former wholeness so much as an icon of modern fragmentation. (For Remington, painted marks also came to seem as arbitrary and death dealing as the written marks that we have just discussed—a fact that I shall explore in my last chapter.) The central figure in Remington's painting holds his pistol near the cow; by showing the man brandishing it in this way, Remington equates the gun and the brand, as though the attempt to make one's mark ineluctably caused the death of what one would record. Remington's figures are as much written as shot down, prone upon that papery ground.

Chapter Four / Dark Thoughts

If we open our eyes instantaneously upon a scene, and then shroud them in complete darkness, it will be as if we saw the scene in ghostly light through the dark screen.
—William James, *The Principles of Psychology* (1890)

In all of Remington's pictures the shadow of death seems not far away.
—Unidentified newspaper clipping in Remington diary, December 11, 1909

In 1905 Remington posed for a photograph in his New Rochelle studio (fig. 98). He stands, hands in pockets, before a massive fireplace, his confident, proud pose that of a prosperous city-dweller. If he at all resembles the military men he painted, it is because his stance is that of a soldier at ease. His great weight—reportedly close to three hundred pounds when the photograph was taken—also testifies to his leisured prosperity: at the time, "a man's success . . . could often be measured by his girth."[1] Yet our attention keeps focusing on the mantel, where a skull stares out—a second, less prosperous face.

In one obvious sense, the skull was nothing more than an artistic prop. Remington had retrieved it from a cliff dwelling; sometimes his art required a skull. In another sense, it indicates Remington's late-life preoccupation with death. In 1909 his friend Homer Davenport gave him a copy of *The Quatrains of Abu'l Ala* (1903), a selection of morbid verses by the medieval Arabian poet. One of the 126 quatrains suffices to give a sense of the character of the book:

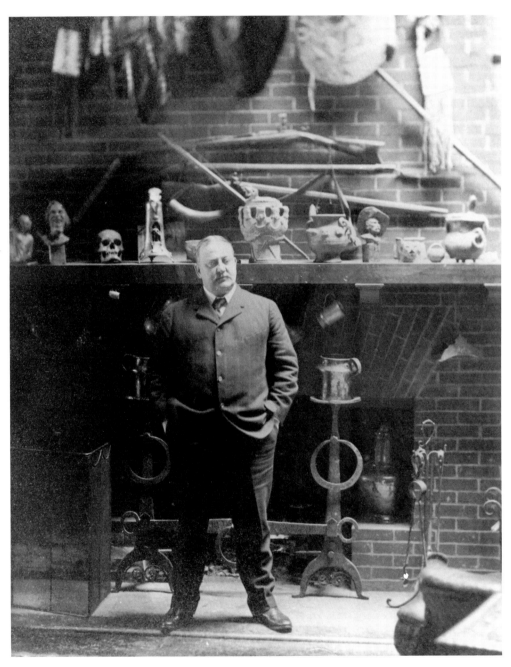

98. Anonymous, *Frederic Remington in His New Rochelle Studio,* 1905. Frederic Remington Art Museum, Ogdensburg, New York.

Tread lightly, for a thousand hearts unseen
Might now be beating in this misty green;
 Here are the herbs that once were pretty cheeks,
Here the remains of those that once have been.

On April 27, 1909, Remington recorded another of the quatrains in his diary:

Thou art the creature of thy Present Age,
Thy past is an obliterated Page;
 The rest that follows may not see thee more,
Make best of what is worst and do not rage.[2]

The skull is not marginal but central in the studio photograph. It is angled slightly toward the artist; its features naturally echo Remington's own, and the curve of the jaw is also picked up by the gathered folds at the bottom of Remington's jacket. The two large andirons, with their feet astride exactly like Remington's own, repeat his standing posture; yet their circular mid-portions, backed in black, echo the skull's staring eyes, asserting the extinction of the eyes' own fires. The andirons thus formally connect Remington and the skull. The equivalence suggests that even the most comfortable person is haunted by death. If we ourselves stare at the photograph long enough, the skull, with its petrified grin, comes to possess some of the evident self-satisfaction of the artist, as though it were the purpose of this strange image to announce that another, bonier ease always lurks within corpulent contentment: a Death as satisfied and comfortable as oneself.

Then again, Remington knew that his weight was as much a memento mori as the bones it concealed. "We who are about to Dine—salute thee," he wrote in his diary on April 7, 1909. On the one hand, his voracious eating and drinking were typical for a man of his class and background. For sheer historical evocation of turn-of-the-century eating habits, let me quote a passage in Atwood Manley and Margaret Manley Mangum's *Frederic Remington and the North Country.*

At that time, thick homemade soup began a meal, after the men had lingered in the barroom. Several meats were offered after a fish course of bass or trout or salmon. Fred loved ham and other forms of pork, although a beef roast sometimes satisfied him. Fowl was always on the menu, especially St. Lawrence County turkey. Fresh vegetables were available in summer, of course. Corn was drenched in butter or served "cream-style." Tomatoes and lettuce could be had in their season, with homemade sweet-sour "boiled" dressing—made with eggs, vinegar, and

sugar—or mayonnaise. Cabbage and potatoes were North Country staples. Fred smothered a heap of salted, buttered mashed potatoes with gravies made of pan juices, plus fat and flour to thicken them. Parker House rolls, named for the famous hotel that first served them, had become popular, and other hot breads were part of every meal, with plenty of good North Country butter to coat them. North Country people liked deep-fried fritters in a side dish, to be set afloat in a pool of golden maple syrup. Some people liked a dab of an ice or a lemon sherbet (made with county cream, of course) to clear the palette between courses. Desserts included berry pies and hearty cakes, all confected with plenty of butter or lard, sugar, eggs, and cream. Ice creams were becoming popular: real cream an essential ingredient in the egg custard base, all frozen in hand-turned freezers. Cheddar cheese was a northern New York must to accompany pie. Fred always promised himself that he would stay "dry" on these Ogdensburg trips, and some-times he did.[3]

On the other hand, there seems to have been something morbid—"We who are about to Dine"—about Remington's constant overindulgence in food and alcohol. "The body had been splendidly cultivated and came to be unwisely overtaxed," Thomas wrote of his friend.[4] Remington's diaries often refer to the ill effects of overeating, poor eating, and drinking, although he continued to indulge. In 1909 alone: "In evening awful dyspepsia—liver of yesterday"; "cooked 4 fried eggs for breakfast—they gave me indigestion"; "fried eggs for luncheon and dyspepsia all afternoon"; "I ate too much"; "ate cod-fish cakes—dyspepsia—hell"; "ate beef twice today experimentally"; "we ate cold bacon for lunch and got dyspepsia"; "had too much scotch"; "raw—walked—feel rocky—whiskey tore my guts out."[5] In the studio photograph, death does not follow prosperity; instead, prosperity is a kind of death. The water hole swal-lows the cowboys.

If Remington was preoccupied with his own death, he was also acutely conscious of the dead past. The skull in his studio evoked not just the artist's mortality but the lost world that he gluttonously tried to restore in his art. Although Remington's initial sense of historical preservation was nothing more complicated than to try to make direct records of what he saw, he later adopted a far more melancholy attitude. "Cow-boys? There are no cowboys! Indians? They became extinct thirty years ago!" he reputedly told the interviewer Perriton Maxwell in 1907. "Here was Remington, of all men," Maxwell continued in his purple way, "asseverating with indubitable earnest-ness the non-existence of the very things which he has taught us to expect from him, to accept as literal transcriptions from real life." Maxwell then quotes himself asking

Remington: "And the West of the roistering cow-boy and the hate-inflamed Indian exists then only in your imagination and in your pictures—ghosts conjured up from the past?"[6] Remington answers the question in his diary on January 15, 1908: "There are no people such as I paint." They were all dead or else they existed purely in memory, where the flitting, insubstantial forms were as good as ghosts. On his last trip west, in Wyoming in September 1908, Remington looked at the modernizing western towns, places expanding like himself, and remembered the fictive characters whose stories he had illustrated earlier in his career: "Wolfville, Ranson, and others all dead now."[7] "It may be someone else's America but it isn't mine," he wrote in his diary on March 8, 1908, describing the state of the nation. "I guess mine is about dead anyway and I seem to be doing an obituary."

It is not surprising, then, that Remington's pictures represent the insubstantiality of the past. They do so, however, in different ways. For much of his career, Remington made sharp-detailed, "realistic" pictures like *The Last Stand* (see plate 5)—works clearly inspired by the art of such military painters as Jean-Baptiste-Edouard Detaille, Alphonse-Marie de Neuville, and Jean-Louis-Ernest Meissonier.[8] Yet the pictures seemed artificial, despite all their crisp and exacting realism. "It was of a military picture by Meissonier," writes Royal Cortissoz, "that Degas remarked that everything in it was of steel except the swords."[9] In our imagination, were we to run our hands over the objects depicted in *The Last Stand*, we might as soon cut our fingers on the troopers' outlines—the yellow stripes of their trousers, say—as on the swords that evoke the troopers' steely resolve: such is the picture's sharpness of execution. Paintings like *The Last Stand* fail to convey the poetic sense of loss, of evanescence, that occasioned their making. The transition was too abrupt between mournful proclamations like Remington's "There are no people such as I paint" to pictures in which the West appears brand new. The desire "to bring the past to life"—to restore it to our eyes as if we were there—paradoxically renders it more remote. The truth of boots, buckets, and canteens turns out to be not much of a truth after all—something that other period figures, including Joseph Conrad, recognized: "To snatch, in a moment of courage, from the remorseless rush of time a passing phase of life, is only the beginning of the task."[10]

Conrad's alternative was to "disclose the inspiring secret" of the rescued object—to reveal, through intense scrutiny, the object's inner essence. This kind of spiritual or deep recording might then safely preserve the past. For Fredric Jameson, the great example of this method is Stein's butterfly collection in Conrad's *Lord Jim* (1900). "The passion for butterfly collecting," for Jameson, allegorizes Conrad's "vocation to

arrest the living raw material of life, and by wrenching it from the historical situation in which alone its change is meaningful, to preserve it, beyond time, in the imaginary."[11] In some intangible way—felt more in the impulse behind the work than in anything visible within it—Remington's art betrays this same sense: a belief that if an object is beheld acutely enough—and if the record of this beholding is successfully transferred to canvas—the object will somehow exist for all time. It is as though the purpose of painterly inspection of the world were somehow to take that world away from itself—to render it with an acuity that would leave the original object of perception but a discardable shell. As the example of the widespread ethnographic portraiture of the era attests, once a subject was suitably represented and thus preserved—as in, say, Edward Sheriff Curtis's Indian photographs—the subject himself or herself became largely irrelevant, a husk whose identity, whose life, like that of Stein's butterflies, had been transferred into representation.

Another aesthetic strategy for arresting time was the less modernist, more allegorical linking of the present with the universal. In "Dante and the Bowery" (1913), Theodore Roosevelt admires the way Dante was able to take everyday figures from his time, people who would have been forgotten but for his poetry, and make them immortal via references to figures and events from the Bible and classical antiquity. The same immortalizing references, Roosevelt writes, were sadly absent in the writing of early twentieth-century Americans. "What one among our own writers," he asks, "would be able simply and naturally to mention Ulrich Dahlgren, or Custer, or Morgan, or Raphael Semmes, or Marion, or Sumter, as illustrating the qualities shown by Hannibal, or Rameses, or William the Conqueror, or by Moses or Hercules?" Such a recognition, for Roosevelt, would be a way "of penetrating through the externals into the essentials," of finding in the transient modern world what is "elemental in the human soul."[12]

Like other western artists from the time—I think in particular of George de Forest Brush's classicized Indians—Remington used this strategy. Above the mantel at his studio on the Saint Lawrence was an anonymous relief carving of a chariot—an artwork that allows us to see that Remington may well have considered the stagecoaches he painted in that very studio (*Downing the Nigh Leader*, for example; see fig. 126) as similarly classical vehicles. *Leaving the Canyon* (around 1894, Gene Autry Museum, Los Angeles, California), one of Remington's Tenth Cavalry scenes, is clearly derived from images of Christ's Deposition from the cross. John Ermine, similarly, is a Christ figure, who asks at one point, "God, God, have you deserted me?"[13] Commentators could see eternal symbolism in Remington's work, even where none per-

haps was intended. Of *The Sheep-Herder's Breakfast* (around 1897, location unknown), Wister wrote that Remington "has taken a ragged vagrant with a frying pan and connected him with the eternal. The dog, the pack-saddle, the ass, the dim sheep in the plain, those tender outlines of bluffs and ridges—it is Homer or the Old Testament again; time and the present world have no part here!"[14]

Yet for the most part Remington was not interested in the strategies described by Conrad or by Roosevelt and Wister. If there is a core, an essence, to his paintings, it is often the hollowing effects of the temporality that such pictures would ostensibly eradicate. In place of Conrad's desire to render the things of the world in an almost sculptural way—with an acuity that would make them, as it were, almost graspable by perception—Remington was drawn late in his career to a kind of representation that privileged the diaphanous, the evanescent: not the plenitude but the emptiness at the core of an object.

This compulsion took a couple of forms in Remington's art. *Fight for the Water Hole* (see plate 2), as we have seen, is one of his great images of passing time. In the bullet cartridges strewn around the foremost figure, the artist literalizes his compulsion to show within the work the discardable shell or husk of the "real" event that the picture ostensibly preserves, as though it were his desire to let us know, in this and in the painting's other temporal metaphors, that a work of art could not transcend but only depict the ruin of its subject.

Then there are the late paintings, particularly the moonlights, where Remington investigates more complex attitudes about memory and the perception of time. The moonlights, with their all-over green hues, relate to the work of such tonalist painters and photographers as Willard Metcalf and Edward Steichen. By placing objects in a softening haze, divesting the world of some prosaic specificity, tonalist artists attempted to convey an aura of mood and mystery. Yet the aura indicates only partly (if at all) a haze within the world itself; instead, tonalist pictures show an interest in simulating mental worlds—in portraying the world not as it exists out there but as it is created within the mind itself.

Metcalf's *May Night* (1906), for example, shows a lone woman in white approaching a classical building at night (fig. 99). The building emits a faint light from its doorway and a lower-story window, yet easily the brightest parts of the picture are the four columns brilliantly illumined by the moon. The moonlight makes the building seem ethereal, dematerialized, almost floating in space, an apparition akin to one of Thomas Cole's cloud castles. The illumination proceeding from the object itself, the picture tells us, is but a tiny part of its glow; objects come into being primarily by

99. Willard Metcalf, *May Night,* 1906. Oil on canvas, 39½ × 36¾ in. Corcoran Gallery of Art, Washington, D.C. Museum Purchase, Gallery Fund.

100. *With the Eye of the Mind,* 1908. Oil on canvas, 27 × 40 in. Thomas Gilcrease Institute of American History and Art, Tulsa, Oklahoma. *(opposite page)*

means of a projected light. In this case, the moonlight comes from the space of the woman, as if it were a simulation of her own powers of mental illumination. To be lured into the past, the picture suggests, is to be seduced by the temple of one's own mind.

As viewers, we do not simply observe this phenomenon. As much as we are meant to observe the white-clad woman from afar, like Van Helsing and company watching the "dim white figure" of the dead Lucy Westenra glide to her tomb in a London churchyard, we are also meant to identify with her.[15] She stands before the building's facade, as we stand before the picture. A path of shadows extends from our space to hers, providing a further connection. Her activity of conjuring—of seeing the world in the mind—is somehow an illustration of our own powers of projected consciousness: the scene itself simulates a world beheld, not out there, but in our own minds. The chief trope of this projected consciousness, in this and other tonalist pictures, is the unifying haze cast over the scene—a metaphor for the way the world is altered by the beholding consciousness. The woman herself, painted thinly enough to be a ghost, flits through the picture as evanescently as a thought in the mind.

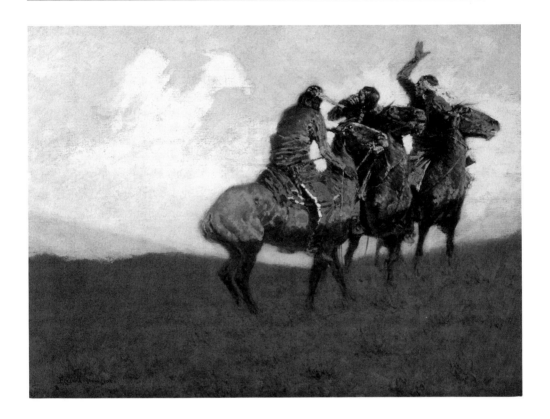

With the Eye of the Mind

Although not a moonlight scene, Remington's suggestively titled *With the Eye of the Mind* (1908) shows a similar interest in mental worlds (fig. 100). Three Indians regard a cloud in much the same way that Metcalf's woman beholds the classical building. The Indians are puzzled: one scratches his chin, another reflexively raises his hand, perhaps in imitation of the form he beholds. The picture is Remington's take on a well-known convention. In "An Essay on Man" (1733–34), Alexander Pope expressed the formula: "Lo! the poor Indian, whose untutor'd mind/Sees God in clouds, or hears him in the wind."[16] It is not clear, however, exactly what Remington's Indians see in their cloud.

One answer is that they see a bird. The rightmost part of the cloud resembles a bird's neck, head, and beak. The hump behind this head would then not be a hump at all but a raised wing. The one Indian's raised hand duplicates a beak and wing as might the hand of a person making shadow projections on a wall. Then again, the bird's head repeats the angle and shape of the horses' heads. The hump behind the

head, in this reading, becomes a rider, its form closely matching that of the back-turned Indian at the left; the cloud head and beak match the head of that rider's horse. Whether as bird or horse and rider, the cloud augurs the Indians' doom. The bird, perhaps meant as a predatory American eagle, is one and the same as the form of the riders it seems to pursue. We notice that the "real" Indians are framed against the sky that they contemplate, as though their apotheosis were taking place before our eyes. Remington's picture, on its most basic level, is, then, another evolutionary image of civilization replacing doomed savagery.

Yet, as much as the Indians regard a future fate, they also regard a past glory. Like the forms in the billowing smoke of Russell's *Last of His Race* (see fig. 29), Remington's cloud warrior harks back to a heroic past. Indeed, the cloud form occupies virtually the same heightened space, seen dramatically from below, as the proud central warrior of *The Snow Trail* (see plate 6), another painting from late in Remington's career. Like the future, the past is hazy, literally cloudy; it is even more difficult to conjure here than in *The Trail of the Shod Horse*. Whereas those Indians could at least rely on indexical vestiges—marks left by the object they would reconstruct—the Indians in this other clue-finding painting must, as the title suggests, rely purely on their imaginations.

The task relates to Remington's own enterprise as a history painter. As we saw in Chapter 1, he told the interviewer Maxwell in 1907: "I am now painting the things which I saw as a boy or things which I heard about from men who took an active part in the stir of the early West." Like the Indians in his picture, Remington had to reconstruct the past from his own mind. But what was the nature of this cloudy past? Perhaps it was something he could almost hallucinate into being. *With the Eye of the Mind* repeats the composition of an illustration that Remington made ten years earlier for one of his *Harper's Monthly* stories, "How Order No. 6 Got Through, as Told by Sun-Down Leflare." *Un I Was Yell Terrible* (1898) depicts Leflare, a fictive half-breed army scout on whose exploits Remington based several stories (fig. 101). As Leflare attempts to deliver a military order, he becomes delirious with cold and hunger, at one point imagining that Sioux warriors are in pursuit. "'Pears lak my head she go plumb off," Leflare tells the narrator in his characteristic dialect: "I was wave my gun; was say I not afraid of de Sioux. Dam de Sioux!—I was fight all de Sioux in de worl'. I was go over de snow fight dem, un I was yell terrible. Eet seem lak all de Sioux, all de Cheyenne, all de Assiniboine, all de bad Engun een de worl', she come out of de sky, all run dar pony un wave dar gun. I could hear dar pony gallop ovar my head. I was fight 'em all, but dey went 'way."[17]

101. *Un I Was Yell Terrible.* Reproduced in Remington, "How Order No. 6 Got Through, as Told by Sun-Down Leflare," *Harper's Monthly* 96 (May 1898): 849.

Eye of the Mind, much like *Un I Was Yell Terrible*, features Indians engaged with a ghostly horse and rider in the sky. We might imagine, therefore, that the Indians in the later painting are to be understood as having hallucinated the cloudy shape. Yet their examination of the cloud is far more detached; they seem to believe in its reality less than Leflare does in the reality of the ghostly horsemen over his head—perhaps because what they see is less a hallucination than a memory. "Whenever a past experience is recalled clearly we have what is termed a 'memory picture' of it," wrote James H. Hyslop, vice president of the American Society for Psychical Research, in his book *Borderland of Psychical Research* (1906). "This means that our minds represent to themselves the past in simulacra or like forms to those which were originally experienced. In vision we have a distinct picture before the mind's eye of what we have seen."[18] For Hyslop, such memory pictures never seem real. They "can be easily distinguished from the real sensations from which they come. There is no judgment or illusion of reality in them." He continued: "If I remember or imagine the mountain or valley that I have seen, I do not *see* it before me, in any proper sense of the term 'see,' but I think of it in its place, though I imagine or picture in the mind the form and appearance of it as it was seen in reality; but I do not in any way mistake what I thus picture for an object now presented to me, as I should do in an illusion or hallucination."[19]

If, then, the Indians in *Eye of the Mind* examine a memory picture—an image of what once was—we might ask what the nature of this hazy picture is. On a literal level, it is outside their consciousness: it is a cloud. It exists prior to and apart from them; the act of mind to which the picture refers is merely the matter of deciding what this preexistent "real world" shape resembles. On a more figurative level, however, the cloud occupies the space and perhaps some of the function of a giant thought balloon; as such, it seems to evoke workings inside, rather than outside, the mind. The cloud is the objective correlative, as it were, of the Indians' thoughts.

This interpretation would be in keeping with how Remington's contemporaries understood the workings of memory. "Suppose I think of the Creation, then of the Christian era, then of the battle of Waterloo, all within a few seconds," wrote William James in *The Principles of Psychology* (1890). "These matters have their dates far outside the specious present [James's term for the few seconds to a minute just passed, of which humans can conceive *direct* memories]. The processes by which I think them, however, all overlap. What events, then, does the specious present contain? Simply my successive *acts of thinking* these long-past things, not the long-past things themselves."[20] Memory, for James, occurs in the specious present. Likewise,

Remington's *With the Eye of the Mind* seems concerned less with an actual past, even in its vestigial state, than with the present-tense operations of memory. Unlike the footprints in *The Trail of the Shod Horse*, the cloud in *Eye of the Mind* bears no indexical relation to the past; it is an emblem of mental operations conducted without even the slightest real-world historical vestige (something like a footprint) upon which to work. The past is reduced to something that lives purely in the mind.

Our only way of noting time beyond the few seconds of the specious present, according to James, "is by counting, or noticing the clock, or through some other symbolic conception." He continues: "When the times exceed hours or days, the conception is absolutely symbolic. We think of the amount we mean either solely as a *name*, or by running over a few salient *dates* therein, with no pretence of imagining the full durations that lie between them. No one has anything like a *perception* of the greater length of the time between now and the first century than of that between now and the tenth. . . . There is properly no comparative time *intuition* in these cases at all. It is but dates and events, *representing* time; their abundance *symbolizing* its length. I am sure that this is so, even where the times compared are no more than an hour or so in length."[21] For James, to say that an event took place long ago—to set it in the past—does not involve a perception or intuition of passing time. Even to count off passing time—to show the clock ticking as primitive masculinity recedes into the past—relies more on a symbolic conception than on one of James's privileged perceptions or intuitions. Only dwelling on the act of memory might invest the past with a sense of its evanescence: "*The original paragon and prototype of all conceived times,*" wrote James, "*is the specious present, the short duration of which we are immediately and incessantly sensible*" (James's italics).[22]

There is no evidence that Remington knew William James's work. Yet Remington's late pictures, so concerned with passing time in its various permutations, share affinities with James's writing on memory and temporality. After an earlier career spent evoking the past, first, in crisp and, as it were, "new" detail and, second, in such symbolic conceptions as the clock, bullet shells, and shadows in *Fight for the Water Hole*, Remington entertained an altogether different and possibly more compelling imagery of temporality, evident in *Eye of the Mind*. He seems to have asked himself, What if I were to render the past *in terms of* the specious present—in terms of fleeting thoughts? What if I were to show what we see with our eyes closed? Then presumably the past itself would be invested with the fleetingness of thought, as though it were evanescing at a discernible rate. Time would no longer be a conceptual but an intuited entity in art. I would no longer show the long-past things themselves but my acts of thinking these long-past things.

Memory was Remington's chief subject in the last few years of his life. Indeed, to the extent that his art concerned the evolutionary themes outlined in Chapter 1, memory—in particular, racial memory—was a thematic preoccupation his entire career. Theories of evolution were, by definition, based on durational concepts of time—except, in this case, with the few seconds of the specious present elongated to cover the millions of years over which creatures had evolved. In *The Last Cavalier* (see fig. 66), Remington's cowboy possesses within himself the spirits of the long-dead horsemen who travel at his side. When London's dog Buck "pointed his nose at a star and howled long and wolflike, it was his ancestors, dead and dust, pointing nose at star and howling down through the centuries and through him."[23]

Yet, of all the work that Remington did in 1906–9, it is his nighttime scenes that most evoke the sense of memory. The night in *Apache Medicine Song* and in other moonlights, such as *Night Halt of the Cavalry* (fig. 102; plate 7), acts as a hazy screen through which we see the figures. The figures so beheld might be thought of as simulations of a hazy past world, as though it were this world itself, apart from the consciousness of the beholder, that was gradually disappearing. But Remington's pictorial

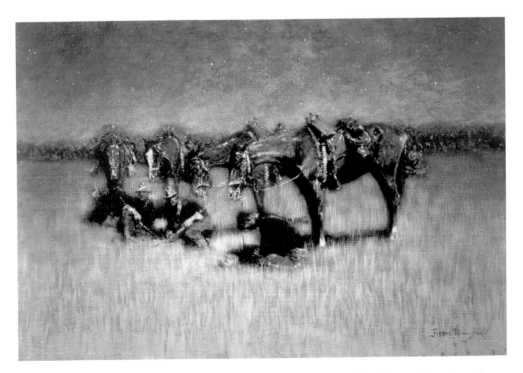

102. *Night Halt of the Cavalry,* 1908. Oil on canvas, 27 × 40 in. Private collection. Photograph courtesy of Gerald Peters Gallery, Santa Fe, New Mexico. See plate 7.

effects resonate more with conventions for showing the past (dis)appearing *in the mind*.

The sense of evanescence in Remington's nocturnes—the sense of figures dissolving even as we look at them—relates perhaps to conceptions of the fleetingness of thought more than to conceptions of the fleetingness of the past itself. Mental duration, as James describes it, is filled with loss and vanishing: "With the feeling of the present thing, there must at all times mingle the fading echo of all those other things which the previous few seconds have supplied. Or, to state it in neural terms, *there is at every moment a cumulation of brain-processes overlapping each other, of which the fainter ones are the dying phases of processes which but shortly previous were active in a maximal degree. The* AMOUNT OF THE OVERLAPPING *determines the feeling of the* DURATION OCCUPIED" (James's italics and capitalization).[24] Remington's nighttime scenes, with their hazy figures seeming to disappear even as we behold them, evoke James's analysis of the evanescent phases of thought. It is as if, beholding the figures through the misty darkness, we are seeing "the dying phases of processes which but shortly previous were active in a maximal degree." For James, moreover, the workings of the brain are a nighttime world: brain processes are always "in either a waning or a waxing phase."[25]

Thoughts, like the moon, glow and fade in a constant cycle. Although many of Remington's moonlights, *Night Halt of the Cavalry* included, rely on the illumination of a fully waxen moon, the obscurity of the figures paradoxically connotes an image on the wane. It is as though the brilliant illumination in Remington's moonlights exists only to proclaim its fleetingness—as though the figures are brought into view only to portend their fading. In this manner, these pictures simulate the dynamics of thought as someone like James understood them. Dramatically lit, yet blending into their own shadows, the troopers wax and wane, glow and fade, at the same time.

The subject of *Night Halt of the Cavalry* augments this sense. Like many of Remington's late pictures, *Night Halt* emphasizes the figures' states of mind rather than their actions. Virtually everything is quiet. The horses are almost statuesquely still. Two of the men in the foreground appear to sleep. The other two, in the middle, seem to have noticed something outside the picture—particularly the figure second from the right, who appears to be rising, his weight on his left foot, to investigate whatever he has seen or heard. Yet even this gesture is muted and quiet. All in all, as many scholars have noted, it is a big step from Remington's early interest in cavalry charges and last stands to his late emphasis on quiescence.[26]

In *Night Halt* the figure closest to us epitomizes Remington's interest in states of mind. The man may be asleep; then again, with his head down and hat off, his hands

apparently clasped, he resembles a man in prayer. Whether asleep or in prayer, his pose is profoundly meditative; it is his state of mind on which we are invited to speculate. The entire scene could be an image of this man's mind, his thoughts or dreams, an emanation of his consciousness, much the way the cloud in *Eye of the Mind* seems to be an emanation of the Indians' thoughts. The trooper is at once set in the past—a part of the scene he dreams—and separated from the scene, an emblem of Remington himself, culling from his memory the things that he saw as a boy. The scene around and containing him is as ghostly as the cloud observed by the gesturing Indians in *Eye of the Mind*, themselves surrogates for Remington.

The prayerful figure evokes Remington in one other way as well. Bent intently over a flat ground, with one hand visible, and contained within an interior space (that afforded by the perfect sprung arch of the nearest horse, from front hooves to mouth), he resembles an artist hunched over an image (as well as a writer hunched over a page). In this respect, he is like the back-turned figure in *Apache Medicine Song*, also painted in 1908 (see plate 1). In other words, as much as the hand might appear to be clasped in prayer, it also reads as the hand of an artist working intently on a pictorial surface. When we take into account the meticulously worked surface of *Night Halt of the Cavalry*, with its shimmering prairie grass (made by dragging a lightly loaded brush vertically upon a dry underlayer), we see that close attention to surface was a crucial part of the construction of the picture. More specifically, the ground to which the artist-figure, praying as he paints, devotes his attention is an inky black shadow. The space before the artist-figure is a kind of meta-nocturne, a blackness within the overall darkness of the picture. In this other sense, the picture contains within itself an image of its creation. The inky image is, moreover, composed of the shadow of the artist-figure himself. Bending over his historical document, the artist-figure casts a shadow that not only colors his subject but quite possibly informs its entire appearance, so that what the artist paints is really only a projected image of himself. This detail resonates with the painting as a whole, which, as I have suggested, is an attempt to simulate Remington's consciousness rather than a world, a scene, imagined, however vestigially, apart from that consciousness.

Projections

This idea of projected consciousness brings us back to *Eye of the Mind*. For if the painting evinces an interest in the workings of the mind, it also evinces an interest in how these workings might be projected—that is, made visible, made palpable, outside

the mind. In the diary entry for November 3, 1907, Remington mentions talking with his good friend Augustus Thomas about Thomas's new play, *The Witching Hour*. On December 1, Remington reported that the play was "a howling success" (which indeed it was; it was performed 212 times in New York in 1907 alone).[27] On December 5, given a box by Thomas, Remington and his wife went to see *The Witching Hour*, and Remington called it "a great play."

The Witching Hour was the most successful of Thomas's "psychic" plays. Its plot embodied the playwright's wide knowledge in the field of psychical research—a knowledge augmented by Thomas's friendship with Hyslop, the vice president of the American Society for Psychical Research. The play concerns a murder. In a Louisville gambling house run by the hero, Jack Brookfield, Brookfield's godson—a young architect named Clay Whipple—kills a man who had been tormenting him with a cat's-eye, a semiprecious jewel of which Whipple has an unnatural fear. During the trial it emerges that the prosecutor, Frank Hardmuth, hates Whipple; Hardmuth is in love with Viola, Whipple's fiancée. Things look bleak for Whipple, who is being defended on the grounds that the cat's-eye made him temporarily insane. Then a break occurs. After meeting with the elderly and kind Justice Prentice, a firm believer in psychic powers, Brookfield discovers that he himself can influence others to do as he thinks. Brookfield gives several demonstrations of his powers, notably by influencing the sequestered jury to find on Clay Whipple's behalf and, afterward, by causing Hardmuth to drop a derringer with which the vindictive prosecutor had intended to shoot him. "You can't use that gun—you can't pull the trigger—you can't even hold the gun!" Brookfield tells Hardmuth, focusing on the villain with eyes "like two burning coals" (fig. 103).[28]

The Witching Hour illustrates Thomas's studied belief that thought is dynamic. As Brookfield says, "Every thought is active—that is, born of a desire—and travels from us, or it is born of the desire of some one else and comes to us. We send them out or we take them in—that is all."[29] Behind this idea is Thomas's belief that human beings are united by a universal collective consciousness—the "ocean of infinite mind," symbolized in the play by the seascape above Brookfield's mantel.

Not only did Remington enjoy Thomas's play, but, we remember, he loved Du Maurier's *Trilby*, a tale replete with its own kind of dynamic thought. The book contains the original Svengali—a gifted and evil Jewish musician capable of hypnotizing the heroine. "But all at once," recalls one character, explaining how Svengali made the tone-deaf heroine the most famous singer in all Europe, "—pr-r-r-out! presto! augenblick! . . . with one wave of his hand over her—with one look of his eye—with a

103. *I'd Like to Know How in Hell You Did That to Me!* Reproduced in Augustus Thomas, *The Witching Hour* (New York: Grosset and Dunlap, 1908).

104. George Du Maurier, *Au Clair de la Lune*. Reproduced in Du Maurier, *Trilby* (New York: Harper and Brothers, 1894), 319.

word—Svengali could turn her into the other Trilby, *his* Trilby—and make her do whatever he liked . . . you might have run a red hot needle into her and she would not have felt it" (fig. 104).[30]

It is not surprising, then, that *Eye of the Mind* betrays an interest, if not in hypnotism per se, then at least in forms of dynamic thought. If the cloud is a metaphor for thought, the three Indians all think the same thing; of one mind, they know what each other thinks. Because we can see their thought, we are allowed to read their minds; it matters little whether the thought of the Indians' ghostliness originated with us or with the Indians, for what Remington's picture seems to demonstrate is the "infinite mind" that links all human beings to one another—that allows us to know one another's thoughts. "That Eye of the Mind hit me very hard—," the North Country novelist Irving Bacheller wrote to Remington; "[there is] something terribly true in the lift of those hands, in the turn of those heads."[31]

This sense of reading the thoughts of another has several implications. First, there is a "1984" quality to the notion of dynamic thought—a quality that Thomas himself made explicit in his curtain speech on *The Witching Hour*'s opening night. His friends, he told the audience, "have long been accustomed to regard their private minds as parks in which there might be neither prohibition nor policeman; but if, as scientists assert, a malignant and destructive thought of mine, like a circling Marconigram, affects, first my family, then friends, then acquaintances, before it finally filters impotently to its finish, I want to know it; and if, after twenty years of fairly intelligent investigation, I believe that it is so, I feel it is my duty as a dramatist to state it."[32] *The Witching Hour* itself dramatizes a character's repentance for just such a malignant and destructive thought: Brookfield assists Hardmuth over the border after Hardmuth has been charged with a murder because Brookfield fears that his own private thoughts—he had wished the murdered party dead—had transmitted themselves to Hardmuth. A second implication of thought reading, the notion of benignly influencing another—of transmitting good thoughts to those previously unable to think them—resonated with the contemporary endorsement of colonialism. Preparing to hypnotize one of his black servants, Brookfield acknowledges misgivings about invading "the personal domain of another soul." Here we detect the ambivalent feelings of the playwright, a Bryan supporter, on the subject of colonialism. Yet, almost like Roosevelt himself, Brookfield immediately goes ahead, convinced he can do some good: "Brookfield felt that a darky boy's sub-conscious territory could not but be improved by the squatter immigration of a white man's volition, and especially when the filibusterer came to eject a Voodoo usurper."[33]

But let us return to the relation between dynamic thought and the action in Remington's late paintings. The three Indians are much like Thomas's Brookfield in terms of their special powers of visualization. "Brookfield had one mental quality that distinguished him in a degree from most of his fellows," wrote Thomas in the novel version of *The Witching Hour*, published in 1908. "His power of visualization was greater than theirs. Such ideas as were capable of graphic representation he saw in pictures; ideas that might not be so represented he saw in diagrams."[34] The Indians, too, see their ideas in projected pictures. Moreover, Brookfield, a picture collector, is an "artist"—a maker of pictures. In the same way, *Eye of the Mind* seems to connect imaginative activity—the power of visualization—to the work of the artist. The cloud at which the Indians stare seems simultaneously a projection—a mental image—and an actual image, a kind of meta-picture installed within the picture as a whole. (Indeed, the cloud, seen in profile, is markedly two dimensional, as though Remington

wished to underscore its purely pictorial qualities.) The effect is to suggest that mental projection and picture-making are one and the same thing—that the artist's act might metaphorically be understood as a projection of consciousness onto the canvas.

Another Remington painting from 1908 has decided affinities with *Eye of the Mind*. In *The Stranger* a lone figure on horseback stares at a distant firelit camp (fig. 105, plate 8). Imperfectly in the distance we (and presumably the horseman) can see three figures (one crouching, one sitting, and one standing). They stare at the stranger just as the stranger stares at them. Like the three Indians in *Eye of the Mind*, the lone figure stares at a flat white object in the distance. There are many ways to understand this action. On the most basic level, the picture concerns a drama of identification: Is the stranger friend or foe? True to the manner of Remington's late pictures, *The Stranger* leaves this question undecided. In another way, however, *The Stranger* resonates with theories of dynamic thought—and its application to painting. "The pictures of you don't come just when I want them to come, especially in the dark," Clay Whipple tells Viola, confiding to her his own acute powers of visualization. "In the dark sometimes they form like the views from a magic lantern. They glow strong and vivid, and then fade into the black, and then when I lie down at night that effect sometimes repeats and repeats until I've had to light the gas in order to go to sleep." "Pictures of me?" Viola asks. Whipple replies: "Pictures of my work or anything that's been in my mind a good deal during the day, and sometimes pictures of things that I can't remember having seen before."[35] Like the nighttime projections of Clay Whipple, like Metcalf's classical building, the distant camp seems an emanation of the lone figure's consciousness: at once an image of his thought and a projection of that thought into the world at large. Further, the distant wagon that constitutes the stranger's "projection" is notably paintinglike. It is partly a flat canvas. It is also remarkably rectangular, perfectly ruled on the right edge and neatly squared off on top. Like a painting, the wagon is also propped up at a right angle to the ground. The stranger scrutinizes the camp as might an artist a canvas. Like *Eye of the Mind*, *The Stranger* seems to link mental projection and picture making.

It does so, moreover, in ways that perhaps owe unconsciously to film. Clay's description of his own projections—that "they form like the views from a magic lantern"—suggests affinities with movie images, but so, too, does the action of *The Stranger*. The "screen" of the wagon, dramatically lit in the surrounding darkness, beheld by the foreground viewer, pointedly, though unconsciously, recalls the interior of a movie theater. Many movies were already being made by this time. In 1910 alone, more than two hundred westerns were produced.[36] Remington himself disgustedly

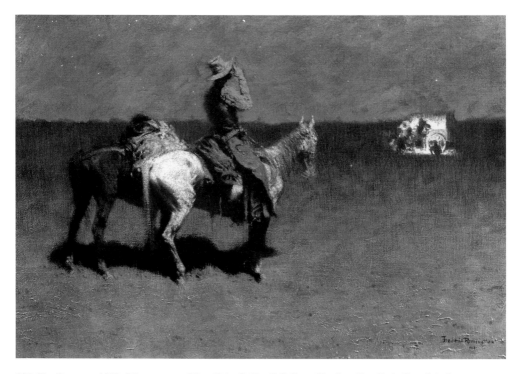

105. *The Stranger,* 1908. Oil on canvas, 27 × 40 in. Caldwell Gallery, Manlius, New York. See plate 8.

regarded movies as purveyors of an inauthentic West. We have seen that he thought Kinrade, his Indian model, "acts tongue bred and dresses western actor fashion." Yet in view of the cinematic quality of *The Stranger,* it stands to reason that Remington's primary metaphor for mental projection was derived unconsciously from the paradigm of cinematic projection.

Ghosts

Perhaps Remington used the cinema metaphor in part because of the ethereal quality of a filmed image. (Elsewhere I have argued that Charles Russell's 1915 picture *When Shadows Hint Death* represents movie projections as a kind of shadowy, ghostly imagery.)[37] The distant camp in *The Stranger,* as much as it seems projected *upon* a physical screen, also appears to hover, apparitionlike, over the prairie, like a floating, disembodied light. The cloud form in *Eye of the Mind* more fully resembles an apparition, for it hangs ghostlike in the air, just like Sun-Down Leflare's hallucinated Sioux warriors. In fact, many of Remington's contemporaries not only found ghosts fascinat-

ing but also conducted the study of otherworldly phenomena for the first time according to empirical methods. In "Phantasms of the Dead," a chapter in *Human Personality and Its Survival of Bodily Death* (1903), Frederic W. H. Myers attempted to dismiss folkloric conceptions of ghosts and offer a more scientific definition: "Instead of describing a 'ghost' as a dead person permitted to communicate with the living, let us define it as a *manifestation of persistent personal energy*, or as an indication that some kind of force is being exercised after death which is in some way connected with a person previously known on earth."[38] This is another version of the concept of dynamic thought, but this time the dynamism is not between two living people but between a living person and a dead one. *The Witching Hour* contains one such scene of otherworldly contact, in act 2, wherein Justice Prentice is seemingly persuaded by the ghost of his old sweetheart—who, as it turns out, was Clay Whipple's grandmother—to act on Clay's behalf.[39]

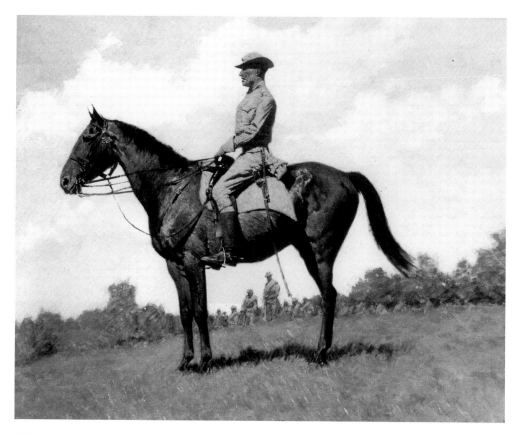

106. *Portrait of Major General Leonard Wood,* 1909. Oil on canvas, 40 × 40 in. West Point Museum, United States Military Academy, West Point, New York.

Recalling ritual walks together with Remington, Augustus Thomas talked about his friend's late-career move to landscape painting: "Nature . . . made more and more appeal to him, until in our Sunday-morning and weekday-evening tramps the tints of sky and field and road almost totally dislodged the phantom soldiery from the hillsides."[40] It is admittedly difficult to tell, in his mention of phantom soldiery, whether Thomas was not here imposing his own interests on Remington, yet Thomas's phrase does specifically evoke one of Remington's late paintings. The little-known *Portrait of Major General Leonard Wood,* one of Remington's few formal portraits, was made in September 1909 (fig. 106). It shows Wood, Remington's longtime acquaintance and one of the heroes of San Juan Hill, sitting on a horse. The portrait was the result of months of requests for Wood to visit and pose for Remington at the artist's new Ridgefield, Connecticut, home (to which Remington had moved in May 1909). Wood finally visited on September 4–6, 1909. "Sat up in library," Remington reported in his diary on September 5, "and Wood talked about the Island Empires—very interesting. He has been everywhere. Without in the least sensing it, Wood has been a king." Remington's equestrian portrait, evoking the genre of the king or nobleman upon his steed, correspondingly shows Wood not just as military leader but as ruler, lord of his surroundings.

What is most interesting about the picture, however, is not the mounted figure of Wood, shown parallel to the picture plane, but what takes place behind the general. There on the hillside, in the rectangle formed by the horse's legs, a group of faint figures, perhaps the prototypes for Thomas's phantom soldiery, appears in the semblance of a military maneuver. These distant, strangely evanescent figures are not simply unfinished; Remington announced the completion of the portrait in his diary on September 25 and again in a letter to Wood dated October 10, 1909 ("The portrait is done") and offered it for sale at two thousand dollars, making it easily the most expensive of the twenty-three pictures offered at his exhibition at Knoedler's in December 1909. Why might he have included these strange figures on the hillside?

On the most basic level, they transform the painting from portrait to battle scene. Whereas the predominant motif of the picture is Wood's static pose parallel to the picture plane, the soldiers imply that this pose takes place within the context not merely of a portrait but of a military action. Wood does not so much avert his face from the painter as direct it, we feel, toward some distant military occurrence. His is thus no longer the passive, objectified pose of the sitter but the active look of the general in the field. The background figures nonetheless have the quality of afterthoughts. Their presence is strange for at least three reasons. First, in a picture in which Remington

placed so much emphasis on working direct from his subject, waiting months and months until Wood could come to Ridgefield, these figures are odd in that they seem purely imagined. Although Wood was met at Ridgefield by two assistants who had brought his horses, neither Wood nor Remington mentions that these men posed as soldiers in the portrait; it seems likely, then, that the distant soldiers are inventions of Remington's imagination.[41] Second, their action—moving toward Wood and the viewer—makes tenuous sense within the context of the military situation they evoke. (Wood looks elsewhere than in the direction they move.) Third, although their position in the picture is distinctly tangential, the distant soldiers are also strangely emphasized. Enclosed by the meta-frame of the horse's legs, they stand almost directly at the center of the painting. Although our attention unquestionably falls first on Wood and his horse, the picture hollows out at the center, to make room for a second, simultaneously subordinate yet central image.

The subject of this second picture invites us to see through or *past* the present—that is, beyond the dull would-be indexicality of Wood posing on Remington's land—and back into a purely imagined realm. In this sense, the picture embodies Remington's late-life dictum: "These transcript from nature fellows who are so clever cannot compare with the imaginative men in the long run."[42] It is as though *Leonard Wood* rewrites itself from within, changing its subject from a transcript from nature to an imaginative creation, in order to validate this assertion. Perhaps Remington had this sense in mind when he called the picture "experimental" in a letter to a friend.[43] The imagined realm of the picture, in turn, is the past. The distant figures, bedrolls draped diagonally across their bodies, probably refer to the famous charge at San Juan Hill itself (and, for that matter, to Remington's depiction of it, which, like *Leonard Wood*, contains a lone mounted figure; see fig. 36 and plate 3). In another sense, they perhaps refer generically to Wood's and Remington's earlier and long-lost time in the West. "Talked Arizona and old times with Remington until late in the evening when we turned in," Wood wrote in his diary for September 4, the day before the portrait was begun. The soldiers in Remington's portrait are perhaps the spirits of this earlier time.

One particularly observant critic noted the morbidity of the paintings at Remington's 1909 exhibition: "Indeed, in all of Remington's pictures the shadow of death seems not far away. If the actors in his vivid scenes are not threatened by death in terrible combat, they are menaced by it in the form of famine, thirst or cold. One sees the death's-head through the skin of the lean faces of his Indians, cowboys and soldiers; his figures are clothed and desperately active skeletons, and even about his animals there is a strong suggestion of the nearness of the moment when their bones will

lie bleaching on the desert." The critic does not mention *Leonard Wood*, but even this picture, unenthusiastically singled out by another critic as a "'service' portrait," hints at its own ghostliness.[44]

The position of *Leonard Wood*'s phantom soldiers—in the distance, behind a mounted protagonist—recalls Remington's manner of evoking a ghostly presence not only in the previous year's *Eye of the Mind* but in *The Last Cavalier* (see fig. 66) as well. The disparity in *Leonard Wood* between a lone foreground horseman and a group of distant evanescent figures also pointedly evokes *The Stranger*. It is as though *Leonard Wood* offers us, in the guise of a dull service portrait, a sublimated rearticulation of Remington's late preoccupation with memory, distance, and death. The general and his horse, shown mostly in profile against the sky, poised on an undulating ground, evoke the Indians of *Eye of the Mind*. His lone presence as he stares into the distance recalls the lone cowboy of *The Stranger*. The only difference is that, unlike in these other "ghost" pictures, the main depicted figure is not a surrogate for Remington himself. Rather, as Wood stares to the left, he must experience something radically separate from what viewer and artist focus on. Military and artistic vision, at least in this painting, divide. *Leonard Wood*, seemingly such a strange departure from Remington's late-career interest in imagined or remembered themes, turns out to be just such a work after all: through Wood, past him, is Remington's favored phantom soldiery.

The late paintings most devoted to phantom imagery, however, are unquestionably the moonlights. Of *A Scare in the Pack Train* (1908), a nighttime scene in which a number of mules raise their ears at an unexpected sound, Remington wrote that his friend Joel Burdick "thought my 'Pack Train' was wonderful—ghost painting he calls it."[45] Apart from sudden bright appearances, like that of the illuminated wagon in *The Stranger*, virtually everything in Remington's nighttime scenes is ethereal. No figure escapes the day-for-night tonalist green that pervades the paintings. It does not finally seem accurate to say that we are meant to see through the green, as through a mist, to a "reality" that would be crisp and clear were we to behold it unobtruded; instead, Remington's figures seem like emanations of the surrounding green mist. To say that the figures appear "behind" the unifying green hues is not logical, for figures and green lie upon the same plane. Depth and surface are indistinguishable, as Royal Cortissoz noted in his review of the 1909 exhibition: "His gray-green tones fading into velvety depths take on unwonted transparency."[46]

The mist, as we have discussed, might be the mist of memory; and in some sense, the pictures do come across as simulacra of the artist's mental operations. Yet it is also

possible that the pictures signify a ghostliness that exists, at least in part, apart from the artist's mind. In "Phantasms of the Dead," Frederic W. H. Myers wrote: "It is theoretically possible that this force or influence, which after a man's death creates a phantasmal impression of him, may indicate no continuing action on his part, but may be some residue of the force or energy which he generated while yet alive. There may be *veridical after-images* . . . [figures suggesting] not so much 'any continuing local interest on the part of the deceased person, as the survival of a mere image, impressed, we cannot guess how, on we cannot guess what, by that person's physical organism, and perceptible at times to those endowed with some cognate form of sensitiveness.'"[47] The notion of veridical after-images, it is true, need not be linked exclusively to contact with the dead; in fact, it seems to describe some of the normal functions of sight. "As a rule," William James wrote, "sensations outlast for some little time the objective stimulus which occasioned them. This phenomenon is the ground of those 'after-images' which are familiar in the physiology of the sense-organs." James continued, in a passage that is extremely suggestive in terms of the moonlights: "If we open our eyes instantaneously upon a scene, and then shroud them in complete darkness, it will be as if we saw the scene in ghostly light through the dark screen. We can read off details in it which were unnoticed whilst the eyes were open."[48] The veridical after-image can be regarded as just another function of the mind's processing of the specious present. In this sense, once again, we might think of these paintings as imaginative transformations of the distant past—that is, the intellectually apprehensible past—into the more perceptual, more intuited realm of the specious present.

Nonetheless, another way to think of Remington's nighttime pictures is as evocations of some entity existing not purely in the artist's mind—that is, as conjurings of the dead. The late pictures certainly struck many, including Remington himself, as morbid. He specified that his moonlights be framed in black, which is how letters written about the dead can be framed, as though the pictures were communications about the dead.[49] It is likely that the reviewer who wrote about the presence of death in Remington's 1909 paintings was most impressed by the moonlights, of which there were at least four among the twenty-three works in the exhibition. Even the reviewer's phrase *the shadow of death* evokes these paintings. Yet "doing an obituary" is not a form of conjuring the dead; Remington's description does not satisfy as an explanation of the ghostly quality of the works. "These apparitions," wrote Myers, "are not purely subjective things—[they] do not originate merely in the percipient's imagination."[50] The space of Remington's moonlights is a space of conjuration; the artist's

medium, brought in these paintings to an "unwonted transparency," shares affinities with another kind of medium, then at the height of its popularity.

The Crystal Ball

There is no evidence that Remington himself participated in the then-popular activity of crystal gazing. But his diary refers to his wife Eva's interest in communicating with the dead. We also know that Eva returned to see *The Witching Hour* a second time, whereas her husband did not.[51] It is common knowledge among Remington scholars that Eva Remington attempted to communicate with her husband after he died; conjuring the dead was a popular activity at the turn of the century. Within the field of western art alone, any researcher comes across examples. Two years after Charles Russell died, his wife received a letter from George Sack, one of the artist's upper East Side patrons: "Well, Nancy, we went to a meeting on the 23rd & I talked with Charlie for about 3/4 of an hour," Sack wrote, "and I cannot tell you how happy I am because of it."[52]

The procedure was simple. "Let the observer gaze, steadily but not fatiguingly, into some speculum, or clear depth, so arranged as to return as little reflection as possible," prescribes Myers, in a passage worth quoting fully: "A good example of what is meant will be a glass ball enveloped in a black shawl, or placed in the back part of a half-opened drawer; so arranged, in short, that the observer can gaze into it with as little distraction as may be from the reflection of his own face or of surrounding objects. After he has tried (say) three or four times, for ten minutes or so at a time—preferably in solitude, and in a state of mental passivity—he will perhaps begin to see the glass ball or crystal *clouding*, or to see some figure or picture apparently *in* the ball."[53]

In a photograph, *The Crystal Globe* (around 1903), Clarence White violates some of Myers's rules (fig. 107). Although the globe is relatively free of reflections, it is not placed in a darkened space that would preclude other objects being seen through it. Yet White's is probably a knowing violation, for what the placement of the globe by the window allows him to do is simulate the apparitional powers of the globe. In the window behind the globe reside two dark and indeterminate shapes that mysteriously suggest a cloudy vision within the globe. The flowers, their curves echoing the shape of the globe, perhaps attest to the way its transient apparitions bloom and fade. Mapping the globe onto the window enables White to identify the globe as a window, a pictorial space, in which an observer might see strange conjurations. (In the way the window echoes the shape of the photograph as a whole, White aligns photography

107. Clarence White, *The Crystal Globe,* ca. 1903. Library of Congress, Washington, D.C.

itself, as a medium, with the conjuring powers of the windowed globe, suggesting that the photograph, possessed of its own visionary murkiness, is itself a window onto another world.)

The indeterminate shapes "inside" White's globe evoke the cloud bird-warrior of *Eye of the Mind*. Still more so, they suggest the cloudy, eerie figures in Remington's moonlights. The nighttime scenes go to great lengths to efface their own materiality; they seem nothing more than captured splashes of moonlight—Cortissoz's "unwonted transparency." Looking into them is like looking into the cloudy depths of a crystal ball. In *Night Halt of the Cavalry* (see plate 7), the prairie grass shimmers and glows in such an immaterial way that we wonder that the weight of horses and men is borne upon such an insubstantial ground. The figures float on the ground as if it were water or something even less tangible. It is as though it were Remington's desire that the materiality of the ground in this picture should not exceed the weight of a single one of the infinite blades of grass of which it is composed. Great care seems to have been taken, in other words, that the figures appear as though in a vision. Remington's word for this allover glow—a quality that he tried to impart to many of his late pictures, not just the moonlights—is significant: "vibrations." In his diary on October 3, 1908, he describes finishing *Cavalry Charge on the Southern Plains in 1860* (see plate 12): "Finished Cavalry picture. Quite [*sic*] vibrations and good times. I have always want-ed to be able to paint running horses so you would feel the details and not *see* them." The word becomes all the more interesting in view of Remington's diary entry for the very next day, where he mentions the telepathic investigations of Eva Remington and another party: "The women folks are all full of vibrations—psychic Boston high brow books." The proximity of these two uses of the word—once where it connotes the shimmer of Remington's paintings; next, impulses felt from beyond the grave—sug-gests all the more that we can understand the glow of the late paintings partly in psy-chic terms, as a sort of telepathic palpitation.

The kinds of vision that the crystal ball might afford, according to Myers, fall into four categories: visions of material objects in the same room, seen as with ordinary sight; visions of "bilocated" material objects, that is, real objects located beyond the percipient's normal field of vision ("travelling clairvoyance"); visions of immaterial apparitions, like those in dreams and hallucinations; and, finally, visions of apparitions located apart from the percipient's purely mental operations as well as beyond his or her vision.[54] Remington's conjurations, set in the past, belong to these last two class-es. What else were his late pictures if not conjurings of the dead?

The Telltale Dead Man

Remington's art, including some early examples, nevertheless betrays a dissatisfaction with merely conjuring the past—with simply beholding its figures and events. Instead, there is a desire expressed in some of his pictures for some sort of communication from the dead. In *Your Soldier—He Say* (around 1902), a cavalry column has stopped before the skeletal remains of a human being and a horse (fig. 108). A white officer and two Indian scouts investigate the partial human skeleton. A scout, bending down, holds up a spur, indicating that the skeleton is a white man's. Speaking the words of the title, the buckskin-clad scout translates the Indian's discovery for the cavalry officer. On a basic level, the grotesque scene relates to the "war is hell" paintings of Vasily Vereshchagin, the Russian military painter whose work Remington had seen and greatly admired at an American Art Galleries exhibition in November 1888. Vereshchagin specialized in scenes of military carnage, as in *The Forgotten Soldier* (1871; destroyed), a picture of a lone dead man swarmed over by a flock of carrion birds. In *Your Soldier*, Remington adapts Vereshchagin's brutal imagery to the American West, thereby promoting his early- and mid-career project to deromanticize the frontier: stark death was one of his key metaphors for the real.

On a more fundamental level, however, *Your Soldier* refers to the act of historical recovery. The skeleton lies on the ground and is inspected in much the same way as are the tracks in *The Trail of the Shod Horse*. Like the tracks, the skeleton is an indexical mark of a past event. So, too, is the spur, which occupies the midground between skeleton and officer. The officer is an analogue for the historian—that other inspector of a mute past. The artifact, the picture suggests, mediates between the historian and the dead past. It survives the past to become the basis for our understanding of it, existing as a spur to memory or insight. Yet the painter critiques even as he proclaims the artifact's restorative powers: there is something forlorn and anticlimactic about the bony little spur, as though the knowledge it afforded were itself small, not much of a recompense for historical loss. Further, the shape of the spur corresponds to the shape of the skull's grinning mouth. The correspondence implies that the picture offers a choice between two historical stories, two forms of communication from the dead, the one told by the artifact and the one told by the dead party.

The skeleton seems to have a say in proclaiming the man's fate. The skull grins and stares at the cavalry officer. The mouth is open. The extended right arm seems directed toward the officer (although we would be mistaken if we thought it was a genial friendliness for which his partiality is meant to stand). The man is a persistent

orator, still talking from beyond the grave. Certainly the person who captioned the image when it appeared in Remington's book *Done in the Open* (1902) had that impression. The writer, perhaps Owen Wister, told the story from the dead man's point of view:

> My horse is down with thirst, boys,
> The sun it rises higher;
> I wish they'd kill me first, boys,
> But they're building me a fire.
> My heart it is not broken, boys,
> But my lips are sealed with flame;
> Therefore I leave this token, boys,
> To tell you I died game.[55]

The suggestion of speaking is emphasized by the title of the picture. Although it is called *The Last Token* in *Done in the Open*, Remington listed the picture as *Your Soldier—He Say* in the back of his diary in 1908, counting it among the early paintings

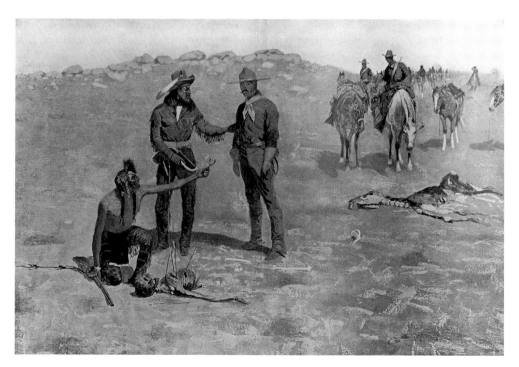

108. *Your Soldier—He Say,* ca. 1902. Reproduced in Owen Wister et al., *Done in the Open: Drawings by Frederic Remington* (New York: P. F. Collier and Son, 1902), n.p. Original destroyed. Thomas J. Watson Library, Metropolitan Museum of Art, New York.

that he had burned that year. Although we are to understand the sentence "Your sol-dier—he say" as having been spoken by the buckskin-clad scout, the actual "author" of the words is ambiguous. Is the interpreter translating the Indian's words, or is the "he" in question the skeleton itself, which, as we have noted, appears, with open mouth and gesturing hand, in an attitude of address?

Skulls and partial skeletons appear a number of times in Remington's art. But generally these motifs do not belong to the fabled motif of the animate skeleton, as seen, for example, in the works of Holbein and Bruegel. Remington's skulls, when they do appear, usually have all the visual interest and animation of rocks. To say that the unfortunate trooper in *Your Soldier* departs from this sort of prosaic inanimation is not, however, to say that he is as limber as one of Holbein's dancing skeletons; on the contrary, the eeriness of the figure seems to lie in the way he is neither animate nor inanimate, in the way his existence as a jumble of bones cannot be separated from our sense that he somehow has something to say.

The skeleton is reminiscent of the skulls in Vereshchagin's *Apotheosis of War* (fig. 109). Far from animate, the skulls in the painting nonetheless seem alive. Several of

109. Vasily Vereshchagin, *The Apotheosis of War,* 1871. Oil on canvas, 50¾ × 78¾ in. Tretyakov Gallery, Moscow.

the foremost skulls are among the most animated; their mouths wide and obscenely open, they seem to address the viewer. The yammering pile is alive and well. Each skull is a vivid contrast of blacks and whites; together, the skulls make a heap that vibrates with energy even as it seems inert. The similar inert vibrancy of the partial skeleton in *Your Soldier* also calls to mind the contemporaneous skeleton paintings of the Belgian artist James Ensor (fig. 110)—a comparison I propose not to claim "influence," but to evoke the macabre, almost Ensorian humor of Remington's seemingly straightforward image. The effect is to make *Your Soldier* not an obvious fable or fairy tale, as would be the case if it showed an animate skeleton, but to give it an authentic sense of showing a voice from beyond the grave: "Et in Arizona ego."

Your Soldier is one of several western paintings participating in a period discourse of ghostly voices. Henry Farny's famous painting *The Song of the Talking Wire* (1904) shows a solitary Indian leaning against a telegraph pole, listening to inscrutable messages click on the wires overhead (fig. 111). On one level, Farny's picture concerns the effects of technology on primitive peoples; unable to comprehend the telegraph, the Indian is as doomed as the buffalo whose skull sits on the frozen ground. On another level, the disembodied sound evokes voices from nowhere, from the grave, as though the poles were not so much technological as spiritual totems. (Although Plains Indians obviously did not have totem poles, I believe that Farny uses the telegraph poles as totems in his painting.) Listening to recorded or transmitted voices could entail a kind of ghostliness, as when a contemporary writer, G. S. Lee, in *The Voice of the Machines* (1906), likened hearing a phonograph record to listening "backwards" to the dead.[56]

Remington bestowed the skull in his studio with a "voice." On the skull's forehead is an inscription in Remington's hand (fig. 112):

> "Gnawed by the wolves
> And bleached by the sun,
> tossed about as the buffalos run."

We cannot read these lines, as we can the caption below *Your Soldier,* as having been spoken by the skull. The lines more properly read as having been written *about* the skull. Yet the lines describe events of which only the skull itself, as it were, could have direct knowledge. The placement of the words on the skull's forehead implies that they are the skull's thoughts, that the words are visible emanations of the skull's mind. In another sense, the inscribed forehead, as an expanse of white, has clearly and logically been conceived as a page. The metaphoric juxtaposition of bone and page—of

110. James Ensor, *Skeletons Warming Themselves,* 1889. Oil on canvas, 29½ × 23⅝ in. Kimbell Art Museum, Fort Worth, Texas.

111. Henry Farny, *The Song of the Talking Wire,* 1904. Oil on canvas, 22⅛ × 40 in. Taft Museum, Cincinnati, Ohio. Bequest of Mr. and Mrs. Charles Phelps Taft.

writing itself as in some way related to the dead—resonates with the way the dead were thought sometimes to communicate their thoughts: that is, through writing.

The kind of writing at issue here is automatic writing—the concept of a deceased person writing through the medium of a living person's hand. Myers's account of an incident from 1899 typifies descriptions of the procedure: A woman at a spiritual sitting "seizes a pencil. . . . Then she drops the pencil and takes a pen, and holding it between thumb and forefinger writes slowly in an unknown handwriting."[57] *Symbolism of Light* (around 1903), another of Clarence White's crystal-ball photographs, simulates how ghostly writing might also appear in a globe (fig. 113). The symmetrically placed forms in the ball resemble two inverted commas (or single quotation marks) and two periods. Punctuating the ball, they evoke a spoken sentence—a text circumscribed on either side by a period and enclosed by inverted commas—although the precise content is invisible. In view of the notably tadpolelike shapes of the inverted commas—their presence as a kind of apostrophic sperm—they suggest the procreative quality of crystal vision. The crystal ball, a place of creation, is likened to a womb impregnated by messages from the dead.

The script on the skull in Remington's possession is not, of course, an instance of automatic writing, yet the juxtaposition of death and writing evokes this form of telepathic communication. In other instances, moreover, Remington produced work that more closely represents voices from beyond the grave. The pretense of "Joshua

112. *Human Skull, Inscribed on Forehead by Remington.* Buffalo Bill Historical Center, Cody, Wyoming. Gift of the Coe Foundation.

113. Clarence White, *Symbolism of Light,* ca. 1903. Library of Congress, Washington, D.C.

Goodenough's Old Letter," a fictive story published in *Harper's Monthly* in 1897, is that an old document has fallen into the hands of the narrator, who after a brief opening statement is content simply to publish the letter verbatim.[58] The letter, written by a father to his son in 1798, details the father's exploits some forty years earlier as a member of Rogers' Rangers during the Seven Years War. It is not as a document of that conflict that the letter should most interest us, however, but as an example of Remington's compulsion to invent the past—to make it speak through him. The effect of the story is to suggest that the narrator is the medium for the words of the dead.

The Underworld

There is a sense of futility about Remington's representational attempts to wake the dead. *In from the Night Herd*, painted in 1908, shows a solitary horse and cowboy arriving at a firelit camp where three men are sleeping (fig. 114). The cowboy prepares to nudge one of the sleeping men with his right boot, presumably so that the man may take his turn in the business of night herding. Yet this strange painting suggests much more than the simple narrative would imply. Unlike many of Remington's nighttime scenes, *Night Herd* has little or no moonlight or starlight; the light of the campfire, which alone illuminates the scene, casts a lurid glow. On the left the surrounding darkness blackens a saddlebag not directly exposed to the firelight, transforming it into a gaping mouth that echoes the open mouth of the adjacent sleeping cowboy. The surrounding blackness lends a disturbing quality to the sleep of the men. In particular, with the image of a figure coming upon the supine forms of three men, *Night Herd* recalls Remington's earlier illustration *We Discovered in a Little Ravine Three Men Lying Dead with Their Bodies Full of Arrows* (1899), a reference that invests *Night Herd*'s sleeping figures with a deathly connotation (fig. 115). With a slack-shouldered standing figure looking down at a prone form to the left, the painting also repeats the grisly narrative of *Your Soldier—He Say*.

Nor is *Night Herd* without its sense of ghosts. In many ways, the man sleeping in the immediate foreground formally relates to the standing cowboy. His head is almost directly below that of the standing figure, and the two heads are connected via the upward-pointing triangle of space between the standing figure's legs. They are also connected by their similar hats; by the parallel lines of the sleeping man's left arm and the bottom of the standing figure's coat. There are differences, too: sleep versus wakefulness; horizontality versus verticality; a certain rocklike solidity, accented by the modeling of the bulky blanket, against a papery, almost two-dimensional lightness.

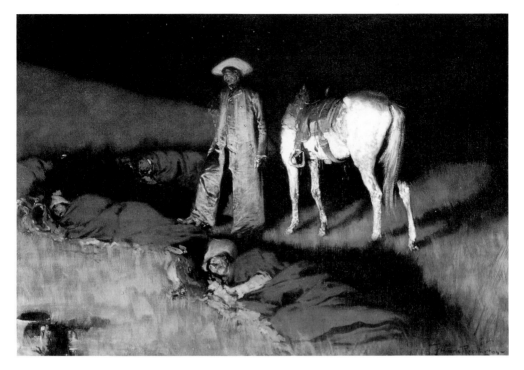

114. *In from the Night Herd,* 1908. Oil on canvas, 27 × 40 in. National Cowboy Hall of Fame and Western Heritage Center, Oklahoma City, Oklahoma.

One figure sleeps heavily; the other walks lightly. The formal relations suggest that the two figures can be interpreted together. The standing cowboy himself is light not only in having a comparative lack of weight; a surface reflecting the fire, he *is* light— he is made of light. He is an evanescence, an apparition, conjured out of the darkness. An airy upward-pointing triangle, he evokes a spirit ascending from the slumbering body below him, implicitly his own in death. It is as though the cloud horseman in *Eye of the Mind* has come diaphanously to earth, the better to enact his ascension.

Yet this account says nothing of the most spectacular feature of the painting: the headless white horse. A pentimento reveals that Remington deliberately sought the headless effect after first representing the horse staring, like the standing figure, at the leftmost sleeping man. (The trace of the horse's head is visible to the left of the standing man.) The narrative enacted by the sleeping figures and this headless horse takes us one step further into this stygian painting.

First there are the bodies, or, more particularly, the body at which the standing figure stares. *In from the Night Herd* is another of Remington's late-career evocations of his early life in the West. Yet by this time, recalling his youth often meant recalling

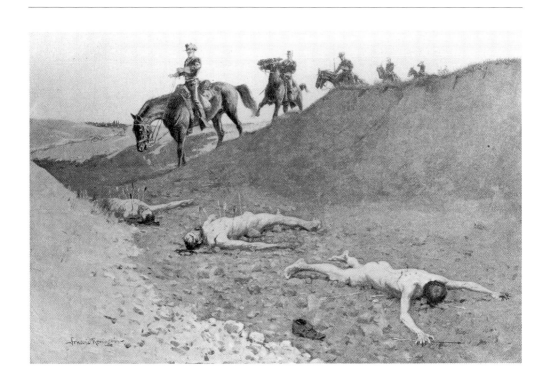

This is a diagram of Ralphs
mouth while he is sleeping –
The Human Caliope

Julian Ralph

115. *We Discovered in a Little Ravine Three Men Lying Dead with Their Bodies Full of Arrows,* 1899. Reproduced in *McClure's* (June 1899). Thomas J. Watson Library, Metropolitan Museum of Art, New York.

116. *Ralph Asleep,* 1896. Pencil on paper, 5 3/4 × 4 1/4 in. Frederic Remington Art Museum, Ogdensburg, New York.

people who were dead. There was Lt. Powhatan Clarke, Remington's "role model for rash derring do," who had drowned in 1893. There was the writer Julian Ralph, Remington's good friend and hunting companion, who had died on January 20, 1903, from wounds suffered while covering the Boer War.[59] On a Canadian hunting trip in 1896 Remington made a tiny (5¾-by-4¼-inch) informal sketch of Ralph asleep that remained in the artist's possession throughout his life (fig. 116).[60] The sketch is meant to be humorous; the inscription beneath it says, "This is a diagram of Ralph's mouth while he is sleeping—the Human Caliope." But after 1903, when it became Remington's one selfmade image of his friend, the keepsake-sized sketch may have become an eerie commemoration of Ralph not just asleep but dead.

Ralph's portrait, with the black open mouth and the focus on the head, prefigures the iconography and themes of *Night Herd*. The main action of the painting—the stare of the standing man at one of the sleepers—takes on a special significance in connection to the earlier drawing. The standing cowboy, preparing to wake his fellow, does so in a notably contemplative way. The downward tilt of his head implies both introspection and mourning. His gaze is directed at the sleeping figure's head. It is this head, with its open mouth, that resembles Ralph's. The standing cowboy's special engagement with the Ralph-like sleeping figure invites interpretation as a figure of Remington himself coming upon, trying to wake, a figure from his past.

The headless horse contributes to the mournfulness of the artist's conception of his task: a search through "dead" subjects. The most startling aspect of *Night Herd*, the headless horse is probably the solution to an awkward pictorial situation, evident in the pentimento. The standing cowboy eclipses the horse's neck; to have the horse's head appear on the cowboy's other side, as Remington originally intended, created an unduly distracting two-part, neckless animal. It also would have interjected a somewhat comic note of equine curiosity at odds with the mournful mood of the picture. So Remington simply painted out the horse's head. Yet he undertook the omission, I think, not only to solve a technical problem but to take advantage of the open-ended mystery that the horse's headlessness would (dis)embody. Flanked by a "dead" figure on one side and a headless horse on the other, the artist-figure inhabits a ghostly otherworld. His job is to wake the dead past on canvas—to restore to it a life and a wholeness that he is nonetheless compelled to disavow within the very picture that would enact the recovery. The men lie on the ground, their energy as spent as the bullet shells whose husks they evoke. The past can exist only as corpse or fragment, and then only in memory. To be convincing, the figures that would bring the past back to life must be dead.

Chapter Five / Merely Paint

Remington's moonlight scenes, more than any of his other works, aspire to escape their materiality. Their point, as we have seen, is either to reproduce the artist's own mental processes—specifically, his memories—or to conjure ghosts that might exist outside these mental processes. Which a picture represents cannot be decided, I believe. Yet, in each case, the moonlight paintings show something diaphanous or immaterial. This calculated evanescence mitigates the materiality both of the objects shown and of the paint itself. Likewise, each mark of Remington's brush upon *Night Halt of the Cavalry* (see plate 7) could be seen as intended to hide its materiality, to reduce itself to the weightlessness of thought.

Yet when does a veil become a wall? At what, if any, point is thought separable from language? The blades of grass provide *Night Halt of the Cavalry* with its shimmering opticality, the sense that the figures float upon a carpet whose threads are made of air (fig. 117). Yet the same blades just as insistently announce their own materiality. (Any painting can be understood to be about both "imagery" and the materiality of its paint, but I mean more than that, as I shall make clear below.) Each clump of grass in *Night Halt of the Cavalry* is the breadth of the brush that made it. The result is that the clumps—the means by which the work aspires to escape its materiality— also read as startlingly direct indexical markers of Remington's act of painting. Further, the laddering of the grass in horizontal rows, so that the clumps appear to stack one on top of another, underscores the flatness of the picture plane and in this way also calls our attention to the materiality of the painting. Finally, the pronounced horizontal weaves of the canvas, visible through the paint, accentuate the sense of the

ground as a stacked pattern. It is ultimately indeterminate what sort of brush—prairie or paint—the marks signify.

The equivocation between transparency and opacity is at the heart of not just this painting but many of Remington's late works, not all of them nighttime scenes. In *The Snow Trail* (see plate 6), painted around 1908, our attention is not called to the paint so much as to what the paint realistically represents. Yet if we inspect a detail—the central horse's left front leg—we see a curious mishmash of different colored brushstrokes jockeying for position within the leg's smooth, certain outline (fig. 118, plate 9). From a distance, to be sure, the compilation of slashes and globs creates the illusion of a three-dimensional leg. Up close, however, the marks of paint assert themselves *over and against* the subject matter—assert themselves, as in Remington's letter to Al Brolley, as "merely paint." Like the Indian on his horse, the paint in *The Snow Trail* sits atop the representation, astride it. To a certain extent, this point is truly unremarkable, because all painting must betray this tension between illusion

117. *Night Halt of the Cavalry* (detail). 118. *The Snow Trail* (detail). See plate 9.

and opacity. The difference, in Remington's case, is that the tension seems inherent in each brushstroke, as though the person laying the strokes down were not certain, with each touch of brush upon canvas, exactly what paint was supposed to accomplish. Was it a veil or a wall?

The equivocation was not Remington's alone. It can be found in the work of other artists from the time, notably the paintings of the American impressionists—including especially the art of Remington's friend Childe Hassam.[1] In *Indian Summer in Colonial Days*, a painting from 1899, a man and a woman sit on a bench beside the Putnam cottage in Greenwich, Connecticut (fig. 119, plate 10). (The cottage was a historic site, which Remington reported visiting in June 1909.)[2] Hassam marshals the paint to make an eighteenth-century scene. The two figures are colonial: we can see their old-fashioned clothing—the man's tricorn hat, for example. Yet it seems beside the point to talk about the picture as a nostalgic evocation of colonial America.

In a much more prevalent sense, Hassam uses the colonial setting merely in order to investigate the materiality of paint and canvas. The tree trunk and the tracery of branches create a flat pattern, almost like that of a sprig pressed upon the page of a book. The sharp outline of the tree, as well as the equally sharp outlines of the bench and the figures, further make the picture a series of flat patterns. In parts of the painting, like the upper right, Hassam allows the primed canvas to show through, to signify as itself. The blotches of yellow and orange on the ground, representing fallen leaves, read also as marks of raw paint whose pattern echoes that of the leaves still on the branch. If any part of the picture evades materiality, it is the side of the Putnam cottage, where the weathered shingles seem somehow to evanesce into the light that allows them to be seen. Yet the flat wall exists almost parallel to the picture plane; and it is composed of a series of horizontal striations that resonate with the striations of the canvas itself, as though it were Hassam's purpose here to represent the lines of the canvas—to make these lines his subject matter. In this detail we find the same equivocation, in virtually the same form, that Remington would investigate in the diaphanous opacity of *Night Halt*'s rows of glowing grass.

For all the similarity between Hassam's and Remington's evocations of the past, however, there is also a substantial difference. Although *Indian Summer in Colonial Days* is ostensibly a historical scene, no sense of tension or conflict exists in the way it privileges its materiality. The serenity of the scene suggests Hassam's calm in using the past to investigate form. The slippage in the subject—a colonial couple engaged in a curiously touristic activity, examining a book as though it were some sort of late nineteenth-century guidebook to the house before them and, on a larger level, a guide

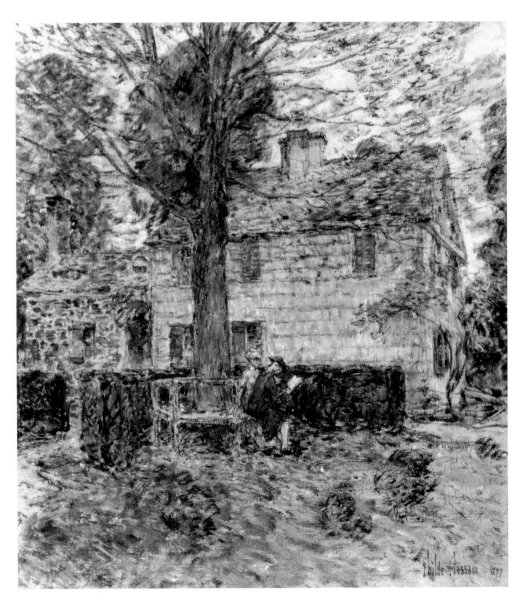

119. Childe Hassam, *Indian Summer in Colonial Days*, 1899. Oil on canvas mounted on board, 22 × 20 in. Private collection. Photograph courtesy of David Findlay, Jr., Inc., New York. See plate 10.

to the very "history" of which they are part—suggests that Hassam was hardly concerned here with a convincing re-creation of the past.

Yet Remington investigated the materiality of paint and canvas in a very conflicted way. On the one hand, as Peter Hassrick and others have noted, he admired the work of Hassam and other American impressionists, including Willard Metcalf and John Twachtman, and self-consciously emulated their style in his own late work.[3] On the other hand, Remington prided himself on his ability to recapture the past. He predicated his art on the ability of paint to efface itself and effectively merge with the objects and scenes that it represents. As we saw, he also feared the associations of mere paint with feminized civilization, hence his statement to Al Brolley: "I stand for the proposition of 'subjects'—painting something worth while as against painting *nothing* well—merely paint."

The statement itself, its quality of protesting too much ("I am right," he insists), reveals Remington's anxiety about the nature of his enterprise. It alerts us to an often-overlooked fact about his art—namely, that Remington made his paintings and sculptures at an embattled and indeed lethal time for realist art. In 1906–9, when Remington made his most impressionistic pictures, the longstanding belief in the ability of paint to capture the world, merging imperceptibly with it, was under severe attack. First, the protomodernist investigation of the flatness of the picture plane and the opacity of paint powerfully critiqued the pretensions of realist art. Hassam's art was part of this tradition. Second, photography had begun to usurp the traditional documentary place of realist painting. The seeming transparency of photographs—the way they ostensibly provided an unmediated view of the subject—made suspect the claims of realist paintings (and sculptures) to a similar transparency. Photography, it seems to me, implicitly focused attention on the materials with which painters and sculptors summoned the world, causing the artists to emphasize or, at any rate, point to the opacity of the materials—the arbitrariness of the materials' claim to immanence—compared to the seemingly effortless transparency of photographs. In turn, the uncertainties about realism embodied the collapse of truths on a larger cultural level. Concern with the lack of meaningful reference in the picture acted, as T. J. Clark has written, as a "sign inside art of this wider decomposition . . . an attempt to *capture* the lack of consistent and repeatable meanings in the culture—to capture the lack and make it over into form."[4]

Remington's anxiety about this state of affairs—the collapse of the old verities, for which, in his late work, the opaque brushwork is as much a metaphor as the dying Old West itself—comes across, ironically, in the subject matter of the late pictures.

Whereas *Indian Summer in Colonial Days* is calm, Remington's late subjects often evince heightened states of anxiety, fear, and even curiosity. I believe that these acute psychological states relate less to the Old West than to Remington's own concerns about the ability or, more precisely, the inability of paint to recapture the past. Would it not be terrible for a history painter to discover that the medium used for the subject's portrayal was inherently inadequate for the task? That even memories of the past, each as wispy as a filament of grass, could not be but brushed into being?

Mutations

No late Remington work demonstrates the concern better than *Fired On*, painted in 1907 (fig. 120, plate 11). The painting shows six horsemen spilling into the canvas from the left, calling to mind *The Snow Trail*. Here, however, the comparison seems to end. Whereas the riders in *The Snow Trail* pass through their wintry landscape, those in *Fired On* come to a dramatic halt. The white horse, its rider reaching for his gun, stares in terror at twin splashes (made by gunshots) in the water. (Two more gunshots raise dust at the lower left.) Another horse, immediately to the right, rears while its rider struggles for control. A man on horseback, also poised at the border of water and rocky beach, reaches for his gun as he and his horse stare into the blackness. Three other mounted men complete the entourage: two immediately behind the front three and another one farther back, the outlines of his horse barely visible at the upper left. One of the latter figures opens his mouth and raises his arm, probably saying and signaling "Halt."

Not just the action but also the technique is different in *The Snow Trail* from that in *Fired On*. The white horse is the dominant figure in the painting, recalling the similarly dominant central horse in *The Snow Trail*. Yet the horse in *The Snow Trail* is all daubs and dashes, whereas the one in *Fired On* is, if anything, testimony to Remington's ability to merge paint into what it represents. On first glance, the horse is modeled with an acuity that denies paint and canvas. Indeed, in a painting whose details are elsewhere difficult to discern (what, for example, is the expression of the man whose horse is directly behind the white horse?), there is even something odd about the excellence of the modeling of the white horse—something insistent and almost obsessive in the way its two near legs stand vigorously away from the black shadows beneath, the way the belly rounds out of sight, the way the upper part of the rear leg makes a knife edge against the body behind it. The white horse is a statement, even an overstatement, of Remington's skill in modeling in paint.

Yet in its own way the white horse in *Fired On* is much like the paint-caparisoned horse of *The Snow Trail*. It stares at the splashes of water, which occur upon the water's flat surface, a surface that analogizes the surface of the canvas itself. The splashes represent the water displaced by the gunshots; but to represent a liquid Remington had to render the splashes in a highly painterly way (fig. 121). The horse thus stares in terror at a liquid that is much like inchoate paint itself. There is, in turn, a powerfully narcissistic quality to the horse's stare. Looking into the water, it may not literally see itself, but in a figurative sense perhaps it does. It sees splashes of paint that echo its own tail and mane (fig. 122). The reverberation that we are to imagine the figures hearing somehow applies to the formal echoes in the picture. The distance between the two splashes, as well as the way one is slightly above the other, repeats the placement of the horse's nearer two hooves. (Also, the left splash seems a reflection of the horse's muzzle.) In these paintlike splashes, then, the horse sees itself, for all its extraordinary modeling, as vaporized, abstracted, bodiless—as the mere paint that it ultimately is. This paint, like the gunshots, is lethal to the horse's existence. It is as though all of the daubs and dashes of *The Snow Trail* had been magically displaced, set off, and offered for the terrified inspection of the horse that they constitute.

Wolf in the Moonlight, likely painted in 1909, shows a lone wolf stopped at the edge of a body of water, just like the white horse in *Fired On* (fig. 123). From its position on a rocky shore much like that in the earlier painting, the wolf stares at the viewer (and the painter) with gleaming, vicious eyes. Again, like the white horse, the well-modeled wolf seems at first a triumph of Remington's realism, of paint merged into a convincing representation. In Remington's time, wolves symbolized a primitive killing spirit. They were evolutionary holdovers in a progressive era. "It is quite disheartening," Remington wrote in "The Curse of the Wolves," a short piece published in *Collier's Weekly* in 1898, "that such a pest cannot be gotten rid of in this advanced day."[5] We think not just of Buck and White Fang but of Wolf Larsen himself, who believed, "I struggle to kill and to be not killed."[6] In all of these cases, wolves symbolize primitive hostility within the natural world. Yet *Wolf in the Moonlight* problematizes the connection.

The painted wolf is linked to the picture as a whole. Strangely, in a painting where the shoreline zooms into the distance, the wolf's body is parallel to the picture plane, emphasizing the flatness of both wolf and picture. The wolf and the canvas are the same green. The wolf is central within the painting, like a heraldic device at a shield's center. The wolf is also formally related to the surrounding scene. Its eyes match the

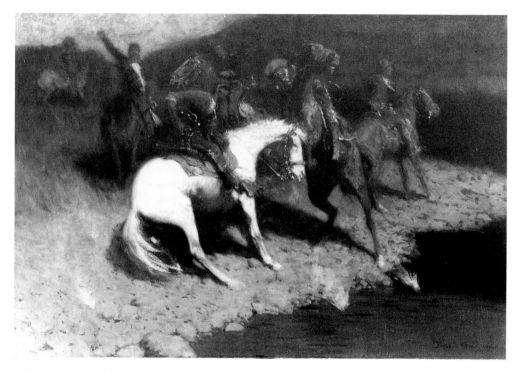

120. *Fired On,* 1907. Oil on canvas, 27⅛ × 40 in. National Museum of American Art, Smithsonian Institution, Washington, D.C. Gift of William T. Evans. See plate 11.

121. *Fired On* (detail).

122. *Fired On* (detail).

two most prominent stars in the sky, its body is reflected in the water, the line of its back and head parallels the line of the distant sloping hill, its white-tipped tail assumes the colors and elongated form of the hill and sand, and, finally, its body is arranged in a more or less compact rectangle that echoes the rectangle of the picture itself. In all of these ways, the wolf's body confronts us (as it would have Remington) exactly as the flat canvas does, its flat body almost a kind of meta-canvas. The result: hostility and artifice are linked, their qualities imparted to one another. The wolf is no longer a hostile natural thing; it is hostile, rather, because it is unnatural. The painting "is" a wolf, the wolf "is" a painting.

The wolf's starlike eyes in particular make the connection. In 1906 Hassam commented on the stars in another Remington moonlight, *A Taint in the Wind* (see fig. 130): "The only thing to say in criticism is your stars look 'stuck on.'"[7] This was per-

123. *Wolf in the Moonlight,* ca. 1909. Oil on canvas, 20 × 26 in. Addison Gallery of American Art, Phillips Academy, Andover, Massachusetts.

haps an odd thing to say for one so personally devoted to stuck-on paint, yet Hassam knew that, for his friend, subject matter was truly paramount. In any case, the two prominent stars in *Wolf in the Moonlight* are no less stuck on than anything in *A Taint in the Wind*. They are further instances within Remington's art of curiously equivocal paint, simultaneously depicting the world and itself. To the extent, then, that the stars are repeated in the eyes of the wolf, the eyes read as similarly stuck on; in the two gleaming points the wolf's hostility and artifice are inextricably combined.

This link produces two conflicting readings. In a way, the wolf differs from its equine counterpart in *Fired On*. Instead of showing a figure comprehending its own dissolution, *Wolf in the Moonlight* shows the reverse: paint gathered or coalesced, seemingly from the peripheries of the image, into a convincing form at the center. (In citing the example of the eyes, we could say that the drama of the picture lies in providing an illusionistic or realistic locus for what are elsewhere in the painting just dots of paint.) Yet the wolf's realistic form cannot be read apart from the abstract, disparate elements that it coalesces. As much as its form seems centrally gathered, it also seems broken apart, exploded, cast into a far-flung abstraction of its constituent parts. With its eyes echoed in the stars, which are themselves reflected in the water, the wolf appears to stare at us, disembodied, from every corner of the image.

Note the hostility of the wolf's stare. On one level, its gaze might embody the anxiety of the artist before the painting itself—it might be understood as providing something like a mirror reflection of the artist's own anger and frustration before a work in which he could not help but thematize an artifice, a mere paintedness, disastrously at odds with claims to historical accuracy. In the same way, the stare of the white horse in *Fired On* might embody Remington's fear before a canvas representing a similar conflict. More fundamentally, the wolf's glower suggests its own antipathy, insofar as Remington was able to imagine it, toward the artistic creator who had thus consigned it to a merely painted world. The wolf may be seen metaphorically as the image of paint itself, confronting Remington with its brute materiality, not as fur, snout, eyes— the stuff that suspends our disbelief—but as an opaque paste that bears no intrinsic relation to any of these things. The wolf's hostility is no longer that of a natural beast—no longer that of a thing of this world—but that of an unnatural creature. Like Freud's contemporaneous "Wolf Man," Remington is haunted by a staring wolf (though just one instead of seven); but the Wolf Man is haunted by a scene from his past—a past that, like the wolves in the tree, will not go away—whereas Remington is haunted by an absence, an emptiness, a past that does not reappear naturally, loyally, unbidden, but only by means of a horrible artifice. The picture thus casts Reming-

ton as a kind of Dr. Frankenstein, a man who has grafted together a thing that only represents a living being. Just as Remington is confronted by the stare of his perpetually artificial wolf, Dr. Frankenstein's punishment is to be forever haunted by his awful creation. "I am alone and miserable; man will not associate with me" is the Frankenstein monster's hateful reproach to its maker.[8]

The same metamorphosis, full of anxiety for artist and subject, is also the focus of *The Horse Thief*, a sculpture made in 1907 (fig. 124). It is strange, admittedly, to focus on the same motifs in a sculpture—not just because of the inherent differences of the medium but also because Remington often worked on sculptures and paintings at separate times, cultivating a different mindset for each: "Switched from sculpture to painting today," he reported in his diary on December 15, 1909. "After modeling a time one has to change his view point which does not happen in a minute but in a few days I shall think in color again." Yet, with the flat backdrop of a buffalo robe—a robe that evokes a canvas—*The Horse Thief* is a peculiarly paintinglike sculpture. It stands to reason, moreover, that here and elsewhere Remington's concerns about mere materiality would also extend to clay and bronze.

The Horse Thief shows an Indian warrior racing at high speed on a stolen horse, holding a streaming buffalo robe and looking over his shoulder, presumably at his pursuers. Several things are odd about the sculpture. One is its dramatic combination of extreme movement and stasis. The horse is in full gallop; the speed snaps the Indian's buffalo robe straight back. A triangle of rearward points—the horse's hind hooves, the buffalo robe's upper right edge, and the Indian's knife—imparts a whoosh to horse and rider. All four hooves are in mid-air; only the foliage through which the speeding horse runs supports it. Yet, strangely, the horse's speed creates a sense of extreme stillness. The foliage and the buffalo robe are blocky rectangles compressing the fleeing Indian between themselves; the buffalo robe is a weight pulling the Indian backward; the foliage is a lugubrious, retarding slop.

The Horse Thief suggests, further, not just momentum slowed but the horse and rider's transformation into, or from, the very materials that impede them. The Indian's body protrudes in high relief from the buffalo robe; the right half of his torso and his right leg appear to emerge from the robe. The Indian's melded connection to the background gives him an unfinished look, reminiscent of one of Michelangelo's slaves struggling within the block, as though he were attempting to emerge from the unformed material behind him. Similarly, the shape of the horse's tail, thrust down between its legs, resembles and almost connects with the foliage below, suggesting that the horse has somehow emerged from the claylike substance beneath it. In

this sense, horse and rider literalize the process of their own creation out of raw, or mere, clay.

As in *Wolf in the Moonlight* and *Fired On*, the horse and Indian simultaneously appear to subside back into the ooze from which they emerge. The foliage springing up below the horse recalls the splashes of water in *Fired On*, painted in the same year. The foliage amounts to a similar image of mere material, as though the real subject of the rider's concern were not so much his unseen pursuers as the raw forms that indicate his own materiality and through which he attempts to navigate. Specifically, *The Horse Thief* evokes baroque sculptures of Ovidian transformations. Like Bernini's Daphne, who turns into a laurel tree before our eyes, Remington's Indian, also pursued, is seemingly arrested in motion and transformed into an inanimate object (fig. 125). It is as though the horse were being transformed into the raw forms beneath it, as though the Indian were melding into the mottled "bark" of the robe—a surface as flat and pictorial as the side of Israel Putnam's cottage.

We might understand the Indian's contorted expression in such terms. On a certain evolutionist level, which I do not wish to deny, the thief's face is much like the "brute" faces in *Apache Medicine Song* (see plate 1). Yet here (and as we shall see,

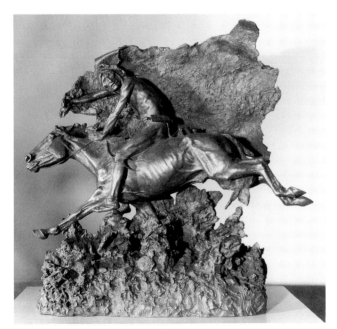

124. *The Horse Thief,* 1907. Bronze, h. 26½ in., base 23¾ × 8 in. J. N. Bartfield Galleries, New York.

125. Gian Lorenzo Bernini, *Apollo and Daphne,* 1623. Marble, 97 in. high. Galleria Borghese, Rome. Photograph courtesy of Art Resource.

126. *Downing the Nigh Leader,* 1907. Oil on canvas, 30 × 50 in. Alan and Cindy Horn Collection.

in *Apache Medicine Song*), the savagery is not distinguishable from a hatred, an anguish, that concerns mere materiality. The thief's glower is much like the wolf's in *Wolf in the Moonlight*: it cuts two ways. It embodies Remington's own anxiety and pain at having made a figure compromised, slowed down, or imprisoned by its materiality; and it represents the Indian's own antipathy, as Remington conceived it, toward his artistic creator. The savagery of the figure—its stereotypical subhumanity—relates not just to race but to materiality. In more than just the obvious sense, Remington's Indian is a monster.

Puppets

The same theme of monstrosity informs two other works, both paintings, made in 1907: *Downing the Nigh Leader* and *The Trail of the Shod Horse*. At first glance, *Downing the Nigh Leader* is an image whose power-packed realism defies the idea that Remington questioned whether his paint could "become" subject matter (fig. 126). One of his most famous paintings, *Downing the Nigh Leader* seems a triumph of realism—a hell-bent chase, all snot, froth, and flying hooves, in which a group of Indians overtakes a six-horse stagecoach. A spear protrudes from the jaw of the

stricken, stumbling nigh leader, directly in the center of the canvas, signaling that the stagecoach is in its final moment before catastrophe. The last thing we think about, before this compelling drama, is the material composition of the painting.

Yet it was during the weeks that Remington painted *Downing the Nigh Leader* that he made one of his most succinct assertions of the fictitious quality of his art. He worked on the painting in the summer of 1907, at his island studio on the Saint Lawrence River. On July 10 he reported in his diary that some visitors had come to see the paintings in his studio: "Jack English and some well-bred boys called and they take my pictures for veritable happenings and speculate on what will happen next to the puppets so ardorous are boys' imaginations." For Remington, his studio visitors are naive because they think that the images are veritable happenings. The word that stands out most in Remington's statement, however, is *puppets*. Significantly, he does not choose a more neutral word, such as *figures*; he could have referred to *figures* in a painting without occasioning any special sense of their difference from living things. Puppets, on the other hand, depend on animation lent by another. "'Puppet' is a term of contempt," wrote Edward Gordon Craig in *On the Art of the Theatre* (1911). "To speak of a puppet with most men and women is to cause them to giggle. They think at once of the wires; they think of the stiff hands and the jerky movements; they tell me it is 'a funny little doll.'"[9]

Craig's comments, made in defense of puppetry, date back to a revival of artistic puppetry in the United States. "By 1915," writes the puppetry historian Paul McPharlin, "American amateurs were thinking seriously of the aesthetic and educative possibilities of puppetry."[10] In fact references to puppetry appear often between 1900 and 1910. There was London's description of living creatures as puppets: inhabited and governed by racial ancestors, White Fang has no control over his own actions. I can also mention *First Steps Alone*, the *Puck* cartoon of 1902 showing Cuba as a puppet-child of the United States (see fig. 35); N. C. Wyeth's livid statement, in 1906, that his teacher Howard Pyle had "manipulated me about like a puppet"; stories and articles about puppetry, such as two that appeared in *Scribner's* in 1899 and *Century* in 1902 (fig. 127); and John Singer Sargent's painting of 1903, *Marionettes* (private collection).[11] The last kind of puppet is what *Downing the Nigh Leader* seems most to evoke. Like marionettes in contemporary illustrations, the horses in *Downing the Nigh Leader*, one of the paintings that Jack English and his companions saw that day in July, are controlled via strings from above.

But let us postpone further discussion of this painting for a moment and look at another work in Remington's studio that summer, one we have already examined: *The*

Trail of the Shod Horse (see fig. 92). The picture shows a column of Indians moving through a landscape crusted in moonlit snow. The leaders have stopped to examine tracks in the snow. Two of the front three figures—the dismounted man and the one to the left—raise their arms to indicate the sign of the shod horse. It is a strange scene, but one of the oddest things is not the ghostly landscape or even the column of Indians, faceless wraiths trailing off into the distance, but the peculiar relationship between the two raised-arm figures (fig. 128). The narrative tells us that their arms have risen in virtual unison—a point emphasized by the way the mounted Indian raises his hand directly above the other's. The effect is to suggest that the two arms exist in a magnetic relation, as though the raising of the one had caused the raising of the other. The stance of the standing Indian adds to this idea. He is strangely slack or limp: his lifted right leg, his raised right arm, and his hanging right hand—all of them vaguely inert—lack the taut, springy muscular action that Remington could so vividly impart to his figures. His hidden feet, submerged in the snow, divest him of the fixity of a figure whose feet we could see plainly planted on the ground. His action seems hauntingly dependent on the action of the figure above him.

The standing Indian is puppetlike. His right arm and right leg appear to have been raised by the hand of the "puppeteer" above him. His sleeved rifle, parallel to the rifle of the mounted figure directly above him, suggests the horizontal sticks to which a marionette's strings are attached. The strings are virtually literalized in the rein connecting the standing Indian's left hand to his horse's muzzle and in the rein squiggling down the left horse's flank. The standing Indian's hand holding the rein would in fact be jerked upward were the horse to raise its head. Appended to sticks and strings, frozen in a grotesque jig (the figure is based on a plaster cast of the hellenistic *Dancing Faun*), Remington's puppet is as eerie as his wolf—a Frankenstein monster, a mere mimic of life.

In *Downing the Nigh Leader*, the "puppets," unlike the Indian in *The Trail of the Shod Horse*, move with all of the naturalism of the Eadweard Muybridge motion photographs from which they are derived.[12] Or do they? The action of *Downing the Nigh Leader*, for all its fast pace, is exaggeratedly frozen. The two rows of coach horses, each a regularly spaced unit of three, are aligned in a centralized static frieze. (The regularly spaced row of three Indians in the left background adds to the symmetry.) The first row in particular, with the flanking horses each turning its head inward, is symmetrical enough even to recall a heraldic device. The head of the front left horse is especially heraldic: its neck has been jerked back by the falling nigh leader, so its head appears almost perfectly in profile. The front row of horses is as static and symmetrical as the triptych of darkened windows on the side of the stagecoach.

 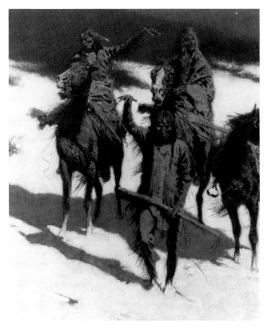

127. Arthur Keller, *The Marionettes Are Operated from Above*. Reproduced in Francis H. Nichols, "A Marionette Theater in New York," *Century* 63 (March 1902): 680.

128. *The Trail of the Shod Horse* (detail).

Each object is shown with a remarkable stillness. No matter how fast the wagon wheels churn, they remain visible, even down to their individual spokes. There is no "mist of motion"—Upton Sinclair's phrase, in 1906, for the frenzied activity at the meat-packing plants.[13] Likewise, the horses are rendered with an acuity that contradicts their frenzied galloping. Remington was well aware of the contradiction. "I have always wanted to be able to paint running horses so you would feel the details and not *see* them," he wrote the following year. "I am getting so I can stagger at it."[14] The nigh leader itself, at the center of the composition, iconically declares the contradiction. According to the narrative, Remington had to show the horse both moving and stopping; his challenge as an artist was to show movement stopped. Tethered and trussed, its wounded head jerked one way as its back legs splay the other, the body of the nigh leader is, if anything, more grotesquely twisted, more "puppeted," than the standing scout whom its contortion recalls.

The tension between action and stillness relates to the use of photography. Inasmuch as Remington, like many artists, sought to "correct" his running horses

with reference to Muybridge's photographs, he admitted the greater mimetic authority of photography. Specifically, he admitted that in the wake of photography the mimetic inadequacy of painting was registered as a lack of immanence between itself and its referent—a lack most forcefully felt, perhaps, in the failure of painting to represent movement convincingly. The failure was chronicled in art criticism, such as Ernst Te Peerdt's *Problem of the Representation of Instants of Time in Painting and Drawing* (1899). Images of single moments of time, according to Te Peerdt, fail to the extent that they do not acknowledge the multitude of moments of which an "instant" is comprised. "Each instant of perception," writes Stephen Kern, summarizing Te Peerdt's argument, "synthesizes a sequence of numerous perceptions."[15]

The apparent immanence between a photograph and its referent, on the other hand, was never clearer than in motion sequences like Muybridge's. If a painted figure failed to move "photographically"—if it moved stiffly, frozenly, in a way that did not acknowledge the immanence of the past in the present—it existed in the condition of mimetic failure. Specifically, such stiffness called attention away from the allegedly immanent relation between realist painting and the world and directed it instead toward the mediation that makes immanence impossible: paint and canvas. The nigh leader's tortured body expresses the condition of its mere paintedness—its inability truly, photographically, to move. Like Remington trying to make his paintings more real, it staggers. Like the puppet scout's strange movement, the nigh leader's grotesquely contorted pose—torn between movement and stillness—owes to Remington's compulsion to represent the fact that what moves in a painting is always perfectly still: I fled. I could not run.

Strangers

To this point we have considered two paintings, *Fired On* and *Wolf in the Moonlight*, whose drama centers on a figure's recognition of its paintedness. A third work, *The Horse Thief*, concerns an analogous drama in the realm of sculpture. All three works emphasize the unnatural or monstrous quality of their merely painted or sculpted figures—a theme carried to powerful fruition in the "puppetry" of *Downing the Nigh Leader* and *Trail of the Shod Horse*. This all proceeds, I have argued, from Remington's conflicted exploration of the "reality" of the West and of his medium. We now come to a different, though very much related, expression of the same conflict.

With the exception of *Wolf in the Moonlight*, none of the works that we have considered has more than obliquely acknowledged the artist. Such an acknowledgment

would produce the same recognition of mere artifice that greets the white horse in *Fired On* and the other figures that we have been considering. With awareness of a painter comes awareness that one has been painted. Thus the implicit object of the wolf's stare is as much an acknowledgment of its monstrous paintedness, its quasi-reality, as the glowing eyes themselves. No painter appears in *Wolf in the Moonlight*, but in other late works Remington introduces his own presence almost explicitly, and it is to these late works that we now turn.

The first, *Apache Scouts Listening*, is much like *Fired On* (fig. 129). Painted in 1908, the work shows five Apaches and several white soldiers in a forest clearing where, motionless and illuminated by one of Remington's day-for-night moons, they strain to see and hear an unidentified presence outside the painting. Although no gunshots spray around them, the situation seems almost as dangerous as the one in *Fired On*: the shadow extending from the bottom of the painting indicates the ominous unidentified presence. In one sense, this is unremarkable; Remington often evoked a threatening realm just outside the picture. The tactic relates to his late-life desire to activate the viewer's imagination: "Do your hardest work outside the picture," he

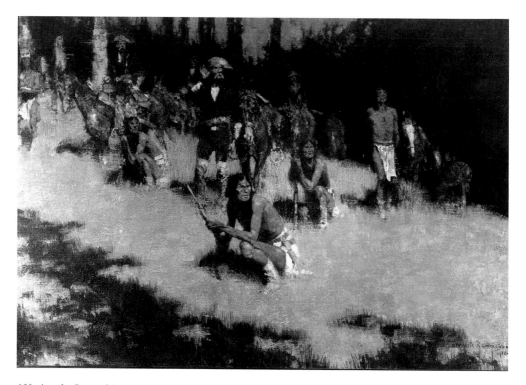

129. *Apache Scouts Listening*, 1908. Oil on canvas, 27 × 40 in. Alan and Cindy Horn Collection.

advised, "and let your audience take away something to think about—to imagine."[16] Remington wants us to wonder, and never be able to decide, who the Apaches are looking for. The tree shadow exemplifies his credo of the imagination. As much as it might convincingly suggest the presence of a tree just outside the depicted space, the shadow is the only evidence of the tree's existence, a nice metaphor about the power of imagination to make a world more suggestive than the world of verifiable facts. Yet the tree shadow suggests more.

In several crucial ways the shadow evokes the presence of the painter before the canvas. Emanating from the bottom edge of the painting, it is a created image—suggesting that it is from this realm, that of the painter, that images emerge. In the story "In the Sierra Madre with Punchers," Remington mentions "the tall pines painting inky shadows across the ghostly grass," thereby explicitly likening the kind of shadows in *Apache Scouts Listening* to painted images.[17] (The shadows in the painting also evoke the similar shape, tone, and placement of the meta-surface of blackened water in *Fired On*.)

On a more compelling level, the tree shadow suggests not just the act of painting but, more specifically, a tall, even towering presence directly in front of the picture plane. The tree shadow reminds us of the photographers' habit of including their own attenuated shadows within their photographs as a form of signature or self-portrait. Remington, who took many photographs as preparatory studies for his paintings, employed this "signature" device.[18] Remington's actual signature in *Apache Scouts Listening* occurs in the lower right corner, below a smaller and separate area of shadow cast (most likely) by the same tree. The smaller shadow, in turn, falls directly into the diagonal line defined by the shadows of the nearest Apache, the left kneeling Apache, and the leftmost horse. Formally, the small foreground shadow is in fact like all the shadows cast by figures in the painting, as though it, too, were cast by a human presence—specifically, that implied by Remington's signature. The signature crucially provides a presence—the suggestion of an actual being who casts the shadow—that is missing in the case of the tree. Significantly, it is toward the artistic presence, as if toward an enemy, that the Apaches look. The Apaches thus undergo a kind of realization much like that of the wolf in *Wolf in the Moonlight*. Coming to realize, or at least suspect, the artist's presence before the canvas, they become aware that they are nothing more than the artist's creations, that their flesh and blood is mere paint and canvas.

Their realization parallels that taking place in another late nocturne (fig. 130). Much like the Apache painting, *A Taint in the Wind*, painted in 1906, shows figures

130. *A Taint in the Wind,* 1906. Oil on canvas, 27⅛ × 40 in. Courtesy of Sid Richardson Collection of Western Art, Fort Worth, Texas.

(horses) staring into and, this time, even frightened by something in the lower right space, which is again occupied by Remington's signature. No shadow attaches to the signature, but the darkened sagebrush to its left takes on the appearance of such a shadow. "Thrown" at an angle that matches the cast shadows of the frightened horses and extending from the realm in front of the picture, the sagebrush suggests Remington's own shadow. *A Taint in the Wind* is derived closely from *The Hold-Up,* an illustration that Remington made around 1902 for Richard Harding Davis's novel *Ranson's Folly* (fig. 131). It shows Lieutenant Ranson holding up a stage, as a joke, with only a pair of scissors. *The Hold-Up* allows us to see that both *A Taint in the Wind* and *Apache Scouts Listening,* with their shadowy presences at the lower right, relate to a painting in which an actual shadowy presence, a human being, does appear. Moreover, the figure in *The Hold-Up,* appearing above Remington's signature, conjures an artist destructively at work upon a painting: the scissors that he holds in his right hand resemble the thin forms of paintbrushes and, strikingly, the hat that he

131. *The Hold-Up,* ca. 1902. Oil on canvas, 27⅜ × 40⅛ in. Amon Carter Museum, Fort Worth, Texas.

holds in his hand looks like a palette. (Similarly, the sage/brush in *A Taint in the Wind* seems a reference, in both name and appearance, to the act of painting.)

The Stranger, another moonlight from 1908, depicts a similar confrontation, but one that evokes the artist's presence more fully (see plate 8). In the foreground, as we have seen, a lone figure atop a white horse, his pack horse at his side, pushes up his hat and stares toward a distant firelit camp. Three figures in the camp—one crouching, one sitting, and one standing—stare back at the stranger. The painting depicts a drama of recognition much like that in *Apache Scouts Listening,* except that it explicitly introduces the intruder and, moreover, substantially distances the figures struggling to see and hear him.

The drama thus unfolding seems to concern art as much as the West. The wagon, as we have seen, is partly but literally a flat canvas. It is remarkably rectangular, perfectly ruled on the right edge and neatly squared off on top. It is also at a right angle to the ground. Its material, shape, and orientation thus all evoke a canvas before a painter. The stranger, in turn, orients his body toward the camp and focuses his vision

upon it, as would an artist in the act of painting. More fully than the shadow and the signature in *Apache Scouts Listening*, the lone figure suggests Remington's compulsion to embody his own presence within his canvases. The drama of the painting—the tense interaction between a lone figure and a canvas—also suggests that for Remington the West itself was not as tense a place as the studio itself, or, to put it another way, that drama and tension in the West were somehow bound up with, or expressed in terms of, dramas more fundamentally related to the act of painting. *The Stranger* suggests that Remington unconsciously represented his own confrontation with the canvas, as it stood before him, as the very subject of his picture. What was occurring in the studio was for him far more intense, more immediate, more powerful, than anything the West could offer—thus the drama of realization. The little campbound figures stare at their maker from their little canvas rectangle as though upon someone incomparably strange, the inhabitant of another world. The artist, the stranger, stares back at the alien realm that he has made—alien because, lit up and alone in the middle of nowhere, it bears no relation to anything else in the world.

In this way, *The Stranger* virtually diagrams the simultaneously exalted and useless status of the work of art, and of what we could call the aesthetic moment, in the first years of the century. Brilliantly illuminated, standing out from the world around, the meta-canvas offers an alluring escape, a place of rest, from the vast, dim, utterly empty prairie of the world. The camp glows with an intensity that somehow exceeds narrative; watching it, the cowboy seems caught in aesthetic wonderment as much as practical calculation. The surrounding empty space, we feel, indicates not so much some Great Plains as the modern United States in which Remington worked—a place that he claimed, in the same year he made *The Stranger*, was "someone else's America, but it isn't mine." Feeling a stranger in his own land, Remington focuses on all that remains to catch his attention: a circumscribed space in which those privileged aestheticized autonomies—mind, painting, and past—those final enclaved spaces resisting what was for him the crass limitless emptiness of the modern world—coalesce into one pure, glowing, unreachable point: something like the light at the end of Daisy's Dock. All that is left are these little epiphanies.

Yet the same exalted uniqueness, making the work of art shine from the dreary world, condemns it to irrelevance. The seductive light of mind, painting, and past illuminates nothing but itself. The depiction of alienation in *The Stranger* consists not only in the lone figure's separation from the camp but in the camp's separation from the world. We are back to T. J. Clark's idea that the breakdown of reference in art is part of a wider decomposition. The title of Remington's picture evokes the artist's

alienation not just from his art—from what he had always assumed paint and canvas, suddenly strange, could do (or perhaps even be)—but also from the past that this art could no longer re-create. The title, in turn, suggests that art itself is strange, though perhaps seductively so, in a wasteland that it can no longer hope to illuminate.

Shotgun Hospitality, yet another moonlight from 1908, restates this alienation, but close up (fig. 132). The painting shows a solitary white man kneeling on one knee, scratching his chin, and staring, shotgun across his lap, at a figure in front of him. It is unclear who the mysterious figure is, but the blanket and long hair, the latter spilling down shoulders and back, suggest that, like the two figures on the right, it is an Indian. The fire from the lone white man's camp has presumably attracted the three visitors. Their intentions are doubtful; the skeptical host's welcome is guarded—a shotgun hospitality. The relations between this painting and *The Stranger* are clear. Except for the dismantlement of the canvas, the wagon in *Shotgun Hospitality* is identical to that in the other painting. Also, the kneeling figure resembles the three figures staring from their camp, and the mysterious figure is another stranger, now cast in dramatic proximity to the wagon.

In one sense, *Shotgun Hospitality* concerns racial evolution. At the end of his career Remington made several images of doomed Indians and setting suns. Although *Shotgun Hospitality* does not explicitly concern such a theme, it is in fact much like these elegiac paintings. Like *The Story of Where the Sun Goes* (see fig. 21), painted a year earlier, it contains garishly illuminated figures, but more specifically it contains figures standing before a wheel—the right wheel of the wagon—which strikingly suggests the sun, not visible in *The Story of Where the Sun Goes* but dominant in another of the late elegies. In *The Outlier*, painted in 1909, a solitary bare-chested Indian sits on his horse next to a setting sun, just as the bare-chested Indian in *Shotgun Hospitality*, the one second from the right, stands next to the wheel (fig. 133). Each figure is just to the right of a circular shape; each poses proudly, chin up, shirtless, and wears one feather; and each holds a rifle butt to the right of the circle like pool cue to outsized pool ball. The resemblance is strong enough to suggest that in this one detail *Shotgun Hospitality* contains a completed prototype for the later painting. The resemblance also suggests that we can regard the firelight before the wagon wheel as figuratively emanating from the wheel itself, as if it were a kind of sun.

One other Remington image suggests that this is so. In 1878, before he had ever been west, the seventeen-year-old Remington kept a sketchbook. (We have already examined one drawing from this sketchbook, the work called *The Indian War*; see fig. 49.) The last page of the book shows a solitary figure, his back turned to us, marching

toward a setting sun (fig. 134). The light of the setting sun radiates, in the customary fashion, in wheellike spokes. *Shotgun Hospitality*, with its back-turned figure standing before a radiating wheel, evokes the sketchbook page of thirty years earlier. The wheel is sunlike not only because it is positioned like a sun in another of Remington's works and not only because light falls in front of it but also because the spokes suggest the radiation of that light. Finally, just as the sketchbook sun is partly lost as it sets behind the hill, so the wheel is sunken or set partly in the grass.

The sketchbook page helps us to see that *Shotgun Hospitality* eulogizes not only Indians but the realist painting that might preserve them. The figure in the sketch holds three brushes in his left hand and, in his right, a sketchbook on which are printed the letters REM. The figure, the youthful Remington on his way west, is of interest to us with respect to the mysterious back-turned figure in *Shotgun Hospitality*—all the more so in view of a self-portrait made by Remington while a Spanish-American War correspondent in 1898. Called *The Biggest Thing in Shafter's Army Was My*

132. *Shotgun Hospitality,* 1908. Oil on canvas, 27 × 40 in. Hood Museum of Art, Dartmouth College, Hanover, New Hampshire. Gift of Judge Horace Russell, Class of 1865.

133. *The Outlier,* 1909. Oil on canvas, 40¼ × 27¼ in. Brooklyn Museum, New York. Bequest of Miss Charlotte R. Stillman.

134. *Finis,* 1878. Pen and ink on inside back cover of sketchbook, 10½ × 8 in. Frederic Remington Art Museum, Ogdensburg, New York. *(top right)*

135. *The Biggest Thing in Shafter's Army Was My Pack,* 1898. Reproduced in Remington, "With the Fifth Corps," *Harper's Monthly* (November 1898): 962. *(bottom right)*

Pack, the illustration shows Remington standing in much the same manner as the central Indian in *Shotgun Hospitality* (fig. 135). The resemblance is strong enough to suggest that the shadowed and identically ample figure in *Shotgun Hospitality* is Remington himself. The Remington figure, like the lone horseman in *The Stranger*, also stands before a rectangle—the right half of the wagon's side—that echoes the shape of the painting as a whole; moreover, again as in *The Stranger*, the figure stands before an actual canvas, though this time the canvas is (perhaps significantly) collapsed. Here again is evidence of Remington's compulsion to include himself in the act of painting within one of his works.[19]

The act of painting, moreover, is fraught with tension. Like the wolf, the Apaches, and the campbound men of *The Stranger*, the kneeling white man in *Shotgun Hospitality* stares at a mysterious presence strongly identified with the artist himself. Here, however, the reaction is not fear or horror but acute curiosity. The white man's face, easily the most painterly part of the entire picture, is every bit as daubed and dashed as the horse in *The Snow Trail* (see plate 9). It is this sur-face that the trader touches. As a result, he seems to scratch his chin not merely in wonderment but also in self-exploration, as if the sight of the artist were causing him to feel the paint of which he is made. Ultimately his stare is a more "civilized" version of the savage glower of the squatting Apache, Remington's "human brute opposite" in *Apache Medicine Song* (see fig. 32). In that painting the head of the Apache is formally related to the foreground pot of paint. The pot is tilted at an angle that reciprocates the tilt of the Apache's head. The band of highlight on the inner lip of the pot is a reverse curve of the Apache's headband. Also the black mouth of the pot repeats the black mouth of the Apache. The connection between the two disparate emblems—the fierce masculine savage and the paint-pregnant pot—suggests that we can understand the Apache as having been made from the contents of the pot. This awareness—the awareness of having been merely painted—informs the Apache's wolflike stare at his maker.

Like *Apache Medicine Song*, *Shotgun Hospitality* thus turns its evolutionary narrative on itself. It shows the sun setting on Indians and on realist painting—setting, that is, on the claim of realist painting to immanence with the world that it depicts. The sun-wheel in the picture, with its bolts, spokes, and hub, is constructed; it is a sun whose wooden radiance epitomizes the artifice thematized throughout the painting. *Shotgun Hospitality* concerns the extinction not only of the Old West but also of realist painters and painting.

In the First Place

The end of realist painting, as much as the end of the Old West, is what Remington's late works eulogize. Yet his mourning of the Old West was strange. He remembered events of which he himself had little experience. Although many of his paintings recall events from the 1880s and 1890s, when he visited the West as a reporter-illustrator, many other works depict scenes from the 1860s and 1870s, when Remington himself was just a youth living in the East. One cannot miss what one never had. What did Remington miss? What, if not the Old West, did he try to recover in his art?

Remington made *Shotgun Hospitality*, as he made many of his works, in the studio on his private island, "Ingleneuk," on the Saint Lawrence (the same studio visited by Jack English and some well-bred boys). Remington had bought the island and the house on it in 1899, and every summer from 1900 to 1908 he and his wife stayed there. Located among the northeasternmost of the Thousand Islands, Ingleneuk was about thirty miles from the artist's boyhood homes in Canton and Ogdensburg. Routinely Remington completed the bulk of the year's painting during these summer months on the island in the region where he had lived as a boy.

The construction of *Shotgun Hospitality* suggests the oddity of painting western scenes in the place of his youth. It seems strange that a western scene painted in 1908 should unexpectedly incorporate a motif from an adolescent drawing, a sketch made thirty years earlier. Yet the confluence of images—and of the West and Remington's boyhood home—may be explicable. In many specific ways Remington's career as a western artist suggests the powerful influence of his father. Seth Pierre Remington was not an artist but a soldier—a major and a brevet colonel in the Union army during the Civil War.[20] Veteran of a bloody confrontation with Jeb Stuart in Virginia, commander at the Battle of Doyal's Plantation in Louisiana, Remington's father had returned home a hero. Among his war mementos, he most treasured a Confederate commander's handwritten demand for him to surrender at Doyal's Plantation—a demand the elder Remington had ignored. The note was found among Frederic Remington's possessions when the artist died in 1909.

In Canton, Seth Pierre Remington owned the *Saint Lawrence Plaindealer* from 1867 to 1873, when he moved the family a few miles north to Ogdensburg, a town on the Saint Lawrence River, where he became port collector. A letter from Seth to the nine-year-old Frederic—the only one extant between father and son—evokes the model of masculinity emphasized in the Remington household: "Your mother has bought you some [toy] soldiers," Seth wrote his son while in Chicago on business, "and

they are no little 'pea nuts' but regular 'square-toed' veterans."[21] The difference between pea nut and square-toed veteran could not have been more emphatic in the Remington family, where Frederic was the only child. Yet the younger Remington never became a soldier; the closest he came was at the two military academies to which his father sent him—the Vermont Episcopal Institute in Burlington, Vermont (1875), and the Highland Military Academy in Worcester, Massachusetts (1876–78)—and in the West and in Cuba as a war correspondent, and, perhaps, on the football field at Yale.

After Seth Pierre Remington died of tuberculosis in 1880, Remington dropped out of Yale and went west. One of his initial stops, in 1881, was the battlefield at the Little Big Horn. It had been only five years since Custer and his command had been killed. Wandering reverently around the graveyard, his own father recently buried, the young Remington might then and there have conflated the identities of his father and the legions of western heroes whom he would go on to represent and whose passing he would mourn. Both Custer and Seth Pierre Remington were Civil War heroes who had made it through the war only to be struck down later in life. They even looked somewhat alike. Seth Pierre Remington "was a good deal like General George Custer in appearance and rank," write Peggy and Harold Samuels, Remington's foremost biographers, basing their opinion on the only surviving photograph of the elder Remington.[22] In preserving the deeds of western soldiers like Custer, Remington would unconsciously attempt to preserve the deeds of his father. "He adored the memory of his father," wrote Augustus Thomas, "and he remembered him in his uniform."[23]

Remington's art often suggests that the identities of his old-time soldiers were entwined with the memory of his father. "His young cousin Ella," according to the Samuelses, "recalled her father saying that 'he never saw a picture made by Fred in which there were several faces, but [that] one was of his father Col. S. P. Remington. I could see it also.'"[24] *Cavalry Charge on the Southern Plains in 1860*, begun in 1907, the year Remington made arrangements to have his father's remains and tombstone transferred to a new family plot, may have been one of these paintings (fig. 136, plate 12).[25] Although the subject and title of the work suggest a southwestern scene, the possibility that the Southern Plains of the title are located in Oklahoma or perhaps Texas suggests that the painting refers to both West and South: Texas had been part of the Confederacy. Thus *Southern Plains* evokes the place in which Seth Pierre Remington fought. The year 1860 is similarly eye-catching, evoking, if not the literal, then the general time of the war (and Remington's birth). Like many of Remington's figures, some of the charging cavaliers have facial hair that resembles that of the mustachioed Seth Pierre Remington.

But it is another aspect of the work that demonstrates the depth of Remington's attempt to conjure his father. There are certainly differences among the riders, yet *Cavalry Charge on the Southern Plains* is remarkable for the similarity of its horsemen. They are dressed alike (except for the scout, second from the left); seven of them raise their guns. The similarity makes us aware that Remington likely composed the painting from the slightly adjusted pose of one figure—a man astride a saddle display in the artist's backyard in New Rochelle (fig. 137). This points to the artifice in the picture, as though the artist were compelled to make his model discoverable in the picture. And indeed there is something self-reflexive about the sheer repetitiveness of that gun-raised pose.

More significantly, the artist aspires to transcend such artifice. If the same model is obsessively repeated, so is the old-time soldier that the model represents. We see each trooper discretely, in his own pocket of space, as though the painting were a vignette of a single figure: like a sycophantic illustrator called upon to portray a great man, Remington shows one figure over and over again, from a variety of angles. In a more powerful sense the picture invites us to see each figure as somehow coalesced into one. The foremost figure—the one closest to the picture plane—gives the impression of being a version of the figure to the right, except at a slightly later moment in time. The scout immediately to the left of the central figure, by the same logic, would "be" the same figure at a still later moment.

The sense of motion is most dramatically shown, however, in the strip of gun-raising men extending across the sky (fig. 138). These figures evoke one of Muybridge's photographs of one man sequentially performing the same action—or, better yet, a strip of film showing the same sequence. Although the figures are similar, minute differences in their poses encourage us to imagine them as the same figure seen sequentially. We can understand the figures' gun-holding arms, for example, as moving, even as we watch, from the thump and bump of the gallop. Unlike *Downing the Nigh Leader, Cavalry Charge* divests the merely painted figure of its damning stasis, making an essentially cinematic attempt to show, as Ernst Te Peerdt might have had it, the sequence within the instant.

Not just the figures but also the hazy atmosphere contribute to this sense. The dust kicked up by the horses—note the space directly above the buffalo skull—occludes our view of churning hooves: unlike the stagecoach wheel in *Nigh Leader*, each of whose spokes is visible, the horses in *Cavalry Charge* move, as it were, almost invisibly. The figure at the far right virtually dissolves as well, though not just in dust: anxious to show movement, Remington blurs him into being. On the day that he

136. *Cavalry Charge on the Southern Plains in 1860*,
1907–8. Oil on canvas, 30⅛ × 51⅛ in. Metropolitan
Museum of Art, New York. Gift of Several Gentlemen,
1911. See plate 12.

137. Attributed to Remington, *Untitled (Model Posed
on a Saddle Display)*, ca. 1900. Albumen print.
Frederic Remington Art Museum, Ogdensburg, New
York.

138. *Cavalry Charge on the Southern Plains in 1860* (detail).

finished this picture—October 3, 1908—Remington made the statement that we have considered previously: "I have always wanted to be able to paint running horses so you would feel the details and not *see* them." In place of the static heraldry of *Nigh Leader* we have here the alkaline equivalent of Upton Sinclair's "mist of motion."

Cavalry Charge expresses Remington's deep-felt dissatisfaction with the stasis and artifice of conventional realism. The dissatisfaction—never more powerfully expressed than in his attempts in this picture to show the sequential instant—seems, I think, bound up with Remington's obsessive desire not just to represent nor even to see but somehow to touch his father (to feel the details), to bestow this legendary figure with a flesh-and-blood presence that mere paint could not achieve. *Cavalry Charge* is one of the pictures to which Remington said he applied "vibrations." In this context, the word suggests telepathic contact with his dead father, along with the kind of moving or vibrating representation that would make such contact possible. *Vibrations*, it seems to me, refers to the movement of the figures across and through the scene; to the secondary movement, or vibration, of the up-and-down of their bounce in the saddle; and to the fluttering, flickering movement of the projected movie images whose effect the picture attempts to duplicate. Finally, however, circumscribing all of these meanings, the word applies to the layer of mere paint—the pulsating but at last static network of daubs and dashes—that Remington flecked upon the surface of the canvas. (This was the explicit sense in which he used the word *vibration*.) Each of the vibrations of the picture—and indeed its overall sense of movement— simultaneously expresses Remington's desire to summon his father and the inability of mere paint to perform the trick.

The buffalo skull is the emblem of mere paint. On one level, the skull is a bit of "semantic prattle," as Roland Barthes called motifs that emphasize the already obvious: without it, we know that the soldiers belong to a bygone era.[26] There is more. Planted at the bottom of the picture, the skull is a strangely static motif in a painting otherwise given over to movement. Yet the skull is not so independent of the action as

it might at first appear. Pointed in the same direction as the troopers, with its one upturned horn that mockingly echoes their own raised weapons, the skull suggests the "eternal movelessness" (to use Wolf Larsen's phrase) of the troopers' vibrations.[27] The West's "jewel and symbol," according to one of Remington's critics, "is the dry skull reposing on the desert's breast."[28] Here, pinned to the canvas, as dead and fetishized as one of Stein's butterflies, the skull evokes the delicate dead beauty of Remington's father-troopers. For all their fluttering movement, they are specimens, toys, puppets—the square-toed veterans of a little boy's collection.

Remington's representations of the past were bound not just with his father's identity but with his own. His father wanted him to join the military, which may be why Remington, in his life and work, often tried to merge his artist's identity with a soldier's. He painted military subjects, he traveled with soldiers and cowboys, affecting an esprit de corps with them, and in his paintings and his life sometimes assumed the identity of these masculine heroes. In a self-portrait made around 1890, the year he moved from the Bronx to New Rochelle, he cast himself neither as an artist nor as a New York resident but as a cowboy (fig. 139). Remington neatly recopied at least two of the letters of Lt. Powhatan Clarke, the friend and military hero whom he idolized. These letters—Remington himself writing "My Dear Remington"—dramatically demonstrated his desire to *be* Clarke, to subsume his own identity into that of a soldier.[29]

At other times, however, Remington let surface an anxiety at having chosen to become an artist and not a soldier. In the central group of *The Last Stand*, that great early image of a Custer-like massacre, a young, mortally wounded soldier clutches the buckskinned leg of the dominant figure, the old scout (fig. 140; see also plate 5). Though not literally father and son, the two figures suggest a family relationship—a wizened veteran, with the beard of an Old Testament patriarch (and the buckskin of Custer), and a younger subordinate. Made when Remington was twenty-nine (roughly the age of the wounded subordinate), *The Last Stand* evokes Remington's desire to be a soldier—to be with and to touch a father figure in the thick of battle—and thus, if only symbolically, to renounce his artist's career. But the painting also perhaps shows Remington's sense of his own childlike weakness next to such a herculean warrior. Wounded, the subordinate exhibits a dependency more often associated with young children than young men. He clutches the veteran's pant leg in exactly the manner (and at exactly the height) of a small child at his father's side. Remington casts himself as a weak boy next to a towering father. *The Last Stand* thus recapitulates, in 1890, the two men's status during the artist's early childhood: Seth Pierre Remington, intrepid Union colonel, risking his life in a war, and Frederic Remington, "pea nut."

Many years later, Col. Schuyler Crosby would hit upon this galling situation. In 1903 the *New York Herald* reproduced Schreyvogel's painting *Custer's Demand* (Thomas Gilcrease Institute; Tulsa, Oklahoma), prompting Remington to write an angry letter accusing his rival of perpetrating all sorts of historical inaccuracies.[30] Soon thereafter Remington publicly offered to give Crosby, one of the men shown in Schreyvogel's picture, one hundred dollars for the charity of Crosby's choice if he "ever saw a pair of trousers of the color depicted in Mr. Schreyvogel's picture in the year of 1869 in any connection with the regular United States army."[31] Crosby soon replied, expressing regrets that Remington had drawn himself into the affair but going on to support the accuracy of Schreyvogel's picture in every detail except the trousers. About these he wearily proclaimed: "Mr. Remington is absolutely correct. They were not the shade of blue depicted in the picture; they were blue, but not that

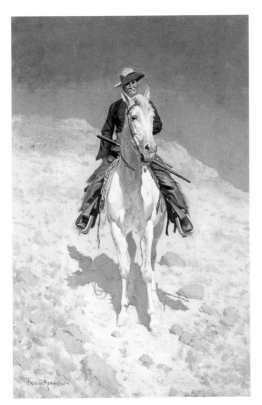

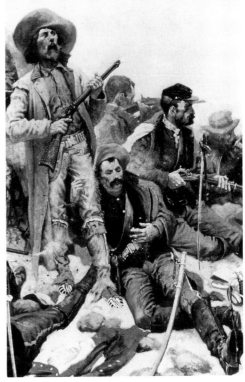

139. *Self-Portrait on a Horse*, ca. 1890. Oil on canvas, 29⁹⁄₁₆ × 19¾ in. Courtesy of Sid Richardson Collection of Western Art, Fort Worth, Texas.

140. *The Last Stand* (detail).

shade. Neither Mr. Schreyvogel nor Mr. Remington can enlighten me as to the exact shade, because they were not there, and I have forgotten, but Mr. Remington is right. I know it was a different shade of blue."[32]

"Our clothes were few and far between," Crosby added, referring to his life with Custer in the late 1860s, "and they were not changed as regularly as Master Frederic Remington's probably were at that date." At another point: "I was present at the moment Mr. Schreyvogel depicts on canvas, and Mr. Remington was riding a hobby horse, which he seems to do yet." Crosby focuses on an idea that Remington himself seems to have represented in *The Last Stand*: he was a child at the time to which his art refers, and even into adulthood he was a helpless infant, playing with puppets, next to the square-toed veteran. Eva Remington thought the same way, writing to Powhatan Clarke about one of her twenty-eight-year-old husband's artistic trips west: "Gen. Miles invited my *small* boy to go with the Commission and he accepted and I am sure he will have a charming time and see lots of Indians &c that he so much enjoys" (her italics).[33] In *The Last Stand* the blood on the wounded man's hands—the badge of courage that would evince his continuation of the Remington family's military identity—was in Frederic's case "merely paint."

The same anxiety recurs in "Joshua Goodenough's Old Letter," the Remington story that takes the form of a letter written by a father to his son. Dated June 1798, the letter is an account of the father's exploits as a member of Rogers' Rangers during the Seven Years War. In many ways, the father is an image of Remington's own father. He tells his story "not as I . . . used to tell it to you when you were a lad," as we can imagine Seth Remington telling his young son, "but with more exact truth." Like Remington's father, Goodenough goes to war at mid-century, joining the Rangers in 1757. Even the specific cause of Goodenough's enlistment, the death of an innocent black boy, strangely suggests the Civil War: "One Sunday morning I found a negro boy who was shot through the body with two balls as he was hunting for stray sheep."[34] In displaced form, the story suggests Remington writing a letter to himself from his father, evoking the artist's desire not only to merge his own identity with that of his heroic soldier-father but to be his father's continued subordinate, the mere recipient of his war stories. The family name, Goodenough, refers to the father's understated heroism—although he claims that "I did not do much," he has fought valiantly.[35] But it also refers to Frederic Remington's own attempts, as an artist, to be "Goodenough" to warrant the family name.

In his attempts to identify with soldiers and cowboys, Remington was at pains to demonstrate the masculinity, the soldierliness, of art. This was particularly evident in

his habit of describing his extended "battles" with his pictures: "Fought and have Wood picture on the go"; "I modeled and laid in 'Outlier' for 10th time. I will not be licked."[36] It also appeared in his embattled defense of subject matter. Even in the last month of his life, as the letter to Al Brolley indicates, Remington was vigorously protesting his allegiance to a masculinized subject matter, condemning as "recerchia ruffles on women's pants" the very sort of formal experiments in which he was then engaging. Thus the quotation shows the profound threat of mere paint to Remington, even as he found himself drawn to it. The "femininity" of his late style betrayed not only the memory of his father—mere paint could not restore that heroic presence—but also his father's example. In both ways, being a fine artist was, at last, not good enough.

Two late paintings, both of them set on the Saint Lawrence, demonstrate the personal stakes in Remington's re-creation of the past. *Radisson and Groseilliers*, painted in 1905, shows the two French explorers on their journey down the river in 1659 (fig. 141). Radisson stands in the middle of the canoe while Groseilliers sits beside him. The painting, the only survivor among the ten images of the Great Explorers series, shows us another of Remington's old-time aristocrats. Although Radisson himself was far from a nobleman, Remington portrays him almost as though he had come straight from the background of *The Last Cavalier*. Standing straight up, surveying the course ahead, Remington's Radisson is not so much a French explorer as a dead ringer for John Ermine, that King Charles cavalier. (In fact, Remington seems to have modeled several of his seventeenth-century Great Explorers, including La Verendrye and La Salle, on the example of Van Dyck's English cavaliers.) His arm akimbo, holding a musket, Radisson is also much like the figure at the apex of the compositional pyramid in *The Last Stand* (although his buckskins link him to the scout in that painting).

The kind of aristocratic rule that *Radisson and Groseilliers* shows is heavily autobiographical. The painting is set on the Saint Lawrence, where Remington frequently went canoeing (fig. 142). It is, however, the similarity between the names Remington and Radisson, a similarity that exceeds phonetic coincidence, that best demonstrates the personal narrative of the painting. Deployed on a horizontal similar to the line of Remington's signature (located at the lower left), the canoe also corresponds in many particulars to the signature in shape. Its ornate, scrolled prow roughly duplicates Remington's distinctive *F*; its humpbacked stern matches the last *n*; and, most strikingly, in a sublimated manifestation of one of the artist's "initial pieces" (see fig. 94), Radisson's vivid *R* matches the *R* in Remington.[37]

141. *Radisson and Groseilliers,* 1905. Oil on canvas, 17 × 29¾ in. Buffalo Bill Historical Center, Cody, Wyoming. Gift of Mrs. Karl Frank.

142. Edwin Wildman, *Untitled (Remington Canoeing on the Saint Lawrence River),* 1903. Albumen print, 2¾ × 4½ in. Frederic Remington Museum, Ogdensburg, New York.

On one level, the painting takes us back to the first Remington—John, who came to America in 1637—aligning his early presence in the country with this near contemporary scene of continental exploration. Even more specifically, in view of another striking correlation—between the names Pierre Radisson and Pierre Remington—the painting evokes one ancestor in particular: Remington's soldier-father, himself a native of the region where Remington sets the scene of the painting. Remington could not come closer to making an explicit image of his father than to portray an intrepid military forebear, traveling down the Saint Lawrence (the river on which his father was port collector), whose name was, if not Seth Pierre Remington, then Pierre Radisson.

Even as *Radisson and Groseilliers* successfully invests the past with this personal history, affording the artist some fantasized glance at his father, hero and leader of men, it nonetheless has one other and conflicting story to tell: namely, one about the inroads of mere paint, feminized mere paint, on the preservation of the past. The painting repeatedly calls attention to its own flatness. With the last two Indians in the canoe, the overlap of arm and leg—as if the rear Indian's foot grasps the oar—suggests Remington's tentative willingness to acknowledge the two-dimensional limits of the canvas. The flattening reeds of the foreground, which stretch up and overlap the canoe, become difficult to distinguish from the paint of which they are made, appearing as so much raw pigment applied onto the already completed picture. The water lilies express the interest in flatness even more powerfully. If they float on the water, their blankness—their status as flat dots—makes it possible to say that they float, like so many blind spots, upon the surface of the canvas. Their blankness denies the illusionistic capacity of both water and canvas.

Radisson and Groseilliers is thus like a mirror whose surface has been painted on in places. It is both reflective and opaque. The painting summarizes Remington's conflicting late-career aims: his interest in acts of narcissistic historical recovery, acts in which his own, his father's, and other military heroes' identities were inextricably coalesced, and his interest in the nonreferential, opaque, "recerchia" properties of paint. *Radisson and Groseilliers*, painted in 1905, is a nascent image of the encounter between paint and subject, between feminine and masculine codes, thematized in such later works as *Fired On, Wolf in the Moonlight*, and *The Horse Thief*. The lilies recall Monet and hence the "knitted" pictures of impressionism. As interruptions of the water's surface, they dramatically suggest that the splash of gunshots of *Fired On*, for all their connotation of a vigorous masculinity, flower like lilies. (Like flowers, the

143. Clarence White, *Raindrops*, 1902. Royal Photographic Society, Bath, England.

splashes are arranged in sprays.) No wonder the horse fears them. In Remington's world, flowers are more lethal than bullets.

To see how such evocations of paint were feminized in these years, we have to turn, paradoxically, to a photograph. *Raindrops*, made in 1902, is one of Clarence White's self-conscious attempts to "aestheticize" his seemingly prosaic medium (fig. 143). Like Edward Steichen and Alfred Stieglitz, White wanted to make his photographs look like contemporary paintings, so he invested his images with hazy atmospheres, careful compositions, and contrived poses. *Raindrops* shows a child holding the familiar crystal ball; in the background we can see a distant, diaphanous landscape dimly through the screen. It is the screen and the raindrops, the most salient feature of the photograph, that recall the painting of the time. The screen, parallel to the picture plane, evokes the striated surface of a canvas. (In this respect, it is very similar to the Putnam cottage in Hassam's *Indian Summer in Colonial Days*.) The raindrops evoke drops of paint arrayed upon the screen. Yet screen and raindrops exist independent of the landscape that we see in the distance. The photograph suggests a tension between transparency and material surface in the impressionist paintings that it emulates. Focusing on the foreground, White identifies the surface material as more interesting, more of a subject, than the world beyond.

White codes this mere material as feminine. Each drop hangs on the screen like an opal, bringing to mind the gendered convention of describing painterly surfaces as jeweled. Each drop also suggests a suspended tear, as though the screen itself were crying—in this way evoking the world of mere paint, or mere material, as a place of feminized sentiment. The jeweled drops repeat the shape of the womblike crystal ball itself. The globe, surrounded by the firmament of jeweled tears, amounts to a "feminized" rewriting of the contemporary imperialist language of conquerable worlds and universes (think of Roosevelt and Bucky O'Neill gazing at the stars aboard the *Yucatán* or of Roosevelt grasping that athletic ball of a world in Sargent's portrait). With the little boy staring into the globe, as well as the focus on a screened interior at the expense of the world outside, White's photograph signals a shift from outer to inner spaces.

It is strange, then, that the art of Remington of all people should ultimately come down on this side of the screen. The reeds and blind-spot lilies in *Radisson and Groseilliers* evoke a world as feminized as White's raindrops. Like the buffalo robe in *The Horse Thief* (see fig. 124), the reeds recall an Ovidian story of metamorphosis: in this case, the tale of Syrinx, the woodland nymph transformed into reeds to escape

the amorous pursuit of Pan. Strikingly, the lilies cluster and hang on to the surface of the picture (note the area just to the left of the canoe) as do White's raindrops upon the screen. The lilies are intermediate points between the raindrops and the sprays of water in *Fired On*. *Radisson and Groseilliers* thus sets up a drama between a masculinized realm of subject matter—represented by the canoe—and a feminized realm of abstraction, pattern, and mere paint. Unlike the figures in such later works as *Fired On*, however, the men in the canoe pass by without seeing these feminized tokens of paintedness. But the genesis of the conflict is there. Significantly, it is from among the reeds and lilies that the artist watches his idealized soldier-father-self glide by. With his hidden vantage (a vantage that, incidentally, may very well correspond to a view obtainable from Remington's own island), the viewer-painter is a nascent version of the hostile unseen presences in the later works. Trying to be a fine artist and, at the same time, to copy his father's soldier image, Remington signs his name amid the reeds and lilies and *as* the men and canoe. He identifies with both.

Three years later, this dual identification would not be possible. The title of *Chippewa Bay*, a little landscape painting made in 1908, refers to the inlet a mile away from which lay Remington's summer island home (fig. 144). (Ingleneuk is not visible on the canvas; it would be just off the left edge.) Remington made the picture from the farm of William Cuthbert, whose house, still standing today, was to Remington's right as he painted. The painting reproduces many of the same qualities of *Radisson and Groseilliers*: evidence, in the rocky foreground hilltop, of the painter's own position; the Saint Lawrence in the distance, with its islands now acting the part of the floating lilies in the earlier painting; and, now further removed but still brightly visible, a distant object of attention—the white house (and its barn).

The drama of the painting centers on the viewer's relation to the distant buildings. Although the viewer is atop the foreground rocks, the distant house and barn seem reachable. The pictorial structure of *Chippewa Bay* creates a unity between foreground and background, indeed, between all parts of the painting, that to an extent overrules the viewer's apparently isolated vantage. The splotches of sunlight on the foreground rocks repeat the shapes of the islands and clouds. The big rectangular rock in the left foreground matches the shape of the barn, creating a wonderful rush of space in which foreground and background, the space of the painter and the space of the distant object, are magically united. Yet, as a little geometry of white, the distant house also recalls the distant glowing wagon of *The Stranger*, a painting that Remington made in these months (see plate 8). Similarly, considering the precipitous drop from our vantage—not to mention the fence intruding between us and the

house—we seem, like the lone horseman in *The Stranger*, profoundly estranged from the object of our vision.

Remington, painting in 1908, may well have invested the house and barn with a personal symbolism. It was in this year, dismayed at the commercialization of the area and wanting to build a new house in Connecticut (what would eventually be Lorul Place, in Ridgefield), that he would decide to sell his island home. With the abandonment of this last connection to the North Country, he was consigning himself never to go back to the place of his youth. The distant house perhaps evokes his home of the future but also, more dramatically, the homes of his birth and growing up. The picture casts these places, powerfully associated in his mind with his father, as tiny, diminished, and unattainable. The three dark windows stare back at us like the campbound figures in *The Stranger*, as if the three men were entwined, in Remington's mind, with memories of home and his military father, and as if his boyhood home were in turn his first and now irrevocably distant camp.

What produced the distance, however, was not time or moving away. It was paint. The big rectangular rock in *Chippewa Bay* relates not only to the shape of the distant

144. *Chippewa Bay*, 1908. Oil on board, 12 × 18 in. Buffalo Bill Historical Center, Cody, Wyoming. Gift of the Coe Foundation.

barn but also to the shape of the canvas. Its dark left side is perfectly visible from the front, suggesting that it is a flat surface. Remington's signature and the words *Chippewa Bay* extend in perfect flatness from the side to the front of the rock, heightening our sense of its two-dimensionality. The foreground rock reads as further evidence of Remington's late-career compulsion to include evidence of his own act of painting within the images he made. The rock with his signature and the swaths and splotches across its surface looks not only painted on but painted on in a suggestively abstract way—"merely" painted on. Echoing the shape and size of the barn, the rectangle of light gray splotches on the rock simultaneously asserts Remington's desire to copy the distant buildings—to preserve the distance on canvas—and his desire to acknowledge that the nature of paint makes such preservation impossible. The splotches of sunlight on the rock, evoking both light itself and the heavy density of paint, express as powerfully as the brush in *Night Halt of the Cavalry* (see plate 7), also painted in 1908, the equivocation at the heart of Remington's late paintings. Here, as elsewhere, the equivocation is melancholy. Remington saw his home as the past and the past as his home. These he could paint.

Notes

Introduction

1. For a view of Remington's art as a literal illustration of the Old West, see Harold McCracken, *The Frederic Remington Book: A Pictorial History of the Old West* (Garden City, N.Y.: Doubleday, 1966); for a view of Remington's art (and all western art) as an illustration of the spirit, if not the facts, of the Old West, see William H. Goetzmann and William N. Goetzmann, *The West of the Imagination* (New York: Norton, 1986); and for a view of Remington's paintings as Impressionist, see Peter Hassrick, "Remington: The Painter," in *Frederic Remington: The Masterworks*, ed. Hassrick and Michael Shapiro (New York: Abrams, 1988).

2. See, e.g., John Russell, "A Popular Favorite, a Poor Reputation," *New York Times*, February 10, 1989.

3. For a description of this kind of method, see Fredric Jameson, *The Political Unconscious: Narrative as a Socially Symbolic Act* (Ithaca, N.Y.: Cornell University Press, 1981).

4. See, e.g., Stephen Greenblatt, *Marvelous Possessions: The Wonder of the New World* (Chicago: University of Chicago Press, 1991).

5. See Jules Prown, "Mind in Matter: An Introduction to Material Culture Theory and Method," *Winterthur Portfolio* 17 (Spring 1982): 1–19; and Prown, "Style as Evidence," *Winterthur Portfolio* 15 (Autumn 1980): 197–210.

6. Sadakichi Hartmann, *A History of American Art* (New York: Tudor, n.d.), 2:114.

7. In Edwin Wildman, "Frederic Remington, the Man," *Outing* (March 1903): 715–16.

8. Although this book includes a number of Remington's lesser-known and obscure works, it excludes some of his most famous: *The Fall of the Cowboy, A Dash for the Timber*, and *The Bronco Buster*, to name three. Each fits well with portions of my thesis; I have chosen to omit them only in the interest of making as concise an argument as possible.

9. Roland Barthes, *S/Z: An Essay*, trans. Richard Miller (New York: Noonday, 1974), 21.

Chapter 1: Stirring and Crawling

1. Leonard Wood diary, September 4, 1909, Library of Congress, Washington, D.C.

2. Frederic Remington diary, January 6, 1908, Frederic Remington Art Museum, Ogdensburg, N.Y. All references to Remington's diary are to this one. I have retained his spellings and punctuation here and elsewhere.

3. Remington talks about visiting the Bronx Zoo to study buffalo in his diary entry of September 16, 1907; he mentions Kinrade calling him on the telephone on January 4, 1908, to schedule posing.

4. Quoted in Perriton Maxwell, "Frederic Remington—Most Typical of American Artists," *Pearson's* 18 (October 1907): 399.

5. The first campfire scene is from Remington, "On the Indian Reservations," *Century* (July 1889), reprinted in *The Collected Writings of Frederic Remington*, ed. Peggy Samuels and Harold Samuels (Garden City, N.Y.: Doubleday, 1979), 34–35, quoted in Brian W. Dippie, *Remington and Russell* (Austin: University of Texas Press, 1982), 46. The second campfire scene is also from Remington, "On the Indian Reservations," 31. The third scene is from Remington, "Lieutenant Casey's Last Scout: On the Hostile Flanks with the Chis-Chis-Chash," *Harper's Weekly* (January 31, 1891), reprinted in *Collected Writings of Remington*, ed. Samuels and Samuels, 75.

6. Frederic Remington, *John Ermine of the Yellowstone* (Ridgewood, N.J.: Gregg Press, 1968), 112.

7. Remington diary, April 19, 1908. In the back of the diary Remington lists *A Century of Science* as purchased on April 16.

8. John Fiske, "The Doctrine of Evolution: Its Scope and Purport," in Fiske, *A Century of Science and Other Essays* (Boston: Houghton Mifflin, 1900), 42–43, 47.

9. See Remington, letter to Roosevelt [Summer 1906], and Roosevelt, letter to Remington, August 6, 1906, in *Frederic Remington—Selected Letters*, ed. Allen Splete and Marilyn Splete (New York: Abbeville, 1988), 359–60.

10. Theodore Roosevelt, "In Cowboy-Land," *Century* 46 (June 1893): 276.

11. Remington, "Buffalo Bill in London," *Harper's Weekly* (September 3, 1892), reprinted in *Collected Writings of Remington*, ed. Samuels and Samuels, 98.

12. Jack London, *The Sea-Wolf* (New York: Penguin, 1989), 221.

13. Jack London, *The Call of the Wild* (New York: Vintage, 1990), 62.

14. London, *Sea-Wolf*, 189; see also London, *White Fang*, in London, The Call of the Wild *and* White Fang (New York: Bantam, 1963), 148.

15. London, *Sea-Wolf*, 189. London's identification with Larsen is quoted in Andrew Sinclair, introduction to *The Sea-Wolf* (New York: Penguin, 1989), 9.

16. Remington, *The Way of an Indian* (New York: Fox Duffield, 1906), 175.

17. Georg Simmel, "The Metropolis and Mental Life," in Simmel, *On Individuality and Social Forms*, ed. Donald Levine (Chicago: University of Chicago Press, 1971), 332.

18. The other sculpture in which horses' veins appear is *The Wounded Bunkie* (1896). See Michael Shapiro, "Remington: The Sculptor," in *Frederic Remington: The Masterworks*, ed. Hassrick and Shapiro, 215.

19. Owen Wister, *The Virginian* (New York: Penguin, 1988), 11.

20. Remington, letter to Jack Summerhayes [1904], quoted in *Frederic Remington—Selected Letters*, ed. Splete and Splete, 347.

21. Theodore Roosevelt, "Biological Analogies in History," in Roosevelt, *History as Literature and Other Essays* (New York: Charles Scribner's Sons, 1913), 81. Roosevelt delivered "Biological Analogies in History" as a lecture at Oxford University on June 7, 1910.

22. Julian Ralph, *People We Pass: Stories of Life Among the Masses of New York City* (New York: Harper and Brothers, 1896), 179.

23. Remington, letter to Powhatan Clarke [1887], reprinted in *Frederic Remington—Selected Letters*, ed. Splete and Splete, 44.

24. Frank Norris, *The Surrender of Santiago* (San Francisco: Paul Elder, 1917), 19–20.

25. For this interpretation of the symbolism of flaying, see Edgar Wind, *Pagan Mysteries of the Renaissance* (New Haven: Yale University Press, 1958), 142–46.

26. Remington, letter to Carl Rungius [1908], Carl Rungius Papers, Glenbow-Alberta Institute, Calgary, Alberta, in Dippie, *Remington and Russell*, 11.

27. Theodore Roosevelt, "Sheriff's Work on a Ranch," *Century* 36 (May 1888): 39–51; see also Roosevelt, *Ranch Life and the Hunting Trail* (New York: Century, 1888).

28. London, *Sea-Wolf*, 166.

29. Remington, "A Gallop Through the Midway," *Harper's Weekly* (October 7, 1893), reprinted in *Collected Writings of Remington*, ed. Samuels and Samuels, 111.

30. For a valuable interpretation of Galton, see Allan Sekula, "The Body and the Archive," *October* 39 (Winter 1986): 3–64.

31. Remington, "An Outpost of Civilization," *Harper's Monthly* 87 (December 1893), reprinted in *Collected Writings of Remington*, ed. Samuels and Samuels, 118.

32. Joseph Conrad, *Heart of Darkness* (Harmondsworth, Eng.: Penguin, 1973), 51.

33. Fiske, "Doctrine of Evolution," 43.

34. Frederick W. Taylor, *The Principles of Scientific Management* (New York: Harper and Brothers, 1911); Henri Bergson, *Matter and Memory*, trans. Nancy Margaret Paul and W. Scott Palmer (London: Allen, 1910); and William James, "Memory," in *The Principles of Psychology*, vol. 1 (1890; reprint, New York: Dover, 1950), 643–89. In Chapter 4, I discuss James's ideas about memory and the perception of time.

35. Remington, *John Ermine*, 194, 226–27.

36. Ben Merchant Vorpahl, *My Dear Wister: The Frederic Remington–Owen Wister Letters* (Palo Alto, Calif.: American West, 1972), 310–16.

37. Remington, *John Ermine*, 165.

38. Remington, *John Ermine*, 163, 55, 85, 129.

39. Remington, *John Ermine*, 263–64; John Seelye, "Remington: The Writer," in *Frederic Remington: The Masterworks*, ed. Hassrick and Shapiro, 253.

40. Remington, *John Ermine*, 163, 187, 169.

41. Remington, *John Ermine*, 156. See also 102, 109, 138, and 206.

42. Remington, *John Ermine*, 130–31.

43. Remington, *John Ermine*, 207, 246.

44. James Ballinger, *Frederic Remington* (New York: Abrams, 1989), 112.

45. Remington, *John Ermine*, 184.

46. Remington, *John Ermine*, 56.

47. Remington, *John Ermine*, 87–88.

48. Remington, "Coursing Rabbits on the Plains," *Outing* 10 (May 1887), reprinted in *Collected Writings of Remington*, ed. Samuels and Samuels, 1–10.

49. Remington, letter to Owen Wister, October 24 [1895], reprinted in *Frederic Remington—Selected Letters*, ed. Splete and Splete, 276.

50. London, *White Fang*, 205–6, 251.

51. Helen Cooper, *Winslow Homer Watercolors* (New Haven: Yale University Press, 1986), 216.

52. See Albert Boime, *The Art of Exclusion: Representing Blacks in the Nineteenth Century* (Washington, D.C.: Smithsonian Institution Press, 1990), 36–46.

53. Remington, *John Ermine*, 268.

54. Remington, *John Ermine*, 137, 92, 95.

55. Stephen Crane, "The Bride Comes to Yellow Sky," reprinted in Crane, *The Open Boat and Other Stories* (New York: Dover, 1993), 79–88.

56. For more information on this painting, particularly as it relates to the town of Great Falls, see Alexander Nemerov, "Projecting the Future: Film and Race in the Art of Charles Russell," *American Art* 8 (Winter 1994): 71–89.

57. Roosevelt, "The Round-Up," *Century* 35 (April 1888): 855.

58. London, *Sea-Wolf*, 52.

59. Owen Wister, "The Evolution of the Cow-Puncher," *Harper's Monthly* 91 (September 1895): 604.

60. Remington, *John Ermine*, 88.

61. Remington diary, January 16, 1908.

62. In his diary entry for March 19, 1908, Remington mentions seeing Whistler's paintings at the Macbeth Gallery in New York. Remington's ownership of the Pennells' *Life of James McNeill Whistler* (Philadelphia: J. B. Lippincott, 1908) is cited in Doreen Bolger Burke, "Remington in the Context of His Artistic Generation," in *Frederic Remington: The Masterworks*, ed. Hassrick and Shapiro, 261 n. 66. Arthur Jerome Eddy's *Recollections and Impressions* (Philadelphia: J. B. Lippincott, 1904) is in Remington's library at the Frederic Remington Art Museum. It is inscribed to Remington from his wife's sister Emma Caten on Christmas 1905. Remington's sculpture scrapbook is in the collection of the Frederic Remington Art Museum.

63. Remington diary, March 19, 1908.

64. "Personally I find the picture a little black, but that is the fault of a good many Whistlers," wrote the painter Walter Gay, who helped the Metropolitan acquire *Nocturne in Green and Gold* as a gift in 1906. In 1909 Roger Fry referred to the work as "ill-fated" and advised against the purchase of other bitumen-laden Whistlers. Both of these accounts are quoted in Natalie Spassky et al., *American Paintings in the Metropolitan Museum of Art*, vol. 2 (Princeton: Princeton University Press, 1985), 372.

65. Remington's remark is in "Under the Spreading Chestnut Tree," *Everybody's* 20 (April 1909): 581. Remington attached the clipping to his diary entry of March 26, 1909.

66. Remington, letter to Al Brolley, December 8 [1909], reprinted in *Frederic Remington—Selected Letters*, ed. Splete and Splete, 435.

67. London, *White Fang*, 220.

68. Remington diary, September 17, 1907, July 1, 1908, and February 24, 1908.

69. Remington, *John Ermine*, 149.

70. Remington, *Way of an Indian*, 54.

71. "Finished 'The Love Call' in one sitting," Remington wrote in his diary on July 6, 1909.

72. Remington, *John Ermine*, 86.

73. See Linda Merrill, *A Pot of Paint: Aesthetics on Trial in Whistler v. Ruskin* (Washington, D.C.: Smithsonian Institution Press, 1992).

74. Remington diary, January 16, 1908.

75. Remington diary, December 9, 1909.

76. Peter Hassrick, *Frederic Remington: Paintings, Drawings, and Sculptures in the Amon Carter Museum and the Sid W. Richardson Collections* (New York: Abrams, 1973), 146.

77. Augustus Thomas, "Recollections of Frederic Remington," *Century* 86 (July 1913): 354, 361.

Chapter 2: The Death of Triumph

1. Remington, "With the Fifth Corps," *Harper's Monthly* 47 (November 1898): 962.

2. Thomas, "Recollections of Frederic Remington," 357.

3. Hassrick, "Remington: The Painter," 122.

4. Seelye, "Remington: The Writer," 239–41.

5. Remington, "With the Fifth Corps," 962.

6. Another precedent in Remington's work for advancing figures—figures, moreover, advancing upward in a military attack—is *The Storming of Ticonderoga*, one of the illustrations that he made for his story "Joshua Goodenough's Old Letter" (*Harper's Monthly* 95 [November 1897]: 885). Yet in this picture, which shows soldiers struggling to avoid defense thickets before a withering fire, the figures are as much stationary as anything else.

7. Theodore Roosevelt, *The Rough Riders* (New York: Charles Scribner's Sons, 1906), 10–11.

8. Roosevelt, *Rough Riders*, 4–5.

9. Caspar Whitney, "Amateur Sport," *Harper's Weekly* (Weekly Department, 1891–99), quoted in Michael Oriard, *Reading Football: How the Popular Press Created an American Spectacle* (Chapel Hill: University of North Carolina Press, 1993), 212–13.

10. Walter Camp, "Team Play in Foot-ball," *Harper's Weekly* (October 31, 1891): 845, quoted in Oriard, *Reading Football*, 45.

11. Anonymous, "Future of Football," *Nation* (1890), 395, quoted in Oriard, *Reading Football*, 217.

12. Paul Fussell, *The Great War and Modern Memory* (London: Oxford University Press, 1975), 27. The survivor quoted is Pvt. L. S. Price.

13. Quoted in Fussell, *Great War and Modern Memory*, 25–26.

14. Oriard, *Reading Football*, 203.

15. Oriard, *Reading Football*, 202.

16. Oriard, *Reading Football*, 42.

17. Frank Norris, "The Frontier Gone at Last," in Norris, *The Responsibilities of the Novelist and Other Literary Essays* (New York: Haskell House, 1969), 69.

18. For an account of the Carlisle football team, see Oriard, *Reading Football*, 233–47.

19. Lewis Sheldon French and Walter Camp, *Yale: Her Campus, Class-Rooms, and Athletics* (Boston: L. C. Page, 1899), 163.

20. Walter Camp, *Walter Camp's Book of College Sports* (New York: Century, 1893), 142–46, quoted in Oriard, *Reading Football*, 53–54.

21. Oriard, *Reading Football*, 55.

22. Remington, "With the Fifth Corps," 972.

23. French and Camp, *Yale: Her Campus, Class-Rooms, and Athletics*, 169.

24. William Jennings Bryan, "Imperialism," quoted in *Bryan on Imperialism* (New York: Arno Press, 1970), 79.

25. Bryan, "Jefferson Versus Imperialism," *New York Journal*, December 25, 1898, quoted in *Bryan on Imperialism*, 25, 29.

26. Remington, "With the Fifth Corps," 968, 970, 974, 970, 966, 968.

27. Remington, "With the Fifth Corps," 962, 963.

28. Remington, "With the Fifth Corps," 974, 968.

29. Richard Harding Davis, *The Cuban and Porto Rican Campaigns* (1898), quoted in Arthur Lubow, *The Reporter Who Would Be King: A Biography of Richard Harding Davis* (New York: Charles Scribner's Sons, 1992), 184.

30. Roosevelt writes of a person living a leisured life thanks to the strenuous effort of his ancestors: "If he treats this period of freedom from the need of actual labor as a period, not of preparation, but of mere enjoyment, even though perhaps not of vicious enjoyment, he shows that he is simply a cumberer of the earth's surface" (Theodore Roosevelt, "The Strenuous Life," in his *Strenuous Life: Essays and Addresses* [New York: Charles Scribner's Sons, 1906], 5).

31. Remington, "With the Fifth Corps," 970.

32. Remington, "Military Athletics at Aldershot," *Harper's Weekly* (September 10, 1892), quoted in *Collected Writings of Remington*, ed. Samuels and Samuels, 100.

33. Remington, "Wigwags from the Blockade," *Harper's Weekly* (May 14, 1898), quoted in *Collected Writings of Remington*, ed. Samuels and Samuels, 305–6.

34. Remington, "Wigwags from the Blockade," in *Collected Writings of Remington*, ed. Samuels and Samuels, 305. In "The Dynamo and the Virgin," the most famous chapter in *The Education of Henry Adams*, Adams writes, "As he grew accustomed to the great gallery of machines, he began to feel the forty-foot dynamos as a moral force, much as the early Christians felt the Cross" (Henry Adams, *The Education of Henry Adams* [New York: Random House, 1931], 380).

35. Thomas J. Vivian, *The Fall of Santiago* (New York: R. F. Fenno, 1898), 155–56.

36. Roosevelt, *Rough Riders*, 64, 37, 65.

37. London, *Sea-Wolf*, 24.

38. Roosevelt, *Rough Riders*, 62.

39. Solon Irving Bailey, "Exploring the Southern Sky," *Harper's Weekly* 49 (September 2, 1905): 1269.

40. "We had enjoyed San Antonio, and were glad that our regiment had been organized in the city where the Alamo commemorates the death fight of Crockett, Bowie, and their famous band of frontier heroes" (Roosevelt, *Rough Riders*, 43–44).

41. Roosevelt, *Rough Riders*, 58, 68, 126, 133.

42. Greenblatt, "Kidnapping Language," in Greenblatt, *Marvelous Possessions*, 104.

43. Bailey, "Exploring the Southern Sky," 1284.

44. Bryan, "The National Emblem," in *Bryan on Imperialism*, 7.

45. Edgar Rice Burroughs, *A Princess of Mars* (New York: Grosset and Dunlap, 1917), 21.

46. John Seelye, introduction to Edgar Rice Burroughs, *Tarzan of the Apes* (New York: Penguin, 1990), xiii.

47. L. Frank Baum, *The Wizard of Oz* (London: Puffin, 1990), 11, 15, 19, 15, 32, 32.

48. William H. Pickering, "The Origin of Our Moon," *Harper's Monthly* 115 (June 1907): 129.

49. Bailey, "Exploring the Southern Sky," 1284.

50. Wister, *Virginian*, 170, 11, 166. The extensive documentation of the eruption of Mont Pelée, on Martinique, on May 7, 1902, exemplifies the period discourse of volcanoes, craters, and exotic spaces. See Robert Hill, "A Study of Pelée: Impressions and Conclusions of a Trip to Martinique," *Century* 64 (September 1902): 764–85; and Israel C. Russell, "Phases of the West Indian Eruptions: Deductions from Personal Observation of the Regions Devastated by Mont Pelée and La Soufriere," *Century* 64 (September 1902): 786–800.

51. Pickering, "Origin of Our Moon," 129.

52. Ballinger, *Frederic Remington*, 113.

53. Burroughs, *Princess of Mars*, 20–21.

54. Dippie, *Remington and Russell*, 54.

55. Henry James, *The American Scene* (New York: Charles Scribner's Sons, 1946), 422–23.

56. Remington, "An Outpost of Civilization," in *Collected Writings of Remington*, ed. Samuels and Samuels, 117.

57. Remington diary, November 4, 1908.

58. London, *White Fang*, 154, 156, 155, 155.

59. Quoted in Stanley Karnow, *In Our Image: America's Empire in the Philippines* (New York: Random House, 1989), 189.

60. For an account of Balangiga, see Karnow, *In Our Image*, 188–91.

61. For an account of the way Filipinos were divided into evolutionary grades see Robert Rydell, "The Louisiana Purchase Exposition, Saint Louis, 1904: 'The Coronation of Civilization,'" in Rydell, *All the World's a Fair: Visions of Empire at American International Expositions, 1876–1916* (Chicago: University of Chicago Press, 1984), 167–78.

62. Remington, "With the Fifth Corps," 966.

63. James F. J. Archibald, "What I Saw in the War: No. 7.—True Heroism in the Muddy Trenches," *Leslie's Weekly* 88 (January 5, 1899): 9.

64. Remington, letter to Wister [April 1896], quoted in *Frederic Remington—Selected Letters*, ed. Splete and Splete, 216.

65. Baum, *Wizard of Oz*, 15.

66. *Collier's Weekly* (November 11, 1905): 8.

67. Conrad, *Heart of Darkness*, 63.

68. Burroughs, *Tarzan of the Apes*, 227.

69. Julian Ralph, *Towards Pretoria* (London: C. Arthur Pearson, 1900), 277, 276.

70. Conrad, *Heart of Darkness*, 20.

71. Conrad, "An Outpost of Progress," in *Great Short Works of Joseph Conrad* (New York: Harper and Row, 1966), 35–36.

72. Vivian, *Fall of Santiago*, 164.

73. Roosevelt, *Rough Riders*, 140.

74. Norris, *Surrender of Santiago*, 15.

75. Remington, "With the Fifth Corps," 974.

76. Conrad, *Heart of Darkness*, 20.

77. Vivian, *Fall of Santiago*, 163.

78. Roosevelt, *Rough Riders*, 137.

79. Jacob Riis, quoted in Edward A. Johnson, *History of Negro Soldiers in the Spanish-American War* (Raleigh, N.C.: Capital, 1899), 68–71.

80. Roosevelt, *Rough Riders*, 137–38.

81. Presley Holliday, quoted in Johnson, *History of Negro Soldiers*, 67–68.

82. W. B. Phillips, quoted in Johnson, *History of Negro Soldiers*, 84, 86.

83. Remington, "A Scout with the Buffalo-Soldiers," *Century* (April 1889), in *Collected Writings of Remington*, ed. Samuels and Samuels, 25.

84. Remington, "With the Fifth Corps," 974.

85. Roosevelt, *Rough Riders*, 9.

86. Remington, "A Scout with the Buffalo-Soldiers," 26.

87. Dippie, *Remington and Russell*, 46.

88. Amy Kaplan, "Black and Blue on San Juan Hill," in Kaplan and Donald Pease, eds., *Cultures of United States Imperialism* (Durham, N.C.: Duke University Press, 1993), 235.

89. Orison Madison Grant, *The Passing of the Great Race; or, The Racial Basis of European*

History (New York: Scribner's, 1916).

90. Remington, "The War Dreams," *Harper's Weekly* (May 7, 1898), in *Collected Writings of Remington*, ed. Samuels and Samuels, 301.

Chapter 3: Bloody Hands

1. "Mr. Remington's Pictures: Something Less Than 100 Works Fetch Something More Than $7,000," unidentified newspaper clipping [1893], Woolaroc Museum, Bartlesville, Okla.

2. Remington, *John Ermine*, 184.

3. Owen Wister, "The Evolution of the Cow-Puncher," *Harper's Monthly* 91 (September 1895): 606.

4. Arthur Wheelock, Jr., et al., *Anthony Van Dyck* (Washington, D.C.: National Gallery of Art, 1990), 259.

5. John Higham, *Strangers in the Land: Patterns of American Nativism, 1860–1925* (New York: Atheneum, 1968), 159.

6. Peggy Samuels and Harold Samuels, *Frederic Remington: A Biography* (Garden City, N.Y.: Doubleday, 1982), 5.

7. Remington, letter to Poultney Bigelow [June 14, 1894], Owen D. Young Library, Saint Lawrence University, Canton, N.Y.

8. Remington's copy of *The Saints Everlasting Rest* by Richard Baxter (London, 1659) is in my own collection.

9. George Wharton Edwards, "Lines to the Happy Life of F.R.," unpublished poem, Frederic Remington Art Museum.

10. Remington diary, March 8, 1908.

11. Remington diary, January 17, 1908.

12. Wallace Irwin, "Immigration," in *At the Sign of the Dollar* (New York: Fox Duffield, 1905), 57.

13. Homer Davenport, letter to Eva Remington, May 15, 1909, Frederic Remington Art Museum.

14. Leonard Wood diary, December 26, 1909.

15. Remington diary, January 10 and January 9, 1908.

16. Remington, *John Ermine*, 22.

17. London, *Call of the Wild*, 14.

18. F. Scott Fitzgerald, *The Great Gatsby* (New York: Charles Scribner's Sons, 1925), 177.

19. Van Wyck Brooks, *The Wine of the Puritans: A Study of Present-Day America* (London: Sisley's, 1908), 10–11.

20. John Dos Passos, *Manhattan Transfer* (Boston: Houghton Mifflin, 1925), 69.

21. James, *American Scene*, 131.

22. See, e.g., Upton Sinclair, *The Jungle* (New York: Penguin, 1985), 5.

23. Remington, "A Few Words from Mr. Remington," *Collier's Weekly* 34 (March 18, 1905): 16.

24. London, *White Fang*, 128.

25. Burroughs, *Tarzan of the Apes*, 32.

26. "Four Paintings by the Modern Artist Charles M. Russell," *Scribner's* 70 (August 1921): 146.

27. Peter Hassrick, *Charles M. Russell* (New York: Abrams, 1989), 66.

28. Remington, "Chicago Under the Mob," *Harper's Weekly* 38 (July 21, 1894), in *Collected Writings of Remington*, ed. Samuels and Samuels, 154.

29. Nicholas Murray Butler, "The Revolt of the Unfit," in Brander Matthews, ed., *The Oxford Book of American Essays* (New York: Oxford University Press, 1914), 489. Eva Remington mentions attending the lecture in her diary of 1910, saying that Butler takes "the long view" (Eva Remington diary, private collection).

30. Butler, "Revolt of the Unfit," 491.

31. Remington, "Chicago Under the Law," *Harper's Weekly* 38 (July 28, 1894), in *Collected Writings of Remington*, ed. Samuels and Samuels, 156.

32. Burroughs, *Tarzan of the Apes*, 172.

33. Remington, "Coolies Coaling a Ward Liner—Havana," *Harper's Weekly* (November 7, 1891), in *Collected Writings of Remington*, ed. Samuels and Samuels, 88.

34. Henry Fairfield Osborn, introduction to Grant, *Passing of the Great Race*, xxxi.

35. See Virginia Couse Leavitt, *Eanger Irving Couse: Image Maker for America* (Albuquerque, N.Mex.: Albuquerque Museum, 1991), 66–67.

36. George Du Maurier, *Trilby* (New York: Harper and Brothers, 1894), 18–19.

37. For other representations of this subject, see Bram Dijkstra, "Dead Ladies and the Fetish of Sleep," in Dijkstra, *Idols of Perversity: Fantasies of Feminine Evil in Fin-de-Siècle Culture* (New York: Oxford University Press, 1986), 50–63.

38. Bram Stoker, *Dracula* (New York: Penguin, 1993), 213.

39. Du Maurier, *Trilby*, 112.

40. Du Maurier, *Trilby*, 112.

41. "I never got my letter from De [*sic*] Maurier saying 'thanks d—— you. I would frame it but one can't have everything" (Remington, letter to Poultney Bigelow [1895], in *Frederic Remington—Selected Letters*, ed. Splete and Splete, 270).

42. Remington, *John Ermine*, 211.

43. London, *Call of the Wild*, 78.

44. London, *Sea-Wolf*, 116.

45. Wister, *Virginian*, 192, 195.

46. Remington, "The Affair of the ——th of July," *Harper's Weekly* (February 2, 1895), in *Collected Writings of Remington*, ed. Samuels and Samuels, 181–82.

47. Remington, "Affair of the ——th of July," 178; Remington, "Chicago Under the Mob," 154.

48. Sinclair, *Jungle*, 32, 115.

49. Remington, "Chicago Under the Mob," 154.

50. Sinclair, *Jungle*, 232, 182, 191, 210.

51. Sinclair, *Jungle*, 45, 183.

52. London, *Call of the Wild*, 64.

53. Ernest Poole, "Cowboys of the Skies," *Everybody's* 19 (November 1908): 641–53.

54. Norris, "Frontier Gone at Last," 74–75.

55. Remington, "Chicago Under the Mob," 152.

56. Richard Slotkin, *The Fatal Environment: The Myth of the Frontier in the Age of Industrialization, 1800–1890* (Middletown, Conn.: Wesleyan University Press, 1986); and Slotkin, *Gunfighter Nation: The Myth of the Frontier in Twentieth-Century America* (New York: Atheneum, 1992). For an account of Remington's Pullman strike coverage, see Slotkin, *Gunfighter Nation*, 95–101.

57. Remington, "Chicago Under the Law," 157.

58. Remington, letter to Poultney Bigelow [May 1893], in *Frederic Remington—Selected Letters*, ed. Splete and Splete, 171 (Remington refers to Bigelow's article "The Russian and His Jew," *Harper's Monthly* 88 [March 1894]: 603–14); Remington, "Affair of the——th of July," 183.

59. Remington, letter to Al Brolley, December 8 [1909], in *Frederic Remington—Selected Letters*, ed. Splete and Splete, 435.

60. Remington diary, August 19, 1907.

61. See Remington's December 8, 1909, letter to Al Brolley.

62. See Ronald Davis, *Augustus Thomas* (Boston: Twayne, 1984), 21–31.

63. Augustus Thomas, *The Witching Hour* (New York: Grosset and Dunlap, 1908), 100.

64. Augustus Thomas, "The Stage and Its People," *Philadelphia Telegram*, October 19, 1908, in Davis, *Augustus Thomas*, 26.

65. Augustus Thomas, "A Play to Be Seen," *New York Times*, December 5, 1909, in Davis, *Augustus Thomas*, 27.

66. Augustus Thomas, "An Inquiry Concerning Drama," *Art World* 1 (October 1916): 53, in Davis, *Augustus Thomas*, 27.

67. Davis, *Augustus Thomas*, 30.

68. Remington, letter to Martha Summerhayes [1907], in *Frederic Remington—Selected Letters*, ed. Splete and Splete, 402.

69. See Hassrick, "Remington: The Painter," 123.

70. "Every independent master has his own special conception and treatment of landscape, and what is more, of the form of the hand and ear. For every important painter has, so to speak, a type of hand and ear peculiar to himself" (Giovanni Morelli, *Italian Painters: Critical Studies of Their Works*, trans. Constance Jocelyn Ffoulkes [London: John Murray, 1900], 76–77).

71. Arthur Conan Doyle, "The Adventure of the Cardboard Box," reprinted in Doyle, *Memoirs of Sherlock Holmes*, 17–29, in *The Sherlock Holmes Illustrated Omnibus* (New York: Schocken, 1976). Quotations are from pp. 24 and 27.

72. "If the mysterious story can be made to make sense, then the world itself makes sense and has meaning. It too ceases to be incoherent, elliptical, mysterious, and apparently arbitrary. Hence the meaningful nature of existence itself is validated by rendering a puzzling and mysterious story into causal or temporal sequences in which every odd detail fits and finds its significant place" (Steven Marcus, introduction to *The Adventures of Sherlock Holmes*, in Doyle, *Sherlock Holmes Illustrated Omnibus*, x–xi).

73. Carlo Ginzburg, "Morelli, Freud and Sherlock Holmes: Clues and Scientific Method," *History Workshop* 9 (Spring 1980): 13.

74. Ginzburg, "Morelli, Freud and Sherlock Holmes," 13.

75. Remington, "A Few Words from Mr. Remington," 18.

76. In formulating this argument, I was indebted to Michael Fried's essay "Stephen Crane's Upturned Faces," in Fried, *Realism, Writing, Disfiguration: On Thomas Eakins and Stephen Crane* (Chicago: University of Chicago Press, 1987).

77. Remington, "Julian Ralph," *Harper's Weekly* (February 24, 1894), in *Collected Writings of Remington*, ed. Samuels and Samuels, 131.

78. Remington, *John Ermine*, 75.

79. Rudyard Kipling, "How the Alphabet Was Made," in Kipling, *Just So Stories for Little Children* (New York: Penguin, 1987), 115.

80. Kipling, "How the First Letter Was Written," in Kipling, *Just So Stories*, 95–105.

81. Arthur Conan Doyle, "The Adventure of the Dancing Men," *Strand Magazine* (December 1903), reprinted in Doyle, *The Return of Sherlock Holmes*, 33–47, in *Sherlock Holmes Illustrated Omnibus*.

82. Doyle, "Adventure of the Dancing Men," 43.

83. Doyle, "Adventure of the Dancing Men," 36.
84. Doyle, "Adventure of the Dancing Men," 41.
85. Wister, "Evolution of the Cow-Puncher," 615.

Chapter 4: Dark Thoughts

1. Tom Lutz, *American Nervousness, 1903: An Anecdotal History* (Ithaca, N.Y.: Cornell University Press, 1991), 35.
2. *The Quatrains of Abu'l Ala*, selected and translated by Ameen F. Rihani (New York: Doubleday, Page, 1903), 14, 123.
3. Atwood Manley and Margaret Manley Mangum, *Frederic Remington and the North Country* (New York: E. P. Dutton, 1988), 175.
4. Thomas, "Recollections of Frederic Remington," 354.
5. Remington diary, April 20, April 24, May 4, June 6, July 2, July 20, August 12, August 2, and March 14, 1909.
6. Maxwell, "Frederic Remington—Most Typical of American Artists," 394, 396, 398.
7. Remington diary, September 14, 1908. The books in question are Alfred Henry Lewis, *Wolfville* (New York: Grosset, 1897), and Richard Harding Davis, *Ranson's Folly* (New York: Charles Scribner's Sons, 1902).
8. For Remington's artistic debt to these painters, see Doreen Bolger Burke, "Remington in the Context of His Artistic Generation," in *Frederic Remington: The Masterworks*, ed. Hassrick and Shapiro, 50.
9. Royal Cortissoz, "Frederic Remington: A Painter of American Life," *Scribner's* 47 (February 1910): 192.
10. Joseph Conrad, *The Nigger of the Narcissus*, in *Great Short Works of Joseph Conrad*, 59.
11. Jameson, *Political Unconscious*, 238.
12. Theodore Roosevelt, "Dante and the Bowery," in Brander Matthews, ed., *The Oxford Book of American Essays* (Great Neck, N.Y.: Core Collections, 1968), 485, 486.
13. Remington, *John Ermine*, 246.
14. Owen Wister, preface to Remington, *Drawings*, in Vorpahl, *My Dear Wister*, 223–24.
15. Stoker, *Dracula*, 270.
16. Alexander Pope, "An Essay on Man," in Aubrey Williams, ed., *Poetry and Prose of Alexander Pope* (Boston: Houghton Mifflin, 1969), 125.
17. Remington, "How Order No. 6 Went Through, as Told by Sun-Down Leflare," *Harper's*

Monthly 96 (May 1898), in *Collected Writings of Remington*, ed. Samuels and Samuels, 297–98.
18. James Hyslop, *Borderland of Psychical Research* (Boston: Herbert B. Turner, 1906), 102.
19. Hyslop, *Borderland of Psychical Research*, 102.
20. James, *Principles of Psychology*, 1:638.
21. James, *Principles of Psychology*, 1:622–23.
22. James, *Principles of Psychology*, 1:631.
23. London, *Call of the Wild*, 22.
24. James, *Principles of Psychology*, 1:635.
25. James, *Principles of Psychology*, 1:637.
26. See, e.g., Hassrick, "Remington: The Painter."
27. Davis, *Augustus Thomas*, 78.
28. Thomas, *Witching Hour*, 217.
29. Thomas, *Witching Hour*, 84–85.
30. Du Maurier, *Trilby*, 457–58.
31. Irving Bacheller, letter to Remington, December 5, 1908, in *Frederic Remington—Selected Letters*, ed. Splete and Splete, 403.
32. Thomas, preface to *Witching Hour*, in Davis, *Augustus Thomas*, 85.
33. Thomas, *Witching Hour*, 140–41.
34. Thomas, *Witching Hour*, 99.
35. Thomas, *Witching Hour*, 48.
36. Edward Buscombe, *The BFI Companion to the Western* (New York: Atheneum, 1988), 24.
37. Nemerov, "Projecting the Future."
38. Frederic Myers, *Human Personality and Its Survival of Bodily Death*, vol. 2 (New York: Arno Press, 1975), 4.
39. Thomas, *Witching Hour*, 165–78.
40. Thomas, "Recollections of Frederic Remington," 361.
41. Wood mentions the two men bringing the horses to Ridgefield in his diary entry for September 4, 1909 (Wood diary, Library of Congress).
42. Remington diary, January 15, 1908.
43. Remington, letter to Al Brolley, December 8 [1909], in *Frederic Remington—Selected Letters*, ed. Splete and Splete, 435.
44. Unidentified newspaper clipping, Remington diary, December 7, 1909.
45. Remington diary, March 26, 1908.
46. Royal Cortissoz, "Frederic Remington: A Painter of American Life," *Scribner's* 47 (February 1910): 192.
47. Myers, *Human Personality and Its Survival of Bodily Death*, 2:4.
48. James, *Principles of Psychology*, 1:645.
49. Remington refers to ordering six black

frames for his pictures in his diary entry for November 4, 1908.

50. Myers, *Perspectives in Psychical Research*, 2:4–5.

51. Remington diary, February 13, 1908.

52. George Sack, letter to Nancy Russell, May 30, 1928, Homer Britzman Papers, Colorado Springs Fine Arts Center, Colorado Springs, Colo.

53. Myers, *Perspectives in Psychical Research*, 1:237.

54. Myers, *Perspectives in Psychical Research*, 1:230.

55. Remington, *Done in the Open: Drawings by Frederic Remington* (New York: P. F. Collier and Son, 1902), 10–11. The authorial credit—"With an introduction and verses by Owen Wister and others" —makes it impossible to determine whether Wister himself wrote the poem in question.

56. G. S. Lee, *The Voice of the Machines* (New York, 1906), in Stephen Kern, *The Culture of Time and Space, 1880–1918* (Cambridge: Harvard University Press, 1983), 39.

57. Myers, *Perspectives in Psychical Research*, 1:142.

58. Remington, "Joshua Goodenough's Old Letter," *Harper's Monthly* 95 (November 1897), in *Collected Writings of Remington*, ed. Samuels and Samuels, 268–76.

59. Samuels and Samuels, *Frederic Remington: A Biography*, 77, 336.

60. Although no date is on the sketch, an entry in Eva Remington's diary (June 24, 1910) refers to sketches of Ralph in Remington's possession as having been made in 1896 (Eva Remington diary, Collection of Mrs. Betsey Caten Deuval, Gouverneur, N.Y.).

Chapter 5: Merely Paint

1. My focus is on visual artists, but other historians have concentrated on turn-of-the-century writers whose work betrays a conflict between materiality and representation. See Michael Fried, "Stephen Crane's Upturned Faces," in Fried, *Realism, Writing, Disfiguration: On Thomas Eakins and Stephen Crane* (Chicago: University of Chicago Press, 1987); Fried, "Almayer's Face: On 'Impressionism' in Conrad, Crane, and Norris," *Critical Inquiry* 17 (Autumn 1990): 193–236; and Walter Benn Michaels, "The Gold Standard and the Logic of Naturalism," in Michaels, *The Gold Standard and the Logic of Naturalism* (Berkeley: University of California Press, 1987), 137–80. For a critique of Fried, see Bill Brown, "Writing, Race, and Erasure: Michael Fried and the Scene of Reading," *Critical Inquiry* 18 (Winter 1992): 387–402. See also Fried, "Response to Bill Brown," *Critical Inquiry* 18 (Winter 1992): 403–10.

2. Remington diary, June 27, 1909.

3. See Hassrick, "Remington: The Painter," 145–67.

4. T. J. Clark, "Clement Greenberg's Theory of Art," *Critical Inquiry* 9 (September 1982): 154.

5. Remington, "The Curse of the Wolves," *Collier's Weekly* (January 27, 1898), in *Collected Writings of Remington*, ed. Samuels and Samuels, 285.

6. London, *Sea-Wolf*, 117.

7. Hassam, letter to Remington, December 20 [1906], in *Frederic Remington—Selected Letters*, ed. Splete and Splete, 361.

8. Mary Shelley, *Frankenstein* (Harmondsworth, Eng.: Penguin, 1985), 185.

9. Edward Gordon Craig, *On the Art of the Theatre* (New York: Theatre Arts Books, 1956), 90.

10. Paul McPharlin, *The Puppet Theatre in America: A History* (New York: Harper and Brothers, 1949), 320.

11. N. C. Wyeth, letter to Henriette Wyeth, August 10, 1906, in *The Wyeths: The Letters of N. C. Wyeth, 1901–1945*, ed. Betsy James Wyeth (Boston: Gambit, 1971), 174. The story on puppetry is Albert White Vorse, "The Play's the Thing," *Scribner's* 26 (August 1899): 167–78; the article is Francis H. Nichols, "A Marionette Theater in New York," *Century* 63 (March 1902): 677–82.

12. For a discussion of Remington and photography, see Estelle Jussim, *Frederic Remington, the Camera, and the Old West* (Fort Worth, Tex.: Amon Carter Museum, 1983).

13. Sinclair, *Jungle*, 160.

14. Remington diary, October 3, 1908.

15. Kern, *Culture of Time and Space*, 22.

16. In Wildman, "Frederic Remington, the Man," 715–16.

17. Remington, "In the Sierra Madre with the Punchers," *Harper's Monthly* (February 1894), in *Collected Writings of Remington*, ed. Samuels and Samuels, 128.

18. See, e.g., the photographic source for *Fight for the Water Hole* (Frederic Remington Art Museum). In *The Second Shot* (1892), an illustration showing a man photographing a dead moose, he painted the photographer's shadow extending into the space of his photograph.

19. The large, shadowed, blanket-clad figure also strikingly resembles the figure of Rodin's *Balzac* in

Edward Steichen's evocative photographs of the sculpture, also made in 1908. In my mind, the resemblance solidifies the sense in which the blanket-clad figure in Remington's work is an artist, for it suggests that Remington's work shares with Steichen's a fascination with the creative artist as a darkened, brooding loner or stranger.

20. For Seth Pierre Remington's Civil War record, see Samuels and Samuels, *Frederic Remington: A Biography*, 8–12.

21. Seth Pierre Remington, letter to Frederic Remington, March 9, 1871, in *Frederic Remington—Selected Letters*, ed. Splete and Splete, 9.

22. Samuels and Samuels, *Frederic Remington: A Biography*, 9.

23. Thomas, "Recollections of Frederic Remington," 354.

24. Samuels and Samuels, *Frederic Remington: A Biography*, 5.

25. In the diary entry for March 11, 1907, Remington mentions transferring his father's remains to the new family plot.

26. Roland Barthes, *S/Z: An Essay*, 179.

27. London, *Sea-Wolf*, 74.

28. Unidentified newspaper review, Remington diary, December 11, 1909.

29. The letters are in the collection of the Frederic Remington Art Museum. My thanks to Laura Foster for calling them to my attention.

30. "Finds Flaws in 'Custer's Demand,'" *New York Herald*, April 21, 1903. The articles and letters pertaining to the *Custer's Demand* controversy can be found in the Carothers Collection, National Cowboy Hall of Fame, Oklahoma City, Okla.

31. Remington's offer was appended to the end of "Schreyvogel Right, Mrs. Custer Says," *New York Herald*, April 29, 1903.

32. John Schuyler Crosby, "'Mr. Schreyvogel Paints the Facts,'" *New York Herald*, May 2, 1903.

33. Eva Remington, letter to Powhatan Clarke, October 23, 1890, in Samuels and Samuels, *Frederic Remington: A Biography*, 144.

34. Remington, "Joshua Goodenough's Old Letter," 268, 269. The second quotation contains a clearly sexual subtext that could also be explored.

35. Remington, "Joshua Goodenough's Old Letter," 276.

36. Remington diary, September 20 and October 14, 1909.

37. There are many doubts concerning the authenticity of the signature on *Radisson and Groseilliers*. A strip of canvas, including Remington's original signature, was cut sometime from the bottom of the picture. The signature now on the painting was added subsequently, possibly by Remington himself (if he was responsible for cutting the canvas down, as perhaps he was, given his general dissatisfaction with the Great Explorers series). Even if the second signature is by Remington, at some later date the middle portion of the signature—specifically, the letters *ic Reming*—was reconstructed by an unidentified restorer (see David C. Bauer, letter to Sarah Boehme, undated, Buffalo Bill Historical Center, Cody, Wyo.). The most primary evidence of the signature now available—the "Frederic Remington" on the color illustration of *Radisson and Groseilliers* that appeared in the *Collier's Weekly* for January 13, 1906—I have reproduced in "'Doing the Old America': The Image of the American West, 1880–1920," in *The West as America: Reinterpreting Images of the Frontier, 1820–1920*, ed. William Treuttner (Washington, D.C.: Smithsonian Institution Press, 1991), 337.

Select Bibliography

Archival Sources

Homer Britzman papers, Colorado Springs Fine Arts Center, Colorado Springs, Colo.

Carothers papers, National Cowboy Hall of Fame, Oklahoma City, Okla.

Curatorial files, Woolaroc Museum, Bartlesville, Okla.

Frederic Remington diary, Frederic Remington library, and Frederic Remington papers, Frederic Remington Art Museum, Ogdensburg, N.Y.

Frederic Remington papers, Archives of American Art, Smithsonian Institution, Washington, D.C.

Frederic Remington papers, Owen D. Young Library, Saint Lawrence University, Canton, N.Y.

Leonard Wood diary and Leonard Wood papers, Library of Congress, Washington, D.C.

Books and Articles

Adams, Henry. *The Education of Henry Adams* (1907). New York: Random House, 1931.

Ala, Abu'l. *The Quatrains of Abu'l Ala*. Selected and translated by Ameen F. Rihani. New York: Doubleday, Page, 1903.

Archibald, James F. J. "What I Saw in the War: No. 7—True Heroism in the Muddy Trenches." *Leslie's Weekly* 88 (January 5, 1899): 9.

Bailey, Solon Irving. "Exploring the Southern Sky." *Harper's Weekly* 49 (September 2, 1905): 1268–69, 1284.

Ballinger, James. *Frederic Remington*. New York: Abrams, 1989.

Barthes, Roland. *Mythologies*. Trans. Annette Lavers. New York: Hill and Wang, 1972.

———. *S/Z: An Essay*. Trans. Richard Miller. New York: Noonday, 1974.

Baum, L. Frank. *The Wizard of Oz* (1900). London: Puffin, 1990.

Bigelow, Poultney. "The Russian and His Jew." *Harper's Monthly* 88 (March 1894): 603–14.

Boime, Albert. *The Art of Exclusion: Representing Blacks in the Nineteenth Century*. Washington, D.C.: Smithsonian Institution Press, 1990.

Brooks, Van Wyck. *The Wine of the Puritans: A Study of Present-Day America*. London: Sisley's, 1908.

Bryan, William Jennings. *Bryan on Imperialism* (1900). New York: Arno Press, 1970.

Burroughs, Edgar Rice. *A Princess of Mars*. New York: Grosset and Dunlap, 1917.

———. *Tarzan of the Apes* (1914). New York: Penguin, 1990.

Buscombe, Edward. *The BFI Companion to the Western*. New York: Atheneum, 1988.

Butler, Nicholas Murray. "The Revolt of the Unfit." In Brander Matthews, ed., *The Oxford Book of American Essays* (1913). Great Neck, N.Y.: Core Collections, 1968.

Clark, T. J. "Clement Greenberg's Theory of Art." *Critical Inquiry* 9 (September 1982): 150–62.

Conrad, Joseph. *Great Short Works of Joseph Conrad*. New York: Harper and Row, 1966.

———. *Heart of Darkness* (1902). Harmondsworth, Eng.: Penguin, 1973.

———. *Lord Jim* (1900). Harmondsworth, Eng.: Penguin, 1986.

Cooper, Helen. *Winslow Homer Watercolors*. New Haven: Yale University Press, 1986.

Cortissoz, Royal. "Frederic Remington: A Painter of American Life." *Scribner's* 47 (February 1910): 181–95.

Craig, Edward Gordon. *On the Art of the Theatre* (1911). New York: Theatre Arts Books, 1956.

Crane, Stephen. "The Bride Comes to Yellow Sky" (1898). In Crane, *The Open Boat and Other Stories*. New York: Dover, 1993.

Davis, Ronald. *Augustus Thomas*. Boston: Twayne, 1984.

Dijkstra, Bram. *Idols of Perversity: Fantasies of Feminine Evil in Fin-de-Siècle Culture*. New York: Oxford University Press, 1986.

Dippie, Brian W. *Remington and Russell*. Austin: University of Texas Press, 1982.

Dos Passos, John. *Manhattan Transfer*. Boston: Houghton Mifflin, 1925.

Doyle, Arthur Conan. *The Sherlock Holmes Illustrated Omnibus*. New York: Schocken, 1976.

Du Maurier, George. *Trilby*. New York: Harper and Brothers, 1894.

Fiske, John. *A Century of Science and Other Essays*. Boston: Houghton Mifflin, 1900.

Fitzgerald, F. Scott. *The Great Gatsby*. New York: Charles Scribner's Sons, 1925.

Foucault, Michel. The Archaeology of Knowledge *and* The Discourse on Language. Trans. A. M. Sheridan Smith. New York: Pantheon, 1972.

"Four Paintings by the Modern Artist Charles M. Russell." *Scribner's* 70 (August 1921): 146.

French, Lewis Sheldon, and Walter Camp. *Yale: Her Campus, Class-Rooms, and Athletics*. Boston: L. C. Page, 1899.

Fried, Michael. "Almayer's Face: On 'Impressionism' in Conrad, Crane, and Norris." *Critical Inquiry* 17 (Autumn 1990): 193–236.

———. *Realism, Writing, Disfiguration: On Thomas Eakins and Stephen Crane*. Chicago: University of Chicago Press, 1987.

Fussell, Paul. *The Great War and Modern Memory*. London: Oxford University Press, 1975.

Ginzburg, Carlo. "Morelli, Freud and Sherlock Holmes: Clues and Scientific Method." *History Workshop* 9 (Spring 1980): 5–36.

Goetzmann, William H., and William N. Goetzmann. *The West of the Imagination*. New York: Norton, 1986.

Grant, Orison Madison. *The Passing of the Great Race; or, The Racial Basis of European History*. New York: Scribner's, 1916.

Greenblatt, Stephen. *Marvelous Possessions: The Wonder of the New World*. Chicago: University of Chicago Press, 1991.

Hartmann, Sadakichi. *A History of American Art*. Vol. 2. New York: Tudor, n.d.

Hassrick, Peter. *Charles M. Russell*. New York: Abrams, 1989.

———. *Frederic Remington: Paintings, Drawings, and Sculptures in the Amon Carter Museum and the Sid W. Richardson Collections*. New York: Abrams, 1973.

———. *The Remington Studio*. Cody, Wyo.: Buffalo Bill Historical Center, 1981.

Hassrick, Peter, and Michael Shapiro, eds. *Frederic Remington: The Masterworks*. New York: Abrams, 1988.

Higham, John. *Strangers in the Land: Patterns of American Nativism, 1860–1925*. New York: Atheneum, 1968.

Horan, James. *The Life and Art of Charles Schreyvogel: Painter-Historian of the Indian-Fighting Army of the American West*. New York: Crown, 1969.

Hyslop, James. *Borderland of Psychical Research*. Boston: Herbert B. Turner, 1906.

Irwin, Wallace. *At the Sign of the Dollar*. New York: Fox Duffield, 1905.

James, Henry. *The American Scene* (1907). New York: Charles Scribner's Sons, 1946.

James, William. *The Principles of Psychology*. Vol. 1 (1890). New York: Dover, 1950.

Jameson, Fredric. *The Political Unconscious: Narrative as a Socially Symbolic Act*. Ithaca, N.Y.: Cornell University Press, 1981.

Johnson, Edward A. *History of Negro Soldiers in the Spanish-American War*. Raleigh, N.C.: Capital, 1899.

Jussim, Estelle. *Frederic Remington, the Camera,*

and the Old West. Fort Worth, Tex.: Amon Carter Museum, 1983.

Kaplan, Amy. "Black and Blue on San Juan Hill." In Kaplan and Donald Pease, eds., *Cultures of United States Imperialism*. Durham, N.C.: Duke University Press, 1993.

Karnow, Stanley. *In Our Image: America's Empire in the Philippines*. New York: Random House, 1989.

Kern, Stephen. *The Culture of Time and Space, 1880–1918*. Cambridge: Harvard University Press, 1983.

Kipling, Rudyard. *Just So Stories for Little Children* (1902). New York: Penguin, 1987.

———. *War Stories and Poems*. New York: Oxford University Press, 1990.

Lears, T. J. Jackson. *No Place of Grace: Antimodernism and the Transformation of American Culture, 1880–1920*. New York: Pantheon, 1981.

London, Jack. *The Call of the Wild* (1903). New York: Vintage, 1990.

———. *The Sea-Wolf* (1904). New York: Penguin, 1989.

———. *White Fang* (1906). In London, The Call of the Wild *and* White Fang. New York: Bantam, 1963.

Lubow, Arthur. *The Reporter Who Would Be King: A Biography of Richard Harding Davis*. New York: Charles Scribner's Sons, 1992.

Lutz, Tom. *American Nervousness, 1903: An Anecdotal History*. Ithaca, N.Y.: Cornell University Press, 1991.

Manley, Atwood, and Margaret Manley Mangum. *Frederic Remington and the North Country*. New York: E. P. Dutton, 1988.

Maxwell, Perriton. "Frederic Remington—Most Typical of American Artists." *Pearson's* 18 (October 1907): 393–407.

McCracken, Harold. *The Frederic Remington Book: A Pictorial History of the Old West*. Garden City, N.Y.: Doubleday, 1966.

McPharlin, Paul. *The Puppet Theatre in America: A History*. New York: Harper and Brothers, 1949.

Michaels, Walter Benn. *The Gold Standard and the Logic of Naturalism*. Berkeley: University of California Press, 1987.

Morelli, Giovanni. *Italian Painters: Critical Studies of Their Works*. Trans. Constance Jocelyn Ffoulkes. London: John Murray, 1900.

Morgan, William Michael. *Strategic Factors in Hawaiian Annexation*. Ann Arbor, Mich.: UMI Press, 1980.

Myers, Frederic. *Human Personality and Its Survival of Bodily Death*. Vols. 1 and 2 (1903). New York: Arno Press, 1975.

Nemerov, Alexander. "'Doing the Old America': The Image of the American West, 1880–1920." In William Truettner, ed., *The West as America: Reinterpreting Images of the Frontier, 1820–1920*. Washington, D.C.: Smithsonian Institution Press, 1991.

———. "Projecting the Future: Film and Race in the Art of Charles Russell." *American Art* 8 (Winter 1994): 71–89.

Nichols, Francis H. "A Marionette Theater in New York." *Century* 63 (March 1902): 677–82.

Norris, Frank. *The Responsibilities of the Novelist and Other Essays* (1903). New York: Haskell House, 1969.

———. *The Surrender of Santiago* (1899). San Francisco: Paul Elder, 1917.

Oriard, Michael. *Reading Football: How the Popular Press Created an American Spectacle*. Chapel Hill: University of North Carolina Press, 1993.

Ovid. *Metamorphosis*. Trans. Mary M. Innes. Harmondsworth, Eng.: Penguin, 1982.

Pickering, William H. "The Origin of Our Moon." *Harper's Monthly* 115 (June 1907): 125–29.

Poole, Ernest. "Cowboys of the Skies." *Everybody's* 19 (November 1908): 641–53.

Pope, Alexander. *Poetry and Prose of Alexander Pope*. Ed. Aubrey Williams. Boston: Houghton Mifflin, 1969.

Prown, Jules. "Mind in Matter: An Introduction to Material Culture Theory and Method." *Winterthur Portfolio* 17 (Spring 1982): 1–19.

———. "Style as Evidence." *Winterthur Portfolio* 15 (Autumn 1980): 197–210.

Ralph, Julian. *People We Pass: Stories of Life Among the Masses of New York City*. New York: Harper and Brothers, 1896.

———. *Towards Pretoria*. London: C. Arthur Pearson, 1900.

Remington, Frederic. *The Collected Writings of Frederic Remington*. Ed. Peggy Samuels and Harold Samuels. Garden City, N.Y.: Doubleday, 1979.

———. *John Ermine of the Yellowstone* (1902). Ridgewood, N.J.: Gregg Press, 1968.

———. *The Way of an Indian*. New York: Fox Duffield, 1906.

Roosevelt, Theodore. "Dante and the Bowery." In Brander Matthews, ed., *The Oxford Book of American Essays* (1913). Great Neck, N.Y.: Core Collections, 1968.

———. *History as Literature and Other Essays*. New York: Charles Scribner's Sons, 1913.

———. "In Cowboy-Land." *Century* 46 (June 1893): 276–88.

———. *The Rough Riders*. New York: Charles Scribner's Sons, 1906.

———. "The Round-Up." *Century* 35 (April 1888): 851–62.

———. "Sheriff's Work on a Ranch," *Century* 36 (May 1888): 39–51.

———. *The Strenuous Life: Essays and Addresses*. New York: Charles Scribner's Sons, 1906.

Russell, John. "A Popular Favorite, a Poor Reputation." *New York Times*, February 10, 1989.

Rydell, Robert W. *All the World's a Fair: Visions of Empire at American International Expositions, 1876–1916*. Chicago: University of Chicago Press, 1984.

Samuels, Peggy, and Harold Samuels. *Frederic Remington: A Biography*. Garden City, N.Y.: Doubleday, 1982.

———. *Remington: The Complete Prints*. New York: Crown, 1990.

Sekula, Allan. "The Body and the Archive." *October* 39 (Winter 1986): 3–64.

Shelley, Mary. *Frankenstein*. Harmondsworth, Eng.: Penguin, 1985.

Simmel, Georg. *On Individuality and Social Forms*. Ed. Donald Levine. Chicago: University of Chicago Press, 1971.

Sinclair, Upton. *The Jungle* (1906). New York: Penguin, 1985.

Slotkin, Richard. *The Fatal Environment: The Myth of the Frontier in the Age of Industrialization, 1800–1890*. Middletown, Conn.: Wesleyan University Press, 1986.

———. *Gunfighter Nation: The Myth of the Frontier in Twentieth-Century America*. New York: Atheneum, 1992.

Spassky, Natalie, et al. *American Paintings in the Metropolitan Museum of Art*. Vol. 2. Princeton: Princeton University Press, 1985.

Splete, Allen, and Marilyn Splete, eds. *Frederic Remington—Selected Letters*. New York: Abbeville, 1988.

Stoker, Bram. *Dracula* (1897). New York: Penguin, 1993.

Tatham, David, and Atwood Manley. *Artist in Residence: The North Country Art of Frederic Remington*. Ogdensburg, N.Y.: Frederic Remington Art Museum, 1985.

Thomas, Augustus. *The Print of My Remembrance*. New York: Charles Scribner's Sons, 1922.

———. "Recollections of Frederic Remington." *Century* 86 (July 1913): 354–61.

———. *The Witching Hour*. New York: Grosset and Dunlap, 1908.

"Under the Spreading Chestnut Tree." *Everybody's* 20 (April 1909): 581.

Vivian, Thomas. *The Fall of Santiago*. New York: R. F. Fenno, 1898.

Vorpahl, Ben Merchant. *My Dear Wister: The Frederic Remington–Owen Wister Letters*. Palo Alto, Calif.: American West, 1972.

Vorse, Albert White. "The Play's the Thing." *Scribner's* 26 (August 1899): 167–78.

Wheelock, Arthur K., Jr., et al. *Anthony Van Dyck*. Washington, D.C.: National Gallery of Art, 1990.

White, G. Edward. *The Eastern Establishment and the Western Experience: The West of Frederic Remington, Theodore Roosevelt, and Owen Wister*. New Haven: Yale University Press, 1968.

Wildman, Edwin. "Frederic Remington, the Man." *Outing* (March 1903): 711–16.

Wind, Edgar. *Pagan Mysteries of the Renaissance*. New Haven: Yale University Press, 1958.

Wister, Owen. "The Evolution of the Cow-Puncher." *Harper's Monthly* 91 (September 1895): 602–17.

———. *The Virginian* (1902). New York: Penguin, 1988.

Wyeth, Betsy, ed. *The Wyeths: The Letters of N. C. Wyeth, 1901–1945*. Boston: Gambit, 1971.

Index